From the Faraway Nearby

Georgia O'Keeffe
as Icon

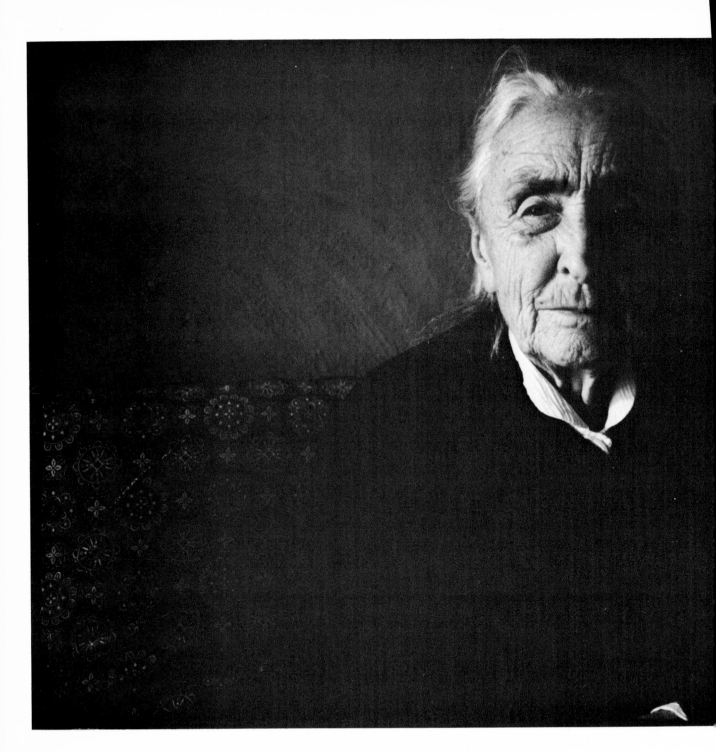

From the Faraway Nearby

Georgia O'Keeffe
as Icon

Edited by Christopher Merrill

& Ellen Bradbury

Addison-Wesley Publishing Company

Reading, Massachusetts Menlo Park, California New York
Don Mills, Ontario Wokingham, England Amsterdam Bonn
Sydney Singapore Tokyo Madrid San Juan
Paris Seoul Milan Mexico City Taipei

The essay "O'Keeffe and the Masculine Gaze" has been reprinted with permission from *Art in America* (January 1990).

The essay "Georgia O'Keeffe in Hawaii" has been reprinted with permission from *Georgia O'Keeffe: Paintings of Hawaii* (Honolulu Academy of Arts).

Part of the essay "O'Keeffe" has been reprinted with permission from *The Light Possessed* (Gibbs M. Smith Publisher, 1990).

The essay "From *Miss O'Keeffe*" has been reprinted with permission from *Miss O'Keeffe* (University of New Mexico Press, 1992).

Many of the designations used by manufacturers and sellers to distinguish their products are claimed as trademarks. Where those designations appear in this book and Addison-Wesley was aware of a trademark claim, the designations have been printed in initial capital letters.

Library of Congress Cataloging-in-Publication Data

From the faraway nearby : Georgia O'Keeffe as icon / edited by
 Christopher Merrill and Ellen Bradbury.
 p. cm.
 Includes bibliographical references and index.
 ISBN 0-201-57070-X
 ISBN 0-201-62476-1 (pbk.)
 1. O'Keeffe, Georgia, 1887–1986. 2. Painters—United States—
Biography. I. Bradbury, Ellen. II. Merrill, Christopher.
ND237.O5F76 1992
759.13—dc20
[B]
 91-36108
 CIP

Front cover photograph by Dan Budnik
Text design by Edith Allard
Set in 11-point Garamond by Compset, Inc., Beverly, MA

1 2 3 4 5 6 7 8 9-VB-96959493
First printing, August 1992
First paperback printing, October 1993

Contents

The Work

The Woman

Preface

From the Faraway Nearby: Georgia O'Keeffe as Icon is a composite biography, the work of many hands. A Recursos de Santa Fe seminar on the artist inspired this editorial undertaking; the essays, memoirs, and creative excursions on and through her life and work included here stem from our conviction that the story of a cultural icon like O'Keeffe might best be presented through a series of lenses. What follows, then, is a gathering of ideas, insights, and opinions about an extraordinary woman.

Divided into two sections, *The Work* and *The Woman, From the Faraway Nearby* alternates between meditations on the artist's achievement and considerations of the mythical figure behind the paintings. If one of the dangers of myth is that it may blind us to essential parts of the truth, then this book represents an attempt to come to terms with the various myths informing our understanding of O'Keeffe. Here are twenty writers—scholars, biographers, poets, and the like—working within or against the mythmaking tradition; in the tension between objective truth (the main points of which are outlined in the introduction) and myth we may discover a useful fiction by which to interpret and appreciate O'Keeffe's artistic legacy. The first section is a scholarly exercise in demythologization, the second a reflection on (and in some cases an extension of) the power of O'Keeffe's myths; together they may offer a broad-ranging view of this significant artist.

In the opening section James Kraft lays out the problems scholars still face in unraveling the mysteries in O'Keeffe's life and work, asserting the need for fuller disclosure of her correspondence, documents, and medical records. Anna

C. Chave, in a pair of essays, examines first the ways in which men have traditionally interpreted O'Keeffe's work, then her efforts to imagine the fact of New York onto canvas. Barbara Buhler Lynes picks up Chave's initial thread to suggest that sexual readings of her early paintings prompted O'Keeffe to abandon her spontaneous abstractions in favor of more controlled imagery—perhaps to her artistic detriment. Lisa M. Messinger takes issue with O'Keeffe's claim to originality in terms of subject matter, making a case for the numerous images she "borrowed" from her fellow artists, while Sharyn R. Udall studies the mystical elements of and influences on her work. Jennifer Saville sheds new light on paintings routinely dismissed by O'Keeffe scholars—that is, her work from Hawaii—and MaLin Wilson considers the business side of the O'Keeffe–Stieglitz partnership. Marjorie Welish closes this section with a meditation on O'Keeffe's shifting relationship to modernism, concluding that "territorial wars within the ideology of modernism place O'Keeffe within a conservative camp of the avant-garde, thus aggravating her retirement from the avant-garde and her fate within later twentieth-century art history."

Melissa Pritchard opens the second section with an essay on the difficulty of penetrating the "hagiographic mist" surrounding O'Keeffe, arguing that our task is "to get on with it: Life. The business of loss. Love." Alan Cheuse, Christopher Buckley, and Terry Tempest Williams offer imaginative improvisations on O'Keeffe's life and work, while Sue Davidson Lowe, John Poling, and Mary E. Adams present a different kind of trilogy—intimate views of O'Keeffe. Meridel Rubenstein recounts her own growth as an artist through the prism of O'Keeffe's example, explaining how the aging artist taught her "to dispel the notion—both for myself and others—that it is dangerous to be a woman artist—alone or in a relationship." Laurie Lisle discusses the problems she encountered writing the first O'Keeffe biography. Christine Taylor Patten and Alvaro Cardona-Hine recreate a crucial moment from the end of O'Keeffe's life, describing the machinations by which she was convinced to radically emend her will and sign over her estate to a young man who had cared for her—an emendation, it should be noted, her relatives would later successfully challenge in court. Finally, Marvin Bell addresses the artist's achievement in a poem especially commissioned for this book, a poem designed to counterpoint the exquisite photographs of O'Keeffe taken by Dan Budnik in 1975.

From the Faraway Nearby: Georgia O'Keeffe as Icon would not exist without the help of several individuals. Ellen Bradbury, my co-editor and Director of Recursos de Santa Fe, assembled the scholars and provided inspiration, as well as many of the ideas, for my introduction: she is in every respect the heart and soul

of this enterprise. Allene Lapides underwrote the seminar out of which this project springs; without her generosity *From the Faraway Nearby* would still belong to myth. James Kraft, Anna C. Chave, Barbara Buhler Lynes, Lisa M. Messinger, Sharyn R. Udall, Sue Davidson Lowe, Meridel Rubenstein, and Laurie Lisle contributed their essays and ideas to the Recursos seminar, insuring that the event would become a model of free and fruitful intellectual exchange. It was Ann Dilworth at Addison-Wesley who suggested we put this book together, suffered through our delays, then steered the manuscript toward production—all with good cheer. Debra Hudak managed the editing of our book, and Tiffany Cobb supervised its production; their good-natured questions made my work both pleasant and interesting. Timothy Schaffner, my agent, offered his usual expertise and wit. Janie Dorman transcribed several talks from the Recursos seminar, Mary Van Ness typed the various versions of these writings, and Susan Kennedy proofread the entire manuscript. The Reverend Doctor Andrew M. France, Jr., and Dr. Robert O. France, my uncles, guided me through the dark woods of speculation about O'Keeffe's medical history, while Linda Asher and Frederick Turner read and critiqued my introduction: my thanks to all of them for their ideas and discrimination. Thanks, too, to Ed Reid, Ellen's husband, and to my wife, Lisa, for their constant support: *From the Faraway Nearby* is lovingly dedicated to them.

Christopher Merrill
Santa Fe, New Mexico

Introduction

"The intellect of man is forced to choose," William Butler Yeats wrote, "Perfection of the life, or of the work"—lines often cited to explain or absolve the turbulent lives of certain artists and writers. If a central feature of the modern age is the divorce between life and work, in our time we have learned to accept—even to celebrate—the way that split can foster self-destructive behavior, particularly in artists. Because such figures may sacrifice everything—health, sanity, life itself—in the name of art, we imagine their work possesses another level of meaning. And indeed it does for artists like Jackson Pollock and Mark Rothko, John Berryman and Robert Lowell, Charlie Parker and John Coltrane. The spectacle of an artist's martyrdom fascinates us.

Yet we are equally drawn to those, like Georgia O'Keeffe, who seem to refuse to distinguish between perfection of the life and work. We admire her as much for how she lived as for her paintings; the values we ascribe to her—independence, integrity, devotion to her craft—may be as important as her flowers, bones, and doors, which have assumed their places in the history of art. For we believe she made her life an integral part of her work, becoming in the process one of America's most famous artists, a cultural icon, almost a mythical figure.

And myths abound concerning her life, some of which she helped create, others foisted on her by the public. What they add up to is an alternative to Yeats's axiom, a myth especially suited to women artists, offering a model for how to live, work, and weather change in the heretofore male-oriented art world. Unlike the myths that have grown up around Sylvia Plath's tragic career, O'Keeffe's myth seems determined to embrace the whole of life, not reject it.

Hers is a healthy, sane, and ultimately redemptive vision, according to the myth.

Like all myths, however, O'Keeffe's tells only part of her story, which is at once sadder and more complex than we might suspect, richer—and more tragic. Although she was in the limelight for over sixty years—her fame extended from the Roaring Twenties into the Slumbering Eighties—and was an artist committed to "making the unknown known," much about her remains unknown, partly because she wanted it that way, and partly because her fabled reserve was—and continues to be—useful in the marketing of her paintings. O'Keeffe was one of the most frequently photographed figures of our time, an intellectual pinup girl of sorts, and still she is an enigma; despite a rash of biographies, she seems to elude us, which may help explain our enduring interest in her.

"Finally, a woman on paper," is what Alfred Stieglitz supposedly remarked the first time he saw O'Keeffe's work—an insight shared by countless people around the world. But who was this woman, and what did she create? Did she heal the split between her life and art? Why does she continue to claim so much of our attention? What we know—apart from the facts ticked off in one book after another, the myths and legends (which alternately illuminate and obscure our sense of her), the sheer power of her work—is that she was an artist who favored intuition and inspiration over the prerogatives of the intellect, painting in an original fashion the story of her emotional life, inventing on canvas a language accessible to a broad range of the public. And she fascinates us.

Born 15 November 1887 near Sun Prairie, Wisconsin, Georgia Totto O'Keeffe was the second of seven children. Her father, Francis O'Keeffe (1853–1918), a prosperous farmer and feedstore owner (and sometime traveler into the wilderness), instilled in her a love of landscape and a taste for adventure. Ida Totto (1864–1916), her strong-willed mother, encouraged her artistic pursuits, teaching her to take pleasure in the life of the mind—a necessary counter to prevailing attitudes on the prairie. Hardworking and frugal, nevertheless the O'Keeffes provided art and music lessons for their daughters, the most gifted of whom was Georgia. She was from the beginning a domineering presence, a child who could command her siblings' attention, and as early as the eighth grade she decided to be an artist.

On the wide expanse of the prairie, encountering nature in all its splendor, she would learn, as Frederick Turner writes of Thoreau, to look "so deeply into a natural fact that at last it reveals its hidden spiritual dimension." Nature would

become for her a constant source of inspiration. When in high school she painted a jack-in-the-pulpit, discovering that an object from the natural world might correspond to her own aesthetic and emotional needs, Georgia set the stage for her later famous flower paintings, which would secure her reputation among the first rank of American artists.

"When you take a flower in your hand and really look at it," she once said, "it's your world for the moment"—a discovery artists and poets since the dawn of romanticism have made for one natural fact after another. "Say it: no ideas but in things," William Carlos Williams asserted. And in her greatest paintings that is what O'Keeffe accomplished: it is the crisis of the object, the way she translated her ideas and passions into flowers, shells, and bones, that still holds our attention. Like Auguste Rodin and Rainer Maria Rilke, Marianne Moore and Paul Strand, she learned to invest the things of the world with her hunger for the truth.

It was also in high school that Georgia found herself uprooted from her native landscape and thrust into a society alien to her deepest instincts—a pattern that would follow her until she was in her sixties. Francis O'Keeffe, tired of the prairie's harsh climate and hoping to avoid the threat of tuberculosis, sold his fields and moved his family to Williamsburg, Virginia—where his luck ran out. He failed at a string of business ventures, forcing his family to take in boarders. Soon his wife contracted (ironically) a terminal case of TB. Georgia suffered as well the loss of security that comes from being grounded in a particular landscape. For the next forty years she would shuttle between the open spaces of the West and the intellectual excitement of the East, drawing artistic and emotional sustenance from her excursions into the hinterland, then returning to New York to study, work, and carry on the social and commercial obligations of a successful artist. Now she was an outsider among the polite young women of Williamsburg, a maverick in her new society.

Isolation, of course, may be useful to an artist, and Georgia was not one to duck such a challenge. "I'm frightened all the time," she later declared. "Scared to death. But I've never let it stop me. Never!"[1] Instead, she used the various kinds of tension informing her life—the East–West, city–country dichotomy, for example, or her urge for independence versus her need for love—to her artistic advantage. Like the polarities between, say, her interest in abstraction and exploration of realism's limits, tension was at once fruitful for her work and no doubt difficult to synthesize in her life. Painful as the move to Virginia must have been, surely the ensuing dislocation speeded up her artistic development.

Likewise, the encouragement of Elizabeth Mae Willis, the principal and art

teacher at Chatham Episcopal Institute, where Georgia completed her high school education. Willis allowed the young artist to follow her impulses. "When the spirit moves Georgia," she told her other students, "she can do more in a day than you can do in a week."[2] At the same time, Willis served as a role model—a woman trained to be an artist. When in September 1905 Georgia entered the School of the Art Institute of Chicago, she did so thanks in large part to her teacher's insistence that she focus on her work.

Her studies there with John Vanderpoel, however, were cut short after only a year: a serious bout with typhoid nearly killed her. Not until the fall of 1907 did she resume her apprenticeship—with William Merritt Chase (1849–1916), at the Art Students League in New York. He instructed his pupils to execute a painting a day, a regimen that may make budding artists more receptive to the materials of their medium, more technically adept, and less fearful of the consequences of failure; the process becomes more important than the product. Georgia learned to paint quickly, and although she kept none of her daily exercises, she acquired enough skill to last a lifetime.

Chase also encouraged his students to "seek to be artistic in every way"— in dress, manners, and conduct—intertwining their lives and work. This was a lesson Georgia never forgot: her simple yet elegant style of dress, the studied image of herself she presented to the world, the spareness of her interior decorating, the care with which she hung paintings—all testify to her determination to live artistically. And that spirit, along with her striking looks, made her a favorite among her male classmates, an ideal candidate for modeling—a role she played with mixed feelings, since it suggested to both the painter and herself that her own artistic ambitions were less important than her beauty. One classmate, Eugene Speicher, told her (after she had declined his request to pose for him), "It doesn't matter what you do. I'm going to be a great painter, and you will probably end up teaching in some girls' school."

Soon his words would seem prophetic—at least as far as Georgia was concerned. She had only enough money to cover a year of study in New York, and when that ran out she took a position as a commercial artist in Chicago. Once again illness shortened her stay in the Midwest; in 1910 she was stricken by measles, which temporarily weakened her eyes and sent her back to Virginia, where the following spring she started teaching at her alma mater. The next several years were crucial to her artistic development. Isolated from the art world, teaching in such remote places as Amarillo, Texas, and Columbia, South Carolina, she liberated herself from the aesthetic conventions her own teachers had imposed on her.

An artist's apprenticeship usually begins with lessons geared toward mastery of the technical skills necessary for the chosen medium, and ends with what may be a lifelong effort to unlearn some of those lessons—that is, to overcome the teachers' influence(s). It is as if a young artist learns a language—or sequence of languages—based on color, line, and form, only to discover that to speak with authority he or she must create an altogether new language. This Georgia came to understand, partly because she had the good luck to spend the summers of 1912 through 1916 studying with, then teaching alongside, Alon Bement at the University of Virginia. Bement, a disciple of Arthur Wesley Dow, introduced her to a radically different idea of art. "Dow taught that through the artist's selective orchestration of format and compositional elements (line, shape, color, value)," Lisa M. Messinger explains, "each subject's true identity could be revealed. Harmony and balance were the key words in his theories." And O'Keeffe took these words to heart.

Bement broadened her intellectual horizons, too. She read—twice—Wassily Kandinsky's *Concerning the Spiritual in Art* (1922), learning that the artist must "endeavor to awake subtler emotions, as yet unnamed," a task that would occupy her for the better part of her career. The urge to name the nameless led her to New York to study with Dow himself, enrolling in 1914 at Teachers College, Columbia University. There she met Anita Pollitzer, who became one of her closest friends; together they visited Alfred Stieglitz's Little Galleries of the Photo-Secession (commonly known as "291"), where they saw the works of artists like Braque, Picasso, and John Marin. But it was Stieglitz, the pioneering photographer and tireless promoter of new art, who would have the strongest influence on Georgia. Stieglitz's 291 was the vibrant center of his efforts to educate the American public about its artistic resources; the gallery was for her an ideal, like its impresario. To Anita she confided:

I believe I would rather have Stieglitz like something—anything I had done—than anyone else I know of—I have always felt that—If I ever make anything that satisfies me even ever so little—I am going to show it to him to find out if it is any good. Don't you often wish you could make something he would like?[3]

Her wish was granted. In the fall of 1915, teaching at Columbia College in South Carolina, she discovered the outlines of her unique artistic vision. Her breakthrough was a series of charcoal drawings she completed on the floor of her room, often working late into the night. Inspired by Dow's teachings, natural

forms, and a romantic attachment to Arthur Macmahon, a political science scholar she had met in New York, in these abstractions she called "Specials" Georgia tapped materials that seemed to spring directly out of her unconscious. These were her first notes toward a fiction of the female self, and there was something almost automatic about the lines traced across the paper, as if her drawing hand had been guided by chance. A letter to Anita records the excitement with which she explored the materials of both her medium and her self:

I've been working like mad all day—had a great time—Anita, it seems I never had such a good time . . . I worked till my head all felt tight in the top—Then I stopped and looked, Anita—and do you know—I really doubt the soundness of the mentality of a person who can work so hard—and laugh like I did.[4]

Anita immediately recognized the power of the *Specials.* On New Year's Day, 1916, she showed her friend's drawings to Stieglitz, who called them "the purest, finest, sincerest things that have entered 291 in a long while." He and Georgia started trading letters—the first in what would be a voluminous correspondence. In March she resumed her studies at Teachers College; in April she saw Marsden Hartley's work at 291; and in May, much to her surprise, she had her first public exhibition, in a group show at 291. Stieglitz had hung her drawings on his walls—without her permission. She demanded to know why. "You have no more right to withhold those pictures," he told her, "than to withdraw a child from the world."[5] By the time she left the city to teach again at the University of Virginia, she was considered an artist to watch.

But she had trouble working in Virginia. Her mother had died in May (after years of failing health), and Georgia's grief on her return home was insuperable. For several days she was too depressed even to leave her bed. Roxana Robinson, in *Georgia O'Keeffe,* makes a telling point about the emotional repercussions of this loss:

A more somber and ominous indication of her psychological state was revealed by a sudden and unprecedented antipathy. For Georgia the landscape had been a perennial source of nourishment, a metaphorical restorative, reliable, soothing, necessary. . . . After Ida's death there is a sudden change: "It has been wonderful weather here—cool—and rain—so that everything is wonderful heavy dark green—and the green is all so very clean—but I hate it."[6]

Turning—in grief—against a landscape she had once loved was her way to distance herself from overwhelming pain; this would not be the last time she grew to hate the "wonderful heavy dark green."

Over the summer Georgia recovered enough to begin painting again, first a series of simple blue watercolors, then one of plumes. Dow's idea of "filling space in a beautiful way," which would become Georgia's motto, helped pull her through this crisis. At the end of August she left Virginia to head the art department at West Texas State Normal College, where she was confronted with enormous spaces to fill—in her life, her work, and in the spare, relentless landscape she came to love.

In the small community of Canyon this newcomer quickly earned a reputation as an eccentric. She wasn't afraid to teach in an unorthodox manner, instructing her students to draw from the life around them, not from their textbooks. (At least one of her unusual subjects for classroom studies in still life—bones found in the desert—would figure prominently in her later work.) Nor did she fear censure for organizing expeditions into Palo Duro Canyon, entertaining unmarried men in her room (including one of her students), or voicing pacifist opinions about World War I. She had her sights set on different matters.

She was reading widely in Ibsen, Dante, and Nietzsche, formulating new ideas about a woman's, especially a woman artist's, place in society. She was reading, too, Stieglitz's publications—*291* and *Camera Work*—and his letters to her; that year he replaced Arthur Macmahon as the central presence in her imagination. Stieglitz was her symbol of the art world, and in the spring he put together her first solo exhibition at 291, a show containing the series of blue watercolors, a phallic sculpture, and several landscapes inspired by her journeys into Palo Duro Canyon. Though she could not get to New York in time to see what would be Stieglitz's last hurrah at 291, he rehung her work to give her a private viewing of the exhibit, which had taken the art world by surprise. "Miss O'Keeffe," the critic Henry Tyrrell had written in the *Christian Science Monitor,* "independently of technical abilities quite out of the common, has found expression in delicately veiled symbolism for 'what every woman knows' but what women heretofore have kept to themselves, either instinctively or through a universal conspiracy of silence."[7]

Stieglitz also tried to tease out that secret, taking the first of hundreds of photographs of her that spring. Before she left the city to travel through the Southwest with her younger sister Claudia, she must have known her artistic destiny was becoming tied to this man who had been born in the same year as

her mother. Returning to Canyon (Her trip to New Mexico had left a lasting impression: "I loved it immediately," she said later of Santa Fe. "From then on I was always on my way back."), she received from him a barrage of letters encouraging her to come East. Struck down by influenza, in February she gave up her teaching responsibilities and moved with a woman (with whom she may have had an affair) to Waring, then to San Antonio. During her sick leave Stieglitz sent fellow photographer Paul Strand (1890–1976) out to rescue her. The young photographer fell for Georgia, and although her heart went out to him, by June they were back in New York.

She moved into a studio apartment belonging to Stieglitz's niece. There Stieglitz took his most erotic photographs of her, and when his wife caught the artist and his model in a suggestive pose, insuring that their recent separation would now end in divorce, he moved into the apartment, too. In August the lovers went to his family home at Lake George, where his mother warmly embraced his mistress, having long since turned against his wife. When Georgia began preparing to return to Canyon, Stieglitz asked her what she most wanted: a year to paint full-time.

"All right," he said, "I'll manage it for you."

Theirs was no ordinary creative collaboration. Unlike the famous partnerships of Wordsworth and Coleridge, or Braque and Picasso, professional and spiritual unions that lasted only a few years, O'Keeffe and Stieglitz stayed together for almost thirty. She was by turns his discovery, fellow artist, model, lover, wife, business partner, widow, and executor. To the art world she was his creation: he showed her work at his various galleries, presented in his own photographs of her a carefully constructed image of a woman and an artist, and controlled the sale of her paintings in a manner consistent with her reserve, establishing for her work the best possible market conditions. His work and ideas inspired her; his approbation gave her courage. If it is true he became a suffocating presence she had to free herself from to preserve her identity, it is also certain he offered her the validation she needed to become an artist as well as the sanction the predominantly male-oriented art world required in order to recognize a woman's achievement. They had a dynamic relationship, which inspired them to produce exceptional work.

"When I make a photograph," Stieglitz once remarked, "I make love." And that is what we feel in front of his portraits of O'Keeffe. In these compositions the line often blurs between aesthetic and erotic elements, leaving some viewers uneasy. Similarly, the large flower paintings she completed in those early, fevered years with Stieglitz make statements we are still learning to accept without blushing. Together they explored and celebrated in their respective me-

diums a whole range of emotions, including delight in their sexuality—a discovery particularly suited to the age of Freud. His photographs of her record the waxing and waning of their feelings for each other, beginning with declarations of her beauty and his virility, and ending in visions of isolation and abandonment. What makes her work so compelling is that she remained true to the spirit of the erotic and passionate vision she shared with Stieglitz—even after her passions cooled. They created maps of uncharted emotional terrain: a world of intimacy shared by two powerful artists.

Consider, for example, in *Pink Sweet Peas* (1927) the way magnification of the subject allows O'Keeffe to concentrate on the delicate folds of each petal; how the cropping Strand and Stieglitz had introduced into photography abstracts this image until it can suggest a number of different readings and associations; why the shadows crisscrossing the canvas seem at once mysterious and transparent: now you see me, now you don't. Throughout her career she routinely dismissed sexual readings of her flower paintings. Even so, it would be foolish to deny the erotic nature of her vision: part of her originality resides in the fact that in her passionate affirmation of the world she didn't ignore the sexual side of life. Although she discouraged such ideas about her work—what artist doesn't turn a blind eye to his or her sources?—in her calla lilies, black irises, and larkspurs it is difficult not to feel a certain sexual excitement. How else are we to explain the ongoing battles over Freudian interpretations of her paintings?

In New York, O'Keeffe and Stieglitz established in short order patterns that would serve them well into the future. They dressed in black and took their meals together in local cafeterias. While he wrote letters, attended to business at a succession of galleries—the Anderson Galleries, the Intimate Gallery, then An American Place—and worked behind his camera, she painted. She also managed their various households—a string of apartments in the city and the house at Lake George—and cared for Stieglitz, who became her husband in 1924. A social magnet (and hopeless incompetent vis-à-vis daily life), he attracted some of the most interesting figures of the day. Strand, Marsden Hartley, John Marin, Arthur Dove, Charles Demuth, William Carlos Williams, Marianne Moore, Sherwood Anderson, Carl Van Vechten, Jean Toomer—the list of artists and writers who regularly gathered to hear Stieglitz preach the coming of an indigenous American art reads like a Who's Who of modernism. And O'Keeffe, silent in the midst of all that talk, must have found it exciting—at least in the beginning. An artist coming into her own, she was living with a charismatic man, and she was famous. What more could she want?

Children. Her *own* family—not Stieglitz's large extended family, which for

a solitary figure like O'Keeffe grew difficult to endure. But Stieglitz was opposed to fathering another child. He had a preternatural fear of childbirth: his favorite sister, Flora, had died bearing a child, and his daughter, Kitty (from whom he was estranged because of O'Keeffe), spent most of her adult life institutionalized, unhinged by postpartum depression. Moreover, caring for a child, he was convinced, would diminish O'Keeffe's artistic output. She argued a family would fulfill her. He claimed to be too old to start again. She remained childless—to her regret.

There were other problems. As she grew older, more independent, and sure of her own ideas, his talk began to weary her; during the nightly gatherings in their living room she would sit by herself in a corner, sewing. Their hectic entertaining schedule spilled over into their time at Lake George; she had no relief from social obligations. Worse, Stieglitz had an eye for younger women. The photographs he took of Paul Strand's wife, Rebecca, suggest his interest in her was more than aesthetic. Other indiscretions O'Keeffe brushed aside, though his behavior must have hurt her deeply. Finally, in 1926 Dorothy Norman, a young woman in an unhappy marriage, started to visit Stieglitz at the Intimate Gallery. Soon she was his confidante, partner in the establishment and daily managing of An American Place, and much more.

O'Keeffe's biographers and critics trace her gradual withdrawal from Stieglitz and the New York art world to his affair with Norman. But her retreat to the high desert country of New Mexico isn't just the story of a woman spurned. What every writer on O'Keeffe has overlooked in assessing the changes she underwent in the late twenties and early thirties is the significance of a far more traumatic event—a tragedy that, coupled with her husband's interest in another woman, profoundly altered her life, outlook, and art.

In August 1927 she entered Mt. Sinai Hospital in New York to undergo surgery for the removal of a benign lump in her breast. Out of that experience came her ghostly *Black Abstraction,* a painting inspired by a vision in the operating room of the overhead light shrinking and whirling away from her as she tried—in vain—to ward off the effects of anesthesia. Even then O'Keeffe knew her life would never be the same: historians remind us that medical practices in those days were relatively primitive, and the standard surgical procedure for the removal of a lump amounted to mutilation of the breast. Even a simple lumpectomy would result in disfigurement; no doubt O'Keeffe was scarred, physically and psychically, by her operation. And when she reentered Mt. Sinai in December to have another lump removed from the same breast, there is reason to believe her doctors performed more invasive surgery, maybe even a mastectomy.

Her medical records are sealed, and although some of her scholars insist that a mastectomy was performed only much later in her life, the superficial evidence suggests she may have had such an operation then. Why else did it take her so long to recover from her second stay in the hospital? And if, as seems unlikely, in both cases she had nothing more than lumpectomies, it is important to remember that those procedures would have left her scarred, perhaps severely.

Thus 1928 finds O'Keeffe in a fragile state. Here was a woman whose beauty had been intertwined in her artistic destiny—think of Stieglitz's photographs of her in front of her paintings—and now she was at once disfigured and displaced in her husband's affections. (Within a few years, as if to compound his wife's pain, he would begin photographing Dorothy Norman in some of the same suggestive poses O'Keeffe had made famous.) Returning to Lake George that spring, devastated by her losses, she wrote to the critic Henry McBride:

I try to remind myself I am here—in the country—that there are things one always does here—but I feel in a sort of daze—I don't seem to remember that I am here—and it is most difficult to remember how to wind up the machinery necessary for living here . . . I look around and wonder what one might paint—Nothing but green—mountains—lake—green . . . and Stieglitz sick.[8]

This is much the same language O'Keeffe used to describe the Virginia countryside after her mother died. Again her grief was overwhelming; two weeks later she left, alone, for the coast of Maine, where she walked the beach or "slept and slept and slept." Now she seemed to live by necessity, out of her instinct to survive. Lake George was more than she could bear that summer; in mid-July she boarded a train for Wisconsin. Hers was a journey into her past, toward the embrace of childhood, where she might heal herself enough to face another year with Stieglitz. She headed for what was familiar.

Back in the Midwest with her sister Catherine, she painted the first of a series of barns, declaring later that her sister's work was in some ways better than her own—less self-conscious perhaps. But O'Keeffe was a professional: that is, she knew too much to paint like a naïf. And she had responsibilities she couldn't ignore. In mid-August she returned to Lake George: Stieglitz wasn't well. When he suffered a mild heart attack in September, she assumed a role she would play with increasing frequency—nurse. That fall, then, she had little time to paint; even before her annual show opened in the winter she told

McBride she didn't "want to exhibit again for a long, long time." Stieglitz had hurt her to the quick, and she had lost a reason for painting. Although she would never divorce him, for her own survival she had to put distance between herself and Stieglitz. She needed a change of scenery, new subject matter. These she would find the next spring when she accepted an invitation from the writer Mabel Dodge Luhan (1879–1962) to visit her in Taos, New Mexico. It was only a matter of time before the high desert became the emotional and imaginative base for her life, her work.

In May 1929 O'Keeffe and Rebecca Strand traveled to the Southwest—the land D. H. Lawrence (1885–1930) was celebrating in poems, fictions, and essays. "The moment I saw the brilliant, proud morning shine high up over the deserts of Santa Fe," the British writer declared, "something stood still in my soul, and I started to attend." What did O'Keeffe attend to? Bones, hills scorched clean by wind and weather, the indigenous Native American and Hispanic cultures. Here was a landscape stripped down to its essentials—harsh, dry, clear. "In the magnificent fierce morning of New Mexico," Lawrence wrote, "one sprang awake, a new part of the soul woke up suddenly, and the old world gave way to the new."

What gave way for O'Keeffe was a kind of innocence. Just as her country was about to suffer an economic depression, which would change forever its sense of itself, so the artist entered a period of mourning punctuated by severe bouts of depression. She spent parts of each of the next several years in New Mexico, quickly abandoning Taos (Mabel Dodge Luhan, an eccentric collector of husbands, lovers, and artists, heaped even more social pressures on her than Stieglitz had) for Ghost Ranch, a dude ranch north of Abiquiu.

Her imagery changed dramatically. The years 1929 through 1933 were instrumental in her artistic development; painful as they were—and listless as she often felt—these were years of genuine growth. "It was a time when she was scraping down her life to its sparest, hardest essence, when she was removing the soft tendrils of emotion, cutting out the tender core of vulnerability," Roxana Robinson writes. "That was the moment in which she chose to paint the bones."[9] And she made other discoveries in terms of subject matter: the clamshells from her solitary visits to the coast of Maine; small artificial flowers suspended in space, cut off from any attachment to living things; the black Penitente crosses dotting the hills of northern New Mexico—signs of a religion distorted by its isolation from traditional Catholic priests; the heavy adobe church in Ranchos de Taos—a haven from her passions; wizened sunflowers and poisonous jimsonweed. These are the subjects of an artist with a new relationship to her work.

From the Faraway Nearby

12

Not that she was comfortable with this change. Robert Frost called poetry "a momentary stay against confusion," and O'Keeffe's paintings from this period were stays against a form of confusion that would eventually undermine her. Everything had been taken from her, except her ability to paint. Art would become her refuge, though not before she suffered a terrible collapse. In the five years between her operations and her nervous breakdown of 1933, she created some of her finest work, reading nature so brilliantly that it seems she was inspired to paint beyond the limitations of her grief and find her way to an adequate expression of universal longing and loss.

The immediate cause of her breakdown was her failure to complete a large mural commissioned by Radio City Music Hall. In fact, she had no control over the many problems built into this project. But she was in such a nervous state that any failure, especially artistic failure, was enough to send her over the edge. She plunged into an abyss out of which she wouldn't climb for almost a year—a year in which she painted nothing. Often she couldn't stand the sight of Stieglitz; much of her recovery—in Bermuda, at Lake George, and elsewhere—she effected on her own. Only when the writer Jean Toomer (1894–1967) stayed with her over Christmas at Lake George did O'Keeffe begin to revive. "I seem to have come out of my daze into another world today," she wrote him after he left, "feeling very good—as tho there is nothing the matter with me any more. Thank you." Half in love with Toomer, still she was resigned to working out her destiny on her own; she didn't want to risk another emotional attachment.

Her breakdown had other consequences. "While she was in the hospital," Robinson notes, "water took on a peculiar horror, threatening and terrifying, as did Stieglitz. The yielding, soothing, beneficent element, intimacy and sensuality, had betrayed her. Thereafter most of the landscapes she painted were arid."[10] Surely her new surroundings played a central role in her decisions after 1933 to explore aridity in her work. But it is also certain O'Keeffe found her spiritual nourishment in the desert. If water is the feminine principle, a symbol of fertility and imagination, no wonder O'Keeffe turned against it; wounded in more ways than she perhaps knew, she repudiated much of what she had loved in the first half of her career. It is as if the excitement and abundance represented by Stieglitz, the New York art world, and the "wonderful heavy dark green" of the eastern countryside demanded from her a counterweight—a life and landscape stripped bare of all affections and ornaments.

New Mexico was the perfect place to settle. Once the site of enormous volcanic activity, the calm Rio Grande Rift is covered with signs of the geological events that shaped this land—soft volcanic tuft, sheer cliffs, chalk-colored hills, the red earth, bottleneck-shaped mountains like Pedernal, which O'Keeffe

painted again and again. What better backdrop for an artist retreating from her own volcanic passions? Over the next fifty years, in images of bones and pelvises, doors and lonely roads, hills and clouds, she worked out her artistic destiny. "I think I only crossed him," she would say of Stieglitz, "when I had to—to survive." And survive she did, asserting in her last years that "the painting is like a thread that runs through all the reasons for the other things that make one's life."[11] Art was now her sanctuary, her commitment to painting a form of religious devotion.

From the Faraway Nearby (1937) is a good example of her work in New Mexico. Here an elk's skull and antlers dominate space in the same way as her magnified flowers, foreshortening perspective to disrupt our habitual ways of seeing the thing itself. Barely anchored to the earth—a series of hills, mesas, and ridges in bluish-white, rose, white, and ocher—the skull and magnificent rack of antlers occupy the whole sky. The skull's expression, fragmented and incomplete, is at once malevolent and sardonic, indifferent and bemused; the surreal juxtaposition of bones and hills nevertheless obeys a ruthless logic—the logic of death-in-life. The flowers have been replaced by a skull. And the element of surprise makes this painting both haunting and slightly comic: our response to it may well be mixed, as our response to O'Keeffe herself so often is. This work is emblematic of her efforts to "make the unknown known"—that is, to make the faraway seem close at hand. She reordered our perspective by focusing on what at first glance was most remote in daily life, enlarging our understanding of an object's significance.

O'Keeffe's next important discovery was the series of pelvises she worked on from 1943 to 1945, directly addressing the consequences of childlessness. "I am moving it seems—more and more toward a kind of aloneness," she had written a year after her breakdown, "not because I wish it but because there seems no other way."[12] Now she found images adequate to her increasing sense of barrenness and isolation, which was reinforced by Stieglitz's death in 1946.

Despite the damage to their marriage, in certain ways they had remained close, trading daily letters during the extended separations they faced every year until the end of his life and otherwise caring for each other in a loving manner. They had made adjustments, had done what was necessary. And now she did the same, turning to the monumental task of settling his estate, carefully inventorying his extensive collection of other artists' work as well as his own, then deeding everything, including his private papers and correspondence, to various museums and to the Beinecke Library at Yale. This arduous undertaking she completed over the course of three winters, during which she painted very little.

Difficult as it must have been, still she worked to insure that his memory and artistic achievement not be slighted. Just as she had learned to cultivate her public persona, a mask partly created by Stieglitz, so now she retained complete control over public access to his work and papers. (Ironically, her strictures limited—and continue to hamper—scholarship about him, impairing our understanding of his achievement and importance.)

By 1949 O'Keeffe was firmly ensconced in New Mexico. Renovations on the rundown house she had bought from the Catholic church in 1945 were largely complete, and thus she had a winter residence to complement her house at Ghost Ranch. Isolated from most of the artists in Taos and Santa Fe, she made friends with the second generation of prominent American photographers, notably Ansel Adams and Eliot Porter, accompanying them in the next decade on camping and river-rafting trips throughout the West. And she traveled all around the world—to Paris (where she passed up a chance to meet Picasso), Rome, the Middle East, Mexico, Peru, and the Orient; until age ninety-six she spent part of every other year exploring foreign countries. Flight exhilarated her: "What one sees from the air," she wrote, "is so simple and so beautiful I cannot help feeling that it would do something wonderful for the human race—rid it of much smallness and pettiness if more people flew." And out of such journeys came her *Rivers Seen from the Air* paintings of the late fifties and in the early sixties a series of cloud paintings.

At the same time, her life took on a more domestic air. In New York she and Stieglitz had dispensed with the trappings of a "normal" marriage—cooking for themselves, raising a family, and so on. But in New Mexico, O'Keeffe eagerly sought out what had been denied her in marriage. She became a gourmet, and her interest in children was immense. She donated a gymnasium to the local parish, paid college tuition and expenses for several young people from Abiquiu, and gradually assumed a matriarchal role in the village. It is true that the quality and quantity of her work fell off after Stieglitz's death—another sign that his presence, the tension and anger he caused her to feel even from afar, was good for her art, if not always for her life. Perhaps in New Mexico she found a measure of happiness, which took the edge off her painting. She had nothing more to prove to her husband, nor did she worry about the New York art world (which, in any case, was more interested now in the abstract expressionists): her fame was secure. And she had more than enough money to live well, thanks to the tireless efforts of Doris Bry, who had taken over Stieglitz's job of selling her work.

Thus, she had little reason to risk, either emotionally or aesthetically, new

voyages into the unknown—a fact she addressed openly in what is for this viewer her last great series, *In the Patio*. In canvas after canvas an invitation is delivered in the form of the door in her patio. These are doors, which in their stark black facades seem locked, to rooms she will no longer enter, rooms in which she might have risked love again. Like the barred doors and windows of the barns she painted in the thirties, these works point to a world she will not wander through again. Like her images of clamshells, bones, and pelvises, these doors haunt.

Yet in her life O'Keeffe was not afraid to open certain doors. Rumors abound of her bisexuality, and she had close, if tempestuous, relationships with women like Maria Chabot and Jerrie Newsome, who served her in a variety of ways, ranging from helpmate and housekeeper to friend. She had countless visits from the famous and near-famous, from public figures like singer Pete Seeger and actress Jane Alexander to hordes of young artists determined to learn from her. She was photographed for a number of publications, confirming the public's perception of a dignified and independent woman. She accepted honorary degrees and was the subject of an acclaimed documentary film. When her eyesight failed in the early 1970s, she grew more dependent on her help, the most important and controversial of whom was Juan Hamilton.

No biographical essay on O'Keeffe can be complete without some consideration of his influence on the last twelve years of her life. No doubt in the beginning he wanted from her what other young artists wanted (and what in fact she had sought from Stieglitz): validation and direction. He was a potter at a crossroads in his career, and she inspired him to go on with his work. Likewise, he encouraged her, despite her failing vision, to begin working again—painting, making pots, and when all else failed, writing the text for the large, full-color book Viking published about her work in 1976. What was at first a professional relationship, with Hamilton serving her, soon turned into an all-consuming partnership, a chaste version of the O'Keeffe–Stieglitz marriage. O'Keeffe became his mentor and guide through the art world, providing him with an entree to galleries and shows in the same way Stieglitz had fostered her own start at 291. Hamilton became her devoted companion, skilled assistant, and manager, Doris Bry being unceremoniously dismissed after more than two decades of service on O'Keeffe's behalf. And he was the son she never had, the guarantee that her artistic vision and memory would endure.

What went wrong? Certainly she was a difficult woman, manipulative, occasionally short-tempered, and every bit as possessive of those around her as Stieglitz had once been. And she needed someone to take care of her. Hamilton, for

his part, liked control, and as he assumed more of a proprietary interest in O'Keeffe, he was bound to alienate people close to her. It isn't hard to understand why he would have wanted to control access to her: it must have been exhilarating to be the favorite of an internationally acclaimed artist. Why should he share that spotlight? She was his sanction in the art world; he insured the inviolability of her sanctuary; each controlled, and was controlled by, the other.

What complicated matters was her sizable estate. Over the years, in a stream of codicils, O'Keeffe signed over everything she had to Hamilton, including works already earmarked for museums around the country. Extensive litigation resulted from these machinations, the fallout from which lingers both in the art world and in Santa Fe, where O'Keeffe spent the last two years of her life. No one associated with either O'Keeffe or Hamilton, it seems, harbors neutral feelings about the disposition of her will. (Although he ended up with much less than what the last codicil had promised him, Hamilton received a substantial amount of money and paintings.) And just as their relationship continues to fuel conversation and speculation, so too the threat of litigation remains. As a well-known poet said, when asked to write about O'Keeffe for this book, "Juan [Hamilton] would kill me." Unfortunately, the true story of O'Keeffe's final years may never be known: most of her former associates have chosen to stay silent.

The sad ending to O'Keeffe's exemplary career doesn't diminish her achievement: her work was complete before she met Juan Hamilton. And since her death in 1986 at the age of ninety-eight it has become increasingly apparent that O'Keeffe is one of our most important artists. "Every work of art is the child of its age and, in many cases, the mother of our emotions," Kandinsky wrote in *Concerning the Spiritual in Art*.[13] O'Keeffe's work was the child of the modern age, the age of the reproduction of images, and it was also the mother of emotional and aesthetic terrain we continue to explore. The correspondences she discovered between her inner landscape and primal images of flowers and bones, shells and doors, enabled her to create a lasting iconography—and to become one of our cultural icons. "I think that what I have done is something rather unique in my time," she once said, "and that I am one of the few who give our country any voice of its own."[14] Hers was a voice that insured our place in the ongoing dialogue artists conduct with one another across the ages. We are still listening to her.

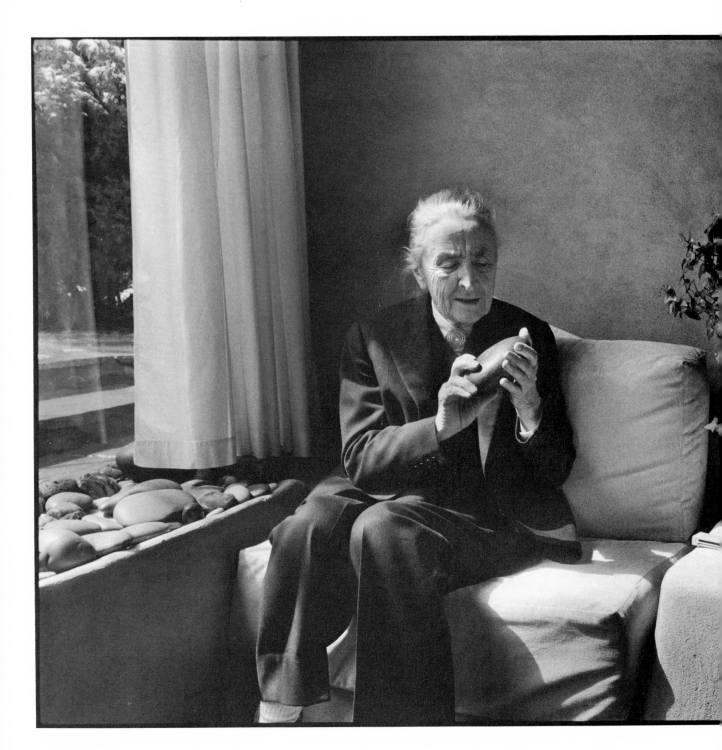

The Work

The Scholarship and the Life

James Kraft

The importance of Georgia O'Keeffe in American art is twofold: as an artist of distinction and as a figure whose life is of considerable significance in the history of twentieth-century American art and culture. Neither of these aspects is easy to evaluate, for two principal reasons: firstly, O'Keeffe's artistic output covers some sixty or more years and includes many works on canvas and paper, more work than we have had the opportunity or time to see and evaluate; and secondly, in her long, distinctively styled life, O'Keeffe touched many areas of the country and involved herself with some of the most important artistic, political, and social issues of this century. Neither the work nor the life has been as fully documented as it needs to be, which makes for a complicated set of problems.

The evaluation of O'Keeffe's art and life is further complicated by what might be called the cult of personality: O'Keeffe's appeal is so strong, both as artist and individual, that it lends itself to personal and superficial interpretations that are at best partisan and not always factually accurate. She cultivated this distinctive personality and seems to have set aspects of her life in dramatic and deliberate confusion. Finally, there are many people still alive who knew her and have invested their life in hers, which is at once an advantage and a problem. Given all of this, we are confronted with a considerable scholarly problem, but we make the assumption that the work and the life are of such importance that we must be willing to address these issues with the most thoughtful standards of scholarship.

The issues in the O'Keeffe scholarship can be addressed from three points of view: the basic scholarship needed; critical issues in the O'Keeffe history; and

some general issues that seriously affect what can be done. My intention here is to suggest what needs to be done in order to evaluate well O'Keeffe's work and life, while avoiding, as far as possible, the more personal issues that may concern me—or to make clear when I am addressing these.

A proper study of O'Keeffe requires, first, a catalogue raisonné of her work. Without this, we are all in the dark, since we cannot know what she did and when, how it was presented to the public, nor what the work could mean. I make the assumption that O'Keeffe is important as an artist and that we are aware of her for this reason. A case could be made that her life is of equal importance to her art, but I make the assumption that if the life is of importance, it is only because her work is there first and is what makes her life important. We need to know what she painted, when and where each piece was done, what her sources of inspiration were, how she exhibited each work, the provenance, and what relationships exist among the works. This project requires the same level of research and scholarship that were given to the Jackson Pollock catalogue raisonné, but I would suggest what is needed is much more than a strict catalogue raisonné. We need also something that supplies a critical context, and I suggest as a model the work Angelica Rubenstine did on the Peggy Guggenheim Collection and the paintings in the Guggenheim Museum. These works, and the soon-to-be-published catalogue raisonné of Edward Hopper, could serve as fine models.

We need other major documents if we are to evaluate well O'Keeffe's work and life. We need an edition of her letters, a collection of all commentary by O'Keeffe and interviews with her, a chronological collection of the reviews of her exhibitions and the essays on her, her medical records, an oral history project, and a research collection center for this material and other documents.

These very considerable assignments indicate the value of O'Keeffe as an artist and individual.

We can gain a sense of the importance of the letters by looking at Sarah Greenough's selections in *Georgia O'Keeffe: Art and Letters* (1987). Someone needs to edit all the letters, or a good selection, for these will reveal the artist in her own voice and in a very immediate way. Along with the letters, we need an edition of O'Keeffe's own writings and interviews. O'Keeffe said a great deal— some comments to make a point important to her, some to dramatize herself, and some that said more than she meant. Also, given her long life, these comments need to be seen as a whole. They are basic to any research and writing.

A well-edited chronological selection of reviews and other writings on

O'Keeffe would be useful in determining what was said and what was revealed over time. We have the beginning of this in Barbara Buhler Lynes's *O'Keeffe, Stieglitz and the Critics, 1916–1929.*

Although her medical records might seem inconsequential, I consider these important in evaluating O'Keeffe's life and ability to work. We know already that health was a serious issue in O'Keeffe's life and deeply affected her work, perhaps more than we now know. These records may no longer exist, and if they do, they may not be easy to obtain, but an effort should be made. Two examples seem sufficient to make my point: What was the exact nature of her breakdown, and when and to what extent did she lose her sight late in life?

Finally, we should begin a systematic oral history project, as inclusive and as frank as possible. Many important associates of O'Keeffe, especially from her later years, are still alive. Although their viewpoints may tend to emphasize the later part of her career, these interviews will give us important documents.

Obviously, some of this work has been done by scholars, but I am suggesting a different approach. All of the steps just described should be done, ideally, as a research project coordinated through a research team, with materials placed in a single center and made available to all scholars. Certainly, whatever can be published should be. Also, this center should create a photographic and video archive.

Most of this work, up to publication, should be done before we reach the next, critical aspect of our O'Keeffe research: a major exhibition. Unfortunately, the exhibition presented in 1987 curated by the National Gallery of Art was, in my estimate, a national disgrace. On no basis was that a serious evaluative and critical effort, with the exception of Sarah Greenough's selection of letters. We need a serious curatorial evaluation of her entire working career, a selection of the best work, a critical evaluation of the work from several points of view, and a tour that is not just national but also international. O'Keeffe must be measured by foreign audiences and critics if we are to know fully what she has done and where to place this work in twentieth-century art, not just American art.

As an example of what should be done, we can consider the three exhibitions that were curated on Wassily Kandinsky at the Guggenheim Museum. Each exhibition was a major presentation of Kandinsky's work in three periods: Munich, Russia and Bauhaus, and France. The result was the first full-scale presentation of what Kandinsky had done, with all the changes that occurred in time and place. I am not suggesting that we necessarily need three O'Keeffe exhibitions and three exhibition volumes, although one can see how this might be

considered, but I am setting a scholarly standard for the exhibition that is beyond anything done so far or even conceived of at this time.

On all of the above there are a few points of concern. We are very close to O'Keeffe—and that is an advantage and a problem, for all the obvious reasons. We have access to living documents, but access is and could be limited by living people. We also do not have the critical advantage that time gives a scholar. It is always good to be engaged in a project, but it is equally good—and wise—to be a bit distant from it. Also, we have in O'Keeffe a painter who was born in the Midwest, lived in various areas of the country, had an intense East Coast experience, and ended her life deeply associated with the Southwest. We need a scholarly approach and apparatus untethered to either New York or Santa Fe. Also, we must not overemphasize the recent years and overlook the earlier ones. We cannot forget that O'Keeffe was forty-one when she went to New Mexico in 1929 and sixty-one when she moved there in 1949. The formative part of her career took place outside New Mexico.

Most critically, we must confront the problem of the quality of scholarship. O'Keeffe deserves the best in compiling these documents, better than what has yet been done on any artist who has lived extensively in the Southwest. It is fair to say that the kind of approach outlined here—encompassing research, publications, and exhibitions—has not been done for many American artists of *any* place or period. Those who conduct such scholarship need extensive training and experience, clear and balanced judgment, and a broad artistic and cultural background.

I come now to my second topic—the critical issues in O'Keeffe's history, territory that has been explored far more but without some of the documents discussed thus far. Here, too, we tend to move from the art to the life, although these issues do not easily separate. Certainly, now, we move into an area fraught with both real and imagined controversy.

Here I want to suggest ideas that need examination, not state opinions, solutions, or conclusions.

For example: What kind of heritage did O'Keeffe's mixed parental background present to her? How important to her career is the idea of the Midwest and the early farm life—and likewise, of the South, Texas, and New York—in forming her viewpoint, especially of the American scene? What are the significant early educational experiences? (To suggest some, I would mention the bravura and European tradition of Chase, the work with Dow and especially her acceptance of his theories, the impact of Oriental art, and the influence of surrealism.) To what degree was she influenced by Ralph Waldo Emerson (1803–

1882) and transcendentalism, consciously or by the nature of what they represent in the American experience? This last is especially interesting to me, for I believe it reveals an aspect of her work that has not been adequately explored.

One of the central problems in studying O'Keeffe is that we do not have a clear understanding of the nature of artistic life in New York City in the first two decades of this century. The tendency is to see New York as a backwater to Paris, or at least peripheral. Perhaps true, but only to a degree. When the French artist Marcel Duchamp (1887–1968) came to New York in the early years of this century, he saw the twentieth century beginning. He saw in New York all the critical issues of the future. Here was the new and multiracial industrial city; the egalitarian heritage of Thomas Eakens and the Eight and their liberal politics; the classic European painting tradition of Chase and the conservatism of the National Academy of Design; the Arensbergs and their circle of aesthetic explorers into our present and past; Stieglitz and his avant-garde galleries, publications, and photographs; and Mabel Dodge, her salon, and its political and psychological experiments. These elements represent a significant blending of art, literature, talent, money, democratic politics, and social life— all in the quintessential city of the twentieth century. This is what O'Keeffe saw, learned from, and finally became a central part of when she became associated with Stieglitz. To know her, we must know the story of these richly interwoven elements, but that story has not yet been told. New York City in the early years of this century may have been the future in a way that we can only now see.

I think these questions begin to suggest the kind of concerns I have with O'Keeffe as artist and individual. We are considering a major artist and key figure in our twentieth-century culture and this fact deserves a concern that is intellectually broad and culturally diverse, which has not always been the approach to her, and it deserves a scholarship that is deep, rich, and inclusive.

Other key issues are more directly related to O'Keeffe: What was the significance of Lake George to O'Keeffe, and how did New Mexico contrast with it? These locales seem to represent two psychological factors that influenced her and her art definitively and that reflect some central directions in her nature. Is there anything in the curious fact that both the writer Willa Cather (1873–1947) and Georgia O'Keeffe focused in their work on Quebec, the French fact on this continent, and on New Mexico, the Spanish fact?

What was the full significance of New Mexico to O'Keeffe? Of course, this is an obvious question that has been variously addressed, but it still seems

unanswered. O'Keeffe largely does not engage with the Indian, Hispanic, or Anglo cultures and almost not at all with the artistic or social scene in the Southwest. The general significance of New Mexico to the artist who visits there and its significance to O'Keeffe seem different: O'Keeffe's reasons for going to New Mexico—a move that took her twenty years to complete—were far more personal and psychological. Portraying my personal bias, I see New Mexico as the releasing factor of her female nature and its freedom, a return to a sense of self before Stieglitz, even a return to the nature her life in Wisconsin represented, making the move a very complicated and significant decision with profound implications for herself and her art.

The question of Stieglitz—what was he in himself and what was his attitude toward O'Keeffe? Here, again, much has been assumed and written, but much has yet to be explored with all the necessary documents. What was he as man and artist, what was his place in the New York scene, why did he take on O'Keeffe and she him, what did he do to her and she to him, why did she have her breakdown and what was his role, why did she leave him—if we can say she did (as I believe she did)? Did Stieglitz even get to her in his photographs; did she ever let him? The influence of Charles Demuth, Charles Sheeler, John Marin, Marsden Hartley, Arthur Dove, and Paul Strand on Stieglitz and on O'Keeffe should be explored.

Obvious as Stieglitz's influence may seem, when the context of O'Keeffe's background and the scene in New York City are broadened and deepened, our answers about him might be very different. Stieglitz's role has to be considered within a scene far broader than we normally have seen it, if we are to see why and how he grasped onto certain artists, and especially O'Keeffe.

Other particular O'Keeffe questions remain: How much of her was pure actress, a self-creator, and how much an original—did she mean what she said; did she know what she meant? What do we make of her as a woman, and how do we understand her relationship with women? Was her significant sex life with men or with women? How bright was she? (In my measure she was both very well educated and exceedingly bright.) How can she be independent and modern yet also coquettish and old-fashioned? Are any of these approaches to her worth bothering with at all?

A tendency exists to want to see O'Keeffe as an embodiment of all kinds of female ideals, roles, and problems. To what degree are we imposing this on her life, or is it all there, and did she cultivate such a view? Is her distinctive voice deliberate and ironic, or is it unconscious and humorous, or can it be all of these?

I conclude with these rather obvious critical questions: What are the important pictures and the important failures? How do we establish her place in American art and twentieth-century art? Do we see her as a realist and as a painter of abstraction? Is she an eastern or southwestern painter, or is this relevant? What is the American character of O'Keeffe's art? I am fairly confident that we have not yet had the materials in hand to answer these questions most effectively.

Some broader issues will affect all that can be done, and these can be stated quite simply: Will we have access to the paintings and documents, and freedom to deal with them? Will O'Keeffe be permitted to stand on her own, or must she be seen through the eyes of others who want to control the scholars' access and O'Keeffe's achievement? Can we, when we are given access, avoid the partisan approach to her?

The last question is significant. One easily finds in O'Keeffe what one needs and then formulates her art and self to the shape of one's own vision. It is one of the exciting factors of her art and self that this happens, but it is a danger we must try to deal with as scholars and critics. These notes toward an evaluation of her art and life are like a cautionary tale, like a symbolic tale of the Danish writer Isak Dinesen: this tale takes great delight in the magnificent and individualistic artistic vision, achievement, and character of our heroine but also warns that we must see her well if we are to see her at all. As with all great artists—and that she is one may be a distinct possibility but not yet a fact—we will find she seduces, challenges, and eludes us, but we must go after her well, both for her value and for our own need.

To indulge, in closing, in my own vision of O'Keeffe, I see her as one of the most significant and compelling artists in this century and, beyond that, one of the people, with Eleanor Roosevelt, Jacqueline Onassis, and Marilyn Monroe, who expresses something mythic about our national character in this century. I am neither suggesting an equality of achievement in these four nor saying they are the only four great American females of this century, but I am suggesting that these four, especially, embody something that is beyond themselves, something that captures and disturbs our imagination and self-definition, something that provokes a sense that the area of the possible is at once larger and more frightening than we ever easily consider in our ordinary daily lives. If this dimension is in O'Keeffe, it makes seeing her well an even greater task for us.

O'Keeffe and the Masculine Gaze

Anna C. Chave

Interest in Georgia O'Keeffe has always been keen in this country—keen enough
to rival even the extreme fervor felt for impressionism. When the Metropolitan
Museum presented major retrospectives of the work of O'Keeffe and the work of
Edgar Degas (1834–1917) simultaneously last winter, the O'Keeffe exhibition—
though a smaller show and mounted with less fanfare—drew almost as many
visitors per day on average as the Degas show.[1] Despite her long-standing popu-
larity, however, O'Keeffe's work is rarely afforded serious critical treatment.
Critical reaction has not been consistent; in the seventy years since her first New
York exhibition, the critical estimation of O'Keeffe's art has actually declined. If
we are ever to be able to see O'Keeffe's art anew—as a worthwhile, complex,
and even daring project—we must examine the prevailing biases and themes
that have dominated the O'Keeffe criticism from the outset.

A negative review in the *New York Times* of the Met's O'Keeffe exhibition
reveals the uncertain critical position her art occupies today. Michael Brenson
found her "dependent upon inspiration . . . immediacy and touch" in her efforts
to convey her "almost mystical feeling for the union of the human body with the
body of the natural world." He described how O'Keeffe filled her pictures "with
organic shapes and swells" that "reflected the changing colors and shapes inside
her"; and he inferred that because the paintings "have a sameness to them," they
revealed an artist "only capable of limited artistic growth." Brenson concluded
that O'Keeffe's paintings were, at most, "skillfully designed and sometimes dra-
matic decor."[2]

Whereas O'Keeffe's obsession with the female body emerged as a limitation
in Brenson's account, a similar preoccupation emerged as a magnificent obsession

29

in a review of the Degas exhibition by Jack Flam in the *Wall Street Journal*. Flam marveled at how, "in picture after picture Degas seems to be probing the female body for its secrets, to be reaching out toward a mystery that he sensed, longed for, and was haunted by, but that he was unable fully to grasp. The efforts to do so, however, created some of the greatest art of a century remarkable for the greatness of its art." Degas's perspective on the mesmerizing female body was necessarily a more removed one than O'Keeffe's, but that distance was deemed an advantage, as the critic described Degas's late bathers as "awesomely impersonal."[3] Flam also reassured his readers of Degas's considerable stature (as if they had any cause to doubt it) by alluding obliquely to the artist's virility—picturing him relentlessly "probing" the female body until it expelled those "secrets" that supposedly inform great art. It matters not that we have no proof that the lifelong bachelor was ever sexually active, for Degas's actual sexuality is not at issue here. A great artist is by definition a potent artist.

Women remain, according to feminist critic Teresa de Lauretis, "the very ground of representation, both object and support of a desire which, intimately bound up with power and creativity, is the moving force of culture and history."[4] Although "'the naked woman has always been in our society the allegorical representation of truth,'"[5] this is a truth that could be articulated only by the knowing probing of the phallic pen or brush—a truth that O'Keeffe could only hope to embody, but never to enunciate. In such a context, there exists little room for examining an endeavor such as O'Keeffe's.

Accustomed to a narrative of art history centered on male artists who commonly created, implicitly for male viewers, images of female bodies, the public's reflexive way of consuming the famously female O'Keeffe has been as the object of its desire rather than as the agent of her own. Her body has been subject to intense public scrutiny from the first, through the long series of highly eroticized nude photographs taken of her by her husband, Alfred Stieglitz.[6] That the literature on O'Keeffe is almost universally biographical is just another sign of how the fascination has been more with the woman than with the art. It is symptomatic that the catalogue for the recent O'Keeffe exhibition consisted mainly of her letters and of a personal memoir by her last assistant.[7] But we might draw other conclusions from the O'Keeffe retrospective, conclusions that diverge from both the recent critical reception of O'Keeffe's works and from earlier, more positive responses. Each of these approaches has, in its way, bound O'Keeffe and her work to the masculine gaze—her body and her art have been eroticized from an exclusively male perspective. But I would suggest that what the recent O'Keeffe exhibition offered the public was something even more ex-

ceptional: a woman's often vivid, poetic, and evocative visual report on her own experience of her body and her desires. Even when O'Keeffe's work was most warmly received by critics, in the 1920s—as when Lewis Mumford wrote in the *New Republic* in 1927 that she was "perhaps the most original painter in America"[8]—they did not generally regard her as entirely responsible for her own achievement. When a critic for the *New York Sun* compared an O'Keeffe show favorably to an impressionist exhibition in 1923, for instance, he said of the latter pictures: "Here are masculine qualities in great variety and reserve. But as in this unfair world, though the man spends a lifetime in careful consideration of a question his answer may seem no more sure than the one the woman [O'Keeffe] gets by guesswork."[9]

To critics then as now, O'Keeffe was an intuitive creature who groped her way along. For that matter, a review of her first solo show, in 1917 at Alfred Stieglitz's 291 gallery, sounds similar to (if somewhat more positive than) Brenson's: "Here are emotional forms quite beyond the reach of conscious design, beyond the grasp of reason—yet strongly appealing to that apparently unanalyzable sensitivity in us through which we feel the grandeur and sublimity of life."[10] This image of O'Keeffe as a purely instinctual creature persisted throughout the 1920s. The critic Waldo Frank portrayed her as "a glorified American peasant . . . full of loamy hungers of the flesh" and given to "monosyllabic speech."[11] And Lewis Mumford conjured an image of the artist as plant, saying that "all these paintings come from a central stem . . . well grounded in the earth."[12] By extension, O'Keeffe's art was often seen as picturing some unevolved creature's native habitat: "There are canvases of O'Keeffe's that make one to feel life in the dim regions where human, animal and plant are one, undistinguishable, and where the state of existence is blind pressure and dumb unfolding," wrote Paul Rosenfeld.[13]

But O'Keeffe was no plant, no amoeba, no dimwit: she was a self-possessed, literate person[14] who formulated with great deliberateness often eloquent visual descriptions of her ideas, perceptions, and feelings. O'Keeffe saw art precisely as a means of saying what she wanted to say in a way that suited her. As she said in a public statement for her first major exhibition, in 1923 at the Anderson Galleries, she knew that as a woman her social freedom was strictly limited: "I can't live where I want to—I can't go where I want to—I can't even say what I want to." Her art was prompted, then, by the realization that "I was a very stupid fool not to at least paint as I wanted to and say what I wanted to when I painted. . . . I found that I could say things with colors and shapes that I couldn't say in any other way—things that I had no words for."[15]

O'Keeffe further explained her motivations when she wrote the same year to the writer Sherwood Anderson (1876–1941), her friend, of her deep "desire to make the unknown-known." Using the then-standard male pronoun, she explained, "By unknown—I mean the thing that means so much to the person that he wants to put it down—clarify something he feels but does not clearly understand. . . . Sometimes it is all working in the dark—but a working that must be done."[16]

For a woman to find a way of picturing her desires was (and remains) an extraordinary feat. That O'Keeffe accomplished that feat effectively was appreciated initially by her closest friends,[17] and slightly later by Stieglitz, who, legend has it, sensed in the first work he saw by her (late in 1915) that he had encountered "at last, a woman on paper." The critics and the public—especially, it is said, the female public[18]—marveled in their turn at this phenomenon. Henry Tyrrell, a critic for the *Christian Science Monitor,* wrote of her first solo show, in 1917, "Artists especially wonder at [her art's] technical resourcefulness for dealing with what hitherto has been deemed the inexpressible—in visual form, at least. . . . Now, perhaps for the first time in art's history, the style is the woman." Rosenfeld exclaimed in 1921, "It is a sort of new language her paint speaks. We do not know precisely what it is we are experiencing. . . . Here speaks what women have dimly felt and uncertainly expressed." And Mumford declared in 1927,

What distinguishes Miss O'Keeffe is the fact that she has discovered a beautiful language, . . . and has created in this language a new set of symbols; by these means she has opened up a whole era of human consciousness which has never, so far as I am aware, been so completely revealed in either literature or in graphic art.[19]

For some critics, certainly, this novel "woman on paper" (or canvas) was merely a kind of freak occurrence. To others, however, O'Keeffe's distinctive art opened vital new territories in the visual realm, bringing credit and honor to a nascent American modernist culture. To the critic Edmund Wilson, writing in 1925, O'Keeffe "outblazed" the work of the men around her, while Henry McBride exulted, "In definitely unbosoming her soul she not only finds her own release but advances the cause of art in her country."[20] As events transpired, O'Keeffe would be ushered briskly out of the limelight once the victory of that "cause" was in sight, however. To Clement Greenberg, mouthpiece of the New York school during its rise to international prominence after World War II,

O'Keeffe was merely a "pseudo-modern" whose work "adds up to little more than tinted photography . . . [or] bits of opaque cellophane."[21] By (what became) the normative, modernist standards, the art of O'Keeffe no doubt fell short. Her abortive relation to abstraction and her manifest indifference to cubism have long since rendered her persona non grata among critics prone to certain modernist orthodoxies.

O'Keeffe was neither ignorant nor contemptuous of European abstraction, however. She had studied Braque and Picasso drawings at 291 as early as 1914, and she had pored over too many issues of *Camera Work* and read Kandinsky's *Concerning the Spiritual in Art* too carefully at the start of her career to dismiss totally what they offered. The "errors" her art was prone to—not only her literalism but her flat-footed way with oil paint, her sometimes cloying palette, and her shallowness of surface—were less a sign of provincialism than of her search for a voice distinct from the European masters'. This difference emerges, for instance, in O'Keeffe's confession that she longed to be "magnificently vulgar . . . if I could do that I would be a great success to myself."[22]

In O'Keeffe's day, painting as an American, like painting as a woman, meant working from a shallow cultural and historical background. Her pictures accordingly tend to express their values on the surface, collapsing depth and focusing on the surfaces of objects. Avoiding telltale references to Cézanne or Picasso, O'Keeffe attempted to develop a voice that would speak, comprehensibly and vividly, of her own experience: a midwesterner's, an American's, a woman's experience. To realize her ambition, O'Keeffe knew she had to paint the "wrong" way, as the approved visual languages were developed in other contexts to serve other ends. It seems that this is what she meant when she wrote: "I just feel I'm bound to seem all wrong most of the time—so there is nothing to do but walk ahead and make the best of it."[23] In the process, she admitted that she felt at times "not steady"[24] or "rather inadequate" and would "wish that I were better," but she knew all along she was a pioneer. And in 1945 she proudly claimed, "I think that what I have done is something rather unique in my time and that I am one of the few who gives our country any voice of its own."[25]

While Stieglitz and his followers proselytized for the development of a native American vision, O'Keeffe noted wryly that, among them, she "seemed to be the only one I knew who didn't want to go to Paris. They would all sit around and talk about the great American novel and the great American poetry, but they all would have stepped right across the ocean and stayed in Paris if they could have. Not me. I had things to do in my own country."[26] In attempting to

devise an American idiom, however, she learned from other artists in Stieglitz's sphere, especially Arthur Dove and Paul Strand. But O'Keeffe managed to formulate a language that, even in its most abstract moments, had a more vernacular tone and proved more popularly accessible and commercially successful than theirs did.[27]

In trying to develop a woman's visual language of desire, however, O'Keeffe was on her own. Her solutions to that problem were, admittedly, uneven: now crude and obvious, now elegant and ingenious. She rejected from the first the dominant modes of picturing desire: she did not depict in a literal way the site of desire itself, the human body.[28] Not only did she deny the (male) viewer the opportunity to look in a sexually predatory way at actual female anatomy (though critics proved remarkably inventive, even so, in their voyeuristic reading of her art's metaphorical content), but she also eschewed the easy, but self-defeating, tack of inviting (female) viewers to gaze at the male body. Instead, O'Keeffe portrayed abstractly, but unmistakably, her experience of her own body, not what it looked like to others. The parts of the body she engaged were mainly invisible (and unrepresented) due to their interiority, but she offered viewers an ever-expanding catalogue of visual metaphors for those areas and for the experience of space and penetrability generally.

A model of sexuality and of sexual development centered around voids (vaginas, wombs) and penetrability, rather than around the probing penis, has recently been posited by feminist theoretician Luce Irigaray in her critique of Freud and Lacan.[29] O'Keeffe's imagery—with its myriad canyons, crevices, slits, holes, and voids, its effluvia, as well as its soft swelling forms—in a sense prefigures Irigaray's vision, as it describes abstractly what differentiates female bodies: the roundness, the flows, and above all, the spaces. In certain paintings O'Keeffe depicted spaces penetrated by long, rigid forms, and these works were often read, and continue to be read, as images of the experience of coition (their abstractness notwithstanding). Wrote Mumford: "She has revealed the intimacies of love's juncture with the purity and the absence of shame that lovers feel in their meeting; . . . she has, in sum, found a language for experiences that are otherwise too intimate to be shared."[30] Said McBride, "It was one of the first great triumphs for abstract art, since everybody got it."[31]

Significantly, O'Keeffe first developed such an imagery when the campaign for the sexual self-determination of women through access to contraception was at a peak—a campaign that reflected a growing acceptance of women's sexual expression by unfastening the instrumental link between sexual activity and procreation. Historians have noted:

By the 1920s Americans were clearly entering a new sexual era [distinguished by] . . . the new positive value attributed to the erotic, the growing autonomy of youth, the association of sex with commercialized leisure and self-expression, the pursuit of love, the visibility of the erotic in popular culture, the social interaction of men and women in public, [and] the legitimation of female interest in the sexual."[32]

O'Keeffe's abstract and highly sensual images of often labialike folds, sometimes rendered in pastel shades, invoked associations not only with the body but with skies and cloud formations, as well as with canyons and the anatomy of flowers. O'Keeffe had intense feelings about certain elements of nature, especially the open skies and spaces of the plains; and she found in natural configurations, large and small, homologies for the felt experience of the body. Her distinctive visual language first took shape when she was living in Canyon, Texas, and struggling to paint the Palo Duro Canyon nearby. The invisibility of the beautiful canyon fascinated her; she said, "It was a place where few people went. . . . We saw the wind and snow blow across the slit in the plains as if the slit didn't exist."[33] Later, even in painting the built environment of New York City, she often focused on architectural canyons or on the spaces between and over buildings as much as on the buildings themselves. Further, once they became available, and once she could afford it, O'Keeffe lived in apartments at the tops of skyscrapers in New York, nearest to the sky. As a native of the rolling Wisconsin landscape who later chose to move to the open plains of Texas and New Mexico, she sometimes wrote to friends out West (when personal circumstances kept her in the city) asking them to "kiss the sky" for her.

O'Keeffe once described herself as "the sort of child that . . . ate around the hole in the doughnut saving . . . the hole for the last and best so probably—not having changed much—when I started painting the pelvis bones I was most interested in the holes in the bones—what I saw through them—particularly the blue from holding them up in the sun against the sky."[34] O'Keeffe's renderings of the empty space framed by pelvic bones made literal what some critics had seen as an oblique reference in many of her earlier pictures: the relation of their voids to the space of the uterus. Critics rhapsodized that "the world [O'Keeffe] paints is maternal," that her pictures' "profound abysses" evinced "mysterious cycles of birth and reproduction" (to take some representative phrases).[35] O'Keeffe's art was not the exalted vision of maternal plenitude that many of these critics liked to imagine, however, but was instead, if anything, a report on the experience of childlessness—of the vacant, not the occupied, womb.

Her earliest exhibited work supposedly prompted Willard Huntington Wright to complain to Stieglitz, "All these pictures say is 'I want to have a baby.'" To this Stieglitz reportedly replied, "That's fine."[36] Stieglitz considered it "fine" because he had a theory that a woman experiences the world through the womb, which he called "the seat of her deepest feeling," and he wanted to see that feeling visualized.[37] However, he refused to father a child by her, insisting that his decision was in the best interests of her work and of refuting the prejudice that women are capable of creating only babies, not art (he preferred not to contemplate their ability to do both).[38]

Stieglitz's denial of his wife's wish to have a child was only one of the many ways he thwarted her in life as in her art. Though he is widely regarded as responsible for her success, the record now shows that Stieglitz's effect on O'Keeffe was more destructive than not, and that the efforts he made, supposedly on her behalf, were often self-serving.[39] The prerogative of giving birth, which he refused his wife, Stieglitz in effect arrogated to himself, saying that he had given birth to her, and that together they had given birth to her art—those much-admired pictures being his progeny.[40] To hear O'Keeffe tell it, her dealer and husband discouraged her innovative moves throughout her career, including the decision to render that priapic urban icon, the skyscraper, as well as the important decision to magnify the scale of flowers.[41] The subject O'Keeffe has been mostly identified with is, of course, flowers—historically a relatively minor subject, and one often relegated to women and amateur painters. Eschewing the artist's customary, innocuous bouquets, however, O'Keeffe chose one or two blooms with particularly suggestive forms and inflated their proportions until they pressed against the pictures' edges. The effect could be intensely, even disquietingly, sexual. But O'Keeffe took offense at the sexual readings of her flower paintings, as well as of her abstractions. Stieglitz represented O'Keeffe and her art in sexual terms from the first, however—introducing her to a wider viewing public (in 1921) not directly through her own work but through his many sensual photographs of her, where her pictures sometimes served as hazy backdrops to her voluptuous nude or lightly clothed body. As far as we know, she made no effort to stop him.

O'Keeffe's objection to the sexual readings of her art probably had more to do with the degrading forms those readings took than with any naïveté about her works' sexual overtones. Her own and others' recollections (of her painting in the nude, for instance) suggest that she had an acute awareness of her sexuality and that she wanted to express that sense in her art. In a letter to her closest friend in 1916 she said, however tentatively, that her work "seems to express in

a way what I want it to . . . it is essentially a womans feeling—satisfies me in a way— . . . There are things we want to say—but saying them is pretty nervy."[42] Some years later, hoping to find a woman who might write about her art more perceptively than the male critics, O'Keeffe wrote to Mabel Dodge Luhan:

I have never felt a more feminine person—and what that is I do not know—so I let it go at that till something else crystallizes. . . . What I want written . . . I have no definite idea of what it should be—but a woman who has lived many things and who sees lines and colors as an expression of living—might say something that a man cant—I feel there is something unexplored about women that only a woman can explore—Men have done all they can do about it.[43]

Year after year, Stieglitz issued pamphlets for O'Keeffe's shows with excerpts from reviews and essays by Marsden Hartley, Paul Rosenfeld, Henry McBride, and others—critics who, as the dealer's friends and supporters, were all influenced by his vision of her art. These accounts that Stieglitz elicited, and that he used to promote O'Keeffe, generally left her "full of furies." She wrote to Sherwood Anderson, "I wonder if man has ever been written down the way he has written woman down—I rather feel that he hasn't been—that some woman still has the job to perform—and I wonder if she will ever get at it—I hope so."[44]

The moral of the story of the reception of O'Keeffe's art could be encapsulated by the axiom that "'sexuality is to feminism what work is to Marxism: that which is most one's own, yet most taken away,' . . . most personal, and at the same time most socially determined, most defining of the self and most exploited or controlled."[45] O'Keeffe's expressions of her sexuality were appropriated and exploited by critics for their own ends, made over into mirrors of their own desires. They habitually homogenized or reduced the sensuality of the artist's work—which varied widely, from the subdued or controlled to the lavish or vulgar, depending in part on the motif she employed: flowers, leaves, shells and bones, canyons and mesas, skyscrapers and barns (as well as abstraction)—into something lurid and literal. In the 1920s, Hartley proclaimed that her images "are probably as living and shameless private documents as exist, in painting certainly, and probably in any other art. By shamelessness I mean unqualified nakedness of statement. . . . Georgia O'Keeffe pictures are essays in experience that neither Rops nor Moreau nor Baudelaire could have smiled away." Rosenfeld wrote, "All is ecstasy here, ecstasy of pain as well as ecstasy of fulfillment."

And Louis Kalonyme declared that, in a "sensationally straightforward, clear and intimate" way, O'Keeffe "reveals woman as an elementary being, closer to the earth than man, suffering pain with passionate ecstasy and enjoying love with beyond good and evil delight."[46]

The problem with all these accounts of O'Keeffe's art is not that her pictures are not sexual, but that the difficult exercise she set herself, and the now-muted, now-declamatory visual poetry it yielded, was crudely translated by critics into a fulsome, clichéd prose. Her art was described not as the vision of someone with real, deeply felt desires but as the vision of that depersonalized, essentialized Woman who obligingly stands for Nature and Truth. To the painter Oscar Bluemner (as to many others), O'Keeffe was the "priestess of Eternal Woman," her art "flowering forth like a manifestation of that feminine causative principle."[47] What we find here, in other words, is what Klaus Theweleit has aptly described in another context as

a specific (and historically recent) form of the oppression of women—one that has been notably underrated. It is oppression through exaltation, through a lifting of boundaries, and "irrealization" and reduction to princi-ple—the principle of flowing, of distance, of vague, endless enticement. Here again, women have no names . . . [and] exaltation is coupled with a negation of women's carnal reality.[48]

In most critics' eyes, O'Keeffe's art conveyed principles of maternity, purity, and (paradoxically) enticement. This contradictory image of the artist as chaste and lustful, as child, seductress, and mother, permeated and permeates the writing on her work. An article on O'Keeffe in *Time* in 1946 was headlined "Austere Stripper," while just two years ago *Vanity Fair* gushed: "Vast and virginal, O'Keeffe's space is one of ecstatic possibility. . . . O'Keeffe is sexy, heartless, canny, wise, stylish, resigned, slatternly, intelligent, pixieish . . . [and] pretty cocky [*sic*]."[49] As early as 1918, for that matter, Stieglitz described the artist to herself as "The Great Child pouring out some more of her Woman self on pa-per—purely—truly—unspoiled."[50] In the 1920s, Hartley found O'Keeffe's work at once "shameless" and near to "St. Theresa's version of life" in its ecstatic mys-ticism.[51]

Rosenfeld wrote provocatively that in O'Keeffe's pictures,

Shapes as tender and sensitive as trembling lips make slowly, ecstatically to unfold before the eye. . . . It is as though one had been given to see the

mysterious parting movement of petals under the rays of sudden fierce heat. . . . She gives the world as it is known to woman . . . rendering in her picture of things her body's subconscious knowledge of itself. . . . What men have always wanted to know, and women to hide, this girl sets forth.[52]

But what was this tantalizing knowledge that women presumably concealed? Rosenfeld was more explicit on another occasion: "Her art is gloriously female. Her great painful and ecstatic climaxes make us at last to know something the man has always wanted to know."[53]

Why would Stieglitz so relish seeing O'Keeffe's art described in these terms—as reports on her wondrous climaxes—that he invariably used just such phrases to promote her work, despite the intense dismay it caused her?[54] Because those "great painful and ecstatic climaxes" (as the public well knew) were given to O'Keeffe by none other than Alfred Stieglitz; her art itself, he liked to intimate, issued out of those experiences. In a review of her first major show, McBride said flatly that O'Keeffe and her art were Stieglitz's creations—that he had fomented the sexual liberation that enabled her (however "subconsciously") to paint:

Georgia O'Keeffe is what they probably will be calling in a few years a B.F. [Before Freud], since all of her inhibitions seem to have been removed before the Freudian recommendations were preached upon this side of the Atlantic. She became free without the aid of Freud. But she had aid. There was another who took the place of Freud. . . . It is of course Alfred Stieglitz that is referred to. He is responsible for the O'Keeffe exhibition in the Anderson Galleries . . . and it is reasonably sure that he is responsible for Miss O'Keeffe, the artist.[55]

On one level, no doubt, this relentless stress on Stieglitz's Svengali role, on O'Keeffe's sexuality, and on her art's sexual content is or ought to be puzzling. Much art that is far more explicitly erotic (Matisse's famous odalisques, for instance) is rarely described in such a sexualized way. Whereas art (by a man) that is literally sexual tends to be discussed in terms of beauty; purity; the sacred; or line, color, and form; or in relation to the transgressions of the avant-garde, art by O'Keeffe that is only metaphorically sexual gets described in the most lurid terms imaginable: where the literal gets metaphorized, the metaphorical gets literalized. In a review of a show featuring the flower paintings (in which he

advised O'Keeffe to get to a nunnery), McBride said of her earlier, supposedly lewd abstractions: "To this day those paintings are whispered about when they are referred to at all."[56]

The woman strange and brazen enough to make public such supposedly explicit reports on her sexual satisfactions would inevitably be viewed, whether mockingly or admiringly, as a creature apart. "Psychiatrists have been sending their patients up to see the O'Keeffe canvases," gossiped the *New Yorker* in 1926. "If we are to believe the evidence, the hall of the Anderson Galleries is littered with mental crutches, eye bandages, and slings for the soul. [People] limp to the shrine of Saint Georgia and they fly away on the wings of the libido." Moreover, "One O'Keeffe hung in the Grand Central Station would even halt the home-going commuters. . . . Surely if the authorities knew they would pass laws against Georgia O'Keeffe, take away her magic tubes and her brushes."[57]

Just what is so subversive or so therapeutic or both about the sensual art of Georgia O'Keeffe? The critics of the time might have it that O'Keeffe's art was illicit and potentially censurable owing to its, at best, thinly disguised lewdness. But O'Keeffe's work may have been experienced as treacherous for other (less consciously perceived) reasons as well. As she spent so much of her long career picturing the not-there—"the sky through the hole" and the "slits in nothingness" (to use her own phrases)—more than beings and things, O'Keeffe might be said to have plumbed the "hole in men's signifying economy," to take a passage from Luce Irigaray: the hole or "nothing" that augurs "the break in their systems of 'presence,' or 're-presentation' and 'representation.' A nothing threatening the process of production, reproduction, mastery, and profitability, of meaning, dominated by the phallus—that master signifier whose law of functioning erases, rejects, denies . . . a heterogeneity capable of reworking the principle of its authority."[58]

So who might find such a treacherous exercise, or such contraband, a salve; and who might stand to profit by it? In the first instance, no doubt, it was Stieglitz who profited: he successfully marketed O'Keeffe's art as a kind of soft-core pornography or as a sop to male fantasies by perverting her images of her experience of her body and her desire into reifications of male desire, of the pleasure men imagine themselves giving women. There are more significant and more salutary benefits to be had from O'Keeffe's improper pictures, however. "[S]ince women has [*sic*] had a valid representation of her sex/organ(s) amputated," as Irigaray put it,[59] O'Keeffe's pictures may appeal to women by articulating the sen-

sation of crevices and spaces not as an experience of lack and absence but as one of plenitude and gratification. O'Keeffe pictured her sexuality in a personal, but resonant, way; and—without making any reductive equations of Woman to Nature to Truth—she created in the same stroke a vivid record of her consoling sense of her relation to nature.

For male viewers, too, O'Keeffe's art may be potentially liberating. There is, after all, that lingering question about the pleasure men give women. The psychoanalytic theorist Jacques Lacan suggested that this question lingers because men yearn for that privilege, conventionally reserved for women, of being the cause and the object of desire: "For each partner in the relation, the subject and the Other, it is not enough to be the subjects of need, nor objects of love, but they must stand [also] as the cause of desire. This truth is at the heart of all the mishaps of sexual life which belong in the field of psychoanalysis."[60] In opening up the possibility for the representation of women as agents of their own desire, O'Keeffe opened up new possibilities as well for the sexual positioning of men; and the commotion raised by male critics over her "shameless" imagery might be explained, in part, by their glimpsing of those possibilities. Since women have not been constituted as subjects under patriarchy, they have had no legitimate basis for experiencing—let alone describing—their own desire; and it follows that men have had little basis for experiencing themselves as the cause or objects of desire. Insofar as she presumed to describe her desire, articulating a female erotics and claiming a full sexual citizenship, O'Keeffe was in a real sense an "outlaw." And insofar as her art endeavored to position itself outside the existing visual practice in which "woman is constituted as the ground of representation, the looking-glass held up to man,"[61] it was, in a sense, both subversive and hygienic.

If O'Keeffe is seen as a shamanistic figure (like many important modern artists) and if her art is construed as a transgressive exercise (such as avant-garde artists are supposed to perform), then what can explain the shabby treatment she receives at the hands of critics and art historians? O'Keeffe was an inconstant modernist, disinclined to use hermetic languages—however well she understood them—and so bound to remain a comparatively parochial or marginal figure. Just as importantly, however, the nature of the project that O'Keeffe pursued and the way it has been used prevent her from attaining a major historical position, as art history is not built around women's desire but around men's, not around a model of permeability or mutuality but around one of closure and domination. O'Keeffe, the female body, has thus inevitably been more the object of interest and exchange than O'Keeffe, the art. The writer Janet Hobhouse has

suggested that O'Keeffe "serves too usefully as an icon for the pictures to be seen as anything other than a gloss on the life."[62]

Even if the art's attractions cannot be separated from the artist's, however, that poor oxymoronic figure—the *femme enfant* and the "austere stripper," not to mention the Woman Artist—might yet be hounded into retirement. O'Keeffe should be allowed to become another kind of icon. She pursued and achieved an elusive goal, a popular art that is also a feminist art,[63] enjoyed not exclusively by women. In this country, if not internationally, she excites an interest exceeding that of any other pre–World War II American artist, and rivaling that of most postwar artists as well. It is time the enduring appeal of O'Keeffe's work be taken seriously and the political content of her art be recovered—in all its specificity, its ingenuousness, and its ingenuity—in a different art history.

The Language of Criticism

Its Effect on Georgia O'Keeffe's Art in the 1920s

Barbara Buhler Lynes

A notable change occurred in the criticism of Georgia O'Keeffe's art in the early years of her career. At the beginning of the 1920s critics characterized her work almost exclusively as the highly personalized, emotional expression of a sexually obsessed woman. During the second half of the decade, however, this perception began to be challenged by commentary that pointed out controlled, intellectual qualities in her work and, thus, described it using terms traditionally applied to the art of men. In what follows, I will demonstrate that O'Keeffe herself was instrumental in inspiring this new voice in the criticism; that in response to the reviews she received on the occasion of her first major exhibition in New York in 1923, she set about to persuade critics to define her and her art on her own terms.

O'Keeffe's 1923 show was the first of what would be annual exhibitions of her work in that decade staged by Alfred Stieglitz. It featured a hundred works, some made as early as 1915, and was introduced, in part, by an essay O'Keeffe wrote late in January 1922 for the exhibition brochure Stieglitz had prepared. In the essay she discussed aspects of herself and of her art.

I grew up pretty much as everybody else grows up and one day seven years ago I found myself saying to myself—I can't live where I want to—I can't go where I want to—I can't do what I want to—I can't even say what I want to—. School and things that painters have taught me even keep me from painting as I want to. I decided I was a very stupid fool not to at least paint as I wanted to and say what I wanted to when I painted as that

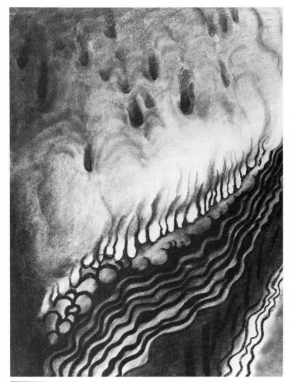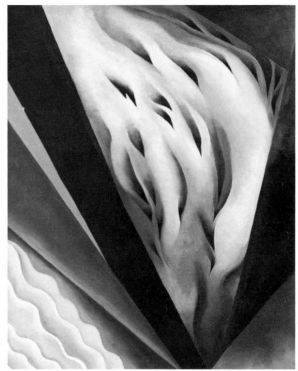

From the Faraway Nearby

44

seemed to be the only thing I could do that didn't concern anybody but myself—that was nobody's business but my own.—So these paintings and drawings happened and many others that are not here.—I found that I could say things with color and shapes that I couldn't say in any other way—things that I had no words for. Some of the wise men say it is not painting, some of them say it is. Art or not Art—they disagree.[1]

O'Keeffe made it clear that she defined her art strictly as self-expression and indicated that she had first begun to think of it in those terms in 1915, exactly a decade after she had begun her formal training at the Art Institute of Chicago. In October of that year, while she was teaching in Columbia, South Carolina, she had realized that her work to that point expressed what her teachers or her friends expected it to; and she determined, then, that she should allow it to express what *she* was feeling.[2] In an effort to achieve this, she began a series of charcoal drawings on inexpensive white paper (such as *Special No. 9* [fig. 1]), which make it clear that what she was feeling could not be expressed with tradi-

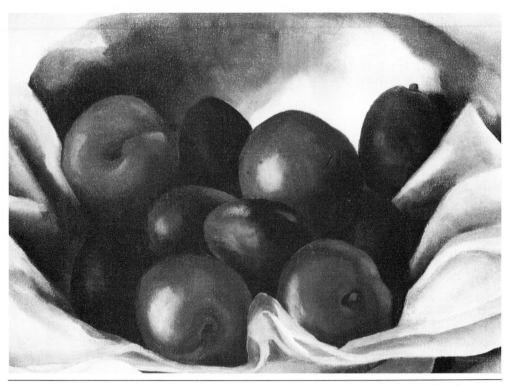

3. Georgia O'Keeffe, *Plums,*
1920.
Oil on canvas, 9 × 12 in.
Collection of Paul and Tina
Schmid.

tional, representational imagery. Although subsequently in the 1910s and early
1920s she furthered her experiments with abstraction in watercolor and oil, ex-
amples of which include the *Evening Star* series of 1917 and *Blue and Green Music*
(1919 [fig. 2]), she also made paintings that were decidedly realistic in charac-
ter, like *Plums* (1920 [fig. 3]), or semiabstract, like *Light Coming on the Plains II*
(1917).

When confronted with the large body of unknown work they saw in 1923
(the brochure stated that ninety pieces on display had never been shown before),
critics were obviously perplexed, and they sought its meaning, especially the
meaning of O'Keeffe's abstractions, in the fact that the artist was a woman.
They interpreted her expression from the perspective of traditional notions about
women—that they were more closely linked to the natural world than men and
that their bodies were the source of their creativity. But in addition, they im-
plied that O'Keeffe's work was a revelation of female sexuality. Such ideas, how-
ever, were not based entirely on the critics' response to what was on display;
rather, they derived from opinions about O'Keeffe and her art that had been for-
mulated by Stieglitz and his circle of friends and published before 1923.

In January 1916, six months before he met O'Keeffe,[3] Stieglitz saw examples of the charcoal drawings she had made the previous fall and exclaimed: "Why they're genuinely fine things—you say a woman did these—She's an unusual woman—She's broad minded, she's bigger than most women, but she's got the sensitive emotion—I'd know she was a woman—Look at that line."[4] Stieglitz immediately revealed that he comprehended the drawings in terms of qualities that he associated with a woman, but he also believed (or came to believe) that their imagery described a very specific dimension of O'Keeffe's femaleness—her sexual nature. For it was precisely this idea that he promoted when he exhibited the drawings at 291, beginning in late May 1916, and when he wrote about them in an issue of *Camera Work* the following October.[5] In 1919, the year after O'Keeffe and Stieglitz began living together in New York, Stieglitz wrote a brief essay, "Woman in Art," in which he restated his belief in the sexual dimensions of O'Keeffe's imagery and which, though not published at the time, was apparently circulated among the members of his circle.[6]

Two years later, he again made his ideas about O'Keeffe evident in a February 1921 exhibition of his photographs at the Anderson Galleries. He had been photographing O'Keeffe for over five years, and among the forty-five prints of her he displayed were extraordinarily candid images of her body, as well as images in which she gestured provocatively, her arms and hands echoing the arrangement of forms in her abstractions, which served as background (fig. 4). In one photograph, which, rather than O'Keeffe herself, featured the juxtaposition of two O'Keeffe works, Stieglitz confirmed what he believed was the meaning of her art. By placing a small phallus-shaped sculpture in front of the large void in *Music—Pink and Blue I* (1919), he equated the meaning of their abstract forms with her sexuality (fig. 5).

Painter Marsden Hartley and critic Paul Rosenfeld, two of Stieglitz's close friends, were strongly influenced by his conception of O'Keeffe and her work, and they extended the influence of his ideas in essays about O'Keeffe's art that were published before her 1923 show.[7] "With Georgia O'Keeffe," Hartley wrote in 1921, "one takes a far jump into volcanic crateral ethers, and sees the world of a woman turned inside out." Almost as if he were describing a Stieglitz photograph of her, he characterized O'Keeffe as "gaping with deep open eyes and fixed mouth at the rather trivial world of living people" and called her art "unqualified nakedness of statement." He pointed out that it had been made by a woman who met life unafraid: "Georgia O'Keeffe has had her feet scorched in the laval effusiveness of terrible experience; she has walked on fire

and listened to the hissing vapors round her person. . . . [Her] pictures . . . are probably as living and shameless private documents as exist."[8]

In "Woman in Art," Stieglitz had written: "Woman *feels* the World *differently* than Man feels it. . . . The Woman receives the World through her Womb. That is the seat of her deepest feeling."[9] Paraphrasing that passage, Rosenfeld stated in a 1921 essay, "American Painting," that O'Keeffe's work "registered the manner of perception anchored in the constitution of the woman. The organs that differentiate the sex speak. Women . . . always feel, when they feel strongly, through the womb." Furthermore, in a discussion filled with oblique references to the O'Keeffe that Stieglitz had revealed in his photographs of her, he made it clear that he agreed with Stieglitz that O'Keeffe's paintings were revelations of the female sexual nature.

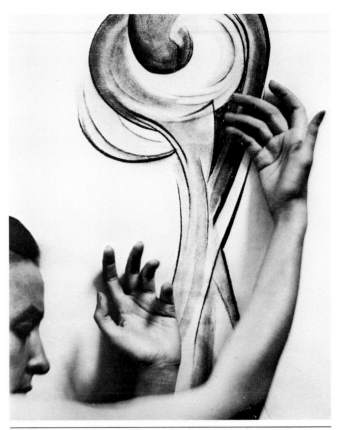

4. Alfred Stieglitz, *Georgia O'Keeffe: A Portrait*, 1918. Gelatin silver print, 9⁷⁄₁₆ × 7½ in. National Gallery of Art, Washington, D.C., Alfred Stieglitz Collection.

The pure, now flaming, now icy colours of this painter, reveal the woman polarizing herself, accepting fully the nature long denied, spiritualizing her sex. Her art is gloriously female. Her great painful and ecstatic climaxes make us at last to know something the man has always wanted to know. . . . All is ecstasy here, ecstasy of pain as well as ecstasy of fulfilment. . . .

It is a sort of new language her paint speaks. . . . She leaves us breast to breast with the fluent unformed electric nature of things. . . . But, whatever it is that her flooding liquid pigment does, one thing it always seems to be bringing about in the beholder. It seems to be leading him always further and further into the truth of a woman's life. . . . For here there appears to be nothing that cannot be transfused utterly with spirit, with high feeling, with fierce clean passion. The entire body is seen noble and divine through love. . . . Here speaks what women have dimly felt and uncertainly expressed.[10]

The Language of Criticism

47

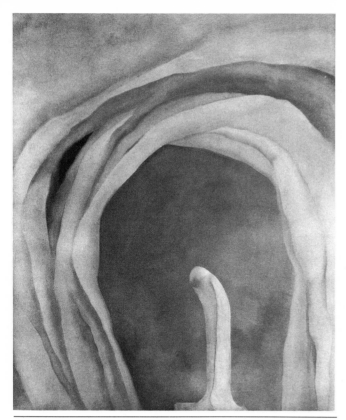

5. Alfred Stieglitz, *Georgia O'Keeffe: A Portrait—Painting and Sculpture,* 1919.
Palladium print, 9³⁄₁₆ × 7⅝ in. National Gallery of Art, Washington, D.C., Alfred Stieglitz Collection.

Critics who wrote reviews of the 1923 exhibition were deeply influenced by what was implied in these essays. Almost half quoted Hartley,[11] and others made correlations between O'Keeffe's art and her body that specifically reflected an awareness of Rosenfeld's ideas.[12] Hartley's essay was available to them in the exhibition brochure, where Stieglitz had reprinted it, and a second commentary about O'Keeffe by Rosenfeld had appeared in *Vanity Fair* the previous October. That article, which was to be a preview of the 1923 show, essentially elaborated Rosenfeld's remarks about O'Keeffe in "American Painting." But in it, he reached new limits in describing the relationship between her and her work. For example, he noted: "There are certain of these streaks of pigment which appear licked on with the point of the tongue."[13]

O'Keeffe's immediate reaction to the criticism generated by the 1923 show is not known, but it is clear from a letter she wrote to Anderson Gallery owner Mitchell Kennerley in the fall of 1922, soon after Rosenfeld's second article appeared, that she had objected from the beginning to Hartley's and Rosenfeld's assessments of her and her art: "You see Rosenfeld's articles have embarrassed me—[and] I wanted to lose the one for the Hartley book when I had the only copy of it to read—so it couldnt be in the book."[14] But when their ideas about her dominated the reviews of her 1923 show, O'Keeffe decided to do something about it.

In the excerpts from those reviews that Stieglitz reprinted in the catalogue of her show the following year, he had removed any references they contained to Hartley's and Rosenfeld's essays—obviously in response to a request from O'Keeffe to do so. In addition, O'Keeffe's statement for the catalogue made the purpose of the exhibition clear: it was intended to "clarify some of the issues written of by the critics and spoken about by other people" the year before.[15] She had good reason to suspect that it would, for long before the 1924 show opened, she had decided to try to convince the critics to change their ideas about her work by changing the nature of what she exhibited. As she revealed to

writer Sherwood Anderson, she had made a con-
scious decision to limit the type of image she be-
lieved had been most susceptible to critical
misreadings in 1923.

My work this year is very much on the ground—
there will be only two abstract things—or three
at the most—all the rest is objective—as objec-
tive as I can make it. . . .

 I suppose the reason I got down to an effort
to be objective is that I didn't like the interpreta-
tions of my other things—so here I am with an
array of alligator pears—about ten of them—calla
lilies—four or six—leaves—summer green ones—
ranging through yellow to the dark somber
blackish purplish red [fig. 6]—eight or ten—hor-
rid yellow sunflowers—two new red cannas—
some white birches with yellow leaves—only two
that I have no name for and I dont know where
they come from.[16]

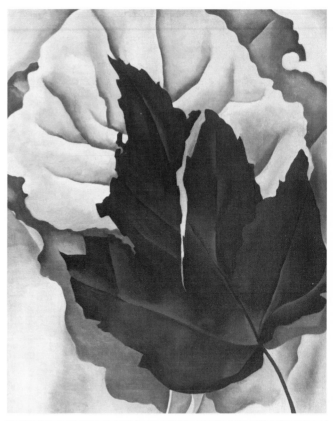

6. Georgia O'Keeffe, *Pattern of
Leaves*, ca. 1923.
Oil on canvas. 22⅛ × 18⅛ in.
© The Phillips Collection,
Washington, D.C.

Although O'Keeffe did not abandon abstraction-
ism after 1923, there is no question that she lim-
ited her experimentation with it, and she never again worked as expressively or
freely with it as she had in the formative years of her career.[17] The forms in *Ab-
straction* (1926 [fig. 7]), *Abstraction Blue* (1927 [fig. 8]), and *Pink Abstraction*
(1929), for example, are decidedly less spontaneous and evocative than those in
her earlier, more impulsive and imaginative abstractions, like *Special No. 9*
(1915 [fig. 1]) and *Blue and Green Music* (1919 [fig. 2]).

 In fact, in her continuing "effort to be objective," O'Keeffe based more and
more of her imagery on observable forms in nature, and she represented them as
exactly and precisely as she could. Thus, in many post-1923 paintings there is a
heightened realism that borders on the photographic, as is evident in the large-
format flower paintings she began making in 1924 (*Black Iris III* [1926
(fig. 9)]).[18] By so changing the apparent concerns of her art, O'Keeffe intended
to end criticism that centered speculations about the meaning of her imagery
around the fact that she was a woman artist expressing emotions that had no

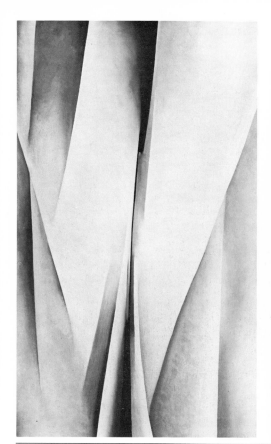

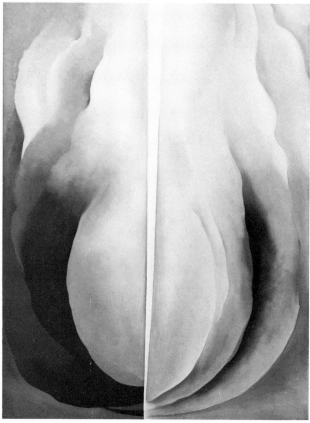

7. Georgia O'Keeffe, *Abstraction*, 1926.
Oil on canvas, 30 × 18 in.
Collection of Whitney Museum of American Art. Purchase 58.43.

8. Georgia O'Keeffe, *Abstraction Blue*, 1927.
Oil on canvas, 40¼ × 30 in.
Collection, The Museum of Modern Art, New York.
Acquired through the Helen Acheson Bequest.

From the Faraway Nearby

50

visual precedents—which was, of course, the way Stieglitz had promoted her from the beginning. This remarkable effort soon caught the critics' attention.

In a review of "Seven Americans," a group show that Stieglitz organized at the Anderson Galleries in 1925 (in which examples of O'Keeffe's enlarged flower paintings were first seen), critic Margaret Breuning wrote:

Georgia O'Keefe [*sic*], who exhibited very worthwhile things last year, shows a few good flower studies, notably a fine one of calla lilies, but the rest of her show might be termed a flop both in color and design. She always paints well, but her color is sickly in many instances here, and her choice of subjects not attractive; to say the least, there was something decidedly unpleasant about them to me, they seemed clinical.[19]

Breuning was not alone in noting the "clinical" character of O'Keeffe's work at mid-decade. A critic for the *Art News* responded to her 1928 exhibition by stating:

Her most seeming abstract pictures are only by elimination abstract. They are not only based on nature, they copy nature, line almost for line. It never seemed to occur to O'Keeffe to draw on her store house of accumulated memories. . . . Willingly or unwillingly, she has bound herself down to a copy book with a fidelity that approaches, and this particularly in her most abstract canvases, the photographic. . . . Let her cast aside her copy book, [and] draw on the memories that must be crowding her mind. . . .[20]

The increasing objectivity and precision of O'Keeffe's imagery also made a strong impression on critic Henry McBride, though he interpreted them in a surprising way. In responding to her 1927 show, he noted: "The work is more frankly decorative than it used to be. . . . The painting is intellectual rather than emotional, though, cool as it is, it unquestionably stirs certain natures almost to the fainting point." As he explained: "It is not emotional work because the processes are concealed. The tones melt smoothly into each other as though satin rather than rough canvas were the base. Emotion would not permit such plodding precision."[21]

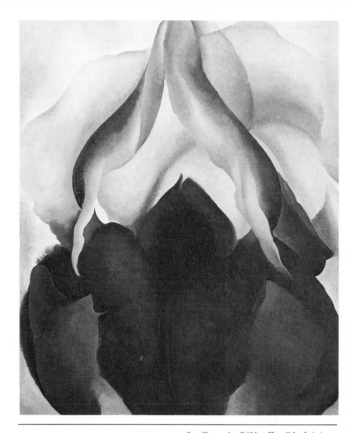

9. Georgia O'Keeffe, *Black Iris III*, 1926.
Oil on canvas, 36 × 29⅞ in.
The Metropolitan Museum of Art, The Alfred Stieglitz Collection, 1949 (69.278.1).

The word *intellectual* had been applied twice to O'Keeffe or her work in earlier criticism, but not without qualification. In a 1922 article in the *New York Sun,* O'Keeffe had been described as "intellectual and introspective," but her work had been described quite differently: "Certainly the most unusual, and perhaps the most characteristic of Miss O'Keeffe's paintings are those which express simply what she feels—a mood perhaps, or a spiritual experience. Entirely subjective, their appeal is hardly to the conscious mind, but rather, like music, to the subconscious."[22] And in his review of O'Keeffe's 1924 show, critic Virgil Barker had maintained that O'Keeffe's emotions were balanced by her intellect: "Miss O'Keeffe's pictures embody intelligent passionateness."[23] But from the beginning, most critics had responded to her art (and continued to do so) primarily in agreement with the position maintained by the Stieglitz circle, a position restated without equivocation by Rosenfeld in 1924, when he wrote that

O'Keeffe was "one who shows no traces of intellectualization and has a mind born of profoundest feeling."[24] Thus, by maintaining in 1927 that O'Keeffe's art was not emotional, McBride was the first to offer a direct and unqualified challenge to the Stieglitz-generated idea that had dominated the earlier criticism. And his conclusion in this regard was remarkable:

Miss O'Keefe [*sic*], therefore, is rather French, for though Proust, Paul Morand and Jean Cocteau have done all they can do to break the old forms, and "French" may come to mean something else in the future; at present it means planning the work out in one's mind completely before beginning upon it. Readers who care to go into this subject more deeply are recommended to read the dialogues of Diderot.[25]

O'Keeffe had become an extraordinary technician by the mid-1920s. Moreover, she thought a great deal about what she was going to do long before she began working, and it had become possible for her to execute a painting with great precision. For example, she described how she had gone about painting *The Shelton with Sunspots* (1926 [fig. 10]), which was exhibited in 1927:

I don't start until I'm almost entirely clear. It's a waste of time and paint. I've wasted a lot of canvas. . . . With that Shelton . . . I started at one corner and I went right across and came off at the other corner, and I didn't go back. For me [that was pretty unusual]. . . . I was amazed I could do it.[26]

Although this feat was probably known to McBride, he most likely was responding to the increasing image control evident in a painting like *The Shelton with Sunspots* as a radical departure from the work he had encountered when he first began to review her exhibitions in 1923. His response to this development in O'Keeffe's art was the first positive assessment of the result of the effort she had made to have her intentions as an artist redefined.

The following year, in her review of O'Keeffe's 1928 exhibition, critic Marya Mannes refused to accept the idea that O'Keeffe's work was, foremost, an expression of the feelings and desires of a woman. She wrote: "Let us once and for all dismiss this talk of 'a woman's painting' and 'a man's painting.' Any good creative thing is neither aggressively virile nor aggressively feminine; it is a fusion of the best of both. . . . Therefore, if we are to exalt the work of Georgia

O'Keeffe, let us not exalt it because it seems to be a rare psychic perception of the world peculiar to a woman, but because it is good painting." However, Mannes, unlike McBride, did not view the increasing formality in O'Keeffe's work favorably:

If there is one quality her painting lacks more than anything, it is plain, pumping blood—that kinship with the earth that even the greatest ecstasies must keep to sustain their flight. . . . Miss O'Keeffe's work suggests to me that kind of passionate mysticism that clouds the seeing eye with visions false to it, like some sweet drug. It is always a question whether the flowers in an opium dream are more beautiful than the flowers in the field; or the Garden of Eden than the first protoplasm. But all this leads nowhere—people will either like the painting of Georgia O'Keeffe or dislike it. This particular paragraph is written by one who realizes its frequent, unprecedented beauty, but is somehow repelled by the bodilessness of it.[27]

Although clearly based on what was observable in her work, the conception of O'Keeffe's art that critics like McBride and Mannes infused into the criticism of the late 1920s did little to lessen the appeal of the Stieglitz-generated ideas they contradicted. In fact, those ideas continued to be strengthened throughout the 1920s in essays written by Stieglitz associates, such as Oscar Bluemner, Louis Kalonyme, and Lewis Mumford. But the fact that several critics began to challenge them as early as 1924 demonstrates that the campaign she had initiated in 1923 met with some success. O'Keeffe's delight in even her partial success was expressed in her response to McBride's 1927 review:

I like what you print about me—and am amused and as usual dont understand what it is all about even if you do say I am intellectual[.]

I am particularly amused and pleased to have the emotional faucet turned off—no matter what other one you turn on.

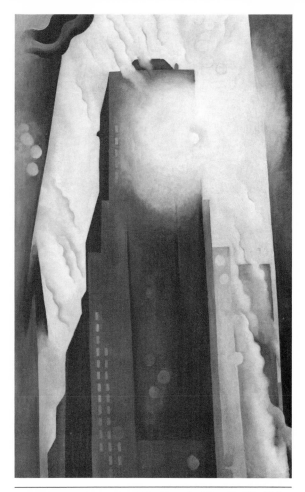

10. Georgia O'Keeffe, *The Shelton with Sunspots*, 1926. Oil on canvas, 49 × 31 in. Gift of Leigh B. Block, 1985.206. Photograph © 1992 The Art Institute of Chicago. All Rights Reserved.

The Language of Criticism

53

It is grand—

And all the ladies who like my things will think they are becoming intellectual—Its wonderful[.] And the men will think them much safer if my method is French[.][28]

The word *intellectual,* of course, had been as traditionally associated with the nature of men as the word *emotional* had been associated with the nature of women. And furthermore, as O'Keeffe continued the direction she had set for her art in 1923, various critics accentuated their assessments of her work with words such as *courageous, imaginative, introspective,* and *original*—all having traditionally "masculine" connotations. Thus, by increasingly objectifying, depersonalizing, and in turn, defeminizing her art in the second half of the decade, O'Keeffe moved closer to what she wanted: to be recognized as an artist, rather than as a woman artist—a term that, when applied to her, had specific erotic implications she could not tolerate.

If O'Keeffe had been able to ignore the criticism of her art that Stieglitz's ideas initiated, she might not have felt compelled to limit her experimentation with abstraction in the early 1920s. Although her decision to do so did not ultimately affect her position as one of this country's most important early modernists, it is my contention that it had a profound effect on the development of her art in the 1920s and, possibly, for the rest of her life. As she increasingly moved her imagery toward precisely controlled representationalism, away from the apparent spontaneity that distinguished her nonrepresentational work of the 1910s and early 1920s, she denied much of the sustained expressiveness and inventiveness that had made her formative work singular among that of her American contemporaries. Had she chosen to continue her experimentation with nonrepresentational imagery, rather than suppressing it in her efforts to redirect the criticism, her contribution to the history of abstractionism in America might have been even more significant.

Sources for O'Keeffe's Imagery

A Case Study

Lisa M. Messinger

Throughout her career, Georgia O'Keeffe stalwartly refused to acknowledge that there were ever any sources of inspiration for her painted images, other than those derived from her own imagination. A remarkable series of highly abstract charcoal drawings, made in 1915, forcefully declared her intentions to throw off the aesthetic influence of her academic training.[1] The radical nature of these works, when first exhibited at Alfred Stieglitz's gallery 291 in 1916, established O'Keeffe's reputation as an independent artist who relied on no one's lead but her own. With the aid of Stieglitz, this initial perception of O'Keeffe was to become her lifelong public persona. It is only now, after her death, that her life and work have come under more critical scrutiny.

During the late 1910s and 1920s O'Keeffe was a prominent figure among the inner circle of early American modernists, both painters and photographers, who gathered around Stieglitz. At the time, the verbal and visual exchange of ideas among the likes of John Marin, Arthur Dove, Charles Demuth, and Paul Strand made Stieglitz's early galleries a vital force in shaping the direction of American art. O'Keeffe, no matter how reticent to join in such discussions, could not have helped but be affected by others' work, which she helped install in numerous exhibitions. The impression that her art developed in a vacuum simply was not true.

Analysis of her own work never particularly interested O'Keeffe. Her comments, when they can be found, are usually poetic and somewhat cryptic. In fact, although she lived to be ninety-eight years old, O'Keeffe rarely spoke about her work in a concrete way, leaving the interpretation of her pictures to the

viewer, despite her frequent dismay at the resulting interpretations. One of the few places where her own words can be found is in the large 1976 Viking publication that was produced when the artist was eighty-nine.[2] In it O'Keeffe selected 108 paintings and watercolors for illustration, and provided brief commentaries.

In a particularly enlightening passage, O'Keeffe revealed her tendency to repeat certain images, often subconsciously. She wrote with surprise about one of her landscape paintings which had its source in her *Shell and Old Shingle* series:

I find that I have painted my life—things happening in my life—without knowing. After painting the shell and shingle many times, I did a misty landscape of the mountain across the lake, and the mountain became the shape of the shingle—mountain I saw out my window, the shingle on the table in my room. I did not notice that they were alike for a long time after they were painted.[3]

Such formal connections between unrelated subjects—in this case, between a country landscape and a still-life arrangement—occur often in O'Keeffe's work.

Part of the fascination in studying O'Keeffe's oeuvre is in deciphering those threads that run throughout her work—those shapes, forms, and images that reappear in various permutations. Images that were once explored separately, like her close-up views of flowers, bones, and landscapes, are often combined at some later date in a single picture, creating unusual juxtapositions. The overall result is a complex, but harmonious, body of work that spans seven decades.

This process of reworking forms and layering various themes also afforded O'Keeffe a method by which she could assimilate outside influences and then transform them into personal expressions. In one particular instance, a black-and-white photograph by the American photographer Edward Weston (1886–1958), a contemporary of O'Keeffe's, inspired an entire series of paintings by the artist. O'Keeffe's initial painting in the series was a rather direct transcription of the main element in the photograph. Eventually, however, it evolved into a purely "O'Keeffean" image.

Early in November 1922, the thirty-five-year-old Edward Weston arrived by train in New York City. Before leaving California, he had already resolved to move away from his wife and young children within the next few months and go live with his lover, Tina Modotti (1896–1942), in Mexico. In part, the trip east

was intended as a farewell visit to his older sister, May, and her husband, John Seaman, in Middletown, Ohio. Weston stopped there in October, en route to New York, carrying with him a selection of his most recent photographs from 1920 to 1922. The group included sensuous figure studies and portraits (many of Tina Modotti), and geometric interiors depicting friends in attic rooms. While in Ohio, Weston took a series of starkly precisionist photographs of machinery at the American Rolling Mill Company. These newest photographs clearly demonstrated his final transition from "pictorial" to "straight" photography—that is, from photography that was manipulated to affect the atmospheric look of romantic painting, toward a more documentary approach to subject matter and form. Weston's ultimate goal was to show his work to Alfred Stieglitz, a pioneering advocate of straight photography, whose work Weston greatly admired.

Although Weston had never before been to New York, he was quite aware, through publications and local exhibitions, of the avant-garde art and photography that flourished there in the first decades of the twentieth century. The works of such leading contemporary photographers as Stieglitz, Strand, and Charles Sheeler were familiar, primarily through reproductions in magazines like *Camera Work*, which Stieglitz published between 1903 and 1917, and through his close friendship with the photographer Johan Hagemeyer (1884–1962) in California. Hagemeyer had been associated with these leaders of modern photography in New York in 1916 and 1917. An article in the April 1921 issue of *The Dial*, by Paul Rosenfeld, praising Stieglitz, might have influenced Weston's desire to go to New York.[4] Weston still quoted from this article in a lecture that he presented in June 1922, just four months before heading to New York.

Upon arriving in New York City, Weston immediately telephoned Stieglitz to make an appointment, but he was informed that such a meeting would have to wait because of the imminent death of Stieglitz's mother. Hedwig Stieglitz died on 11 November 1922, and shortly thereafter the two men met for the first time. Weston was accompanied by a friend, whom he identifies in his notes as "Hazel Jo." They went to a townhouse on East Sixty-fifth Street where Stieglitz and O'Keeffe were then living (from 1920 to 1924) with Stieglitz's brother and his family. Stieglitz occupied the large front room, with his darkroom set up in an alcove. O'Keeffe worked in a sunny room on the floor below. The visit presumably took place in Stieglitz's quarters and lasted about four hours. Weston wrote: "Brilliantly—convincingly—he spoke with all the idealism and fervor of

a visionary."[5] Looking through the photographs one after the other, Stieglitz critiqued the selection, mixing praise with constructive criticism. Weston commented, "Stieglitz has not changed me—only intensified me."[6] Later he often repeated Stieglitz's phrase that the basis of photography was "a maximum of detail with a maximum of simplification."[7]

Although O'Keeffe was not present at this first meeting, Stieglitz spoke to Weston about her paintings, which were stacked around the room. He also showed Weston some of the photographic portraits he had made of O'Keeffe over the past four years. As Weston and Jo were departing, they met O'Keeffe briefly. In his notes, Weston remarked that he "could well see how she and Stieglitz could mean so much to each other—and how he has been able to express so much through photographing her."[8]

Stieglitz and O'Keeffe's intimate relationship at this time, outside the bonds of marriage, no doubt found a responsive chord in Weston; his own impending move to Mexico with Tina Modotti paralleled this liaison. In subsequent correspondence, Weston and Stieglitz discussed their mutual situation (both men left a wife and children to be with the women they loved). Weston wrote to him in 1923: "What you say re 'pulling up roots' is true—it is ghastly for me! To reconcile a certain side of one's life to another—to accept a situation without at the same time destroying another—to coordinate desires which pull first this way—then that—to know or try to know what is best for those one had brought into the world—and even knowing—to be able to do that 'best' without destroying one's self—looms as an almost hopeless problem."[9]

Shortly before his return to California, either in late November or December 1922 (he was home in California by Christmas), Weston phoned Stieglitz to request a second audience. He recounted that Stieglitz said:

"I am glad you called—in fact expected you would—I told Miss O'Keefe {sic} about your work—please bring it with you to show her." . . . It was still more evident from their remarks as they looked it over—that my prints had already been discussed and individually commented upon. . . . Strange how Georgia O'Keefe {sic} responded to the same pictures as did Stieglitz—and made practically the same criticisms—or rather not strange at all considering how close they have been.[10]

O'Keeffe's interest in photography was genuine. In December 1922, around the time of her meeting with Weston, she wrote a letter to the editor of *MSS.* that was published. There she defended such contemporary photographers as Stieg-

litz, Strand, and Sheeler, and although she did not mention Weston by name, she may well have been thinking of him when she wrote:

I feel that some of the photography being done in America today is more living, more vital, than the painting and I know that there are other painters who agree with me. Compared to the painter the photographer has no established tradition to live on. . . . I can only agree with Remy De Gourmont's Antiphilos that there are as many philosophies (I add ideas on "Art") as there are temperaments and personalities.[11]

Weston recorded extensive notes in his "Daybook" (journal) and in letters to his friend Hagemeyer, in California, about his trip to New York—details about the other photographers he met (Paul Strand, Charles Sheeler, Gertrude Kaisebier, and Clarence White) and the places he went. Although Weston later destroyed many pages from this journal, written prior to 1923, these entries about New York survived, an indication of the trip's importance to him. However, despite the relatively lengthy narrative, Weston failed to chronicle such details as the dates and places of his meetings and activities.

Weston also neglected to include a complete list of the photographs that he carried to New York. The only ones we can definitely identify are those for which he recorded Stieglitz's remarks. I would speculate that Stieglitz saw, in addition to *Ramiel in His Attic* (1920), which he "pounced upon" for its "irrelevant detail in the pillows,"[12] Weston's four other photographs in the attic series: *Betty in Her Attic* (1920), *Sunny Corner in an Attic* (1921), *Attic* (1921), and almost certainly, *The Ascent of Attic Angles* (1921 [fig. 1]).

In addition to destroying many journal entries, Weston ruthlessly edited his body of photographs, eliminating almost all examples of his early work from about 1906 to 1921. That the five attic pictures just listed exist today attests to the significance Weston ascribed to them as milestones in his development toward straight photography. One can presume that as examples of his most recent photography at the time of his departure from California in October 1922, the attic pictures would have surely been included in his portfolio.

One other fact makes the inclusion of *The Ascent of Attic Angles* almost certain: the extremely strong similarity between this black-and-white photograph and a later black-and-white painting by O'Keeffe, titled appropriately, *Black and White* (fig. 2). Given this visual connection, it seems highly likely that O'Keeffe saw *The Ascent of Attic Angles* at her meeting with Weston in late November or December 1922.

1. Edward Weston, *The Ascent of Attic Angles,* 1921. Photograph. Collection of Margaret W. Weston.

Like the other attic pictures, *The Ascent of Attic Angles* shows a single figure, placed beneath the sharp, angled eaves of an attic room. The figure in this print is hidden in shadow and contorted in a tight self-embrace, arms wrapped across shoulders and head bent forward. Another photograph in the series, *Attic* (1921), depicts the same corner, expanded horizontally to reveal more of the room. The three-quarter-length figure in *Attic* has been identified as Tina Modotti, and it is likely that she is also the model in *The Ascent of Attic Angles.*[13]

With its strong geometric lines and simplified composition, *The Ascent of Attic Angles* is one of the most visually powerful and abstract versions in this series. The motif of the slender white triangle on the left, slicing decisively into the dark field of the ceiling, creates a most memorable impression. I believe that this distinctive image stayed in O'Keeffe's subconscious mind for eight years until it unexpectedly appeared as a quote in her painting *Black and White* (1930).

The event that could have triggered her memory of this image was Weston's first one-man show in New York City in 1930. The exhibition took place at Alma Reed's gallery, Delphic Studios, 15–31 October 1930. Among the fifty photographs on view, all but five were photographs done between 1929 and 1930; the earliest was from 1924. Thus, the attic photographs, which dated from 1920 and 1921, were not within the scope of this exhibition. It seems likely, however, that as a person both knowledgeable about and interested in photography, and as one who had previously met the photographer, O'Keeffe would have gone to see Weston's show during its short run in New York. It should be noted, too, that between 1923 and 1942, Stieglitz and Weston corresponded sporadically, which O'Keeffe no doubt knew.[14] During October 1930, O'Keeffe was indeed in the city, having just returned in September from a three-month stay in Taos, New Mexico.

I believe that this installation of Weston's photographs made O'Keeffe recall their earlier meeting in 1922, and perhaps, even consciously, pay homage to

Weston in her painting *Black and White*. About this work O'Keeffe said that it was "a message for a friend—if he saw it he didn't know it was for him and wouldn't know what it said. And neither did I."[15] Although O'Keeffe never specified who the "friend" was, it very possibly was Edward Weston.

As the quintessential colorist, O'Keeffe left few black-and-white works. This monochromatic scheme was reserved for her most abstract compositions—namely, the 1915–18 charcoal drawings and her 1926–30 paintings, like *Black Abstraction* (1927 [fig. 3]). The absence of color allowed O'Keeffe to concentrate on the graphic structure of the composition as a means for expressing emotions. Although frequently based on tangible images, these paintings and drawings come close to looking completely nonobjective.

In *Black Abstraction,* point, line, and shading are the only elements of the composition. The picture's imagery was inspired by an operation the artist underwent that year. She recalled that while trying to forestall the inevitable effects of anesthesia, she reached up to a bright light overhead that seemed to whirl and then became increasingly smaller. The composition conveys a nebulous sense of space and is filled with three dark concentric rings. In front of these she has painted the graceful white V formed by her extended arms. At the vertex of the V, a small white spot represents the disappearing light. With this severely limited palette of black, white, and gray, O'Keeffe created a tense and ominous mood that echoed her own fears at the time.

The impact of this image, and the experience that inspired it, remained with O'Keeffe for several years and manifested itself in several painted variations on the theme. In 1928, for example, in a nocturnal seascape titled *Wave, Night,* she used a similar point-and-line motif to describe the light of a distant beacon and the edge of a wavy shoreline. Two years later, O'Keeffe painted *Black and White* and its only slightly more colorful companion, *Black, White, and Blue* (fig. 4). The sweeping black arc in the background of these two pictures comes directly from the concentric rings in *Black Abstraction.* Over this arc O'Keeffe has interjected the slender white triangle from Weston's photograph *The Ascent of*

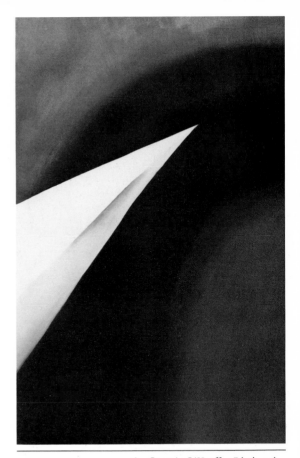

2. Georgia O'Keeffe, *Black and White,* 1930.
Oil on canvas, 36 × 24 in.
Collection of Whitney Museum of American Art. 50th Anniversary Gift of Mr. and Mrs. R. Crosby Kemper 81.9.

Sources for O'Keeffe's Imagery

61

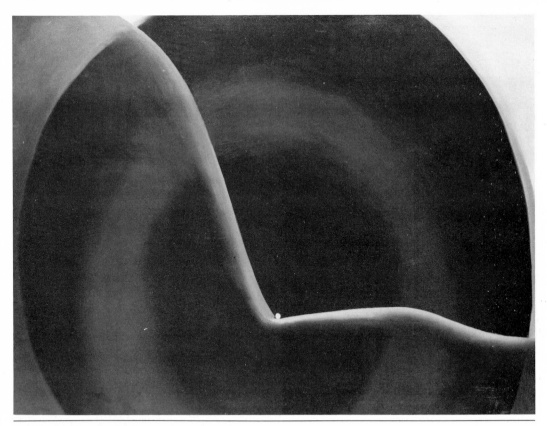

3. Georgia O'Keeffe, *Black Abstraction*, 1927.
Oil on canvas, 30 × 40¼ in. The Metropolitan Museum of Art, The Alfred Stieglitz Collection, 1949 (52.203).

Attic Angles. Its shape and angle are so close to the photographic original that it seems inconceivable that the photograph was not the specific source for these paintings.

In the three years between completion of *Black Abstraction* and *Black and White,* O'Keeffe went to New Mexico from April through August of 1929. There she produced a series of intensely colored canvases depicting the Penitente crosses that dot the New Mexico landscape, the most memorable of which is her masterful *Black Cross, New Mexico* (1929). Here the massive shape of the cross is underlined by a fiery red and yellow horizon line. Beyond it, we glimpse only a small corner of the sky above and the endless succession of rolling hills below. To O'Keeffe, such crosses symbolized the pervasive veil of religion that blanketed the Southwest, both literally and figuratively. It was, she said, also "a way of painting the country."[16]

The crosses constituted one of the first southwestern motifs O'Keeffe incorporated in her standard repertoire of images. One can see how a year later, in

Black, White, and Blue, O'Keeffe integrated this theme into the composition with the addition of a central vertical post. The wide black arc, which sweeps in front of the beam, suggests the horizontal bar of the cross. By adding a cross into her abstract arrangement, O'Keeffe has also suggested another layer of meaning for this painting.

The multilayering of imagery and interpretations is typical of her best work. In this case, what began as the re-creation of the hospital stay in *Black Abstraction,* as already mentioned, was soon combined with her remembrance of Weston's attic photograph and visit—both personal experiences to the artist. To these private images, O'Keeffe then added the cross, a symbol that contains greater universal significance. In both *Black and White* and *Black, White, and Blue,* O'Keeffe's reliance on Weston's 1921 photograph *The Ascent of Attic Angles* is evident. But as the image is reworked in the artist's mind and on canvas, it eventually emerges like a butterfly after a long pupation: no longer looking quite like its former self, it is transformed into a wholly new image—one that relates to the earlier images, but is completely rethought and independent.

The final phase in this metamorphosis occurred in 1931, a year after completion of these two black-and-white paintings. Using two of the same elements—the white triangle and the dark vertical support beam—O'Keeffe produced the classic "O'Keeffean" picture: *Cow's Skull: Red, White, and Blue* (fig. 5). The white triangle of Weston's photograph has now been doubled to become the skeletal horns of the cow. The configuration of the cross is made from two overlapping elements: the cow's skull placed at the top center of the canvas, its horns extending horizontally to either side, and behind it, the slender black vertical support of an easel or tree trunk.

The composition is starkly simple. The skull assumes great mystical power, as if it were a sacred relic. O'Keeffe used bones, like the Penitente crosses, as a symbol for the New Mexico landscape; and she wrote about their eternal qualities: "To me they are strangely more living than the animals walking around. . . . The bones seem to cut sharply to the center of something that is keenly alive on the desert even tho' it is vast and empty and untouchable—and

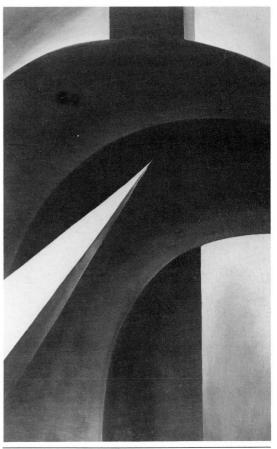

4. Georgia O'Keeffe, *Black, White, and Blue,* 1930. Oil on canvas, 40 × 30 in. Collection of Mr. and Mrs. Barney A. Ebsworth.

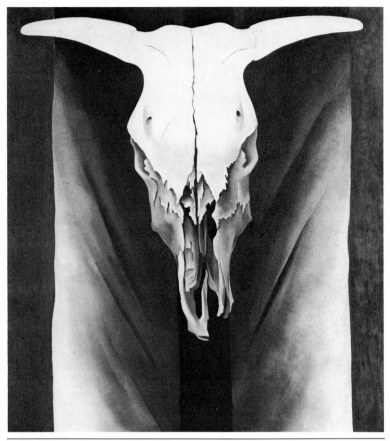

knows no kindness with all its beauty."[17] By infusing her painting with subliminal religious undertones, O'Keeffe reinforced the symbolic import of such imagery and the sacredness of the American landscape in general.

5. Georgia O'Keeffe, *Cow's Skull: Red, White, and Blue,* 1931. Oil on canvas, 39⅞ × 35⅞ in. The Metropolitan Museum of Art, The Alfred Stieglitz Collection, 1949 (69.278.2).

"Who Will Paint New York?"

"The World's New Art Center" and the Skyscraper
Paintings of Georgia O'Keeffe

Anna C. Chave

"FOR THE FIRST TIME EUROPE SEEKS INSPIRATION AT OUR SHORES IN THE
PERSONS OF A GROUP OF MODERNIST FRENCH ARTISTS, WHO FIND EUROPE
IMPOSSIBLE BECAUSE OF ITS WAR-DRENCHED ATMOSPHERE—MACMONNIES
PREDICTS THAT THE EFFECT OF THIS MIGRATION WILL BE FAR-REACHING ON
ART OF AMERICA AND THE OLDER CONTINENT," proclaimed a long headline in
the *New York Tribune* in October 1915. The French artists in question concurred
that New York was "destined to become the artistic centre of the world," and
not only because of the war. Albert Gleizes (1881–1953) averred that New
York's skyscrapers were "works of art . . . which equal the most admired old
world creations," and that "the genius who built the Brooklyn Bridge is to be
classed alongside the genius who built Notre Dame de Paris." Francis Picabia
(1879–1953) argued that "since machinery is the soul of the modern world, and
since the genius of machinery attains its highest expression in America, why is it
not reasonable to believe that in America the art of the future will flower most
brilliantly?" Jean Crotti (1878–1958) predicted "that New York will come to be
looked upon as the cradle of art, usurping the proud place enjoyed so long by
Paris and other important European cities. . . . Americans have come over to
us. Now we are coming over to you."[1] That same year Marcel Duchamp (1887–
1968) lamented: "If only America would realize that the art of Europe is fin-
ished—dead—and that America is the country of the art of the future, instead of
trying to base everything she does on European traditions! And yet in spite of it,
try as she will, she gets beyond these traditions even in dimension alone," he
continued, alluding to the city's great skyscrapers.[2]

65

Though they had sought New York out as a remote haven during wartime, these vanguard Parisians found they had landed not in the peripheries of modern culture but at something like its very center. "The Great War . . . hastened what prophets regarded as inevitable," the critic Frederick James Gregg proclaimed in *Vanity Fair* in January 1915; "New York is now, for the time being at least, the art capital of the world, that is to say the commercial art centre, where paintings and sculptures are viewed, discussed, purchased and exchanged."[3] This momentous declaration—that New York had become "The World's New Art Centre"—was not the last of its kind. The same claim was made in the late 1920s by the critic Henry McBride, for instance, and made again in 1948 by Clement Greenberg—the last of these statements being the only one to lodge in the standard histories. "Now when it comes to the Zeitgeist, we Americans are the most advanced people on earth, if only because we are the most industrialized," Greenberg asserted. That those "most advanced people" should start producing the most "advanced" art in the world's most "advanced" city seems consistent enough, though Greenberg described himself as startled by the realization: "The conclusion forces itself, much to our own surprise, that the main premises of Western art have at last migrated to the United States, along with the center of gravity of industrial production and political power. . . . It is not beyond possibility that the cubist tradition may enjoy a new efflorescence in this country."[4] For Greenberg, then, the migration of influences was to travel one way: because he viewed cubism—as most modern art historians have ever since—as the source of all legitimate modern visual languages, he lauded only those artists who had drunk deep from the "fountainhead" of modern art, artists such as Jackson Pollock (1912–1956) (whose work largely prompted this claim of American dominance). The global shifts in economic and political power to which Greenberg alluded occurred not after World War II, when Pollock hit his stride, however, but after World War I. In the decade after the first world war ended, New York became the financial capital of the world (replacing London), at the same time that the United States as a whole became "incomparably the greatest economic power in the world."[5]

The newfound affluence of the United States was expressed most visibly in a construction boom, and extensive building was necessary to accommodate the flow of people from rural areas to the city. In the 1920s the population of urban America grew by 27 percent, as the nation became for the first time predominantly an urban country. And New York City "got a brand new skyline" in the 1920s, with the area around Grand Central Station, especially, being almost totally rebuilt with those tall buildings that were increasingly greeted as the avatar

of a new architectural era.[6] "Eminent European critics, visiting these shores, are in the habit of declaring that the American Spirit expresses itself most eloquently in jazz music and in the skyscrapers," wrote the American architectural theorist Claude Bragdon. "Not only is the skyscraper a symbol of the American Spirit—restless, centrifugal, perilously poised—but it is the only truly original development in the field of architecture to which we can lay unchallenged claim." Bragdon made these observations in 1925 in an essay on the newly completed Shelton Hotel (then the most celebrated feature of that new skyline near Grand Central), where he lived in an apartment close by that of Georgia O'Keeffe and her husband, Alfred Stieglitz.[7] And it was just this manifestation of the "American Spirit"—the Shelton Hotel (fig. 1) and other new skyscrapers from the same burgeoning Manhattan neighborhood—that O'Keeffe would capture in a remarkable series of urban landscapes painted between 1925 and 1930. Evincing a forthright pragmatism unashamedly overtaken by a visionary romanticism, O'Keeffe's skyscraper paintings glorified that phenomenon which—as the first artifact of American culture to attract sustained international attention—had unexpectedly succeeded in bringing global renown to New York City.

"Paris is no longer the capital of Cosmopolis . . . New York . . . has become the battleground of modern civilization," declared Henry McBride in 1929. American artists who persisted in traveling abroad to work were "jeopardizing their careers for the dubious consummations of the Café de la Rotunde."[8] This counsel was wasted on Georgia O'Keeffe, who spurned the European capitals until her old age;[9] but others were less receptive to such tidings even when they hailed from Paris itself. Writing from Paris in 1921, a puzzled Charles Demuth noted how interested the French avant-garde was in events in New York: "Sometimes it seems impossible to come back,—we are so out of it," he wrote. "Then one sees Marcel [Duchamp] or [Albert] Gleizes and they will say,—Oh! Paris. New York is the place,—there are the modern ideas,—Europe is finished."[10] The problem for American artists, however, was that "our art is, as yet, outside of our art world," as the critic Robert J. Coady put it in 1917, citing by way of example the skyscraper, the steam shovel, and Charlie

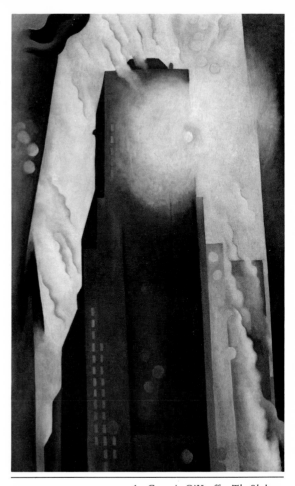

1. Georgia O'Keeffe, *The Shelton with Sunspots,* 1926. Oil on canvas, 49 × 31 in. Gift of Leigh B. Block, 1985.206. Photograph © 1992 The Art Institute of Chicago. All Rights Reserved.

2. Abraham Walkowitz,
New York.
Reproduced in *Soil,* Dec. 1916.

Chaplin, among other examples.[11] To Duchamp, this was no problem: "New York itself is a work of art, a complete work of art," he proclaimed in 1915;[12] and he proposed to designate the Woolworth tower as one of his "ready-mades."[13] But Coady understood that an authoritative image of New York would have to be a painted image, because painting was historically the authoritative medium.

"Who will paint New York? Who?" Coady asked again and again in the first issue of *Soil,* published in 1916; and others echoed the cry. Wrote Henry Tyrrell in the *New York World* in 1923:

New York, grandiose and glittering—the modern Wonder City of dynamic pulses, wireless, magnetism, electricity and tempered steel, of piled-up architecture like magic pinnacles of Alpine ice . . . There she stands, matchless and overwhelming. Who shall paint her portrait? This to modern art is the flaming cynosure, this to modern artists the task that beckons with the fatalistic fascination of the unattainable.[14]

As Coady and Tyrrell saw it, the attempts at painting the city made by artists like Abraham Walkowitz (fig. 2) and Joseph Stella did not solve the problem, for these artists pictured New York more or less as Fernand Léger and Robert Delaunay had pictured Paris: in a cubist vernacular. That fractured idiom stressed the disjunctiveness of lives lived at quickening tempos in ever more crowded surroundings where artifacts of new regimes abruptly insinuated themselves amidst the pervasive artifacts of old regimes and of a pretechnological order. But to paint New York, where the new was fairly continuous with the old (which was not so old in any case), and where the new looked newer than anywhere else, posed a different problem.

Cubism undertook "the task of [the] revaluation of old values in Art and . . . perform[ed] it with violence," Naum Gabo once wrote. Cubist paintings are "like a heap of shards from a vessel exploded from within."[15] The futurists seized on cubism's violence from the first, stressing that artists had to destroy the preexisting visual order to recover space for their own visions. Making room for new structures by demolishing old ones was a radical proposition to

the Italians and the French, but it was a routine practice in an American city like New York.[16] While European artists had liberating dreams of a tabula rasa, then, American artists viewed the specter of a cultural void as a terrifying, because all-too-real prospect; what history the Americans had was secondhand—rootless, eclectic, and reimagined—and that was the kind of history they often endeavored not to eradicate but to integrate into their work. Using remnants of European culture to help piece together their self-image, Americans articulated their identity as ex-colonials. The skyscraper Duchamp wanted to designate as ready-made, for example—the Woolworth Building—was an ornate, ersatz, neo-Gothic cathedral built by a dimestore magnate.

"New York's architecture . . . can be matched nowhere else in the world. Like all great art it has grown from the conditions of our life . . . as an expression of our composite genius," wrote a critic in 1923, singling out the Shelton Hotel for his praise.[17] But those huge, ornamented masonry structures, such as the Woolworth Building and the Shelton, which were seen as exemplary in their day are generally downplayed by historians now in favor of those (less representative) buildings that can be seen as foreshadowing the sleek, modernist vision of the Bauhaus or the international style.[18] By the early 1920s, European architects such as Ludwig Mies van der Rohe (1886–1969) were applying Bauhaus principles to skyscraper design, picturing an ideal modern tower—a geometric volume cleansed of ornament and historical referents (fig. 3)—made possible by new building technologies. There was no call in Europe for such structures, so these architects looked hopefully instead to the United States, perceiving it as a country that had "escaped Europe and its history willfully, in order to create a new universe and to initiate a new time," as Thomas van Leeuwen put it.[19]

The European fascination with the skyscraper is connected with "the appeal America exercised as the ideological reflection of anything inadmissible in ancien regime Europe," van Leeuwen has written. "America was free, it was unlimited in space, it abounded in natural resources and in money. It knew no tradition, it had no history." From this perspective, the fact that American architects and artists persisted in following the precepts of tradition was baffling and

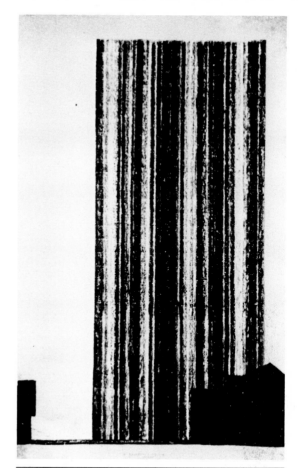

3. Ludwig Mies van der Rohe, *Glass Skyscraper Project*, 1922.

Charcoal, brown chalk, crayon on paper, 54½ × 32¾ in. Collection, Mies van der Rohe Archive, The Museum of Modern Art, New York. Gift of George Danforth.

"Who Will Paint New York?"

69

"unforgivable."[20] Many Europeans became convinced that they had a clearer vision of the new art and architecture that belonged in the New World than those who lived there; and they remonstrated with Americans for their lack of self-perception. "The American character contains the elements of an extraordinary art," because American life is "abstract," "scientific," and "cold," like the twentieth century itself, Duchamp reasoned in 1915; but "the traditions weigh too heavily upon you, turn you into a sort of religious fanatics [*sic*] as little yourselves as possible." For Duchamp as for Mies, the advent of the skyscraper signaled "the call of utility,"[21] whereas for Americans their "cathedrals of commerce" were not only models of efficiency but magic mountains of steel and stone, signifying at once their material and their spiritual ambitions.

"The major formal and theoretical changes in skyscraper design began in the early 1920s with the work of [Hugh] Ferriss, [Bertram] Goodhue, [Raymond] Hood, and others," the architectural historian Carol Willis has argued. "The characteristics of this new aesthetic were an emphasis on formal values of mass and silhouette with the subordination of ornament."[22] The identifiable buildings painted by O'Keeffe all dated from this period and were all located in the city's second great outcropping of skyscrapers. Eschewing the downtown skyscrapers rendered by artists before her—the tall buildings packed along the narrow lanes of the Wall Street area, which Joseph Pennell (1857–1926) had etched; the Flat Iron Building, which Stieglitz had photographed; the ornate Woolworth and Municipal buildings, done in watercolor by John Marin (1870–1953)—O'Keeffe made her own the stately skyscrapers rising along the broad avenues of her midtown neighborhood, an area of fashionable shops, galleries, offices including the famous Radiator Building, designed by Raymond Hood [fig. 4], and her favored subject, upscale residential hotels (the Shelton, the Berkley [figs. 1, 5], the Ritz Tower). Taking some cues on visual poetics from the dark, theatrical drawings of the visionary architectural renderer Hugh Ferriss[23] (fig. 6) and some cues on compositions, perhaps, from the cleanly composed architectural photographs of Charles Sheeler (fig. 7),[24] O'Keeffe contrived her own ravishing vision of New York as a city awash in sunlight or in moonglow and the dazzling aura of an artificial firmament.

It is difficult now, except in O'Keeffe's pictures of it, to see the appeal of the Shelton Hotel—her favorite architectural subject—which exemplified a vital turning point in skyscraper design. But to critics of the day this mammoth, austere structure was a revelation; it was "not a tower on a building, but it is itself a tower and . . . a really thrilling example of vertical movement in composi-

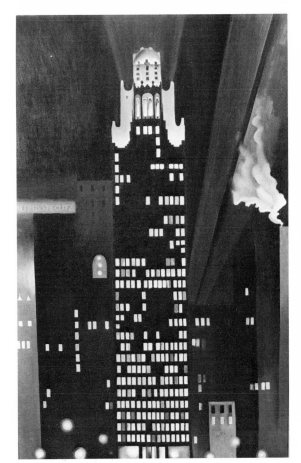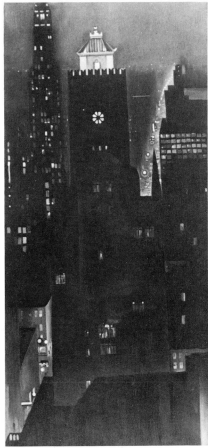

tion. . . . No one, I believe, can look on the Shelton from near or far without some lifting of the spirit."[25] As one of the first major buildings to make effective use of the so-called setback mode necessitated by the 1916 zoning law (enacted to insure that tall buildings not keep sunlight from reaching the streets), the Shelton proved highly influential. Ferriss had executed a series of studies of architectural solutions to the law's stipulations; and in designing the Shelton, Arthur Loomis Harmon followed his basic dictum that the setbacks should be boldly articulated in architectural form, not camouflaged by ornamentation. Ferriss's renderings of the Shelton (fig. 6) shared with O'Keeffe's (fig. 1) an emphasis on its massive, stepped, zigguratlike silhouette. Historically, the ziggurat was a "cosmic mountain," a symbolic image of the cosmos; and both artists rendered the atmosphere enveloping the building in dramatic ways, suggesting cosmic or visionary overtones.[26]

4. Georgia O'Keeffe, *Radiator Building—Night, New York*, 1927. Oil on canvas, 48 × 30 in. The Carl Van Vechten Gallery of Fine Arts, Fisk University, Nashville, Tenn.

5. Georgia O'Keeffe, *New York, Night*, 1929. Oil on canvas, 40⅛ × 19⅛ in. Sheldon Memorial Art Gallery, University of Nebraska, Lincoln.

"Who Will Paint New York?"

71

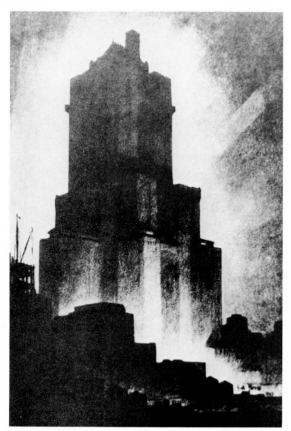

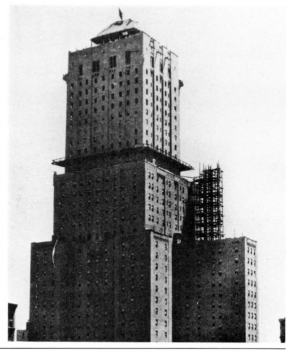

6. Hugh Ferriss, *The Shelton Hotel,* first published in 1927. Reproduced in Ferriss, *The Metropolis of Tomorrow* (New York, 1929).

7. Charles Sheeler, *The Shelton.* Reproduced in *The Arts,* Aug. 1923.

To Hugh Ferriss, there was in the Shelton "something reminiscent of the mountain. Many people choose it as a residence, or frequent its upper terraces, because . . . it evokes that undefinable sense of satisfaction which man ever finds on the slope of the pyramid or the mountainside."[27] O'Keeffe and Stieglitz regarded their lofty quarters as just such a refuge: "New York is madder than ever," Stieglitz wrote to a friend. " . . . But Georgia and I somehow don't seem to be of New York—nor of anywhere. We live high up in the Shelton Hotel. . . . We feel as if we were out at midocean—All is so quiet except the wind—& the trembling shaking hulk of steel in which we live—It's a wonderful place—"[28] O'Keeffe's vision of the Shelton stressed its natural aspect, making of it an architectural mountain faced by a sheer cliff. To her and Ferriss both, the experience of the skyscrapers was one of sublimity; and by omitting human figures (surrogate viewers) within the image itself, they adduced an unmediated access to that experience, picturing a New York viewed from too high up, or with the head tilted too far back, to admit the presence of others.

When asked about his interest in the vaunted architectural traditions of the École des Beaux-Arts, Ferriss replied that he preferred "to seek the masses of the Grand Canyon and the peaks and spaces of southern California for inspiration rather than the past of Europe" because "they are more truly American."[29] The perceived naturalness and Americanness of O'Keeffe's vision was likewise a factor in the reception of her work. "O'Keeffe is America's. Its own exclusive product," the critic Frances O'Brien wrote in the *Nation* in 1927. "It is refreshing to realize that she had never been to Europe. More refreshing still that she had no ambition to go there. . . . In her painting as in herself is the scattered soul of America come into Kingdom."[30] What was so American about O'Keeffe's art was not only that she painted, and painted in, a skyscraper, but also that she painted with such clarity and directness. "Having purged herself of New York's borrowed art theories" during her sojourns West of the Hudson, she had become "of all our modern painters . . . the least influenced by any of the . . . aesthetic fashions of the time," claimed O'Brien.[31] Others also saw her as eschewing the abstruse and dissembling ways of the Continent for a mode of visualization founded squarely on perception and resemblance. "O'Keeffe's pictures are the clean-cut result of an intensely passionate apprehension of things," wrote Virgil Barker in 1924.[32] And in 1927 McBride praised one of her aerial views of New York in 1927, as "a sufficiently literal rendering of one of the most amazing scenes on earth. . . . [T]he mere facts are overpowering without any mysticism."[33]

McBride also perceptively praised O'Keeffe for painting the skyscrapers "as though their largeness was their main attraction—as it probably is."[34] By constructing her portraits of skyscrapers with a few bold, vertical shapes (whose bigness of scale was established by the counterpoint of the rows of minuscule windows), O'Keeffe formulated a vision of the tall building that requited the architects' own. Louis Sullivan identified "the dominant characteristic of the tall office building" as "its *tallness*: the force of altitude must be in it. Let it be therefore 'a proud and soaring thing, without a dissenting line from bottom to top.'"[35] O'Keeffe's sense of the skyscraper's height was surely enhanced by her residing and working in one—as she was the first artist—and among the first people ever—to live in a skyscraper.[36] In fact, the idea of living in a skyscraper prompted the idea of painting New York: "When I was looking for a place to live, I decided to try the Shelton. I was shown two rooms on the 30th floor. I had never lived up so high before and was so excited that I began talking about trying to paint New York. Of course, I was told that it was an impossible idea—even the men hadn't done too well with it."[37]

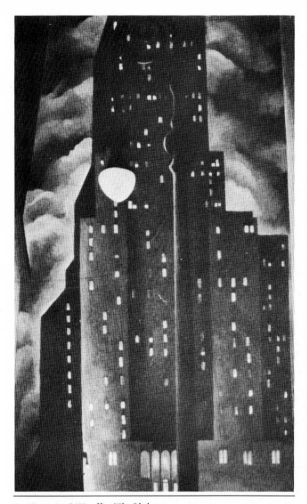

8. Georgia O'Keeffe, *The Shelton
Hotel at Night.*
Reproduced in *Arts and
Decoration,* Mar. 1927.

New York was seen as a man's subject, no doubt, because of the skyscrapers' priapic forms, because rendering the city meant taking the kind of commanding perspective that men alone are ordinarily socialized to assume, and because men control the civic space.[38] O'Keeffe knew well that New York was Stieglitz's milieu more than her own: in her picture of the Radiator Building, she inscribed "ALFRED STIEGLITZ" in an imaginary, brilliant red sign atop an adjacent building (fig. 4). Moving to the Shelton eased that feeling for a time, as she became attuned to the city's poetry and found ways of articulating it. Many of her New York pictures offer relatively intimate views of one or two buildings; and she often focused on the open spaces between or over buildings, emphasizing the void as much as, or more than, the skyscrapers' priapic forms. "I saw a sky shape near the Chatham Hotel where buildings were going up," O'Keeffe recalled. "It was the buildings that made this fine shape, so I sketched it and then painted it. This was in the early twenties and was my first New York painting:—*New York at Night with Moon*" (fig. 9).[39]

To work and live atop a skyscraper was to realize a peculiarly modern and American vision of success and emancipation—one not commonly identified with women. But once she started realizing some income from her art, O'Keeffe's ideal urban home was a corner suite (without a kitchen) on an upper floor of a residential hotel initially designed for bachelors. "Miss O'Keeffe lives there—by choice," McBride assured his readers in 1928. "It [the Shelton] has long lines, long surfaces—it has everything. At night it looks as though it reached to the stars, and the searchlights that cut across the sky back of it do appear to carry messages to other worlds."[40] Though none of her biographers have noticed it, late in 1927 O'Keeffe evidently moved within the Shelton from the twenty-eighth to the thirtieth floor (of a thirty-three-story building), probably to improve her view. A letter to her sister in December 1926 describes two rooms on the twenty-eighth floor with views facing north, east, and south.[41] After January 1928, visitors described going to the thirtieth floor, to a suite with views in every direction;[42] "I am going to live as high as I can this year," she said, when she moved to her new apartment.[43]

"I realize it's unusual for an artist to work way up near the roof of a big hotel in the heart of the roaring city," O'Keeffe told a critic in 1928, "but I think that's just what the artist of today needs for stimulus. He has to have a place where he can behold the city as a unit before his eyes."[44] Gazing east from the Shelton in the late mornings or through the late afternoon haze, O'Keeffe could render one of those spectacular urban vistas—over the river and the industrial districts of Queens (*East River from the Shelton,* 1927 [fig. 10])—that constitute a uniquely modern vision. Looking north from her corner aerie in the evening, she could capture the whimsical, pagoda-roofed tower of the nearby Berkley Hotel and the bright stream of headlights coursing down Lexington Avenue into the red stoplight and neon-lit well at the base of her building (*New York, Night,* 1929 [fig. 5]). Most impressive of all were her awesome views of the towers seen from below: *The Shelton with Sunspots,* 1926, and by moonlight (*The Shelton Hotel at Night,* 1927) (figs. 1, 8), and the black and silvery *Radiator Building—Night, New York* (1927 [fig. 4]), lit up like a colossal Christmas tree, along with other more anonymous structures (fig. 11). In a subtly abstracted way, O'Keeffe limned the flat, continuous shapes the tall buildings carved into the sky as well as (in her nocturnal views of the Radiator Building and the Berkley Hotel), the fantastic ornamentation of the buildings' crowns and the complex patterns created by the profligate displays of artificial light from within and without. O'Keeffe captured New York's spellbinding theater both in its epic and in its vaudevillian aspects: "Her summation of Manhattan, unequalled in painting, has the rude thrust as well as the delicacy and glitter that distinguishes the city of America," pronounced Herbert Seligmann.[45]

O'Keeffe did more than twenty New York paintings between 1925 and 1930; and while her own recollections do not comprise a seamless account of the course of events, she evidently painted her first city picture (fig. 9) early in 1925

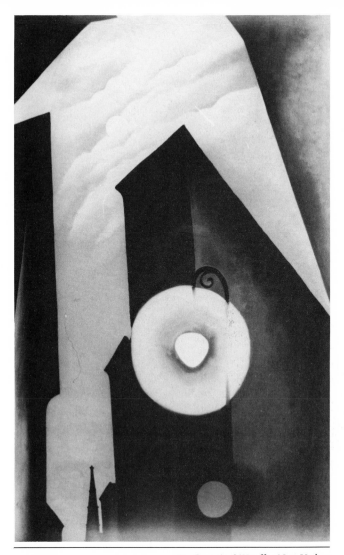

9. Georgia O'Keeffe, *New York at Night with Moon,* 1925. Oil on canvas, 48 × 30 in. Thyssen-Bornemisza Collection, Lugano, Switzerland.

"Who Will Paint New York?"

75

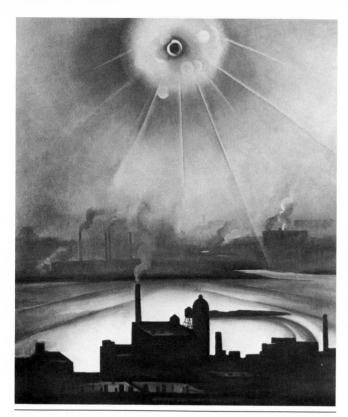

10. Georgia O'Keeffe, *East River from the Shelton*, 1927–28. Oil on canvas, 25 × 22 in. New Jersey State Museum, Trenton, N.J.

when she lived in an apartment at 35 East Fifty-eighth Street.[46] Probably in March of that year (not the fall as she recalled), she urged Stieglitz to exhibit the picture in a group show he was organizing at the Anderson Galleries; but, anxious about premiering her outsized flower paintings at the same show, Stieglitz refused.[47] Her city paintings debuted, instead, in her solo show of February and March 1926; and *New York at Night with Moon* was the first painting to sell, by her account, on the day the show opened. "No one ever objected to my painting New York after that," she wryly remembered.[48] O'Keeffe and Stieglitz had moved to the Shelton in November 1925, and during the few months remaining before her 1926 show, she seems to have painted three detailed panoramas of the view east from her window. Given that she credited the building with inspiring her to paint the city, however, she may have been shown the apartment before painting *New York at Night with Moon*—that is, in January or February 1925—and she probably painted some or all of the four images of the building's facade that were in the 1926 exhibition before moving in.

Nine New York paintings led off the list for O'Keeffe's 1926 exhibition, which the *New Yorker* described as "a marvelous show of a genius which it would be foolish to miss."[49] Six New York pictures would top the list of works at her annual show in 1927; and three city paintings headed the list the following year.[50] These New York paintings drew some special mention in the press,[51] but O'Keeffe's regular supporters included numerous critics who had been attracted principally by the organic quality of her art—Paul Rosenfeld, Waldo Frank, Paul Strand, and Lewis Mumford—and who were known to disapprove of the skyscraper, complaining of its dehumanizing effects. What influenced O'Keeffe to quit painting New York, however (as she did in 1930, with two exceptions), was probably less the disinterest of those critics in her city pictures than the fact that the newfound spirit of American cultural pride that had permeated her New York pictures collapsed in October 1929 with the stock market crash. (Further, Stieglitz resumed photographing the city at this time, and she disliked sharing subjects with him.)

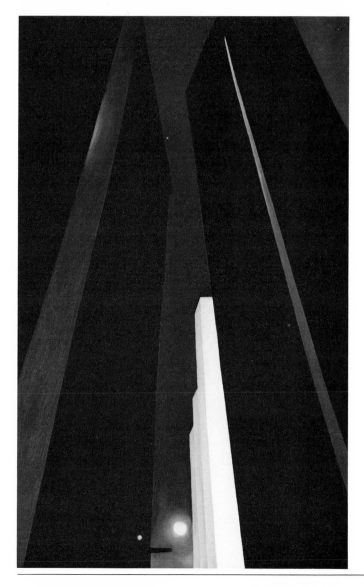

11. Georgia O'Keeffe, *City Night*, 1926.
Oil on canvas, 48 × 30 in.
The Minneapolis Institute of Arts, Gift of the Regis Corporation, Mr. and Mrs. W. John Driscoll, the Brim Foundation, the Larsen Fund, and by public subscription.

O'Keeffe's last painting of New York, executed in the 1940s, was a dry, rigid image of the Brooklyn Bridge. Her other late painting of the city was a failed but telling experiment: a triptych showing a panorama of Manhattan rendered in a cubist syntax and dotted with her trademark flowers (fig. 12). (Whether by intent or coincidence, the central panel of the triptych resembled one of the stage sets for John Alden Carpenter's *Skyscrapers* [fig. 13], first performed as a ballet in 1926.)[52] O'Keeffe contrived this clumsy work for an invitational exhibition of mural proposals by American artists; organized by the

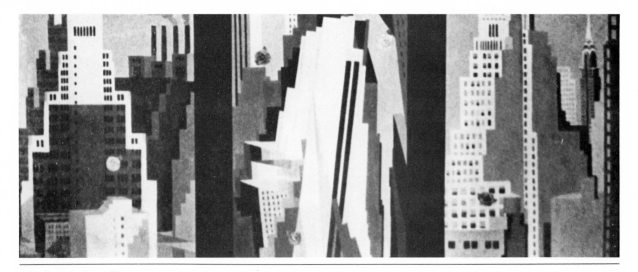

12. Georgia O'Keeffe,
Manhattan.
Triptych. Oil on canvas, about 21
× 48 in.
Reproduced in *Murals by American
Painters and Photographers* (New
York: Museum of Modern Art,
1932).

Museum of Modern Art in 1932, the show was meant to prove to the designers of Radio City Music Hall that they should not look exclusively abroad for talent to decorate the building. The show's premise, and the Eurocentric bias of the Museum of Modern Art, must have influenced O'Keeffe in an exceptional (or unique?) attempt to demonstrate her command of the dominant modernist language. Betraying her indifference to cubism's dire report on the fragmentation of the modern subject would, in this context, only have stigmatized her as a parochial. Her cagy entry to the exhibition brought the desired outcome—the chance to decorate the women's powder room, at least, at Radio City; but Stieglitz interfered, and O'Keeffe withdrew from the project.[53]

Stieglitz was ambivalent about publicizing O'Keeffe's work within the United States, and he declined to promote her career abroad: "I have been asked to let this work go to Europe," he said of the show in which the city paintings premiered, "but they do not take the Woolworth Tower to Europe. And this work here is as American as the Woolworth Tower."[54] European vanguardists might not have recognized in O'Keeffe's pictures their image of the New World's new art or architecture in any case, for they generally perceived as truly modern that art which conformed to their own vision of the new visual order; and they widely intimated that Americans did not yet know themselves—not as well as the Europeans knew them. "When the Americans have travelled sufficiently across the old world to perceive their own richness, they will be able to see their own country for what it is," said a paternalistic Henri Matisse in 1930.[55] While Matisse viewed Americans as cultural "primitives,"[56] however, no paintings come so close as O'Keeffe's *Radiator Building, The Shelton with Sunspots,*

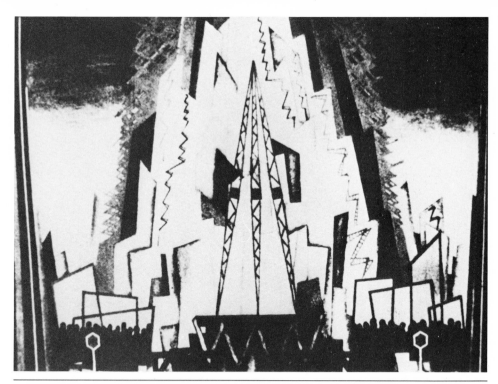

13. Robert Edmond Jones,
Second Stageset for John Alden
Carpenter's *Skyscrapers* Ballet,
1926.
Reproduced in *Theater Arts
Monthly* 10 (Mar. 1926).

or *City Night* of the 1920s (figs. 4, 1, 11) to capturing the exhilarating experience of New York as he described it (while comparing the city favorably both to Paris and to the Swiss Alps): "The first time that I saw America, I mean New York, at seven o'clock in the evening, this gold and black block in the night, reflected in the water, I was in complete ecstasy. . . . New York seemed to me like a gold nugget." Strolling down the "grand avenues" in the midtown area O'Keeffe had painted, Matisse was "truly electrified" as he discovered that the skyscrapers create "a feeling of lightness . . . [and] of liberty through the possession of a larger space."[57]

Just when O'Keeffe was painting the city, in the mid-1920s, the sculptor Constantin Brancusi (1876–1957) was also discovering in New York "a great new poetry seeking its peculiar expression. In architecture you have found it already in the great skyscrapers. We in Europe are far behind you in this field"[58]—although, he added (on another occasion), "I do not think you Americans realize how beautiful they are."[59] The skyscrapers' "wonderful, inspiring flight heavenward" was like the effect Brancusi hoped to achieve with his *Birds in Space,* an image of emancipation: "In America I feel free, I feel alive," he told a reporter. "The movement of the streets, the sweep of the buildings, the virility of life is

tonic."[60] In the early 1940s, the Dutch artist Piet Mondrian (1872–1944) would likewise find in New York a direct relation to what he wanted to accomplish in his art. He relished the way the city plan—especially the clear grid of streets in the midtown area—and the city's architecture reciprocated the structure of his neoplasticist vision; and he deemed his final home "the most modern city in the world—and the most congenial environment in which he had ever lived."[61] Mondrian painted the most ambitious pictures of his career in New York— *Broadway Boogie-Woogie* and the unfinished *Victory Boogie-Woogie*—and he found a circle of devotees there, as well as entrees to the market and the public. "Living for almost a quarter of a century in Paris, . . . he had met no dealer who offered to represent him";[62] astonishingly enough, the first and only solo show Mondrian had in his lifetime was held in New York.[63]

New York's "skyscrapers . . . say that the country understands art," asserted Brancusi, who had found, before Mondrian, similar reasons for deeming the United States "best qualified to speak authoritatively of modern art":[64] all of his solo exhibitions until the year before his death were held there, beginning with a show at Stieglitz's 291 gallery in 1914.[65] "Without the Americans, I would not have been able to produce all this or even to have existed," the sculptor acknowledged,[66] mindful that he had sold few sculptures to the French over the course of five decades in Paris. Matisse also knew that a greater public for modern art existed among Americans than among the French; his most devoted patrons were almost entirely American.[67] "Americans are interested in modern painting because of its immediate translation of feeling. . . . It is more in rapport with the activity of their spirit," Matisse conjectured.[68] As for Duchamp, who would make a home in New York and eventually take American citizenship, from the time of the Armory Show (in 1913) it was Americans, and not the French, who treated him as a celebrity and an authority (Duchamp had both his first solo show and his first major retrospective in the United States).[69]

Many of those pivotal figures of the avant-garde who are typically credited with making Paris the world's art center saw New York in that role instead, in other words, long before the end of World War II. The skyscrapers made the city look the part. And after World War I, New York generally provided better opportunities than Paris for viewing, showing, and selling modern art. American patrons were among the world's most adventuresome; and many of them worked to make modern art publicly accessible in a way it was not in Paris. Katherine Dreier started the public, nonprofit Société Anonyme gallery in a New York brownstone in 1920; the Phillips Gallery opened in 1921 in part of the family home in Washington, D.C.; and A. E. Gallatin opened the Gallery

of Living Art at New York University in 1927. Two years later, the Museum of Modern Art—the brainstorm of a cartel of society women—opened to the public; the Whitney Museum of American Art opened its doors in 1931, financed by the wealthy sculptor Gertrude Vanderbilt Whitney; and Solomon R. Guggenheim made his collection public in the Museum of Non-Objective Art in 1939.

The sense that Paris had become an "onlooker" by comparison to New York occurred to different observers at different times. In an essay on the "most beautiful spectacle in the world," Fernand Léger exclaimed, in 1931: "After six days of crossing the water," the visitor suddenly encounters a "daring vertical new continent." In Léger's eyes, that "steep mountain, the work of men," represented nothing less than a "new world" of egalitarianism and a "new religion" consecrated to business and technology: "New York and the telephone came into the world on the same day, on the same boat, to conquer the world. Mechanical life is at its apogee here." Though he had long been preoccupied with picturing the mechanical, Léger doubted that any artist could ever describe New York: "It is madness to think of employing such a subject artistically. One admires it humbly, and that's all."[70]

So who would dare to paint New York? Léger and Matisse would not even try it, and Mondrian's vision of the city, however compelling, was fundamentally continuous with his vision of Paris and London. It was Georgia O'Keeffe who would paint New York, depicting its towering buildings in a legible, lyrical way that requited the democratized character of the city while enunciating the limitless aspirations embodied in its newfound imago, the skyscraper. O'Keeffe believed that her images of the city included "probably my best paintings," and she hoped that they would "turn the world over," just as the tall buildings she was painting were very nearly doing.[71] That she pictured "the world's new art center" effectively never did bring O'Keeffe her due, however, for in the standard, Eurocentric narratives of the history of modern art New York was *not* the world's art center at the time she portrayed it—no matter who thought so—and O'Keeffe was not a world-wise artist. Perhaps the best answer to the question, Who will paint New York? then, is a second question: Who gets to say when New York has been painted?

From an American vantage point, the most obvious answer to the latter query is Clement Greenberg, which makes the answer to the first question, Jackson Pollock. Pollock did not paint New York in a literal way, of course—no one asked that anymore by the end of World War II—but to Greenberg's eye, his art represented "an attempt to cope with urban life; it dwells entirely in the

lonely jungle of immediate sensations, impulses and notions, therefore is positivist, concrete"—notwithstanding the fact that the poured paintings were all made on a Long Island farm![72] In the standard narratives, Pollock receives most of the credit for having shifted the center of the art world from Paris to New York, thereby "turning the world over." It took a protracted campaign by American critics to persuade Europeans of the legitimacy of Pollock's vision, which bears scant trace of cubism;[73] but his art would finally come to represent a belated triumph of the Old World's vision of the New World as unlimited in space and energy, and innocent of culture. Erasing the colonial past, Pollock invented that much-anticipated art without history. If Pollock found a way to picture the country's stark, cultural nakedness, however, it was Georgia O'Keeffe who first pictured the world's new art center in all its overwhelming and eclectic cultural finery.

An American Phenomenon

On Marketing Georgia O'Keeffe

MaLin Wilson

Here is a conundrum: How did Alfred Stieglitz and Georgia O'Keeffe, two of the most elite artists in America, come to be the subject of so much popular attention? What explains the plethora of biographies, monographs, articles, and titillating speculation about this husband and wife? And what are we to make of today's "Georgia O'Keeffe industry" described in a 1988 *New York Times* article by Grace Glueck—the ubiquitous posters, books, calendars, and note cards (to say nothing of the penchant for decorating with animal bones)? How did the withdrawn Miss O'Keeffe, in particular, get to be an American superstar?

Common sense tells us that there were other women making significant modernist art during the same era. For example, who has heard of the artist Agnes Pelton? She was also an independent, talented, and beautiful woman, a consummate painter of extraordinary, pulsing abstractions, who showed in the famous 1913 Armory exhibition and lived for forty years in the desert near Palm Springs. An obvious difference is that Agnes Pelton never had a passionate patron, famous lover, and demanding companion who was also a wily agent and promoter—that is, Pelton never had a Stieglitz. What elements can be discerned in the elevation of Georgia O'Keeffe and Alfred Stieglitz from the relatively small and insulated world of art? Undeniably, there is the high drama of a passionate love between a powerful and intellectual fifty-two-year-old man who lives in the most dynamic city in the world and a beautiful twenty-nine-year-old woman from the Texas plains who is a painter of the voluptuous—each having found their natural complement and antagonist. Also, for a myth of such proportions to be sustained, it must be supported by art that continues to hold

83

fascination for successive generations. I would like readers to shift their orientation slightly in reviewing Georgia O'Keeffe's passage from a small-town college instructor to Stieglitz's companion living in a New York skyscraper to the most well-known woman artist in America by considering three magnifications of her reputation: America's vibrant popular culture, Stieglitz's talents as photographer and dealer, and the success of O'Keeffe's images in reproduction.

First, in twentieth-century America the public, or formal, world has progressively atrophied, and what continues to push forward as most vigorous in American culture is the exploration of the personal, the intimate. Women have, of course, been essential movers and shakers in this change, and O'Keeffe has been recognized as one of the pioneers of revelation of the interior world of women. Modernism was a "sea change" that can be described by the introduction of such startling ideas as relativity—both scientific and psychological—by Einstein, Freud, and others. Stieglitz, O'Keeffe, and their circle of friends were in the avant-garde and discussed at length the introduction of new ideas. America's virulent popular culture is often infected with the intellectual or more esoteric culture, and the result is a marriage of high and low that is most American. Stieglitz and O'Keeffe embody this marriage as a couple. They can be seen as symbols of refinement meeting boldness, the cognitive meeting the physical. They can be seen to represent a break with tradition and repressive patterns. Their unlikely marriage seems to confirm an American ideal of freedom and possibility. Stieglitz often joked about the disassociation of Americans from their experience, offering the analogy that if Americans approached two signs—one pointing to a lecture on heaven and the other pointing to heaven—every American would go to the lecture. In many ways both Stieglitz and O'Keeffe represent the choice of going to heaven.

As Barbara Buhler Lynes has so brilliantly demonstrated in her book *O'Keeffe, Stieglitz and the Critics, 1916–1929,* Georgia O'Keeffe was terribly wounded by the critics' characterization of her work as erotic and sexually obsessive. Both Stieglitz and O'Keeffe created art that was initially seen as shocking, an affront to polite society and conservative views of culture. While O'Keeffe refused a position as a spokesperson for feminism, her life and work were inspirational demonstrations of her freedom and her vigor.

In certain respects it was Stieglitz's skill as a photographer that anointed Miss O'Keeffe as the first major American woman artist. His photographic portrait of O'Keeffe spanned the years 1917 through 1935 and includes over four hundred images. While Stieglitz claimed that these exquisite and often astounding photographs represented universal "WOMAN," the portraits of Georgia

O'Keeffe are also specifically her in the most private moments—even showing her flushed with postcoital rapture. O'Keeffe is revealed as mischievous, severe, pensive. It is significant in the development of O'Keeffe as a popular heroine that Stieglitz portrayed her with his camera. Since its invention 150 years ago, photography has been imbued with a feeling that it freezes reality. Combine this perception of photography with the widespread human suspicion that the "real" person is behind the "front," Stieglitz's extensive photographic portrait gives the viewer an opportunity to feel privy to the "real" O'Keeffe—that is, to the secrets hidden behind the reserved figure dressed in black who often held her tongue while the garrulous Stieglitz held forth.

In 1921 at the Anderson Gallery in New York, Stieglitz exhibited 145 photographs, including 45 of O'Keeffe, none identified. Of course, everyone knew these were portraits of his lover and companion, often showing her with her startling paintings. Many of the paintings seen in the portraits were exhibited in 1924 in a joint exhibition announced as "ALFRED STIEGLITZ PRESENTS 100 PICTURES BY GEORGIA O'KEEFFE, AMERICAN." From today's jaundiced perspective, it looks as if Stieglitz had a brilliant marketing strategy: how enticing to give the viewer both the woman and a sneak preview of her paintings. I do not want to give the impression that Stieglitz schemed this creation of O'Keeffe's media personality, but the sequence of events naturally fueled her elevation into an iconic figure. She was the first woman who could be possessed by the masses. These photographs were, of course, a clear, resounding demonstration of not only Stieglitz's love for her but also his greatness as a photographer.

Stieglitz's exquisite portraits certainly built the initial illusion that we could come to know the essential O'Keeffe. Their complexity will sustain the interest, and as photographs, they were and can be published extensively. Although O'Keeffe found the publicity infuriating, it certainly contributed to both her fame and fortune.

Many thought of Stieglitz as naive in terms of the market, but he was actually a thoroughly canny and savvy manager of O'Keeffe's sales. The prices for her work were always high. In 1928 Stieglitz sold a series of six small calla lily panels for twenty-five thousand dollars—not only the highest price ever paid until that time for an O'Keeffe, but the highest price ever known to have been received by a living American artist. Furthermore, during the depths of the Depression, Stieglitz only needed to sell one painting for O'Keeffe to purchase a new deluxe Ford V-8. Stieglitz's extended portrait includes some beautiful prints of O'Keeffe with her new car, which she learned to drive in New Mexico. After Stieglitz opened An American Place (1929–1946), it was rumored that the sale

of O'Keeffe's paintings from her annual exhibitions kept the gallery afloat. There is still much research to be done to determine O'Keeffe's actual sales history. Galleries are notoriously closed about their sales, especially in the recent era's volatile markets. There are always rumors about false supports, Japanese investors, impending bankruptcies.

Stieglitz initiated O'Keeffe's market with an aura of secrecy, insuring that only the wealthy and privileged might possess her masterpieces. Stories abound of Stieglitz's interrogation of prospective clients, who had to prove themselves worthy of owning an O'Keeffe. The American who purchased the calla lilies in 1928 promised not only never to separate them but also never to sell them during his lifetime. O'Keeffe, unlike many artists, rarely gave her work to intimates; she referred friends to her agent of the moment. Another fascinating aspect of the Stieglitz–O'Keeffe gallery sales was their refusal to reveal just how many paintings she had painted. The O'Keeffe Foundation, established since her death, has prioritized the research and publication of a catalogue raisonné of O'Keeffe's work. In addition to its value for scholars, the catalogue raisonné is an essential document for the protection of her market from degradation through the production of fakes, frauds, and forgeries. O'Keeffe's work is not difficult to fake and, as can be seen with other popular artists' works, is susceptible to fraudulent operators.

O'Keeffe's production was quite erratic over the years; nevertheless, Stieglitz exhibited and sold paintings annually. In the terminology of economics, Stieglitz, as a career manager for Miss O'Keeffe, cannily exploited the principles of supply, demand, and anticipation. I am convinced that his decisions were primarily based on his own reverence for her paintings and the high value and esteem in which he viewed them, but his approach was a good, solid beginning for establishing a long-term market.

Another contributing factor in the crowning of Georgia O'Keeffe is the abundant and successful reproduction of her images. Biographer Roxana Robinson has stated that O'Keeffe is the most popular woman artist in America because hers is the only work, from an era of well-known male artists, that is completely feminine and intuitive. Although I am not quite sure about Robinson's definition of *feminine* and *intuitive,* other women artists of the period— including O'Keeffe's friend Rebecca Strand James, Agnes Pelton, and Henrietta Shore—created works completely unlike anything done by their male counterparts. But none has had so much market support and none has had her images reproduced so lavishly in books, posters, calendars, and note cards as O'Keeffe.

Another obvious reason for the widespread recognition of O'Keeffe is the proliferation of O'Keeffe reproductions. She was a great image maker. It can be

argued that many of her paintings actually look better in reproduction. Her flowers, trees, hills, and bones, which seem to glow in glossy reproduction, are different from the original paintings, which often look too small with dry, thin, parched strokes. While paint application in the New Mexico landscapes may actually evoke an arid topography, its effects are certainly more palatable with an expansive border on coated paper. The Santa Fe Chamber Music Festival, now in its nineteenth season, has printed a poster each year featuring an O'Keeffe image. These posters, distributed nationally, are surely the most successful posters by any artist at any time in history, as they have done much to make O'Keeffe a popular figure. The posters are faithful to the original size, handsome, and affordable.

Clearly, O'Keeffe's market and her reputation as one of America's most highly priced artists—with publicized sales during the late 1980s boom years hitting the magic million-dollar range—have also contributed to her elevation to stardom. After all, Americans do equate success with money. Access to inside knowledge about O'Keeffe's market today is as obscure as it was during Stieglitz's reign. Since O'Keeffe's death, her work has appeared at the major New York auction houses, but it continues to be sold mostly in private transactions. This, of course, breeds speculation about intrigues and artificial supports. The O'Keeffe phenomenon today involves a huge and disparate community of supporting galleries, publishing companies, printers, academics, museum curators, biographers, editors, musicians, distributors, and many more. Once so many people are invested in ongoing success there is a tendency toward self-perpetuation.

The glorification of O'Keeffe and Stieglitz seems sure to puff up even further. The Santa Fe Chamber Music Festival will continue to print tens of thousands of posters. The biographies will continue to be published. The market for the reproductions will keep her a popular figure. However, the question of a market for O'Keeffe's original paintings is a matter of debate. Many scholars consider only her early work valuable in the long run. The recession of late 1990 and 1991 has many dealers bluffing, trying to maintain high values despite the indications that the U.S. economy will be depressed for a long time. Many people feel that with the 1992 European Common Market, the Europeans will set the pace and determine trends, and O'Keeffe has never had the reputation in Europe that she has had in America. She is primarily an American phenomenon—a symbol of boldness, individuality, success, and passion.

Beholding the Epiphanies

Mysticism and the Art of Georgia O'Keeffe

Sharyn R. Udall

Undeniably, the development of modern painting has been nourished by ideas from a common pool of mystical thought. As an alternative to the dominant current of pragmatic materialism in America, artists have frequently pointed to a long history of antimaterialist philosophy that included Walt Whitman, Henry David Thoreau, and Ralph Waldo Emerson. Visual antecedents appeared in the work of William Blake and Albert Pinkham Ryder. Yet it was not until the organization of a 1986 exhibit entitled "The Spiritual in Art: Abstract Painting 1890–1985" at the Los Angeles County Museum of Art that art historians began to acknowledge fully the pervasive influence of mysticism within American art.[1] Since that epochal show, new light has been shed on the ancient and modern sources from which mysticism derived.

To clarify the concepts of mysticism, understood differently by artists and art historians than by theologians, let us adopt the useful framework established by the catalogue of the Los Angeles show. As outlined by exhibition organizer Maurice Tuchman, mysticism is a "search for the state of oneness with ultimate reality," while occultism "depends upon secret, concealed phenomena that are accessible only to those who have been appropriately initiated." Tuchman has identified some ideas common to most mystical and occult views:

[T]he universe is a single, living substance; mind and matter also are one; all things evolve in dialectical opposition, thus the universe comprises paired opposites (male–female, light–dark, vertical–horizontal, positive–negative): everything corresponds in a universal analogy, with things above

as they are below; imagination is real; and self-realization can come by illumination, accident, or an induced state: the epiphany is suggested by heat, fire or light. The ideas that underlie mystical-occult beliefs were transmitted through books, pamphlets, and diagrams, often augmented by illustrations that, because of the ineffable nature of the ideas discussed, were abstract or emphasized the use of symbols.[2]

These kinds of illustrations contain five visible impulses, according to Tuchman: cosmic imagery, vibration, duality, sacred geometry, and synesthesia (the overlap between the senses). Over many centuries manifestations of the spiritual in art have been more or less visible, depending on political, sociological, and religious contexts. Occasionally they have erupted with unusual vigor, as in Europe with the late nineteenth-century occult revival, then again around 1910, when artists on both sides of the Atlantic gave renewed currency to the presence of the spiritual. In groups or as individuals, visual artists began to move away from perceived reality toward signs, from direct observation to ideas, from natural to symbolic color. They did not dismiss meaning outright, but instead tried to draw on deeper and more varied levels of meaning.

Even some mainstream American art histories began to reflect the union of the abstract and the spiritual. From Arthur Jerome Eddy's treatises, continuing through Sheldon Cheney's in the 1920s and 1930s, the mystical was an accepted component of modern American art.[3] But its halcyon days were brief; by the late 1930s mystical and occult beliefs came increasingly under suspicion in America because of their political associations with fascism and Nazism. By then, purely aesthetic issues had replaced interest in alternative belief systems, and soon a tidal wave of formalist criticism had begun to engulf the popular view of modern art in America. From the 1930s to the 1960s its chief spokesman was critic Clement Greenberg, who argued that modernist practice in art was objectively verifiable and followed certain unchangeable laws. In 1946 he castigated the art of Georgia O'Keeffe, for example, alleging that her painting "has less to do with art than with private worship and the embellishment of private fetishes with secret and arbitrary meanings."[4] Greenberg blamed what he termed her "errors" on a misreading of advanced European art—either cubism, fauvism, or German expressionism—that took place decades earlier when Picasso and Matisse broke with nature. Again according to Greenberg, the misguided early American modernists, led by Alfred Stieglitz, took the new nonnaturalist European art and transformed it into a vehicle for an esoteric message, a signal, in Greenberg's words, "for a new kind of hermetic literature with mystical overtones" that

thenceforth tainted the work of O'Keeffe, Arthur Dove, Marsden Hartley, and others. It was also the stimulus, wrote Greenberg, for O'Keeffe's rapid incursion into the abstract shortly after her earliest encounters with modernist art.

Such criticisms could be deadly in 1946, when mysticism and the spiritual had become anathema to many Americans. But now, nearly half a century later, thanks to the pendulum's swing away from narrow modernist dictates, it is possible again to discuss the spiritual content in modern art and to reassess O'Keeffe's affinities for the mystical in her work. What Greenberg decried in O'Keeffe's work in 1946 is exactly the spiritual element that interests us here. It is the contention of this writer that O'Keeffe did indeed absorb mystical concepts starting about 1915 and that these attitudes and symbols—largely unacknowledged by the artist—pervaded her art for decades. Little has been said of this in the O'Keeffe literature, for three major reasons. First, because of its inherently slippery and various nature, the presence of the mystical is difficult to pin down. Second, O'Keeffe's firm denial of such otherworldly influences has quashed most such discussion. Finally, the paintings themselves, with their visual clarity and precise focus, have conspired to mask any ethereal intent.

But we will see that O'Keeffe's training, her associates, her reading and—not least—her longstanding attachment to New Mexico served her mystical inclinations. Her intensely personal approach to painting and her prolonged absences from New York have much to do with the events of her personal life, as her biographers have clearly shown; but I believe her periods of geographic isolation can be linked also to her affinities for mysticism, which required a degree of interiority. O'Keeffe needed periods of privacy in her pursuit of self-realization. Through O'Keeffe's letters (gradually becoming accessible to researchers, as in the 1987 publication of *Georgia O'Keeffe: Art and Letters*), through her actions and through the paintings themselves these developments will be traced.[5]

First, a word about the structure of the discussion: It is useless to try to proceed in strict chronological sequence; O'Keeffe's time is not historical and linear. The orbit of her artistic development—circular, like the shapes she often used in her paintings—brought her back into contact with subjects and ideas first considered years or decades earlier. A theorist like Wassily Kandinsky, for example, influenced various aspects of O'Keeffe's thinking at various times and must be addressed in multiple contexts. O'Keeffe's development corresponds to what French feminist philosopher Julia Kristeva has called "women's time"—cyclical (i.e., repetitive or naturally rhythmic) and monumental (eternal, mythic, outside of time). This kind of time, Kristeva notes, has long been associated both with women and with mystical cultures.[6]

O'Keeffe wanted to be seen as an American original, and for the most part she got what she wanted. With the help of her dealer-husband Alfred Stieglitz, she took pains to present herself as independent, free of entangling theory. As a result, she has been viewed as such in the literature. Typical is the assessment of art historian William Innes Homer, who wrote:

By deliberately remaining independent of artistic cliques and fashions, she was able to preserve her original vision. In this light, her artistic achievement of the years 1915–1917 is all the more significant, for much of what she did came from her own imagination.[7]

O'Keeffe's imagination may have been her own, but her skills as an artist were honed by a series of remarkable teachers. William Merritt Chase, Alon Bement, and Arthur Wesley Dow were all strong influences on the young O'Keeffe. Dow, one of the most important art educators of his time, taught her at Teachers College, Columbia University, in 1914 and 1915. Dow (who had studied Oriental aesthetics with Ernest Fenollosa [1853–1908] in Boston) advocated a design system that was both harmonious and expressive of human emotion.[8] Using fundamental elements of line and color, along with the Japanese Notan system of composing through the oppositions of light and dark, students were encouraged to discard descriptive realism in favor of flat decorative composition.

Along with an education in aesthetics, O'Keeffe absorbed from Dow the rudiments of mystical thought. Dow had long been associated with Sarah Farmer, who founded a rural retreat in Maine for people pursuing mystical ideas. At Green Acre, Farmer's camp, the celebrated Theosophist Madame Blavatsky and various other mystics were widely discussed and revered. Dow's youthful involvement with mysticism reached its apex when he undertook a spiritual pilgrimage, guided by Theosophists, to sacred sites in India in 1903 and 1904.[9] These experiences, a clear attempt to fuse Eastern mysticism and art with Western thought, were passed along to his students (who included Max Weber, Arthur Dove, and O'Keeffe) for years afterwards. O'Keeffe's interests in Eastern art, mysticism, and abstraction would remain sustaining influences throughout her long life.

Still another influence of her training with Dow was an exposure to principles seen in synthetist-symbolist painting. Symbolism, the mystical wing of the postimpressionist generation, became—along with fauvism and cubism—the chief roots from which abstract art grew.

Though we have long known that in her youth she read the most advanced theorists of her day, it is clear from the recent publication of O'Keeffe's letters that—contrary to W. I. Homer's statement—hers was much more than a casual brush with modernist theory. And modernism, especially as practiced among her New York associates, impinged at many points on mystical thinking. O'Keeffe wrote of "laboring on Aesthetics—Wright—Bell—DeZayas—Eddy—All I could find—everywhere—have been slaving on it since in November—even read a lot of Caffin. . . ."[10]

These theorists of twentieth-century aesthetics adopted slightly different points of view, but they shared several similar principles. Clive Bell, Marius DeZayas, and Charles Caffin, for example, argued for an internal motivation and significance in art; they believed that new forms, whether figural or abstract, presented the artist with new possibilities for expression.

In addition, Caffin emphasized that intuition and instinct rivaled reason in their importance to humanity. This idea carried great appeal to many introspective artists and writers of the era. Paralleling the theory of French philosopher Henri Bergson (1859–1941), whose work *Creative Evolution* was a vital text within the Stieglitz circle, thinkers ranging from Marsden Hartley to Gertrude Stein asserted the primacy of the intuitive in art and life—a primacy also important to mystics. Modernists acclaimed Bergson's work because it supported their desire to break with traditional representation.

Arthur Jerome Eddy saw art moving into a new realm, calling for "the attainment of a higher stage in pure art [which] speaks from soul to soul [and] is not dependent upon one use of objective and imitative forms."[11] Wassily Kandinsky too had seen a new world dawning in the arts:

The great epoch of the Spiritual which is already beginning, or, in embryonic form, began already yesterday . . . provides and will provide the soil in which a kind of monumental work of art must come to fruition.[12]

Even before she met Stieglitz, O'Keeffe had read Kandinsky's *Concerning the Spiritual in Art* twice.[13] First published in English in 1914, this germinal treatise had begun to make its influence felt on the Stieglitz circle several years earlier. Moreover, Stieglitz had purchased a Kandinsky abstraction, *Improvisation No. 27* (1912), from the 1913 Armory Show with an intent to educate his 291 confreres.

Central to Kandinsky's thinking was that artists worked according to spiritual necessity and that their creations, in turn, expressed the inner spiritual

essence of their creator. Simple on the surface, this position (which preceded the views of the British and American theorists O'Keeffe studied in 1916 and 1917) marked a watershed in aesthetics everywhere. For many who encountered his paintings and his musings on art, Kandinsky became the chief apostle of abstraction. He argued that art should be freed from its traditional bonds to material reality. Just as musicians do not depend on the material world for their music, so artists should not have to depend on the material world for their art. "The more abstract is form," he wrote, "the more clear and direct is its appeal."[14]

Clarity and directness were already part of the artistic ideals O'Keeffe had inherited from Dow. Affirmed in this direction by her reading of Kandinsky, the theorist, and teacher Robert Henri (1865–1929), whose pragmatic follow-your-own-road advice she had absorbed secondhand, the young O'Keeffe began to seek an original, inventive style based on abstraction. While teaching at Columbia, South Carolina, in 1915 and 1916, she produced a group of remarkable charcoal drawings, mostly abstract. Their vocabulary of forms suggests an organic relationship to nature; but it is a consonance of shape, rather than specific referents, that speak of possible sources. Wavy lines, bulbous egg-shaped forms, and sawtooth planes are reminiscent of Kandinsky's free abstractions (and of the even earlier *Thought-Forms* [1901] by Theosophists Annie Besant and C. W. Leadbeater), but they also begin to set down a personal visual syntax upon which O'Keeffe would draw for the next six decades.[15]

When O'Keeffe returned to New York and enrolled in one of Alon Bement's classes at Columbia, she was exposed firsthand to the then-popular principle of synesthesia. An idea that has long engaged artists, it has an even longer history in mystical circles. In O'Keeffe's case, the clearest instance of synesthesia was an occasion she recalled when, hearing low-toned music coming from Bement's classroom, she entered and was directed with other students to make drawings from what they heard. Here she discovered that music could be translated into visual form. Out of that insight came several remarkable paintings, including *Music—Pink and Blue I* (1919) and *Blue and Green Music* (1919).

Such ideas often found their first American audiences on the pages of experimental publications such as Stieglitz's *Camera Work* or *291*. There, and within the walls of his progressive galleries, O'Keeffe met and mingled with the major figures of the American artistic avant-garde and grew conversant with the latest European and American painting, sculpture, and theory.[16] Try as she might to downplay her early immersion in the sources of modernist thought—or with aesthetics and intellectual matters in general—it is clear, as will be seen, that the

thoughts and mystical attitudes of such pioneer modernists as Kandinsky remained a vital force in her art.

O'Keeffe's personal associations after 1915—both inside and outside the Stieglitz circle—did much to establish the spiritual as part of her worldview. Chief among these was Stieglitz himself, whose interest in the psychic and mystical has been documented by both Sue Davidson Lowe and Roxana Robinson. As Robinson writes, Stieglitz "was as mystical and baffling as an Oriental sage—a comparison he welcomed."[17] She adds that his interests in the mystical and occult extended to astrology and numerology and that his Intimate Gallery in 1925 contained little else besides paintings and a table that held a crystal ball. Through Stieglitz, O'Keeffe was exposed to many new and esoteric ideas. It was he, for example, who got her thinking about the mystical polarities of masculine and feminine, opposite but complementary. They came to know each other first through their correspondence, which demonstrates a difference in expression they both connected to gender. Stieglitz's letters to O'Keeffe are thoughtful, voluminous, analytical. Her letters, by contrast, are spontaneous, direct, almost stream-of-consciousness in their lack of regard for the niceties of punctuation and syntax. She recognized the differences and noted, at the same time, that her art reflected both her personality and her gender. She wrote to her friend Anita Pollitzer in 1916 about her new drawings: "The thing seems to express in a way what I want it to but—it also seems rather effeminate—it is essentially a womans feeling—satisfies me in a way—. . . ."[18] Stieglitz reinforced these attitudes: he claimed from the first moment he saw her work that he could identify it as a woman's—pure, fine, and sincere.

One of the universal paired opposites common to mysticism, this distinct male/female duality allowed O'Keeffe the clarity to pursue her feminist concerns in art and life.[19] She could argue on the one hand that women were as competent artistically (and otherwise) as men, while accommodating at the same time the belief that there were certain immutable differences in their natures.[20] In praising new work by John Marin, for example, she wrote, "I must add that I don't mind if Marin comes first—because he is a man—its a different class—"[21]

Another conduit between O'Keeffe and certain kinds of cosmic thinking was Claude Bragdon (1866–1946), an influential New York architect-designer. Bragdon was a Theosophist who wrote the treatises *A Primer of Higher Space* (1913) and *Four-Dimensional Vistas* (1916); he also translated P. D. Ouspensky's *Tertium Organum*. Bragdon lived at the Shelton Hotel, where Stieglitz and O'Keeffe moved in November 1925. The three often shared ideas while dining together at the Shelton.[22] Other mystically inclined associates during their New

York years were the Davidsons—Stieglitz's favorite niece, Elizabeth, and her husband, Donald—who were devotees of Hinduism. At one time O'Keeffe and Stieglitz saw a good deal of Marcel Duchamp, whose interests in alchemy and the mystical have been well documented. Later O'Keeffe became very close to Louise March and the writer Jean Toomer, both followers of Russian mystic G. I. Gurdjieff.

O'Keeffe's affinities for the metaphysical were also nourished by other artists within the Stieglitz circle, especially Marsden Hartley and Arthur Dove. Hartley—like Dow, a frequent visitor to Sarah Farmer's Green Acre—often wrote to Stieglitz about his intense involvement with the spiritual, claiming that he was the first artist to use modern painting as a vehicle for mysticism. In the years preceding World War I Hartley lived in Berlin, where he painted several series of emblematic portraits. In these and in concurrent spiritual abstractions he tried to merge three enthusiasms: Oriental mysticism, Christian symbolism, and Native American spirituality.[23]

Hartley also wrote art criticism. In his 1921 study *Adventures in the Arts,* he devoted a section to O'Keeffe; he remarked on the intensely personal quality of her painting, saying that she was "impaled with a white consciousness."[24] O'Keeffe saw Hartley's 1916 exhibition at 291 and borrowed from Stieglitz a Hartley painting she admired. Many years later she wrote, "I have had much of Hartley in my life as you know and I have chosen one of those German ones to keep."[25] Of all Hartley's subjects, the most meaningful to O'Keeffe remained his esoteric symbolic abstractions produced in Germany.

Arthur Dove's longtime goal in painting was extraction from nature, the distillation of its essence. Starting with his first abstractions in 1910, natural phenomena—like waves, wind, and lightning—often inspired Dove to create abstract paintings of great rhythmic power.

And, as Maurice Tuchman has pointed out, the impetus for these transcendent qualities lay in mysticism:

Dove's paintings before 1920 coincide with his interest in vitalism; works after 1920 were directly inspired by Theosophy and reflect his interest in astrology, occult numerology, and the cabala.[26]

O'Keeffe began to incorporate similar ideas and forms into her paintings during the late nineteen-teens. In *From the Plains I* (1919), serrated forms reminiscent of Dove suggest, as art historian Charles Eldredge writes, "the turning of the cosmic sphere." He continues:

Through their pictorial imaginations, O'Keeffe and Dove transported themselves from the mundane plane to a God's-eye view, witnessing the world wheeling in the infinite. Through their abstractions they sought to capture the vital essences of nature, a unity of micro and macro, of man and universal spirit. In this endeavor they were part of America's spiritual tradition.[27]

Though it is now clear that O'Keeffe was seeking connections with first causes and primal forces, she would not have said so openly. Except for a few brief catalogue statements, O'Keeffe rarely communicated with the public in written words. As late as 1937, Dove told Stieglitz that he "hardly knew that she could read and write."[28] It suited O'Keeffe's public image to be so regarded. Seeming intuitive, subjective, even a bit naive freed her from the obligation to refute critics and—more important—from the expectation that she would somehow "explain" her paintings. Besides, O'Keeffe had been wounded by the critics. She was bothered by the things they said about her work, from the psychosexual readings given her flower paintings in the 1920s to Greenberg's dismissive statement quoted earlier. Throughout her career, O'Keeffe often insisted that her paintings should speak for themselves. Asked at age eighty to discuss the meaning of her art, she snapped, "The meaning is there on the canvas. If you don't get it, that's too bad. I have nothing more to say than what I painted."[29]

Such acerbity reflects more than a desire for privacy. More fundamentally, O'Keeffe believed that art was both ineffable and, paradoxically, a private language—a means of communicating between two people.[30] The belief that art constituted a language of its own was common in modernist thinking early in this century. But it was also a much older idea. The young Michelangelo was immersed in Neoplatonism, whose myths were deliberately couched in exotic language, and—according to his contemporary Pietro Aretino—desired that his images be understood only by a few.

Throughout her career O'Keeffe vacillated between her twin desires for public understanding and her need for a private expression. When she made highly subjective "abstract portraits" of friends (a few years after Hartley's), they seemed to her photographically real. "I remember hesitating to show the paintings, they looked so real to me. But they have passed into the world as abstractions—no one seeing what they are."[31]

Over the years O'Keeffe became extraordinarily skilled in disguising the strong subjective content in her work. In a typically dualistic fashion, it became important to her to be understood on one level, but not on all:

I have a curious sort of feeling about some of my things—I hate to show them—I am perfectly inconsistent about—I am afraid people won't understand—and I hope that they won't—and am afraid they will.[32]

Another concept central to the complexity of modernist painting was that of the fourth dimension, conceived in many ways, but linked to the visual arts especially as it was popularized by Theosophy.[33] By denying a clear reading of three-dimensional space and objects (as in cubism), some artists hoped to suggest a higher dimension. These were the ideas conveyed in Claude Bragdon's writings but discussed even earlier in Europe. Picasso and Guillaume Apollinaire, among the avant-garde in Paris, were puzzling over the fourth dimension shortly after the turn of the century. Before she came to know Bragdon's writings, O'Keeffe had encountered the idea of the fourth dimension through an influential essay by Max Weber (1881–1961) published in *Camera Work* in 1910. Weber, who had studied with Dow and shared his interest in the spiritual aspects of art, had been in Paris from 1905 through 1908. There he heard discussions of the fourth dimension–modern painting nexus. His article in 1910 included a discussion of the "dimension of infinity":

In plastic art, I believe, there is a fourth dimension which may be described as the consciousness of a great and overwhelming sense of space-magnitude in all directions at one time. . . . It is the immensity of all things.[34]

For over half a century, this desire for the infinite manifested itself in O'Keeffe's life and art. In a way remarkably similar to Weber's description, she wrote to Anita Pollitzer in 1915 of having "something to say and feel[ing] as if the whole side of the wall wouldn't be big enough to say it on and then sitt[ing] down on the floor and try[ing] to get it on a sheet of charcoal paper."[35] Reducing cosmic immensity to human size would preoccupy O'Keeffe repeatedly. More than forty years later she again wrote about questions of scale and vastness that still echo Weber's mystical statement: "When I stand alone with the earth and sky feeling of something in me *going off in every direction into the unknown of infinity* means more to me than any thing any organized religion gives me"[36] (emphasis added). Clearly, she allied the vastness of the western sky with Weber's "space-magnitude." For O'Keeffe, her life and her art were an adventure into the unknown, the infinite. She longed, as mystics do, to achieve a state of oneness with ultimate reality by venturing into the unknown:

I feel that a real living form is the natural result of the individuals effort to create the living thing out of the adventure of his spirit into the unknown—where it has experienced something—felt something—it has not understood—and from that experience comes the desire to make the unknown—known.[37]

O'Keeffe's desire for merger with the unknown encouraged her to explore it both inside and outside herself. Dreams, that mysterious realm of oddly juxtaposed visions and words, were a source of much inspiration. As she learned to trust her vision, O'Keeffe could allow her mind to move freely between dream and external reality. She recognized that her paintings depended on both: "I hadn't worked on the landscapes at all after I brought them in from outdoors—so that memory or dream thing I do that for me comes nearer reality than my objective kind of work—was quite lacking—"[38]

What O'Keeffe seems to be saying is that memory or dream is usually a component of her abstract work—the catalyst that transforms objective, physical vision into a larger reality. Imagination was as real to O'Keeffe as objects. As easily as she could call up remembered outdoor scenes, O'Keeffe could invoke the presence of absent persons. After the death of Stieglitz, O'Keeffe often imagined his presence at her homes in New Mexico, where he had never visited. In 1956 she wrote to a distant friend: "This seems to be the week you have come to my house tho you were only present in thought—Maybe that is as real as anything."[39] Here again, she equates dream with reality, thought with matter. Still echoing in her words are Weber's, written nearly a half-century earlier: "Only real dreams are built upon. Even thought is matter. It is all the matter of things, real things or earth or matter."[40]

As the years passed, Stieglitz did much (perhaps without intending to) to stimulate O'Keeffe's metaphysical thinking. His own work moved from a firm grounding in the physical world to a somewhat more ethereal approach. In his famous *Equivalents* series of cloud photographs, Stieglitz silently approached the mystical concept that mind and matter are one. In the clouds, he wanted to show that his photographs transcended subject matter concerns to become more of a metaphysical expression. In his photographs and in his beliefs, Stieglitz referred often to sharp visual contrasts—the black and white of seeing. Though he felt himself sometimes "gray" in being, he thought of O'Keeffe as "Whiteness," a quality described by Roxana Robinson as "a metaphysical purity based on her clarity of vision and the lucid wholeness of her mind, which set her apart from other women and, in fact, all other people."[41] Using language similar to that of

Hartley (noted earlier), Stieglitz envisioned her pure artistic spirit as white, and, as he wrote in 1923, "I have a passion for Whiteness in all its forms."[42] A few years earlier he had written of O'Keeffe's surroundings:

Her room is a Whiteness
Whiteness Opens its Door
She Walks into Darkness
Alone[43]

Stieglitz's imagery must have made a deep impact on her, for O'Keeffe used it repeatedly in her future paintings and her letters. She carried her "whiteness," that is, her spirit of artistic discovery, with her into the dark unknown. As she wrote in 1930,

My feeling about life is a curious kind of triumphant feeling about—seeing it black—knowing it is so and walking into it fearlessly.[44]

Walking into blackness is suggested vividly in a number of O'Keeffe's paintings. In *The Flagpole* (1923) she abstracts a few elements of a small building at the Lake George family compound, where she and Stieglitz summered. Used by Stieglitz as a darkroom, the interior of the little building looked black through the open door. When O'Keeffe painted it, she accented its black rectangle of a door. Beyond the visual impact lies a certain symbolic aspect. In one sense, the small black door represents the unknown, the future. But it also signifies a mysterious, dark place where creativity could flourish—where Stieglitz could bring forth his photographic images. As much as O'Keeffe liked the door in a formal sense (demonstrated in her decades-later repetition of the motif), its symbolic value in *The Flagpole* must be counted at least as significant.

The formal "punch" of a single door in a simple wall appears in a number of later paintings of her home in New Mexico. She bought her house at Abiquiu, New Mexico, she maintained, because of its patio door. And she recorded that shape—sometimes a dead-end black rectangle, sometimes as a mystical passage through to the light—in paintings that seem more than studies of form.

The metaphor of walking into blackness is extended in several other O'Keeffe paintings, where doors suggest movement between realms. To the composer Aaron Copland (1900–1990), whose music did not touch her sensibili-

ties as she wished, O'Keeffe lamented, "Maybe I can get to the music one day—It is to me as if our worlds are so different that I dont seem able to get through the door into yours—."[45]

Like recurrent musical motifs, the mystical dualities of blackness and whiteness continued to appear in O'Keeffe's paintings for years. *Black and White* (1930), *Black Abstraction* (1927), and *Lily—White with Black* (1927) all exemplify some of the universal paired opposites central to mysticism.

When she explored the landscape of northern New Mexico and Arizona, O'Keeffe found places in the landscape where the physicality of blackness and whiteness entered the land itself. Driving through Navajo country in 1937, she came across the "Black Place," and between 1940 and 1949 she painted some fifteen works inspired by this natural formation. Recurrently, she used a V configuration, with lights and darks zigzagging through like lightning or, more gently, folding into each other to express both the physical undulations and the dualities of forms flowing together.

The "White Place," located in a rocky cliff face near O'Keeffe's Ghost Ranch home, has an austerity and majestic verticality about it that link this natural rock formation to the human-made monumentality of Greek temple columns or the pale monochrome towers of a medieval cathedral, with its cool, dark interior an enclosure for sacred spaces or veiled cult images. The metaphor is not unlike the outer and inner aspects of O'Keeffe herself.

Even while exploring the implications of value opposites, she began to engage the more complex spiritual affinities of color pairings. Again, she turned to Kandinsky. In his *Concerning the Spiritual in Art* O'Keeffe had read Kandinsky's comments on the duality between certain pairs of hues; for example:

The relationship between white and yellow is as close as between black and blue, for blue can be so dark as to border on black. Besides this physical relationship, is also a spiritual one (between yellow and white on one side, between blue and black on the other) which marks a strong separation between the two pairs.[46]

A look at O'Keeffe's *Black Spot No. 3* (1919 [fig. 1]) instantly confirms that O'Keeffe must have been experimenting with Kandinsky's theories.[47] Wedged diagonally into the composition is a motionless rectangle of black, trailing off into gray. Edging in against it from several directions are bulging, organically derived shapes in blue, pale yellow, and green—all made more distinct and alive

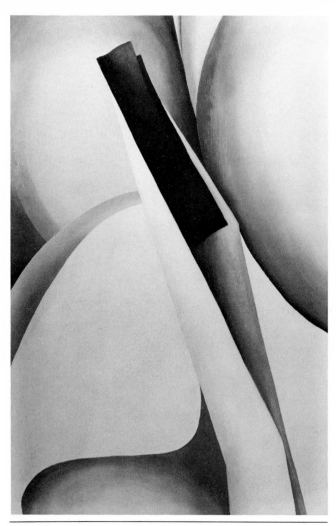

1. Georgia O'Keeffe, *Black Spot No. 3*, 1919.
Oil on canvas, 24 × 16 in. Albright-Knox Art Gallery, Buffalo, N.Y., George B. and Jenny R. Mathews and Charles Clifton Funds, 1973.

From the Faraway Nearby

through their juxtaposition with the inertia, the inorganicity of black. Using a color scheme nearly identical to that by Kandinsky, as just described, O'Keeffe has attempted more than a study of shapes: she has married the spiritual with the physical properties of color, achieving a union of image and sensual effect. By translating them into abstract forms, O'Keeffe could express an equivalence of mood (as Stieglitz had done) denied to most painters of representational form.

On the rare occasions when she could be persuaded to say a few words about color in her work, O'Keeffe sometimes provided an extraordinary insight—perhaps without meaning to. Asked by the director of the Cleveland Museum to comment on their just-purchased painting *White Flower, New Mexico* (1929), the artist addressed several issues pertinent here: "The large White Flower with the golden heart is something I have to say about White—quite different from what White has been meaning to me." What white had previously meant to her, as we have seen, refers to the admixture of ideas she acquired through Kandinsky, Stieglitz, and Hartley. But she had painted white flowers before. What was different about this flower, this "White"? She continued,

I know I can not paint a flower. I can not paint the sun on the desert on a bright summer morning but maybe in terms of paint color I can convey to you my experience of the flower or the experience that makes the flower of significance to me at that particular time.[48]

What was significant about this particular bloom may not have been the flower itself, or even its whiteness, but a set of new experiences that surrounded it, for this is one of the first flowers O'Keeffe painted in New Mexico. Outside her door at Mabel Dodge Luhan's Taos compound stretched a whole carpet of these blooms, inviting her consideration of their presence in a high-desert setting

where the mere presence of wildflowers is reason for pause, for joy.

At Taos in 1929, the world looked new to O'Keeffe (see fig. 2). Released from Stieglitz's shadow, she stepped into the transforming sunshine of New Mexico. She had known for a year that a change was necessary; to a friend she confided, "When I saw my exhibition last year [1928] I knew I must get back to some of my own ways or quit—it was mostly all dead for me—Maybe painting will not come out of this—I dont know—but at any rate I feel alive—and that is something I enjoy."[49]

Feeling alive meant that O'Keeffe wanted to experience every new thing she could in New Mexico. Away from the sometimes stifling nurture Stieglitz provided, she could choose her own friends, her own subjects, and her own lifestyle.[50] With her friend Rebecca Strand, she witnessed Indian ceremonials, camped out, learned to drive, and visited scenic wonders in nearby Arizona, Colorado, and Utah. Mabel Dodge Luhan was away from Taos for much of the summer, but her Pueblo husband, Tony Luhan, often accompanied O'Keeffe and Strand. On one occasion the three drove to a rodeo in Las Vegas, New Mexico, where they consumed some bootleg whiskey. To Mabel, who had once experimented with peyote, O'Keeffe wrote that the next morning she had experienced a state of unusual mental clarity.

Out of that heightened state of consciousness came an enigmatic painting she called *At the Rodeo—New Mexico* (fig. 3). Its direct visual source may lie in the circular concha decoration on an Indian headdress, as Roxana Robinson has suggested, but the image suggests much more. Pulsating with cosmic energy and vibrations, O'Keeffe's painting is strongly reminiscent of mystical diagrams or mandalas common in the work of Ouspensky (known to O'Keeffe via Bragdon), Blavatsky (a favorite source for Hartley), and Buddhist philosophy. (See pp. 22–23 in *The Spiritual in Art*.) Like a great kaleidoscope, like the opening iris of an eye, like a Lamaist mandala to be studied in preparation for meditation, O'Keeffe's circular form evokes the presence of a kind of sacred geometry. Common as a means of describing nature and identifying life-forms, the circle has often been linked with various mystical tenets, especially the belief that the universe is a single, living substance.

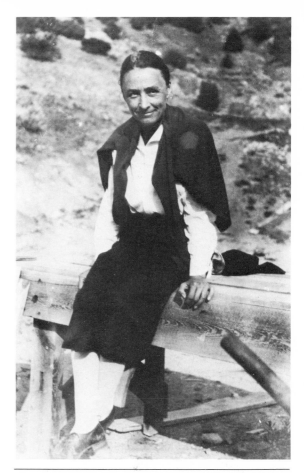

2. Georgia O'Keeffe near "The Pink House," Taos, New Mexico, 1929.
Photograph courtesy of the Museum of New Mexico, Neg. No. 9763.

Beholding the Epiphanies

103

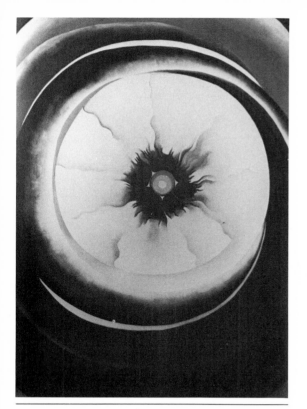

3. Georgia O'Keeffe, *At the Rodeo—New Mexico*, 1929. Oil on canvas, 40 × 30 in. Private collection. Photograph courtesy of Andrew Crispo Gallery, New York.

Another compelling visual consonance (probably unknown to O'Keeffe) lies in the cosmic imagery of Hildegard von Bingen, the twelfth-century German abbess and mystic whose visions, the product of mystical contemplation, were recognized by the papacy and established her as a prophetic voice within the medieval Catholic church. Hildegard's visions, recorded in vivid paintings of ovoid or circular form, encompass much of the scientific and religious knowledge of her day. Her *Scivias* ("Know the Ways of the Lord") appears to be one of the first medieval manuscripts in which the artist uses line and color to reveal the images of a supernatural contemplation. In the twentieth century writer Charles Singer and others have dismissed her visions and the paintings made from them as nothing more than auras of chronic migraine. But whatever their immediate source, they retain a remarkable similarity to the circular cosmic imagery found in mystical diagrams and in O'Keeffe's work. Robinson, incidentally, cites an instance in 1916 when O'Keeffe explained to Stieglitz that the shape in a drawing had come to her while she had a headache.[51]

In Theosophical terms, O'Keeffe's rodeo painting preserves a moment of self-realization—perhaps the first in a long process of discovery that spanned five decades of O'Keeffe's presence in the Southwest. Such self-realization can come, according to mystics, by illumination, accident, or an induced state; O'Keeffe's rodeo experience may qualify as all three.

Other O'Keeffe paintings from about the same time exhibit similarly conscious preoccupations with rhythmic geometry and color. *Pink Abstraction* (1929) is similarly conceived, as is *Abstraction, Blue* (1927). She probably also knew Dove's *Distraction,* a 1929 abstraction based, according to Maurice Tuchman, on circular forms borrowed from the mystical William Blake.[52]

O'Keeffe's longstanding affinities for the mystical were perfectly congruent with a certain transcendent quality often remarked upon by visitors to New Mexico. Critic Paul Rosenfeld, who had written several articles on O'Keeffe in the early 1920s, visited the state in 1926. In a mystical fashion, he called New Mexico "the penetralia of the continent, the secret essence of America, the mysterious projection of a long dormant idea."[53] During her early years in New

Mexico, O'Keeffe gravitated to sensitive, like-minded individuals who sought the spiritual content of the land. During the same summer she visited the rodeo, she traveled around the state with Marie Tudor Garland, a poet, a painter, and the author of *Hindu Mind Training* (1917) and *The Winged Spirit* (1918). Two years later (1931) they again shared responses to the land when O'Keeffe spent the summer at Garland's ranch in Alcalde, New Mexico.

Also present in New Mexico during those years was feminist writer Mary Austin, whose concerns with women's issues and training as a naturalist grew into "a passionate mystical identification with the land and an outrage against the misuse of women's gifts."[54] Austin wrote of "American rhythms" based on the spiritual harmony of the Indian lifeway with that of the earth itself. She also wove eloquent metaphors of the land as woman; in *Lost Borders* she might have been describing an O'Keeffe landscape, decades before it was painted:

If the desert were a woman, I know well what like she would be: deep-breasted, broad in the hips, tawny, with tawny hair . . . eyes sane and steady as the polished jewel of her skies.[55]

Austin, O'Keeffe, and Mabel Dodge Luhan, all highly conscious of the spiritual content of the land, expressed it in quite individualized terms. Cultural historian Lois Rudnick has noted that Luhan wrote an unpublished novel, "Water of Life," in which she dealt with Eastern religious references.[56] Luhan, too, was an outspoken apologist of the lure of New Mexico, rhapsodizing to O'Keeffe and to the world in general about the virtues of the untouched, harmonious life possible in isolated Taos.

At one time O'Keeffe hoped that women writers like Mabel Dodge Luhan could provide the kind of sensitive, personalized account of her work denied her by most male critics. In an article published in 1931, Luhan saw O'Keeffe's creative process itself as a manifestation of the mystical. According to Luhan, Taos was a catalyst for O'Keeffe's artistic and spiritual growth:

Certainly her painting, following its secret flow from her brain and hand, was intensified and deepened there in Taos and God knows she needed, to our more ordinary vision, no more intensity or depth. Yet in her work she added to them, and more significant still—let us never forget it is more significant—in her being she became intensified and deepened.[57]

Unfortunately, in other attempts at criticism Luhan only perpetuated the kind of psychosexual interpretations that O'Keeffe's work had been given by male critics in the 1920s, and which she abhorred. In an unpublished article Luhan wrote that O'Keeffe "externalizes the frustration of her true being out onto canvases which, receiving her outpouring of sexual juices . . . permit her to walk this earth with the cleansed, purgated look of fulfilled life!"[58]

Probably more to O'Keeffe's liking, though it too remained unpublished, was an article about her by Taos painter Lady Dorothy Brett. Titled "Remembered Life," it began with the intriguing line "Man thinks *about* Life—Life thinks in Woman."[59] Brett's own mystical inclinations opened the door to that aspect of O'Keeffe.

Absent when O'Keeffe arrived at Taos, but surviving vividly in his writings, was D. H. Lawrence (1885–1930), whose works O'Keeffe read throughout her life. Lawrence, whose sense of place was highly mystical, had spent much time in the Taos area between 1922 and 1925. He wrote, "I feel like a Columbus who can see a shadowy America before him: only this isn't merely territory, it is a new continent of the soul."[60]

Another of O'Keeffe's favorite writers during her years in New Mexico was James Joyce (1882–1941), whose aesthetic theories corresponded closely to her own. Joyce's formula for the aesthetic experience was that it does not move you to want to possess an object, but rather to hold it and "frame" it. Then you can see it as one thing, while observing the relationship of part to part, the part to the whole, and the whole to each of its parts. This is the essential aesthetic factor for Joyce—the rhythmic relationships. When discovered by the artist, he believed, there occurs a radiance, an epiphany.

In mystical thinking the idea of epiphanies is suggested by heat, fire, or light. O'Keeffe often used such imagery in her paintings, starting long before she came to New Mexico, when she wanted to transcend the literal. *Special No. 21* (1916 [fig. 4]) and *Light Coming on the Plains I and II* (1917) are watercolors of effulgent, disembodied light, removed from their source in the west Texas landscape.

Similar is the effect of her *Red Hills, Lake George* (1927 [fig. 5]), in which soft rings radiate outward, seeming to ignite a fiery redness in the hills below. This Lake George painting, which presages many of her New Mexico works, is one of O'Keeffe's most disembodied landscapes. Surely a landscape of the mind, this painting strongly suggests the epiphany released by heat, fire, and light.

In New Mexico O'Keeffe sometimes invented or combined landscapes that enhance the spiritual effect of her paintings. She wrote of the experience of painting Penitente crosses in the hills:

It was in the late light and cross stood out—dark against the evening sky. If I turned a little to the left, away from the cross, I saw the Taos mountain—a beautiful shape. I painted the cross against the mountain although I never saw it that way. I painted it with a red sky and I painted it with a blue sky and stars.[61]

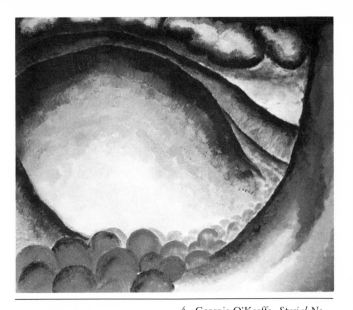

4. Georgia O'Keeffe, *Special No. 21*, 1916.
Oil on board,
13⅜ × 16⅛ in.
© The Georgia O'Keeffe Estate.

She continued, "I painted a light cross that I often saw on the road near Alcalde. . . . I also painted a cross I saw at sunset against the hills near Cameron. . . . The hills are grey— all the same size and shape with once in a while a hot-colored brown hill. . . . For me, painting the crosses was a way of painting the country." They were, she added, "like a thin dark veil of the Catholic Church spread over the New Mexico landscape." Charged with spiritual content and complexity, yet pristine in their geometric spatial divisions and their balance of horizontal and vertical elements, they are at once material and immaterial.

For O'Keeffe the sun was a mystical source of life, passion, and health.[62] In 1932 she did not summer in New Mexico; in the fall, following a series of difficult events, she experienced the onset of an emotional illness. She wrote to a friend in New Mexico, "I miss the sun—that sun that burns through to your bones."[63] And she had remarked earlier on the lack of passion—of fire—in her friend Charles Demuth's work. She described a group of his paintings as "very fine—Only maybe I begin to feel that I want to know that the center of the earth is burning—melting hot." She wanted, in other words, to experience the epiphany released by heat, fire, and light.

But it was not all drama and passion. The quiet openness of the plains in Texas, experienced in her youth, and her later encounters with the vastness of the New Mexico high desert all inspired peak experiences for O'Keeffe, who let the profound silences speak to her: "My world here," she wrote from Abiquiu, "is a world almost untouched by man."[64]

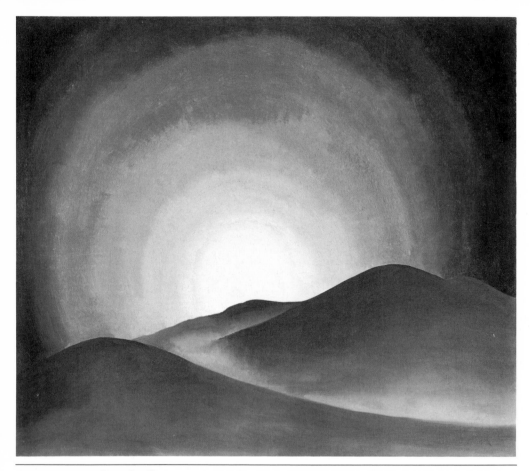

5. Georgia O'Keeffe, *Red Hills,
Lake George,* 1927.
Oil on canvas, 27 × 32 in.
© The Phillips Collection,
Washington, D.C.

If the silences nourished her search for self, so did the rhythmic aural rela-
tionships cherished by Austin and Joyce. In 1954 O'Keeffe painted a reprise of
her 1919 *From the Plains I.* Thirty-five years after she left Texas, she experienced
a cyclical reencounter with its haunting, unforgettable sounds. It was a wordless
drone, like the endless throbbing of the universe, but rising out of the flatness
of the Texas plains. O'Keeffe described it thus:

The cattle in the pens lowing for their calves day and night was a sound
that has always haunted me. It had a regular rhythmic beat like the old
Penitente songs, repeating the same rhythms over and over all through the
day and night. It was loud and raw under the stars in that wide empty
country.[65]

The silence out of which the sound comes, back into which it goes, is a metaphor for the eternal, the infinite, the sublime. Prodigious expanse of space is sublime, as are the storms, the wind, the burning sun of the Southwest. Difficult to express, distinct from the beautiful, the sublime appears repeatedly in O'Keeffe's work. In *From the Plains I* and *II* it finds synesthetic expression—sound given visual form.

In the 1930s, when she began to exhibit paintings based on animal skulls and bones, O'Keeffe intended them as another definition of her feeling about the Southwest. "To me," she wrote,

they are strangely more living than the animals walking around—hair, eyes and all with their tails switching. The bones seem to cut sharply to the center of something that is keenly alive on the desert even tho' it is vast and empty and untouchable—and knows no kindness with all its beauty.[66]

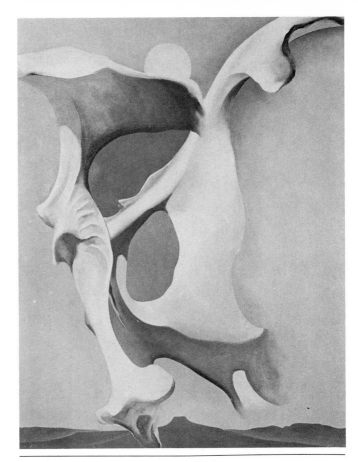

6. Georgia O'Keeffe, *Pelvis with Moon*, 1943.
Oil on canvas, 30 × 24 in.
Collection of the Norton Gallery of Art, West Palm Beach, Fla.

When she painted *Pelvis with Moon* (1943 [fig. 6]), O'Keeffe combined powerful symbols that add up to an experience of the infinite. The holes in animal bones through which O'Keeffe framed the vastness of the sky are, like the doorways in her house, passages to other states of mind. Clear, always in focus no matter how far away, they frame and hold (as Joyce said) an aesthetic experience. And they engage the viewer in visual play: held up against the sky, which are the solid forms, which the negative spaces? Zen scholar Alan Watts, with whom O'Keeffe had contact in her later years, equated such concepts with Buddhist philosophy: "form is emptiness, and emptiness itself is form."[67] In the end, they become interchangeable.

Another element here and in many other O'Keeffe paintings is the moon. Circular symbol of continual rebirth, the moon is an image of cycles and seasons associated since prehistory with women (as are the animal horns, ancient attributes of the Great Goddess, so often seen in O'Keeffe's paintings). Below the

moon is O'Keeffe's beloved Pedernal, the mountain she jokingly said God had promised to give her if she painted it often enough. (The Pedernal's distinctive truncated shape, incidentally, is nearly an exact duplication of Kandinsky's symbolic painting *Blue Mountain* [1908]).

Art critic Lucy Lippard has pointed out that the Navajo believe the Pedernal to be the birthplace of their legendary "Changing Woman," who represents both earth and time—literally, "a woman she becomes time and time again."[68] Female, too, are the contours and surfaces Lippard and Roxana Robinson have seen in O'Keeffe's paintings of the land, though the artist stopped short of making such direct connections. There is, however, an undeniable sensuality in her surfaces, an eroticism more subtle than the flower paintings, but there just the same, uniting living forces in earth, plant, and human. In her serene, meditative paintings, O'Keeffe quietly celebrated these connections and on rare occasions made oblique verbal comments; describing the mud-plastered surface of her adobe home at Abiquiu—soft, warm, pinkish like some shades of human skin—she wrote, "Every inch has been smoothed by a woman's hand." These are the kinds of primal connections O'Keeffe intuited, linking ancient truths to the present in a land that encouraged the cyclical, mythic, transcendence of time into the eternal.

Pelvis is a painting full of the mystery of life and death—a religious painting in the sense that *religio* means linking back the phenomenal person to a source. O'Keeffe denied formal religion, yet she made intensely spiritual paintings. When a prominent Catholic priest visited her at Abiquiu, she remarked that compared to the "rock" of her life, the church seemed like a mound of jelly.[69] By this time O'Keeffe had left the vestiges of Roman Catholicism in her upbringing far behind. Building on the early influences absorbed from Dow and Hartley, she immersed herself in Eastern mystical texts like *The Secret of the Golden Flower, A Chinese Book of Life.*[70] In its extensive commentary by Carl Jung (1875–1961) she could again consider the congruencies and conflicts between Eastern and Western thought. And it gave her new ways to think about herself as woman and to understand the profound relationship she felt to the land.

As Jung interpreted the Golden Flower text, the Anima found within it was "called *p'o,* and written with the [Chinese] characters for 'white' and for 'demon,' that is, 'white ghost,' [who] belongs to the lower, earth-bound, bodily soul, the yin principle, and is therefore feminine." By contrast, noted Jung, the Animus or *hun,* is written with the characters of "clouds" and "demon," that is "'cloud-demon,' a higher 'breath-soul' belonging to the yang principle and

therefore masculine."[71] It is tempting, again, to look for such symbolism in O'Keeffe's paintings. Did she consciously identify herself with the lower, feminine earth forms in her New Mexico landscapes? Are the floating clouds or suspended sky-forms masculine? These are intriguing questions, but highly speculative ones—unanswerable with any satisfying degree of certainty. More probable are loose resonances with her longtime mystical affinities: paired opposites, analogies of things above with those below, the reality of imagination, and the ultimate unity of mind and matter. In *The Secret of the Golden Flower* the Chinese duality of a feminine earth and masculine sky must have reminded O'Keeffe of her musings back in 1916 on masculine/feminine color and value oppositions. Now, nearly half a century later, it might also have suggested the well-known Mother Earth/Father Sky duality familiar to Native Americans in the Southwest (and elsewhere in history).

To O'Keeffe, as to Carl Jung, religion itself could become a barrier to religious experience. In other words, when religion is reduced to concepts and ideas, it can block the path to transcendent experience. The image of God itself becomes the final obstruction. These ideas, of course, are basic to both Hinduism and Buddhism, as O'Keeffe recognized in her later years. It is also mysticism in its most stringent application: that in doing away with images altogether comes an unmediated vision of the Godhead. Yet, in actual practice mystics through the ages have found images useful in constructing a kind of pictorial approximation of their visionary world or as aids to meditation. O'Keeffe's well-known *Ladder to the Moon* (1958) is such a painting, reminiscent of medieval apocalyptic manuscripts in which the heavens open to receive the saint, climbing upward on a ladder. But O'Keeffe's immediate inspiration was from the reality of her surroundings, caught in 1956 by photographer Todd Webb (fig. 7), who positioned O'Keeffe's ladder against her patio wall near the celebrated black door. In its spare simplicity of forms, the photograph (like O'Keeffe's eye) isolates the abstractions in her lovingly arranged world at Abiquiu. She relished their apparent contradictions; the abstractions are at once formally pure and intensely personal. "The abstract," O'Keeffe concluded, "is often the most definite form for the intangible thing in myself that I can only clarify in paint."[72]

O'Keeffe came to realize that the ultimate mystery can be experienced in two senses, one without form and the other with form. She drew the distinction herself in a 1951 letter: "I am really most fortunate that I love the sky—and the 'Faraway'—and being so rich in those things—tonight I'll send you the moon—"[73] The "Faraway" as she called it, was O'Keeffe's personal

metonym for the mystical as revealed in nature. And the impulses of mysticism expressed visually—cosmic imagery, vibration, duality, synesthesia, and sacred geometry—are all there in O'Keeffe's work. Whether one calls them peak experiences, epiphanies, philosophical monism, or encounters with the sublime, they were moments of self-discovery. And, thanks to her ability to give form to the infinite, she left us with a powerful visual record of that search.

7. Todd Webb, *Ladder and Wall, O'Keeffe's Abiquiu House,* 1956. Museum of Fine Arts, Museum of New Mexico.

Georgia O'Keeffe in Hawaii

Jennifer Saville

I had a wonderful time out on the islands and loved it—Yes I worked—it
is beautiful for painting as they have everything—almost tropics—fourteen
or fifteen thousand foot mountains—bare lava land more wicked than the
desert—lovely flowers—and the sea—and it is all in a fairly small space—
many high thin waterfalls pouring down the mountains—

I flew from one island to another—several beautiful trips—Yes I
liked it—

—Georgia O'Keeffe[1]

Celebrated for the beauty and power of her painting, admired for her strength of
character and fiercely unapologetic independence of spirit, and subject of perhaps
this century's most compelling series of portrait photographs, Georgia O'Keeffe
was deeply moved by nature and, drawing on the world around her, created a
remarkable corpus of work ranging from abstraction to realism. During her long
career and after her death, O'Keeffe's life and work took on mythic propor-
tions—she stands not only as a leader but also as a legend in twentieth-century
American art. Numerous retrospective exhibitions and several biographies have
elucidated much about this extraordinary painter.[2] Details of many projects and
endeavors, however, including O'Keeffe's visit in 1939 to Hawaii, remain to be
fully documented. Little known, her nine-week sojourn in the islands represents
a shift of focus from the arid and austere beauty of the American Southwest to
which she had devoted herself for the preceding decade. With representations of
flowers, landscapes, and floating fishhooks, O'Keeffe's depictions of Hawaii refer

to themes examined earlier in her career and provide as well a bridge to later subjects.

During the summer of 1938 N. W. Ayer and Son, one of the nation's oldest and most successful advertising firms,[3] approached O'Keeffe with a proposal from the Hawaiian Pineapple Company (shortly thereafter known as Dole Company). The firm invited O'Keeffe to the islands as its guest and, in exchange, requested two paintings of unspecified subject for use in a national magazine advertising campaign. O'Keeffe described the situation in a letter to William Einstein, a painter and distant cousin of Alfred Stieglitz as well as O'Keeffe's friend and frequent correspondent:

I've been asked to do some work for a pineapple co. out in Hawaii—by an advertising co.—We telephone and telegraph and talk—and now a man has gone out to Hawaii on the [Pan American Airlines] china clipper to see the people—etc. I don't know whether anything will come of it or not.

—At this moment I don't much care—but about ten days ago after I had looked over all the maps and folders and pictures I was much interested.[4]

Eight days before her departure, Stieglitz noted O'Keeffe's enthusiasm for the project in a letter to the painter Arthur Dove: "She is eager for the experience."[5]

Initially considered an embarrassment by businessmen, corporate advertising dates from the late nineteenth and early twentieth centuries. Accompanying the rise of national markets and standardization of products, advertising developed into an applied science with various market strategies.[6] The joining of fine art to advertising emerged during the 1940s as a primary tactic in capturing the dollars released by a rise in American consumerism. Although the use of paintings to market commercially available products already had a long history—Sir John Everett Millais's painting *Bubbles* advertised Pears soap in the 1880s, and Sir Edwin Landseer's *Monarch of the Glen* was associated with the Hartford Fire Insurance Company—the corporate realization of the value of fine art as a tool in merchandising and public relations led to an unprecedented level of cooperation between artists and advertisers. National surveys indicated that campaigns involving "superior" artistic quality rated high in readership and the power to attract attention.[7] Fine art carried an aura of "ostentatious culture" or cultural snob appeal that, when selling a product, was transferred to the product and the consumer—or when marketing a company, reflected on the corporate image: "Great paintings have the most irresistible form of salesmanship that has ever been created. . . . To accept an advertising commission from a really good

painter, and to buy the work of a famous painter is certainly the surest way to greater returns for the manufacturer."[8]

Corporate involvement with the arts appeared in many different forms, including initiating juried and invitational contests, sponsoring traveling exhibitions, establishing corporate collections—IBM acquired its first painting in 1937—and buying art or commissioning artists to create artwork for reproduction in advertisements.[9] One critic of the time felt that corporate patronage was the most important factor in the support of contemporary American painting;[10] in 1944 another writer commented not on starving artists but on fat cats laying out ads.[11] A list of the firms utilizing fine art to help shape their image and sell their products during the 1930s and 1940s is varied and includes many of America's best-known corporations—Pepsi-Cola, Coca-Cola, International Business Machines, DeBeers Diamonds, Lucky Strike, Upjohn Pharmaceuticals, Steinway and Sons, Cannon Mills, Caterpillar Tractor, Container Corporation of America, and Dole Company. The roster of participating artists is equally impressive. The work of Pablo Picasso, Salvador Dali, Raoul Dufy, Marie Laurencin, André Derain, and Aristide Maillol turned around falling sales and sold diamonds to class-conscious Americans; paintings and drawings by Fernand Léger, Ben Shahn, Man Ray, Willem de Kooning, Stuart Davis, and Henry Moore appeared in advertisements for cardboard containers.[12]

N. W. Ayer and Son, perhaps more than any other advertising firm, fostered the marketing strategy that relied on the selling appeal of fine art; Charles T. Coiner, an art director for the company, was instrumental in this regard. He recognized that fine art was a valuable commodity, since the public was sold on art classes, lectures, clubs, and art books.[13] With this in mind, he matched art and product in his different accounts, such as DeBeers Diamonds, Steinway and Sons, and the Container Corporation of America. He selected upscale images for the educated and sophisticated readers of "class," or coated-paper, magazines, believing that even if "they [were] not already familiar with the artist [they suspected] they should be."[14] Typically, Coiner avoided restrictive limitations in commissioning the artists and gave them freedom to create as they liked. The advertisement layouts respected the integrity of the work, allowing an image to stand by itself with a minimum of copy.[15] Shortly after Dole retained Ayer in mid-1933, Coiner implemented a campaign in which leading contemporary artists promoted the delights of pineapple juice, just as they had convinced the public of the style of DeBeers diamonds and the excellence of Steinway pianos.

A frequent topic in board meetings, annual reports, and even local newspaper articles, national advertising was taken seriously by Dole's directors—they

1. Georgia O'Keeffe on her arrival in Hawaii, 8 February 1939.
Courtesy of the *Honolulu Advertiser*, Honolulu.

noted that company financial figures reflected the importance of product promotion. In the pre-Ayer advertisements of the early 1930s, Dole emphasized the health appeal and nutritional qualities of pineapples, stressing that the fruit was high in energy and vitamin content.[16] Coiner, however, promoted a new strategy based on the allure of Hawaii. He used the sketches and paintings of artists such as Yasuo Kuniyoshi and Millard Sheets to promote Dole products; he also arranged for the company to invite Isamu Noguchi and Georgia O'Keeffe to experience the islands' charms in exchange for artwork. He hoped that when reproduced in an advertisement format, the artwork would conjure up in the consumer's mind the attractions of the Hawaiian Islands and convince him or her to choose a Dole product from the grocer's shelf.[17]

Coiner recalled that O'Keeffe took convincing; but apparently by drawing on his experience in selling Hawaii to the American consumer, he was equally successful with the artist: ultimately she decided to take advantage of Dole's offer.[18] Shortly after O'Keeffe hung her annual exhibition at An American Place, Stieglitz saw her off at the train station on 30 January 1939.[19] She arrived in Honolulu from San Francisco on 8 February on the *Lurline*, a Matson Navigation Company ship that plied the waters between California and Hawaii (fig. 1).[20]

O'Keeffe remained in Hawaii for two months, spending the first four weeks on Oahu. Local newspapers noted the arrival of this "famous painter of flowers" and recorded that she was visiting the islands at the invitation of Dole.[21] A few days later the Atherton Richardses, prominent supporters of the arts in Honolulu, held an afternoon tea in her honor.[22] Not surprisingly, further published comment on her activities did not appear. Given her independent spirit and preference for solitude, O'Keeffe probably would have felt the social events and exhibitions that marked the concurrent visits of the photographer Edward Steichen and French painter Pierre Roy[23] burdensome and instead maintained a low profile.

After two weeks on Oahu, O'Keeffe saw the pineapple fields "all sharp and silvery stretching for miles off to the beautiful irregular mountains. . . . I was astonished—it was so beautiful."[24] She mentioned to an Ayer representative in Honolulu that she wanted to live near the fields and paint the pineapples. Since only field workers lived there, the company rejected her proposal, despite

O'Keeffe's protests that she was a "worker" too and could live where she wished. Hoping to placate their guest, Dole presented her with what she described as a "manhandled" pineapple in Honolulu. She was "disgusted with it,"[25] the subject was apparently dropped, and O'Keeffe did not paint the fruit while in the islands.

On 9 March, O'Keeffe flew to Maui, headed directly to Hana, and, after again being the honored guest at a house party, settled in for a week.[26] Robert Lee Eskridge, a painter who spent several years in Hawaii, took credit for directing O'Keeffe to Hana and arranging for her to stay with Willis Jennings, the manager of the Hana Plantation, and his daughter Patricia.[27] Eskridge recalled that he met O'Keeffe at a dinner party in Honolulu and that she seemed very unhappy about the pineapple field incident. Responding to her wish to get away from it all, Eskridge suggested Hana and the Jennings family, friends with whom he often stayed in this small, sugar-supported, and isolated community on the eastern corner of Maui.

2. Georgia O'Keeffe in Hana, 1939.
Photograph by Harold Stein, courtesy of Patricia Jennings Campbell.

Since Jennings's wife was on the mainland and he was busy with plantation work, O'Keeffe borrowed the company station wagon and explored this area of tropical vegetation, spectacular waterfalls, sheer cliffs, and jagged lava flows while Patricia Jennings provided the directions (fig. 2). O'Keeffe spent time on the lava-scarred coastline, visited the Seven Pools of Oheo Gulch (today part of Haleakala National Park), hiked around ancient temple sites and Nahiku, the site of an abandoned rubber plantation, and admired the beauty of Hawaii's exotic blossoms.[28] In a letter to her friend Ettie Stettheimer, O'Keeffe commented on the pervasive smell of the sugar mill and remarked that she had tried raw fish and had worn the thonged sandals of grass and wood favored by the locals (she said "it hurt at first but I get on very well now—").[29] After about a week in Hana and accompanied by the young Jennings, O'Keeffe returned to the center of Maui along the narrow and winding coastal road that had only been built in 1927. Staying at the now-defunct Maui Grand Hotel in Wailuku, O'Keeffe called on at least one local dignitary[30] and, traveling with her guide on a shorter but also serpentine road, visited Iao Valley: "The valley road is so narrow and

twisting that driving 10 miles an hour is fast enough—and 20 is dangerous speeding. I . . . drive up the valley with a feeling of real fear and uncertainty because of the winding road— . . . The road not only winds—it is often just a narrow shelf on the side of the mountain—in many places too narrow to pass another car—"[31]

Reflecting on her visit to Maui, O'Keeffe wrote, "I enjoy this drifting off into space on an island— . . . I like being here and {I'm having} a very good time. . . . I'd as soon stay right here for a couple of months but I seem to have to move on."[32] The visits to Hana and Iao Valley were not only enjoyable but productive, as they ultimately resulted in seven canvases depicting Hawaiian landscapes.

O'Keeffe took the interisland steamer *Waialeale* to Hilo on the island of Hawaii on 24 March and was met by Irma and Leicester W. Bryan, the territorial forester and a good friend of Willis Jennings. Escorted by Mrs. Bryan and Caroline and Margaret Shipman, members of a prominent Hilo family, O'Keeffe spent a day at the black sand beach at Kalapana.[33] She then remained for part, if not all, of her stay on the other side of the island at the Kona Inn in Kailua.[34] At this small hotel O'Keeffe met Richard Pritzlaff, a breeder of Arabian horses, chow dogs, and peacocks; that he also lived near Abiquiu, New Mexico, the small town which, since 1929, had drawn O'Keeffe to the Southwest most summers, no doubt helped initiate and then seal their friendship. As a rancher himself, Pritzlaff had made several trips to the Big Island and knew the owners of numerous cattle spreads. With Pritzlaff as her guide, O'Keeffe investigated the sites of Hawaii, met the local ranchers, and admired the ornamental blossoms in their gardens. At some point when she was on Hawaii, she also was taken to meet the local painter Lloyd Sexton in Hilo.[35] Writing about her sojourn in the islands, O'Keeffe must have been referring to the island of Hawaii when, in a tone of appreciation, if not awe, she commented that she saw "fourteen or fifteen thousand foot mountains—[and] bare lava land more wicked than the desert—."[36] She left the island of Hawaii on 10 April.[37]

O'Keeffe stopped last on Kauai before her return to Honolulu and ultimate departure for the mainland four days later. Unfortunately, little is known about what she did and what she saw. Apparently, however, her local guides wanted to introduce their guest to more than Hawaii's natural wonders. In the same way that O'Keeffe had met the people of Maui and the Big Island by attending house parties and making house calls, one hostess on Kauai took her to the Kapaa studio of the artist Reuben Tam;[38] and a second, Flora Benton Rice, a leading supporter of the arts and grande dame of island society, took her to Lawai Kai, the

estate of Robert Allerton and John Gregg, formerly the summer home of Queen Emma and later chartered as the National Tropical Botanical Garden.[39] O'Keeffe later thanked her hosts: "It is over a year since I spent the day with you on your lovely island—I remember it all very vividly— . . . I hope that if you remembered me you knew that you had given me a lovely day—that I liked it—and that I appreciated it even if I did not write to tell you so."[40]

O'Keeffe left the Hawaiian Islands on 14 April 1939, on the *Matsonia*[41] and, after a brief stop in San Francisco, continued to New York.

Why did O'Keeffe accept Dole's proposition to exchange an expense-paid trip to Hawaii for artwork to be used in their national advertising? The reason was not financial, as the decade of the 1930s was for her a period of growing success and recognition. Her paintings sold for upwards of five thousand dollars,[42] her work entered public collections despite Stieglitz's dislike of museums (the Cleveland Museum of Art acquired *White Flower* in 1937), and she exhibited in museums outside of New York (she was one of five contemporary painters invited to show work at the University of Minnesota in 1937). She also received an honorary doctorate in fine arts from the College of William and Mary in Williamsburg, Virginia. Instead, she probably decided to go to Hawaii after carefully considering a number of factors.

Although from her earliest exhibitions O'Keeffe had enjoyed laudatory critical reviews, a few months before Ayer approached her with Dole's invitation, she was the subject of two negative commentaries, one particularly scathing. One writer chided O'Keeffe about her preoccupation with a limited number of subjects from the Southwest: "[There] is a degree of uniformity that has passed beyond being a personal expression, which is the artist's signature, into a kind of mass production."[43] The artist George L. K. Morris, remarking on her exhibition at An American Place, was maliciously disparaging:

You felt that everything you touched was sensational and "artistic,"
whereas in reality there was only the sign-painter's slimy technique. . . .
Yet how soon you were to exhaust your repertoire! Your flower-pictures
grew tiresome; even the sexual over-meanings became sticky and dull. . . .
You further expanded your subject-matter to include bones, barns, and scenery in the West. And all the time your lack of technical equipment and
your lack of taste lay naked and raw.[44]

O'Keeffe always maintained that she was unconcerned with what people thought and wrote about her work, often not reading reviews until after an exhibition

was closed.[45] It is interesting to speculate, however, that reviews such as these might have caused O'Keeffe to consider the treatment of more varied subjects, an opportunity that Dole dropped into her lap.

The practice of joining fine art to advertising, of creating art for commercial purposes, has been both applauded and condemned in this century, often generating contradictory emotions in the artists themselves. O'Keeffe's attitudes regarding corporate commissions changed during the 1930s. She was no stranger to commercial art, for she had drawn lace and embroidery for a Chicago fashion house's advertisements in 1909 and had received commissions, probably between 1918 and 1923, from Cheney Brothers, a large New York silk company.[46] However, she had left these projects behind, found success as an artist in her own right, and adopted Stieglitz's strongly elitist attitude toward the fine arts. In early 1924, when her sister Catherine contemplated producing work for a commercial firm, O'Keeffe urged caution and wrote, "A large proportion of the people who think they want to be Artists of one kind or another finally become commercial artists—and the work that they send out into the world is a prostitution of some really creative phase of Art."[47]

The following decade O'Keeffe reversed her position and accepted four commissions for commercial or public use. After Diego Rivera was removed from painting interior murals for New York's newly constructed Radio City Music Hall, O'Keeffe was one of many artists approached in 1932 to undertake part of the project. Despite Stieglitz's vehement protest and active interference, O'Keeffe agreed to paint a mural. The work was never completed, and the tension this project generated between O'Keeffe and Stieglitz seems to have been a major factor in causing her serious illness later that year. In 1936 O'Keeffe accepted a commission from Elizabeth Arden Beauty Salons to paint a canvas for their exclusive Manhattan exercise facility; in this, her largest flower painting, she depicted a favorite blossom from the Southwest—four jimsonweeds appear in bloom. The following year, Steuben Glass commissioned twenty-seven artists, including Henri Matisse, Isamu Noguchi, and Fernand Léger, to create designs for the decoration of different glass forms; O'Keeffe's frontal view of a jimsonweed blossom was wheel engraved on the bottom of low and flared crystal bowls.

Working on an advertising project such as that proposed by Dole and Ayer may have seemed a logical extension of these earlier activities and, in view of the extensive participation of her contemporaries in related enterprises, an acceptable proposal. Furthermore, each commercial venture offered something new or interesting that seemingly intrigued O'Keeffe. She wanted to paint a large mural and

thus dominate an interior space—Radio City Music Hall gave her the opportunity to try that. Elizabeth Arden's exercise salon provided O'Keeffe a second chance at painting on a monumental scale—something that O'Keeffe accomplished again at the end of her career with *Sky Above Clouds IV* (1965). Steuben allowed her to to see her work applied to a new and beautiful art form. Dole offered the allure of Hawaii. If "romance" did not appeal to the austere O'Keeffe, the converse side of the islands' attractions might have: "In the midst of the great Pacific Ocean is the tiny group of islands known as our Territory of Hawaii. Lying more than 2,000 miles from the nearest continent and 1,000 miles from any inhabited island this probably is one of the most isolated spots on earth."[48]

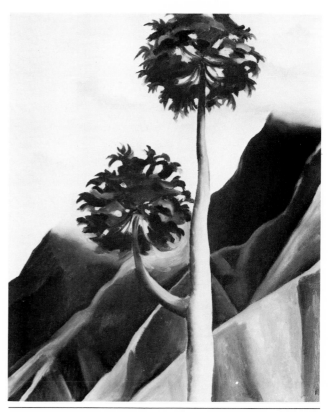

3. *Papaya Tree—Iao Valley (Papaw Tree—Iao Valley)*, 1939. Oil on canvas, 19 × 16 in. The Georgia O'Keeffe Foundation.

If she did not already know it, O'Keeffe probably learned from the "maps and folders and pictures" she examined that Hawaii also represented solitude and encompassed spectacular flowers, an interesting Polynesian lifestyle, and magnificent scenery. She could find new subject matter for her art if she wished or dwell on themes related to her passion for nature, an indigenous culture, and the beauty of the Southwest. Dole presented O'Keeffe with an excuse to travel and experience the tropics afresh (she had enjoyed trips to Bermuda in 1933 and 1934) and perhaps even broaden the power of her art.

Stieglitz noted on 3 May 1939 in a letter to Arthur Dove, "Georgia is back & hard at work.—"[49] This period of industry proved short, as O'Keeffe was weakened by a combination of physical ailments—stomach problems, headaches, and weight loss.[50] Although she had been busy painting in Hawaii, her obligation to present the Dole Company with two canvases remained unfulfilled. She found the strength to paint and probably either in June or early July submitted depictions of a papaya tree (fig. 3) and the spiky blossom of a lobster's claw heliconia. Although Ayer had not stipulated a pineapple plant—an offer of complete freedom regarding subject and execution underlay Charles Coiner's collaboration with artists—they had clearly hoped that O'Keeffe would paint one.

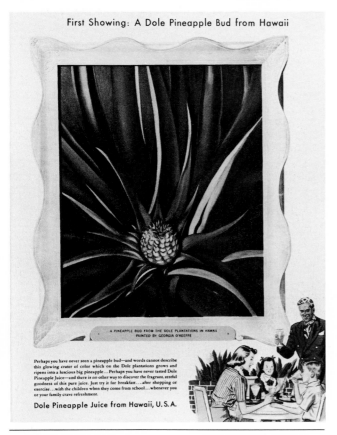

First Showing: A Dole Pineapple Bud from Hawaii

A PINEAPPLE BUD FROM THE DOLE PLANTATIONS IN HAWAII
PAINTED BY GEORGIA O'KEEFFE

Perhaps you have never seen a pineapple bud—and words cannot describe this glowing crater of color which on the Dole plantations grows and ripens into a luscious big pineapple...Perhaps you have never tasted Dole Pineapple Juice—and there is no other way to discover the fragrant, restful goodness of this pure juice. Just try it for breakfast...after shopping or exercise...with the children when they come from school...whenever you or your family crave refreshment.

Dole Pineapple Juice from Hawaii, U.S.A.

4. Dole Pineapple Juice
advertisement featuring *Pineapple Bud*, 1940.
Painting, Collection of Mr. and
Mrs. Jon B. Lovelace.
Photograph courtesy of Dole
Packaged Foods Company.

Disappointed in receiving a papaya tree instead of a pineapple, Coiner spoke with O'Keeffe and, despite her arguments that she would not have accepted the commission under any condition other than absolute liberty of choice,[51] obtained her permission to have a pineapple sent from Hawaii. In thirty-six hours, one appeared at her Manhattan penthouse apartment, somewhat the worse for wear because agricultural inspectors had sprayed it with insecticide.[52] O'Keeffe later begrudgingly conceded the attractions of the pineapple: "It's a beautiful plant. . . . It is made up of long green blades and the pineapples grow on top of it. I never knew that."[53] On 11 July Stieglitz noted, "Georgia did manage to finish the ad painting and it was shipped (they were shipped, 2—) to Calif. to-day. I hope the advertising pages look well."[54] Indeed, the paintings *Pineapple Bud* and *Heliconia—Crabs Claw Ginger* appeared in magazines including *Vogue* and the *Saturday Evening Post,* accompanied by a brief but evocative statement such as, "Hospitable Hawaii cannot send you its abundance of flowers or its sunshine. But it sends you something reminiscent of both—golden, fragrant Dole Pineapple Juice."[55] With their exotic associations, O'Keeffe's images presumably sold American consumers on the romance of Hawaii and Dole Pineapple Juice (figs. 4 and 5).

O'Keeffe regained her strength over the summer and autumn of 1939 and resumed painting in October. Although it is unclear which Hawaiian subject paintings she completed while in the islands and which she worked on in New York "from drawings or memories or things brought home," on 1 February 1940, her annual exhibition opened at Stieglitz's An American Place. Twenty canvases of Hawaiian themes—flowers, landscapes, and fishhooks—appeared on the walls together with one non-Hawaiian subject. The exception was *Sunset—Long Island, N.Y.,* the work selected to represent New York State at the 1939 New York World's Fair. *Pineapple Bud* and *Heliconia—Crabs Claw Ginger* were returned to O'Keeffe for the installation; the two titles appear on the checklist and are noted in reviews, and the artist posed beside the former for a photograph (fig. 6).[56]

O'Keeffe introduced the Hawaiian subjects in her exhibition statement, remarking that "If my painting is what I have to give back to the world for what the world gives to me, I may say that these paintings are what I have to give at present for what three months in Hawaii gave to me."[57]

The response to the paintings was enthusiastic, with critics commenting on each theme represented. The *New York World-Telegram* remarked, "Her pictures, always brilliant and exciting, admit us to a world that is alien and strange. . . . Her bird of paradise, her hibiscuses [fig. 7] and her fishhooks silhouetted against the blue Hawaiian water [fig. 8] are exciting and beautiful."[58]

Henry McBride, O'Keeffe's friend and a critic for the *New York Sun,* noted, "The landscapes, flower pieces and marines in this collection all testify to Miss O'Keeffe's ability to make herself at home anywhere." With tongue in cheek he also mused, "There is something about a Hawaiian fishhook that gets you. I don't mean that it gets the poor fish. It gets the good fish. It is only the most intelligent fish that would feel equal to such a beautiful and reasonable bait."[59] Even Stieglitz reluctantly admitted that the exhibition "is gay.—Better than I hoped for in view of her illness, etc."[60] A few days later he alluded to O'Keeffe's recovery and the freshness of the Hawaiian imagery when he informed Eliot Porter, a friend, photographer, and exhibitor at An American Place, that "her exhibition is on the walls and creating quite a stir. The irony of it all is that everybody feels that her work is better and healthier."[61] To Arthur Dove, Stieglitz commented that the gallery had been a "madhouse" and that the exhibition received "much appreciation. Great adulation."[62] Finally, he summarized the exhibition for William Einstein, stating that "many believe it to be a health-giving one to all coming to the place.—So far 3,000 appreciators but not a nickel to back it up."[63]

Stieglitz was not totally disappointed in this regard, however, since after the closing of the exhibition on 17 March, *Cup of Silver* entered the collection of the Baltimore Museum of Art. Cary Ross, an aspiring writer from a prominent

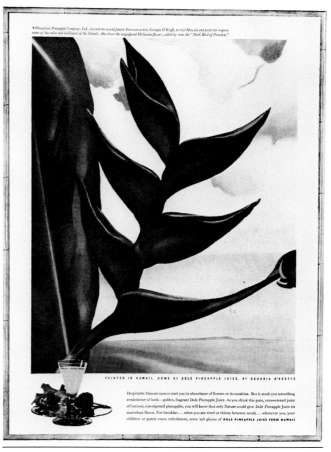

5. Dole Pineapple Juice advertisement featuring *Heliconia—Crabs Claw Ginger,* 1940. Painting, Collection of Laila and Thurston Twigg-Smith, Honolulu. Photograph courtesy of Dole Packaged Foods Company.

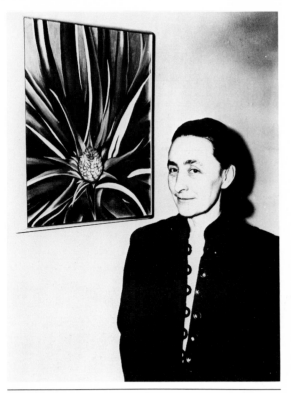

6. Georgia O'Keeffe and
Pineapple Bud.
Painting, Collection of Mr. and
Mrs. Jon B. Lovelace.
Photograph courtesy of Dole
Packaged Foods Company.

Nashville, Tennessee, business family and an unpaid assistant to Alfred Barr at the Museum of Modern Art, was also Stieglitz's friend and helper at An American Place and Lake George. Believing in museums and their role as cultural depositories, Ross recognized the importance of public responsibility in perpetuating them. He donated artwork to the Cleveland Museum of Art, and since he spent a part of each year in Baltimore, he wished to extend his support to the Baltimore Museum of Art. The museum did not have an O'Keeffe painting at the time, and he believed that one would be an appropriate acquisition. After consultation with the museum's director, Stieglitz, and O'Keeffe, Ross returned an O'Keeffe pastel to the artist and, with that work credited to his account, purchased *Cup of Silver* for Baltimore.[64]

Despite her illness, O'Keeffe expressed her delight with Hawaii and contradicted the popular belief that her trip catalyzed her infirmity: "It wasn't the islands that did it to me either— . . . The islands just staved off my having to get into bed before."[65] To her friend Russell Vernon Hunter she wrote, "I had a wonderful time out on the islands and loved it—Yes I worked—it is beautiful for painting as they have everything. . . . I flew from one island to another—several beautiful trips—Yes I liked it—"[66]

At the same time, O'Keeffe regretfully admitted in her exhibition statement that the two months she spent in the islands were not sufficient for her to assimilate fully and express in paint their diversity of flora, topography, and culture:

What I have been able to put into form seems infinitesimal compared with the variety of experience.

One sees new things rapidly everywhere when everything seems new and different. It has to become a part of one's world, a part of what one has to speak with—one paints it slowly. One is busy with seeing and doing new things—one wants to do everything. To formulate the new experience into something one has to say takes time.[67]

O'Keeffe liked to work with a subject over time, returning to it again and again. She recognized that she did not have this opportunity during her brief

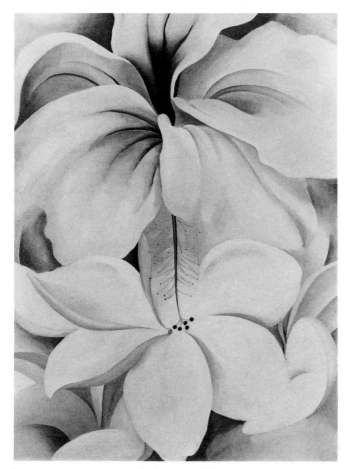

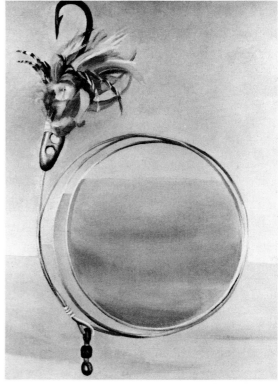

stay in Hawaii and must have realized that she was not likely to in the near future. Once back in New York and considering the course she wanted to pursue in her career, she probably concluded that the American Southwest would always come first and that she would not frequently retrace her route to the islands. She had summered in the Southwest for eight of the preceding ten years and would finalize her commitment to the region in 1940 with the purchase of an adobe house at Ghost Ranch. Indeed, she developed the themes that had the strongest hold on her—those of New Mexico.

Nonetheless, O'Keeffe periodically commented to her friends that she looked forward to visiting Hawaii again; to Ansel Adams she wrote, "I have always intended to return [to Hawaii]. . . . I often think of that trip at Yosemite [with you] as one of the best things I have done—but Hawaii was another."[68]

7. *Hibiscus with Plumeria*, 1939. Oil on canvas, 40 × 30 in. Collection of Laila and Thurston Twigg-Smith, Honolulu.

8. *Fishhook from Hawaii—No. 1*, 1939. Oil on canvas, 18 × 14 in. The Brooklyn Museum, Bequest of Georgia O'Keeffe, 87.136.2.

Georgia O'Keeffe in Hawaii

125

House Beautiful

Marjorie Welish

Like Marlene Dietrich, Georgia O'Keeffe has beguiled us by her very remoteness; her taste for solitude and her physical removal to a landscape of inhospitable beauty have done much to suggest by way of analogy that her art is aesthetically inaccessible as well.

To see her art unintimidated by her character and life, however, is to see early American modernism brave at its genesis, and fluctuating in modern integrity thereafter, less avant-garde than given to defiant eccentricity and flair. It has been said that she made abstraction palatable. It may also be said that her work is not abstract so much as formally stylized. Which is to say that the paradox of O'Keeffe's art is that it looks bolder than it *means*; the ferocity of some of her designs masks a drifting aestheticism dependent on others to initiate and sustain. O'Keeffe's is an art of sensuous, rather than intellectual, conviction.

This is not to say, however, that O'Keeffe's enhancement of American art is negligible. An artist of notable native talent, O'Keeffe made a contribution to American modern art at a time when this country needed recruits badly, and if her emergence as an artist during World War I was auspicious, it remains no less so with hindsight. The abstract notation most famous in *Abstraction No. 10— Blue Lines* (1915), along with other art made before 1920, is some of O'Keeffe's very best work—not, strictly speaking, because it is abstract but because it is radical in form. The jagged lines, like rends in paper, seem intimate with the principles by which art comes into being. She absorbed the modernist ideology by way of Ernest Fenollosa's expressive essences, and by the 1920s had totally integrated it into the way she went about making things; she was thinking with

art, not merely applying it. As much as anything, it is probably O'Keeffe's assured grasp of modernism that mesmerized Stieglitz and won her a place in his circle. She earned it. Yet as her art settled and consolidated its decorative stance, and fame accrued to her, it is easy to forget that O'Keeffe's best work also depended on guidance from strong mentors and a presence derived from her visibility within a group of artists then at their artistic peak. In other words, having been a leading member of Stieglitz's 291 circle lent luster to the art of O'Keeffe well beyond the days of her significant achievement—indeed, throughout her life. We tend to confuse her early success story with the inertia of the career thereafter. As with Horatio Alger, so with O'Keeffe it truly can be said that with luck and pluck she made her mark early on.

If the radical phase of her art emerged during the Great War, the canonical phase of O'Keeffe's art came in the 1920s when, shifting to applied abstraction, she settled there, to perfect the pattern of her own interregnum idiom. Her visual signature was a close-up view of a single flower. Biographers like to stress the individualistic stamp O'Keeffe put on art. But while hers was indeed advanced for its time and very distinctive, it owes a lot to her cross-fertilizing of machine-age aesthetics with the aestheticism on which her style is based.

Jimson Weed (1932), for instance, offers conspicuous visual proof of her cultural indebtedness. Studying with Arthur Wesley Dow at Teachers College, Columbia University, in 1915 had been decidedly beneficial. Sympathetic to the precepts of Fenollosa, and having already absorbed the synthetic tenets of Albert Aurier, Dow taught a progressive curriculum of art education, by then famous up and down the eastern seaboard. In it, he showed would-be art teachers how to transmit to students the principles of decoration, expression, and simplification by way of handbook, his *Composition,* already published in several editions since the 1890s. And lessons from the *Theory and Practice of Teaching Art* (reprinted in 1908) could serve as a primer for apprehending O'Keeffe, even two decades later. His step-by-step lessons on line (which consider both the character of expression and design) and light-and-dark (or "notan," which consider massing, quality of tone, and composition of notan) are particularly applicable. Among the accompanying illustrations are schematic drawings derived from a single floral motif, flattened to become a symmetrical quatrefoil in black and white, centralized and dominant. Where in nature there were leaves are now tracery or trefoils, and these subordinate appendages complete the image by squaring it. The resulting floral emblem packs the visual wallop of a patterned tile.

O'Keeffe's *Jimson Weed* realizes this "grammar of ornament" in painted form. As her floral motifs shift off axis and become cloaked in subtle tonality, Dow's influence is palpable. His course in synthetic aestheticism gave substance and form to her landscapes as well. Paralleling Dow's own studies of the Grand Canyon are *Cliffs Beyond Abiquiu, Dry Waterfall* (1943), with its decided emphasis on planarity, value contrast, and what Dow had called "round-corneredness," or stress laid on contours and boundaries. Many of her mature paintings mimic the principles he taught, including that advocacy of pictorial force over refinement. Her discipleship under Dow is crucial in defining the modernist integrity of O'Keeffe's signature style.

Though she was decidedly the beneficiary of progressive art education and would never have escaped the strait expectations of gender in Victorian times without it, O'Keeffe was also a product of her period enthusiasms. With the turn of this century came the democratic dissemination of aestheticism. The author and educator Charles Eliot Norton (1827–1908) had founded a Bostonian branch of the Arts and Craft movement because of widespread visual illiteracy and "the loss of a sense of personal elegance as expressed in articles of common use."[1] The same era that brought modern aestheticism to the masses through progressive pedagogy, however, also encouraged simplistic understanding of simplicity. Early "outreach" programs brought with them a similar faith in the optimistic possibility of "reaching out to touch someone" through art, the purpose of which was to "communicate" with a broad audience of parvenu art lovers. Furthermore, along with proselytizers for art appreciation and teachers of art as a vocation for women came magazines devoted to home decoration. Promoting their readers' visual self-reliance (as we have seen in our own time), these magazines more surely reinforced an attitude of docility and a philosophy of beauty aligned with, not resistant to, fashion. Even as family indulgence of O'Keeffe's gift for drawing would douse any artistic conformity, her gift for mimesis, spotted early on and rewarded at school, ultimately led to limited creative growth. If as O'Keeffe's career progressed, her art seems to have relied on ingratiating itself with public taste, maybe the roots of this appeal paradoxically seem to lie in an enlightened ideology of dissemination of culture, wherein beauty and beautification receive the fate of most twins: to be seen as interchangeable.

With her mimetic gift, it is no wonder that O'Keeffe learned by imitating the styles of her teachers, then, by shifting situations in an act of rebellion. Reactive as she was, it may well be that when she left for New Mexico to live there, at last gaining freedom, O'Keeffe deluded herself into believing that she

needed no aesthetic initiative to react against and no criticality from the outside world.

But the wish to strike out on one's own is no guarantee of achieving that success, and O'Keeffe was not as intellectually independent as she believed. As a measure of O'Keeffe's intellectual insecurity once she left New York, her art did not evolve; it reacted to extrinsic art "moves." While geographically remote, O'Keeffe allowed periodic adjustment to come from the art capital instead of from certain individual paths the direction of her remote pursuit of beauty implied. The history of her mild infatuations with styling is noticeable early on. During the 1920s, as if in response to "the new gaiety," chinoiserie and picturesque detail enlivened some of her paintings (*Radiator Building—Night, New York* [1927], for instance). In the 1930s, her lone crucifixes, for all their ostensible adherence to formal design, shy away from this and instead exhibit a kind of mission-style realism, as if to hint at an alliance with regionalism. A surrealistic warpage is unmistakable in the landscapes of the 1930s and 1940s depicting deep space surmounted by a near and large monstrance of a skull or a pelvis that has become a semiliquid extrusion of the land. During the 1960s, a mild minimalism governs those compositions, adapting flatness to a vast skyscape of clouds.

Monitoring trends was something Picasso did as well; great artists succumb to the temptation of conformity all too frequently. Yet while this is their prerogative, when they do so they abdicate their authority and greatness by electing to become epigones of the stars whose styles have turned their head. This is true for O'Keeffe also. As art moderne replaced modernity, and conservative swank stylizations beautified home and showroom alike, O'Keeffe did as the period dictated.

Like so many of the abstract artists living between the world wars, O'Keeffe had by then sought a rapprochement with illusionism. Disappointing to the modernist critic, such an alliance with intelligibility signifies retreat from avant-garde form and reveals nothing short of intellectual backsliding. Beyond this particular accommodation, however, O'Keeffe's art had already shown signs of pop splendor. If in O'Keeffe the implementation of formal beauty flirts with beautification and stylish misconstrual, the skill at illusion drifts more and more frequently into illustration—this, even as her wish is for spiritual rejuvenation. To recall her art of the 1920s and 1930s is to see that however bold in pattern, O'Keeffe's meaning is easily grasped by its pictorial "hook." Evoking from depictions of nature the archetypes of light and place, her pictures show her self-

imposed constraints on the quest for form. This may be readily seen through her theme-and-variation approach to still life. As much as the more famous series *Jack-in-the-Pulpit* (1930), the series *Shell and Old Shingle* (1926) reveals a process of abstracting from nature by which an image beginning realistically, as transcription slightly dislodged from perceptual moorings, proceeds by degrees toward a condition of stark extremity. O'Keeffe's notion of abstraction is precisely that of condensation, not imagination. Rarely in her work will there be anything approaching the freely launched arbitrariness of Wassily Kandinsky's vision, although she had loved reading his inspiring words in *Concerning the Spiritual in Art*. Not abstract, but evincing the deliberative process of abstracting from nature, O'Keeffe's paintings are also calculated to fit the dour allegories of mood in America between the world wars. In this sense, O'Keeffe's art conformed to, not resisted, prevailing trends.

After World War II ended and Stieglitz died, O'Keeffe finally experienced spiritual rejuvenation. This passage to unencumbered light is indicated in the move from the dreamy lyricism in *Spring Tree No. 11* (1945) to the concentrated abstract lyricism in *It Was Blue and Green* (1960), in which abstracting from nature carries with it luminism from nineteenth-century American landscape painting; abstracting from nature is about recasting botanical darkness into topographical light. Still tied to landscape and less abstract than that inspired early calligraphy of 1915, *Abstraction No. 10—Blue Lines,* the sentimentalized modernity of *It Was Blue and Green* is O'Keeffe's attempt to hold onto a vitalist tradition conveyed by her native experience. Now in old age, as if to save vitalist immanence from oblivion, O'Keeffe renders it as though it were modernist percept romanticized. Has lyricism from second-generation New York school art wafted in? Meanwhile, Fenollosa's legacy of "harmonious spacing," meticulously limned and toned, here gives materialist concreteness to indwelling. Yet so various are the modes of representation in her late work, shifting in *kind* as well as degree, that one can only conclude that the philosophical basis for O'Keeffe's intuited choices was improvised moment by moment.

However, the romantic modernity supposedly sustaining O'Keeffe's portrayal of nature's immaculate handiwork did not impress those who equate modernism with the intellectual grammar the medium reveals under sustained analysis. The art critic Clement Greenberg, for instance, acknowledging only the legitimacy of cubist preoccupation with the elements of art, dismissed the "esoteric" content in the symbolist and expressionist traditions, and so, in 1946, found O'Keeffe's art of little historical importance. Had he shared the vocabulary

of the cultural historian Jackson Lears, Greenberg would have called O'Keeffe antimodernist.

Antimodernism, by Lears's account of it in *No Place of Grace* (1981), a study of American culture from 1880 to 1920, is nostalgic for transcendental recuperation of the desacralized world. Perhaps her early adventures with the Japanese brush, with which O'Keeffe learned outline and tone, revolutionized the world of art appreciation throughout America. But the Orientalism disseminated by Fenollosa and Dow also satisfied a need to resist the bourgeois world through spiritualized aestheticism. It is no mere coincidence that the late art of O'Keeffe is reminiscent of her early studies in synthetic expressivity that included, in addition to the fixity of centrally placed images, the flow of hypnotic waves. Art theorists on both sides of the Atlantic, Albert Aurier in France and Fenollosa in Boston, were fascinated by the occult nature of undulating forms.

Antimodernism also comes to America as the Orientalist commitment to authentic experience prepares the way for the artist's belief and indulgence in direct expression. Thus, spiritualization of the secular is enlisted to justify self-gratification, Lears argues. And similarly, immanence, originating as an expression of the spiritual life of flowers, is put to celebrating "the erotic fusion of sacred and profane." O'Keeffe's art owes a lot to the cult of "self-expression" and what Lears calls an antimodern liberated desire infusing the modernist search for structures of thought. Says Lears, "The avant-garde preoccupation with authentic experience, like that of the medievalists and Orientalists, has frequently blended with a sleeker version of modern culture stressing self-fulfillment and immediate gratification." Antimodernism and modernism are not only linked, argues Lears, but sometimes synonymous.

Modernity's ambivalence toward vitalist immanence, then, is considerable. And nothing reveals a historian's cultural prejudices more than his or her discomfort with the romantic expression playing itself out in art at the turn of the century when aestheticism brought modernity into being. In part it is this vexed attitude toward the spiritual in art that troubles critics looking to assess O'Keeffe's standing. Defending her is the art critic Fairfield Porter, who in his own paintings became a Yankee Nabi. In 1955 he credited her with anticipating the vast sensitized space as abstract expressionist Mark Rothko practiced it, her voids preparing us for his. Critic Clement Greenberg, a partisan of essences, admired Rothko's felt truth of his surfaces because his groping metaphysics (unlike the pictorial impulse in the abstract expressionist Adolph Gottlieb) did not compromise serious painting. In his dismissal of a similar romanticism in O'Keeffe,

Greenberg may be a modernist ideologue; yet to be fair, O'Keeffe is culpable, for she does not compellingly occupy her artistic territory. With a tendency to rely on illustration to explain romanticism and on beautification to enact a "lifestyle" of beauty, the weakness to which O'Keeffe succumbs may be that of not being immanent enough. Meanwhile, territorial wars within the ideology of modernism place O'Keeffe within a conservative camp of the avant-garde, thus aggravating her retreat from the avant-garde and her fate within later twentieth-century art history.

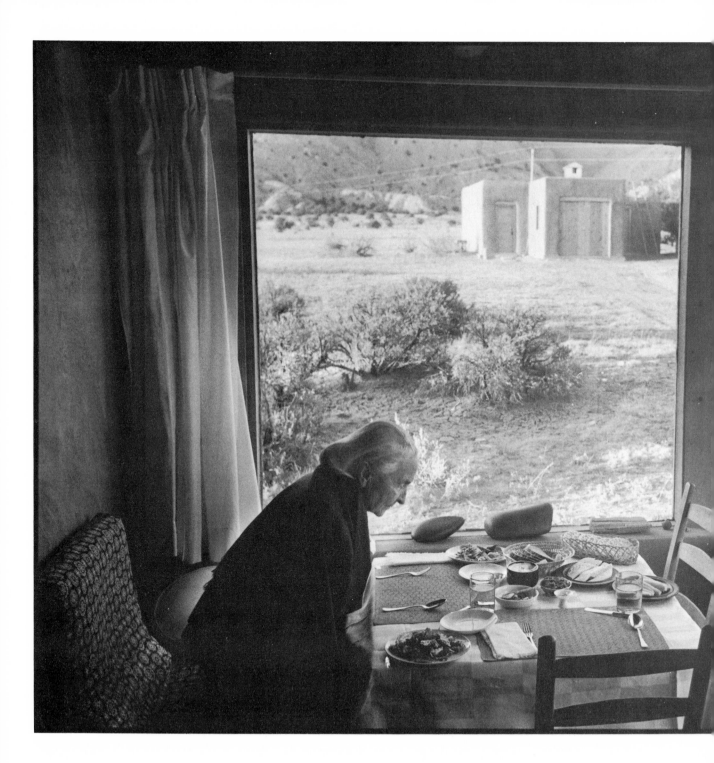

The Woman

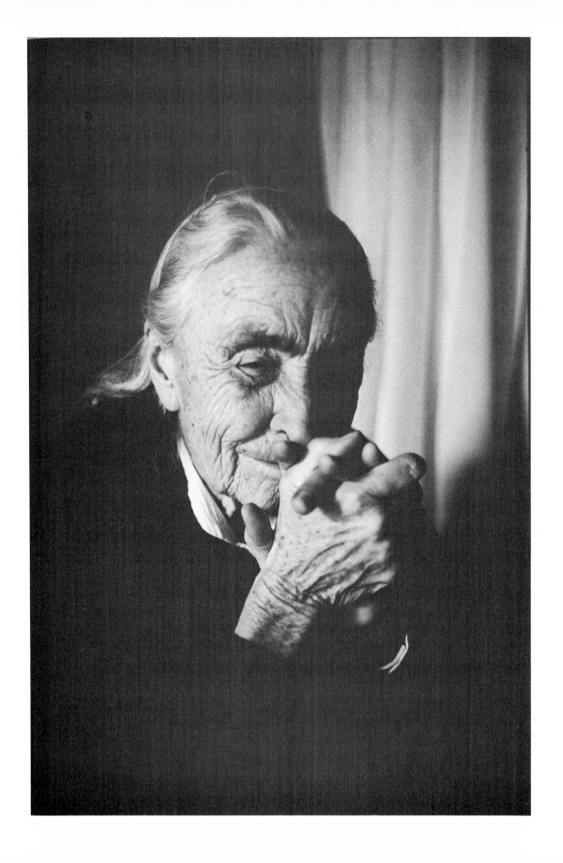

A Graven Space

Melissa Pritchard

A hagiographic mist blurs Georgia O'Keeffe, somewhat like those specious clouds put forth by the theater's notable fog machine. Certain individuals seem fated in life or posthumously to be transfigured into myth, their humanity sacrificed to the mythic process. I suspect the reverence enshrouding Ms. O'Keeffe, suspect the worshipful tendency in myself. There is danger in selectively evoking a life, deliberately arranging events and statements to conjure some saint of the unattainable achievement, some icon at a remove from the rest of us. We are happy to create the graven image; it distracts us from ourselves.

As I began to read about Georgia O'Keeffe, to study the open paintings, the cryptic life, as biographies and photographs lent various lights, I tumbled quickly, as hushed and awed as anybody else. Doubtless I was inspired by her as a role model, for she has given women rare leave and courage to claim space and light and time as artists. Yet as her heroic stature enlarged, she seemed to me humanly misplaced. I admired and took strength from her; I did not particularly like her. As legend accumulated, her human substance receded; the more I wrote glowingly, worshipfully of, oh, the example, the virtue, the brilliance, the feminist ideal, the more remote, inaccessible, she seemed. The thing grasped eludes us.

At this frustrated point, I came upon a photograph of what I thought was Georgia O'Keeffe holding before her face and black mandarin-collared shirt, between those famous hands, a scissored run of paper dolls, and grinning at all us worshippers. Well, I looked directly and no, she was not smiling but enigmatic, androgynous, a dry length of spinal column between her hands like parched,

oversimple lace. I took this mis-sight on my part as a cue. This woman, what I knew of her, had culled from her life, from those bright and dull things netted from a fluid existence, surely, I hoped, beneath the arid self-reliance, heroic independence, and artistic genius, lay humor, levity, some wit gone to giddiness.

I read how she and her sister walked at twilight across the frypan-flat Texas plains, tossing bottles at the sky and shooting them down, exploding thick glass with bullets. I liked her for that. She painted in a shack up at Lake George, in the nude, and screamed at inquisitive children when they came, rather naturally, to spy on her. I liked that. She purchased a car in New Mexico and taught herself—recklessly, perilously inexpert—to drive. I liked that as well. She cultivated gardens, sewed clothing, wanted a child, endured losses and defeats, once threw a charred turkey out and fled Thanksgiving guests, once interred a despised marble bust in the Stieglitz garden. She proved retrievable, as vulnerable, silly, and grieving as any of us.

There is reason to desanctify this woman. We burden someone with mystique in part to evade ourselves—not so much to honor them as to subtly devalue ourselves. Those individuals who splash their life's canvas hugely, exuberantly, more than the timid rest of us, sadly hesitant in the shaping of our lives—this near-deification of an extraordinary artist like Georgia O'Keeffe, the worshipful distancing that creeps insidiously into our innocent study and regard of her, comes from a reluctance to confront ourselves, our lives, an unwillingness to have faith in our own potential. The more we legend her up, trick her out in outrageous character, unsurpassable achievement, the more Promethean her proportions, the less we need ask of ourselves. We hypnotize ourselves with her accomplishment, diminishing any need of our own, ask to be intimidated so we can remain in a familiar, if uncomfortable, state of perpetual self-disappointment—the dark side of admiration.

Humor acknowledges contradiction, and Georgia O'Keeffe was an artist of uncommon and cultivated paradox, her chosen elusiveness provoking diverse interpretation and flurries of theory, her renunciative stance reflecting a profound engagement with the world. She went beyond prescribed female territory, confronting its symbols head-on. The flower, so archetypically feminine, delicate, pale, passive, fragrant, fragile, she painted as fleshy, strong, vibrant, voluptuous, and nearly voracious. She set the white pelvis against red female humps of hill, turning the body of the world, of ourselves, inside out.

Visionary exile, Georgia O'Keeffe turned from the world's quotidian gnawings and concerns. Many of us stay busy inventing reasons not to create—we complain, whine, and will not work because we are terrified of doing so. She

was impatient with this, you do not wait for the perfect setting and mood to be artistic, you seize and breathe your air, lay guiltless, unequivocal claim to the light, the space, the aloneness. You pioneer the unknown, the edges of definition and beyond, the cusp between sky and earth, the brilliant life-cusp where humble and sacred touch. Not without loss, she forsook much of what we consider human paths to fulfillment—romantic love, traditional marriage, motherhood—and went on to invent her own universe, disturbing us with her potent, altered version of reality, giving us glorious, crucial leave to do the same. Yet we impede ourselves, prove the greatest obstacle.

If human life is about loss—the procession of growth, acquisition, and accumulation, then the relinquishment of childhood, of naive faith, of youthful health, of perfect love, of perfect children—then for selfish purposes I demystify Georgia O'Keeffe. I will not place her out of reach, will crank down the pedestal, touch the statue, and find it is a woman who could behave noxiously, act arrogantly and outrageously at close mortal range. She was no oracle we need cast self-declared puny lives into. She broke the scale most of us restrict ourselves within and did so not without fear, yet without fear stopping her; she confronted the profound relation between luminous spirit and humble form, shaping mortality into graven forms and colors suggestive of the infinite. She confronted sexuality, death, and loss, transmuting them, transcending them. She was spartan, aesthetic, stringent, voluptuous, monastic, sensuous, an inspiration from afar, recalcitrant in person. Refusing definition, rejecting all theory, confounding any attempt to pin her down, she eludes us even now, like water, like sand. She made holy the simple. "The vision ahead may seem a bit bleak, but my feeling about life is a curious kind of triumphant feeling—seeing it bleak—knowing it is so and walking into it fearlessly because one has no choice—enjoying one's consciousness."[1]

Rather than idolize Georgia O'Keeffe, making of her some reliquary for deceptive speculation, we would do well, I suggest, to return to ourselves, strengthened by her example, and get on with it: Life. The business of loss. Love.

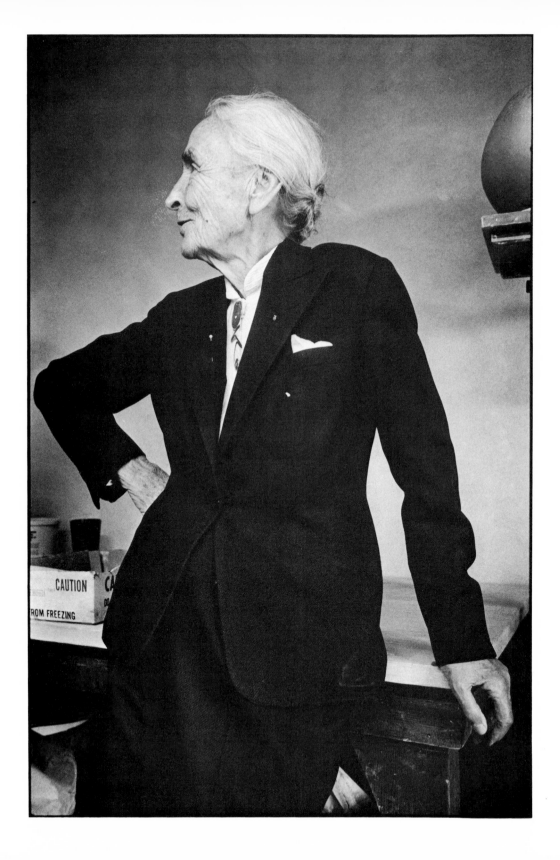

O'Keeffe, Stieglitz, and the Stieglitz Family

An Intimate View

Sue Davidson Lowe

"I was hard on that family," Georgia O'Keeffe admitted in a 1968 *Life* magazine article,[1] uncharacteristically accepting some responsibility for the prickliness of her long relationship with her Stieglitz in-laws, the contentious but close-knit family of Alfred—her lover for six years, husband for twenty-four more, and the only man to play a central and enduring role in her life. More typically, her concluding phrase, "but they were hard on me," both evened the score and dismissed further discussion. Like Alfred, she declared their families generally off-limits to interviewers, for privacy's sake, of course, but also to suggest, quite deliberately, that relatives were so peripheral to their intense artistic lives as to be virtually irrelevant. If pressed, Alfred usually offered a few benign comments, but O'Keeffe's remarks about his kin were more apt to be disparaging or even contemptuous, with little distinction made between those who had once been close to her and those whom she had deplored from the start.

The impression given—that Alfred's near relatives and in-laws were, and had been since first acquaintance, insignificant to O'Keeffe except in their capacity to irritate—was misleading. In fact, during the critical first decade of her life with him, year-round, the Stieglitz family was indispensable to her. Its members provided support not only for her art but also for the physical and financial circumstances under which she lived. Moreover, between 1929 and Alfred's death in 1946—a period when she and Alfred spent many half-years apart—the full-time presence in his life of his remaining siblings, besides affecting the emotional climate between them, enabled her in many ways to claim her independence with minimum concern for his physical well-being.

In the mountain of material by and about these two outsize figures in twentieth-century American art (material that is open to the responsible biographer and the flagrant profiteer alike), comparatively little pertains to O'Keeffe vis-à-vis the Stieglitz family, seldom mentioned either in her letters or in her "autobiographical" 1976 book (an artfully honed nonaccount of her life), or, indeed, in the fabulist reminiscences of Stieglitz's declining years, in which his parents' role became merely symbolic. Matters familial will surely come to light with the eventual release of the immense body of correspondence between the two principals that is housed in the archives at Yale's Beinecke Library, but they are unlikely to be addressed in its impending edited version. The similar release of Stieglitz's correspondence with Dorothy Norman will probably reveal less about relations between his family and O'Keeffe than about his special pleadings and self-dramatizations.

A further caveat about the dependability of these primary sources: Although O'Keeffe's and Stieglitz's integrity may be regarded as virtually unassailable where their arts are concerned (there are few exceptions), what they wrote otherwise was not only humanly contradictory but also sometimes, even in the guise of candor, disingenuous and manipulative. While O'Keeffe, until her 1932–33 breakdown, was remarkably uninhibited in revealing her emotions in those letters to close friends that are available to our scrutiny—letters in which, a careful reader suspects, the occasional "sexually liberated" language is bravado, a screen for a lingering, almost Victorian naïveté—in other circles she began to be circumspect soon after Stieglitz's nudes of her in 1921, and the exhibition of a hundred of her own works two years later, brought her notoriety. Her preferred response to questions thereafter was silence, but when cornered, she learned to evade and dissimulate with consummate skill. Furthermore, in letters to, and conversations with, friends as well as comparative strangers, she could be as charming and flattering in pursuit of something she wanted as she could be coldly dismissive of those who meant well but performed poorly. (Those she deemed disloyal were guillotined. Stieglitz, who was famous for excommunicating disloyal friends, was far less implacable than O'Keeffe; eventually, gingerly, he made up with them. She did not, unless there was some clear profit to a reconciliation.)

Stieglitz's letters offer other hazards. Extravagant and unassuming by turns, almost always true to the moment but often variable and inconsistent over time, sometimes confessional and sometimes didactic, exasperatingly self-absorbed and unstintingly generous, he was capable also of circumspection that, on behalf of

the artists in his galleries, was occasionally Machiavellian. His public writings ring with conviction—of the pamphleteer extolling photography from the age of twenty, in 1884; of the articulate essayist and editor-publisher from 1897 to 1917; and throughout his adult life, of the provocatively unconventional moralist.

My acquaintance with the variable reliability of Stieglitz's letters came in the course of doing research for my 1983 book, *Stieglitz: A Memoir/Biography*. My personal acquaintance with him, which spanned the last twenty-four years of his life, arose from our consanguinity: he was the elder brother of my mother's father. Thanks to my parents' particular closeness to him, I was present consistently, not only during summers at the family compound at Lake George from the year of his marriage to O'Keeffe (1924) until his death in 1946, but also at his third and final New York gallery, An American Place, after its opening in 1929, and at his and Georgia's penthouse between 1937 and 1942. I was a close and sometimes wary observer during those years, and I was also an occasional minor participant in some of their dramas—with and without Alfred's siblings, in-laws, cousins, nieces and nephews (and their offspring), and three ancients of his parents' generation. Thus, I too may be called a primary source. I cannot claim infallibility, but I have corroborated as best I can everything drawn from my memory and have sifted and resifted (never enough) the information that has come from others; and notwithstanding my discovery of errors in my book that I wish I could correct at this late date, I do claim an honest dedication to the search for an at least approximate truth. In that search I owe much to solidly grounded secondary sources, having relished on the way the improbability of much journalistic reportage, the frequent myopia of criticism, and the pablum of hagiography.

By the time O'Keeffe came to New York from Texas in June 1918, having given up the security of teaching for the risks of making her way solo as an artist, she and Stieglitz had been writing each other, intensely and voluminously, for nearly two years, during which they had discovered at least the more attractive of their similarities. Their tastes were compatible. Both were eclectic readers and vigorous hikers. Each played or had played an instrument, she the violin and he the piano. Loving classical music, as did Alfred, Georgia would find much to learn about it from him; he, trying to pick up her enthusiasm for jazz, would fail. Both committed to a basically socialist and pacifist philosophy, neither felt obliged to join organizations founded in the public interest; O'Keeffe's long membership in the National Woman's Party was proof of her affection for

O'Keeffe, Stieglitz, and the Stieglitz Family

143

its secretary (her old friend Anita Pollitzer) and of her belief in the worth of the individual regardless of sex, rather than of devotion to a strictly feminist cause.

Crucial to the longevity of their relationship was Alfred's and Georgia's shared appetite for hard work in the pursuit of the "perfect" product. It did not hurt that each was impassioned by the other's art—the first element, perhaps, in their attraction to each other, and the most durable. Each trusted the probity of the other's artistic appraisals even when they disagreed, which was seldom. (That others, seeking their appraisals, would often find their candor cruel would bewilder them; all they had done, they insisted, was to speak their minds honestly, the only way to be useful.) Both too were intense observers, Alfred initially the more practiced, with thirty-five years of photography behind him (Georgia's arrival would inspire him, within the next seven years, to more than double his production); in the years to come, Georgia would credit him with helping her to see whole. Living together, they would discover similarities and dissimilarities that might not prove so pleasing or sustaining, but the passion for "truth," and the freedom and discipline both found intrinsic to their arts, forged a link between them that would never be broken.

Some of the less pleasing attributes they shared (but saw only in the other) probably derived from the ample self-centeredness common to people at their level of talent and motivation. Neither found accommodation natural or easy, although each genuinely tried when the stakes were high. Always, their best times together would be when, in tandem, each was working at maximum intensity; then generosity and good humor flowed. When that momentum was lost, for any reason short of severe illness, impatience led to righteous indignation and to temper tantrums that, unresolved, settled often into stubborn opposition. Alfred's rages were more easily triggered and more extravagant than Georgia's (he was not above administering public humiliation, even to her, a vicious habit she eschewed except with servants and a few irresistible targets) and were usually more quickly spent than hers, which could fester for days after the first explosion. Each claimed greater patience than the other; in fact, they were fairly evenly matched.

Well before Georgia left Texas in 1918, Alfred was almost certainly in love with her; her love for him flowered soon after her arrival in June. In early July he left Emmeline, his wife of twenty-four years, and their twenty-year-old daughter Kitty, to move in with her. Georgia was thirty, Alfred fifty-four. He had already begun introducing her to his family.

The first to be summoned was his physician brother, Lee (my maternal grandfather), to oversee her recovery from the probable flu she had contracted in Texas. Within the first week, too, she met Lee's daughter Elizabeth (my mother), nine years her junior, with whom she had been corresponding for six months; now she occupied Elizabeth's painting studio full-time. Next came Alfred's sister, Agnes; her attorney husband, George Herbert Engelhard; and their twelve-year-old daughter, another Georgia. By the first week in August, O'Keeffe had met most of the fourteen members of Alfred's close New York–based clan, including his widowed mother, Hedwig, as well as the man Elizabeth would marry within the year, Donald Davidson (my father). From the start, Elizabeth, Donald, and young Georgia Engelhard were embraced by O'Keeffe as friends.

When O'Keeffe met them, Alfred's surviving siblings were in their late forties and fifties, always at odds but fiercely loyal, still playing out the turbulent interactive habits of their childhood. Six children (Alfred the eldest) had been born in Hoboken, New Jersey, to cosmopolitan German-émigré parents who moved them to Manhattan in 1871, where they enjoyed every material and cultural advantage. They were raised only steps from Central Park, in a brownstone off Fifth Avenue commissioned by their martinet father. Edward Stieglitz, having served briefly but proudly as a cavalry officer in the Union army, had subsequently prospered as an importer of woolens. In 1881, at the age of forty-eight, he abruptly retired, leased his townhouse, and took his wife, sister-in-law, three sons, three daughters, and the younger girls' governess abroad for five years of immersion in European culture. The move guaranteed his children a superior education in Germany, while he conducted his wife and her sister around the Continent in pursuit of his new passion, painting, which he had undertaken in New York under the guidance of two noted artists who were his protégés. His most enduring legacy to his offspring included a gregarious nature, an Olympian temper, and the solid conviction that Stieglitzes were intrinsically more refined, intelligent, and sensitive than the rest of humanity.

Alfred absorbed his father's lessons as thoroughly as did his siblings but from his early teens (and for the rest of his life) rebelled against the standards of comfort they regarded as barest essentials. From his twenties on, the money he received from his father (first as allowance and later as trust income) went almost exclusively to financing his photography, his superb fifteen-year quarterly, *Camera Work,* and the artists of his first gallery in New York, 291 (here, in 1917, its final season, he had mounted Georgia's first one-woman show). For twenty-four

years his wife—wealthy in her own right—took care of their domestic expenses. By the time he left her in 1918, his stoical habits worried his family.

A dandy in his youth, he arrived now at their gatherings in clothes grown threadbare (and sopping in wet weather because he refused to take a cab). He ate so little at their tables—except for chocolate ice cream, to which he was addicted—that their cooks were offended. A new dress in a sister's seasonally adjusted wardrobe drove him to rail against all their extravagance as shrilly as he had once scolded his wife, though he paid none of their bills. O'Keeffe earned his praise as much for her frugality as for her skills in cooking, mending, dressmaking, and gardening (in which she was far less competent than she imagined). Meanwhile, his siblings, although devoted to him, regarded him fondly as a rather peculiar fellow, hopelessly impractical, never quite grown up, and indeed rather helpless. To them, his artistic and social philosophy was virtually incomprehensible; he was their bohemian pet.

His brothers and sisters conformed more obviously to the norms of their class: attractive and gracious to their social peers, peremptory with servants (as O'Keeffe would prove also to be), and discreetly just a shade passé in attire. Thin-skinned, they were also opinionated, melodramatic, and—except for diminutive Agnes, whose worship of husband and daughter rendered her more deferential, at least superficially—egregiously self-centered. Flash-tempered like their father (whose rages had paralyzed them in childhood), their own continuous squabbles, ritualized over the years, were played out in whispers or beyond his earshot until his death in 1909, and indulged thereafter without constraint.

Alfred's brothers, identical twins, were scientific prodigies. Both, after taking highest honors at prestigious German universities, gained prominence in their fields, Lee in medicine and Julius in chemistry. Of the two, Julius seemed the milder, but in fact he was as irascible as Lee and more pompous by far. Equally impressed by financial success (although Lee shared his profits more generously), and equally sentimental, both basked in the admiration of the patients and students who were their professional dependents. Both were freely unfaithful to their German-born wives, Protestant sisters they had met as undergraduates in Bavaria. Chicago-based Julius and his immediate family would not come into Georgia's orbit for some time.

Three weeks after moving in with Georgia, Alfred brought her to the waterfront estate at Lake George bought by his father in 1886 after his return from Europe with Hedwig and their daughters. His mother, eighty-year-old Hedwig, watching her middle-aged son prance with joy for the first time in his

adult life, welcomed Georgia to Oaklawn like the answer to a prayer. Without a second thought, she excommunicated friends who disapproved of the lovers' liaison; Alfred's immediate request for a divorce was ignored by his wife for six years. Hedwig's partisanship would endure until her death in the fall of 1922, an event that would deprive Georgia, as well as Hedwig's disputatious children, of her gentle but effective buffering. An oversolicitous mother who was also adamantine in her principles, she kept order usually under the guise of helplessness; when she failed, she called on Alfred as peacemaker, a role she had assigned him before he was ten.

After her death, perhaps missing her summons, or perhaps only bored, he was known to foment collective spats—solely, it sometimes seemed, for his amusement. From the latter 1920s on, I was witness to the siblings' sparring at the round dining table that was their favorite arena. They battled over everything: the exact date the family had assembled in Mittenwald, Bavaria, in 1883 for their joint summer holidays; the literary merits of the latest best-seller; the bloodlines of a favorite at Saratoga; which of them was the best at croquet; what on earth Alfred could find at all engrossing about baseball or boxing. In the 1930s, the scope of Shirley Temple's talents excited heated debate. (A digression: accounts in my book of spats I observed should have been dated 1927; in 1925, Selma and Agnes were not at the lake simultaneously.)

At Oaklawn in 1918, sister Selma (the youngest) appeared with her husband, Lou Schubart, when Alfred was briefly away. Her meeting with Georgia was disastrous, presaging thirty years of animosity that ended only after Alfred's death; in interim summers at the lake, the mere mention of an impending visit from Sel put Georgia on combat alert. Aged forty-seven in 1918, dark-eyed Sel still evoked the fin de siècle beauty who had led a string of admirers through the spas of Europe, chaperoned by her personal maid, infant son Howard, and his nanny, at ruinous expense to Lou's ego and pocket. Her leading beau in 1918, and through his final decade, was Enrico Caruso, whose gifts to her included an obnoxious Boston terrier that fastened repeatedly onto trouser legs or, preferably, ankles. (Alfred placed a vial of iodine with the condiments on the table.)

Fancying herself a latter-day Madame de Staël, Selma spent her mornings "at her desk," and in New York presided over soirées in her Tiffany-decorated apartment while Lou retired to his bottle; in the twenties and thirties she published a slim volume each of stories and poems. Even at Lake George, she was adrift in chiffon and cashmere, corseted, perfumed, nail-buffed, and coiffed, restrainedly bejeweled. In audacity and intellect clearly the superior of Alfred's

wife (her friend since their adolescence), she was her equal in coquetry, vanity, petulance, and tyranny. She was also the only one of the siblings to possess a genuine, if rather nasty, sense of humor, and the only one found consistently entertaining by those of us in her grandchildren's generation; she was our Auntie Mame. To O'Keeffe she was anathema, the embodiment of almost everything she found deplorable in a woman. Her son, Howard, and his wife, Dorothy (whom Sel treated viciously), became Georgia's lifelong friends, but not even Howard could effect a truce between her and his mother until, in her latter seventies, Selma displayed a minor talent for watercolors and worked at it, thereby gaining a soupçon of Georgia's grudging approval.

Only one other woman in the family so thoroughly irritated O'Keeffe, but for qualities diametrically opposite to Selma's. My grandmother, generous and self-effacing Lizzie (Lee's wife), a gifted pianist and indefatigable succorer, won her disdain not only for insipid menus when she ran the Lake George family household in 1925 (after three years of Georgia's exclusive rule), but more profoundly for her exemplification of the perfect wife, stoical in the face of Lee's outrageous temper and blatant infidelity. By 1924, a deeper, more potent reason may well have underlain Georgia's resentment. For six years, she and Alfred had been living rent free, benefit of Lee and Lizzie—for two years in Elizabeth's studio, and for another four on the top floor-and-a-half of their East Sixties townhouse, in quarters refurbished to their order—leaving Georgia with the discomfiting feeling that gratitude was due. Alien to Georgia's nature, gratitude was a sentiment to be dispensed quickly (if not ignored or disputed) and forgotten as soon as possible.

Whatever the source of Georgia's animosity toward Lizzie, there was no excuse for her contemptuously rude treatment of her, so open that it earned the grim displeasure of Lizzie's friends and the open hostility of her servants; Lizzie remained impeccably polite. When she divorced Lee in 1932, freeing him—to his dismay—to wed his inamorata (in the same year, her sister's death released Julius from *his* matrimonial compact), Georgia expressed admiration for her belated independence, but neither, by then, would have tolerated gestures of friendship.

O'Keeffe's relationship with Lee was ambivalent. Until her 1932–33 breakdown led her to a new medical team, she was as slavish to his authoritarian doctoring as his most worshipful patient, but she resented furiously the strictures he imposed on her freedom. Under his care, she took to her bed at the slightest sign of discomfort, including the onset and sometimes duration of her menses,

From the Faraway Nearby

148

times when everyone tiptoed with caution for fear of her wrath, Alfred included. (Today she would be called a victim of premenstrual syndrome.) While she deplored Lee's political conservatism, rigidly at odds with her and Alfred's convictions, Georgia so admired his acuity in the stock market that she sought his tutelage as soon as she began to net small profits from sales of her paintings. At his suggestion, when her capital grew more substantial, she turned over management of her funds to his favorite nephew, and her friend, Howard Schubart. Always in my memory, her responses to Lee's enormous charm were mildly flirtatious; she was skilled at deflecting his rages. In 1924 she expressed toward him the gratitude she begrudged Lizzie, in the form of what was probably her first commission: a painting, as he had requested, that he could understand.

In 1918, inadvertently overstaying their allotted time, Alfred and Georgia were still at Oaklawn when his daughter arrived. Her fury at finding his paramour under her grandmother's roof sent them back to New York on the next train. Kitty and Georgia never saw each other again. Their shocked encounter marked the start of an estrangement between father and daughter that lasted almost until her marriage in 1922. A year later, tragically and permanently, she succumbed to postpartum dementia, an event that contributed heavily to Alfred's opposition to Georgia's wish to have a child.

Alfred's trust income (equivalent today to perhaps twelve thousand dollars a year) continued to cover both Georgia's and his art materials and his traditional weekly hosting of dinner for needier literary and artist friends (at a Chinese restaurant on Columbus Circle in the 1920s), but in their first six years together, it did not provide them shelter or, in the family's view, "proper" sustenance. Prompted to act, Lee and Lizzie, Hedwig, and the Engelhards, in rotation, invited them to three nourishing dinners a week. (In 1925, when Alfred started a gallery again, he began to reward their generosity with intermittent gifts of his photographs and of works by artists in his group, including Georgia.) Imperious Selma's monthly summons to her table were generally ignored until 1921, when Alfred agreed to come as part of a settlement between them of a six-month war over rights to time at Lake George. (The settlement was the work of their Engelhard brother-in-law, a partner of Benjamin Cardozo and a brilliant, droll, and kindly man who was often caught in the crossfire of Stieglitz tempers.) Georgia refused to be mollified. She consented, however, to occasional dinners with Lizzie and Lee's other daughter, Flora Straus, and her husband, and she looked forward with relief to visits with Elizabeth and Donald Davidson. Farming and starting a family at Lee's Westchester weekend home (and dreaming of a

place of their own), the Davidsons provided Georgia with homegrown fare she had missed since her childhood in rural Wisconsin; she relished too their unconventionality, their zest, and their lack of pretension.

In Donald she found kinship in attitudes and experiences that were alien to the Stieglitzes: a nonsentimental and open respect for manual labor (of which he had done a great deal since his middle teens, when his family had abruptly lost a seemingly inexhaustible fortune); an intimacy with the soil quite beyond the ken of his and Georgia's soft-handed in-laws (a native New Yorker, he had found joy in the gardens at his parents' upstate summer lodge); and a wry Celtic wit, inherited from his Scottish forebears, that was equally foreign to—and much needed by—the oversolemn Stieglitzes. Briefly in the early 1920s he, Elizabeth, Georgia Engelhard, O'Keeffe, and a few others clowned occasionally for Alfred's camera, inspiring some of the few truly humorous images of the latter's career.

In every summer that Georgia was at Lake George after Hedwig's death in 1922 (save 1925, when the Davidsons were readying a seventeenth-century farm for their own occupancy), either she or Alfred drafted Elizabeth and Donald for emergency rescues: Elizabeth to take over the housekeeping when Georgia could not stand a minute more of it, Donald to prune or plant or build or paint, and both together to restore good health and humor to their lives. When Georgia's sojourns in the Southwest began, however, Elizabeth declined to serve. Donald, weary too of her demands, agreed nevertheless to intermittent stays with Alfred out of sympathy and accepted with amusement the conscientious but miserly compensations Georgia forwarded, seldom enough to cover his expenses. A consistent silent benefactor to her fellow artists whenever they were in dire need, Georgia bought their works consistently (with no intention, usually, of displaying them), but with those who performed services for her, of whatever magnitude, she was notoriously tight-fisted.

The Stieglitz family aid to Alfred and Georgia continued past the 1920s. When Lee's city house was sold in 1924 (soon followed by his Westchester home, which precipitated his construction of a summer house in the family compound at the lake, and the Davidsons' move), Lee started an allowance to Alfred to help with the rent he and Georgia would face, a stipend Lizzie took over with her alimony in 1932. Georgia's family may have helped sometimes, but it was not until her paintings and investments began to guarantee her an income, around 1935, that her and Alfred's domestic expenses in New York were covered without the aid of his brothers and sisters. (At Lake George their support continued until Alfred's death eleven years later.) Like a clergyman with a respon-

sive congregation, Alfred accepted the arrangement as his due. Georgia, on the other hand, who had been virtually on her own since the age of fifteen (an unthinkably rash state of affairs from a Stieglitz point of view, especially for a young girl), nurtured a growing resentment.

In New York, with lives separate from family even in Lee's house, Georgia and Alfred had as much freedom as they wanted. During their first decade together, all the major artistic riches of the city were within walking distance, and leading figures in the avant-garde world came to their door—novelists, poets, painters, and journalists. Occasionally a wealthy patient of Lee's was enticed upstairs to view, and perhaps buy, one of Georgia's canvases (Joseph Duveen, the internationally influential art dealer, declined, seeing no value in modernism[2]). Only when they were in dire need did Alfred deign, grudgingly, to accept a portrait commission. If Georgia felt sometimes that their evenings were crowded, at least it was by people with kindred interests. At Lake George between late June and early September, when the family was likely to put in an appearance, however, their only hope was to board a writer friend for the summer—Paul Rosenfeld, Louis Kalonyme, Ralph Flint, to name a few—usually in an erstwhile servant's cell up the back stairs. During "family time," too, Georgia's independent boating and hiking were curtailed by the strict scheduling they were accustomed to in a house run by servants.

O'Keeffe's later recollections would suggest that she was a captive in the kitchen at Lake George, forever at the beck and call of a horde of Stieglitzes. In a 1974 interview she described her responsibilities as including service to "fifteen to twenty people at the table."[3] In fact, that number was present only at Oaklawn, in 1918 and 1919, when she herself, a pampered guest, would have been banned by a kitchen staff of three from so much as passing a platter, far less entering the cook's domain. In the three years following the late 1919 sale of Oaklawn and the family's move up the hill to the farm Edward acquired in 1891 (in part, to house bachelor relatives and overflow guests), the housekeeping—under Hedwig's declining supervision—was in Agnes's hands, with a reduced staff, for the summer. Georgia's responsibility, starting only after the family was gone, ended two or three months later when she and Alfred returned to New York; their guests, meanwhile, were entirely of their own choosing.

The first year of her reign at "the Farmhouse" (capitalized by Alfred, as was "the Hill," perhaps to remind correspondents of the simplicity of his environment) was 1923, the year after Hedwig's death. Although she had left the forty-acre property to all her children in more or less equal shares, Hedwig had clearly

intended that Alfred and Georgia have primary use of the house. Her eldest son was not to be deprived of a country summer (a Stieglitz sine qua non) simply because, unlike his siblings, he lacked the funds to travel abroad or sample a resort on his home continent.

Even though the Farmhouse had been restored and redecorated by the siblings only three years earlier, Georgia, reasoning that it was now hers, began almost at once to adapt it to her tastes. (She had already charmed the Davidsons into transforming a tumbledown shanty, in 1920, into a viable and private studio. Comically, in each succeeding letter detailing the metamorphosis, Alfred had ascribed increasing credit to himself and Georgia.) Her first priority was the banishment to the attic of curtains, draperies, dresser scarves, knicknacks, and gewgaws that Alfred's sisters had transported lovingly from Oaklawn. Next she installed harsh blue "daylight" bulbs in fixtures denuded of shades. The overstuffed velvet chairs and the chaise longues Alfred favored were soon draped in muslin sheets, coverings replaced in the 1930s by Navajo rugs and blankets. Before long she had a section of the south porch roof removed to admit fall heat as well as summer light; until 1925, when Alfred opened a gallery of his own again in New York, she and he stayed through November, as they had since 1919. Every one of her decisions won Alfred's approval, but not his sisters'. They found her "simplifications" arrogant and unfeeling; in effect, she was burying their past—and planting the seeds of their discontent.

In the first two summers of Georgia's stewardship, Alfred's relatives collectively (not counting the Davidsons, who were again summoned for help) stayed at the Farmhouse less than two weeks of the twenty she and he were there; all the other guests (and they were numerous) were of their own choosing, including her sister Ida for two autumn months in 1924. After one unfortunate early week in 1923, when Selma commandeered two rooms and service before setting off for Europe, the family responded to Georgia's protests by hiring a cook–cleaning woman to help her for the rest of the summer; a groundsman (Hedwig's former coachman) and a laundress (his wife) were already in place. Hedwig's former personal maid was the first of several helpers unsatisfactory to Georgia. Finally, in 1927, a local resident, Margaret Prosser, once a housemaid at Oaklawn, won the post of live-in summer housekeeper; she remained until after Alfred's death in 1946.

Georgia complained widely also about the work involved in opening and closing the house (a task in which Hedwig's aging retainers can hardly have been very helpful) and about the onerous annual painting of boats and outdoor furni-

ture. In fact, unless she was ill, she found the painting so enjoyable, as a way to unwind after the tensions of the city and as an excuse to postpone setting to work on her canvases, that she seldom accepted the help of volunteers. Donald's assistance was always welcome, but Alfred's was accepted only when she was feeling indulgent; he approached KP and other novel domestic labors with a good deal of gusto but little aptitude.

Georgia's blanket condemnations of the family at Lake George surely owed much to the disastrous summer of 1925, in which I too, aged not quite three, played a role. She had arrived at the lake in poor health following an apparently toxic vaccination, with her glands so swollen and legs so sore that she was ordered directly to bed. She was convalescent only a few days when my sister Peggy (aged five and a half) and I were deposited with Lee and Lizzie in their just-completed bungalow up the hill for the six weeks it would take our parents to ready our new home. Since a second structure designed by Lee to house a proper kitchen and dining room would not be built until 1927, we four bungalow inhabitants lunched and dined daily (except for occasional excursions) at the Farmhouse, with a grimly resentful Georgia, a wary Alfred, and their amiable writer-in-residence, Paul Rosenfeld.

The arrangement would have been trying for Georgia at her best; ailing, and deprived of work and respite both, it was nearly unbearable. It did not help that Lizzie's wifely perfection was no more escapable than her fat cook in the kitchen, preparing and serving meals that, designed for Lee's diabetes and foisted on everyone, were anemically boring. It helped even less, as Georgia wrote in a letter as exaggerated as it was wryly amusing, that "two yowling brats" robbed the adults of appetite and conversation. In fact, as our exacting grandparents later affirmed, Peggy and I were rarely disruptive at meals, needing reminders only not to wriggle, to use our napkins, and to keep our elbows off the table. Outdoors, admittedly, we were noisier, forgetting admonitions to catch the screen door before it slammed and to temper our shrieks at play even up the hill. The intriguing echo in the barn-holding hollow between our houses that amplified to our ears the high-pitched sounds, if not the substance, of Georgia's and Alfred's battles—her voice as loud as his—surely brought them ours equally fortissimo.

Worse still was the faux pas I committed on my first day there, which probably rankled Georgia all summer long. Coached by grandmother Lizzie (in an ill-conceived celebration perhaps of Georgia and Alfred's December wedding), I had curtsied, offered my hand, and piped, "How do you do, Aunt

Georgia?"—to which her response had been a curt warning never to call her "aunt," and a slap across the cheek for emphasis.

Granting that physical distress and constraints on her freedom perhaps made O'Keeffe's impatience with us inevitable, in a woman who had professed several times a powerful wish to have a child—and accused Alfred of "forbidding" her wish—it was certainly out of proportion. Alfred's objections were indeed strong, but they were not just whimsical. First, childbirth itself had terrified him since the 1890 deaths of his favorite sister and her child in an agonizing delivery; in 1923, he saw it rob his cherished daughter of sanity. Second, he had realized too late that, having given more to his career than to his family, ceding almost all of Kitty's guidance and education to a timid mother and a rigid fraülein, he had been—and was still—unsuited to fatherhood. Third, the reality both of his and Georgia's shaky finances and of his age was not to be ignored. Finally, and perhaps most cogently, he was convinced that, with a child, Georgia's painting would not only suffer neglect but might come to an end. Elizabeth's passionate campaign for Georgia's rights to motherhood reverberated with her own rationalizations for having sacrificed to the same end a future as either a painter or a violinist. Did O'Keeffe, he asked, with a talent immensely more significant—one that the world should be allowed to share—have the right, really, to make such a sacrifice?

Despite Georgia's resentment of his opposition in this matter (as in others she catalogued for the rest of her days), there is little question that she was not cut out for motherhood. Although she was known to enjoy, in small doses, the company of children for whom she had no responsibility (and those past the demanding and/or noisy stage), it seems probable that her yearning was rooted less in anticipation of the rewards of child-rearing than in the wish to experience physically that unique province of womanhood, pregnancy—to become mysteriously double, to be the sole provider, the host, to a new life. Beyond delivery, motherhood was something else again, notwithstanding mystical values imputed to it by Elizabeth. Finally, there was the fact of Georgia's incontrovertible distaste for assuming responsibility for any other human being. When she knew that Alfred was truly ill, and not just playing the part, her impulse to take care of him was genuine and generous, but as soon as she had determined that he was out of danger (and that other caretakers were available), she was quick to decamp. Mothering without the resources of a full-time nanny-housekeeper would have wearied her, one suspects, within months. (Puppies and kittens, on the other hand, were reliable pets who did not talk.)

The last straw for Georgia in the 1925 summer was the arrival of Selma, within days of our departure, for a stay of three full weeks. Fortunately, Georgia was healthy again, exercising and at work in her studio. Fortunately, too, Selma had brought her wispy maid to serve her breakfast in bed, and the limousine and chauffeur (provided by another long-devoted admirer) to drive her to "indispensable" golf, luncheon, and tea dates at the clubs to which she belonged, and to swims at the family dock. On most days, Georgia was subjected to her presence only at dinner. Nevertheless, the air was redolent both of Sel's sulfurous scalp treatments and her scented bath powder, and every day she made new demands on the household: extra linens, ice water for her bedside, blankets, a less worn rug, the prettier desk that had been moved to another room. She was insatiable. Alfred's customary message to friends (and his propitiatory offering to jealous gods) that there was "Peace on the Hill," seemed peculiarly inapt in 1925—in which, uncharacteristically, he had failed to dramatize widely his own ailments, including the painful but gratifying passage of a kidney stone in June. To one correspondent, however, he confided grimly that the summer had been "slashed to pieces."

Even without the aggravations of illness and the family invasion in 1925, Georgia's tolerance for Lake George in summer was weakening. In August the humidity and dead-calm air, often as bad as the city's, were relieved only by brilliant and dangerous thunderstorms; earlier and later in the season, the small-scale mountains and intimate views Alfred had loved since childhood became, in full leaf, increasingly suffocating to her. (I would begin to have a similar reaction in my midteens.) For a few years still, she would feel invigorated by the fall's early briskness, the spectacular foliage, the crackling northern lights, and in late November, with naked trees punctuating a broadened vista of snow-same hills, she could recapture briefly the sense of spaciousness she endlessly craved. But her nostalgia for her beloved Texas, and even for a New Mexico seen too quickly in 1916 but vivid still—their vast horizons, unimpeded winds, crisp air, and skies limitless but paradoxically almost touchable—was intensifying. She longed to show that country to Alfred. For a while she had thought a modest cabin on the Maine coast might expand him; there, despite the fogs she found depressing, the restless sea stretched the eye and gales quickened the pulse. Failing to budge him even that far, she had suggested more than once a tiny house at the crest of their own hill, but by 1925 it was too late: Lee's bungalow sat on the very site.

Alfred's perpetual argument that lack of funds made a move impossible was valid only to a point. The truth was that he was wedded to the nest, to the Hill that had been his refuge since the 1890s and to the lake at which the family had vacationed since the mid-1870s; until he was physically unable, his camera would continue sensitively to explore this little landscape. The Farmhouse she found unwieldy and confining afforded him exactly what he wanted: a plenitude of bedrooms (some mere cells), in which to tuck visitors; a modest upstairs room for himself near the communal bath; a downstairs study off-limits to cleaners; a porch from which to monitor comings and goings. Better still, flanking the kitchen and pantry, and the small bedroom and bath of Hedwig's last summers, the widely joined dining and living rooms, hugged by a hospitable veranda, were open to the constant traffic he had enjoyed since childhood. Across the drive, a former potting shed had been converted in 1922 into his very first private darkroom. He had everything. Most of all, notwithstanding his claims of indifference to them, he had his family, inextricably tied to the same landscape.

That linkage afforded Georgia benefits as well as punishments, as she learned between 1920 and 1928, first during solo escapes to friends in Maine and, the year before her first stay in New Mexico, while she visited family in Wisconsin. Although her near-annual departures thereafter would make Alfred miserable, and his family angry (including several she designated friends), the very strength of their ties to him, which she deplored, enabled her to leave. She knew that they could be relied on to fill any gaps in her plans for his care, for however long she chose to stay away.

Georgia could not have anticipated how significantly Alfred's life would change with the December 1925 opening of his new showcase in New York, the Intimate Gallery—the first exhibition space he could call his own since the closing of 291 in 1917—but she began at once to establish her distance from its daily operation. She had seen Alfred previously under a full head of entrepreneurial steam in only seven isolated periods of two or three weeks each during the past four years, when he had presided over the shows he mounted at the Anderson Galleries of his works, hers, and of the leading Americans in his 291 group; now he was going full-time. Clearly, he warmed to the spotlight she fled, embracing the audience drawn daily to his avalanche of words; spellbinding to others, the monologues had grown wearisome to her. Her escape from him in this persona, as well as from the gallery, became essential.

A fair portion of the "contradictory nonsense" Georgia later reported having had to endure from Alfred sprang surely from the dichotomy within him be-

tween his intellectual commitment to giving her freedom to work unhindered and his emotional need to deny it. (She seldom mentioned counterpart conflicts within herself.) Even as he clung to her emotionally, intellectually he endorsed all her moves for autonomy, including her eventual half-year absences. He supported her right to remain "Miss O'Keeffe" and shared her anger when she was addressed as "Mrs. Stieglitz." He defended passionately her artistic parity with men, a "feminist" position that, in the context of the period, was deemed outrageously radical. In 1925, recognizing the primacy of her art, he agreed without demur to her choice of two small rooms for them in a midtown residential hotel where, free of housekeeping, she could paint; their location on the Shelton's thirtieth floor gave her a commanding view of the East River *and* the north light she needed. Inconsistently, however, at Lake George—where, in fact, she did most of her painting—he continued to enjoy the perception of her as principal hausfrau, and himself as benevolent helpmate, during the periods when they were alone or hosting friends at the Farmhouse.

Georgia's later complaint about the time-consuming work she was forced to do at the Intimate Gallery until 1929, and thereafter at An American Place, conjures up images of a stockroom gofer, day after day lugging heavy framed canvases. In fact, other than occasional sessions with Alfred spent in reviewing together the work each had done, her gallery responsibilities added up to an average of one full week a season—one day to hang each of three to five shows, always with assistance (a task in which, exercising perfectly a sense of both the discreteness of a single painting and its interplay with others, she achieved repeatedly a subtle and exciting balance I have never seen duplicated elsewhere) and, at An American Place, one additional day to mix the exact frosty gray she insisted the building painters apply annually to the walls. Her appearances at the gallery were otherwise rare.

The penalty she paid for skirting Alfred's six-days-a-week eight-hour discourse (with time out, at the Intimate Gallery, for prescribed hours of silence) was the near-daily arrivals, starting in early 1926, of a new listener more attentive than she had ever been. Dorothy Norman, eighteen years Georgia's junior, was so taken with the wisdom she heard dispensed so freely that she began to keep notes. At first her innocent devotion seemed innocuous, even amusing, and O'Keeffe took reports of her regular appearances in stride. Gradually, however, the perception grew that she was a potential, and then an actual, rival for Alfred's affections. He, imagining that he had found in Dorothy a talent for words equivalent to Georgia's for painting, was beguiled, attracted, and finally

infatuated. His reciprocation of her intensity would have dire consequences for his relationship with Georgia.

Uncommunicative about the depth of her hurt (as she would be always, in contrast to Alfred, who wore his bleeding or jubilant heart for all to see), Georgia first took her wounds to Wisconsin in 1928 to gain perspective and to give him time to ponder. Their reconciliation was idyllic but, in mid-September, he suffered his first major heart attack, an event that added a new dimension to their problems. Probably she had already begun, involuntarily, to feel repulsed somewhat by his aging body; now, nursing him with her sister Ida, she realized full force how much more dependent on her he would become—a fear he shared, with sympathy for her as well as pity for himself. Intermittently over the next decade he would suffer frightening, but seldom serious, attacks of angina, from which he recuperated sometimes within days. In 1938, however, a major coronary changed his life. Discounting a few "snapshots" taken with a "dinky" camera borrowed from Lee's visiting secretary (whose own casual photos of him with Georgia form a rare document of their relationship), Alfred's photographing days were over. Although for a while he turned out superb reprints of earlier negatives, his art had lost its momentum; Georgia's now took on more importance to him, increasing her sense of confinement. After recuperating at Lake George from a period of exhaustion in 1939, she never returned for another summer; for half of every year thereafter until Alfred's death in 1946, New Mexico was her home. Meanwhile, her allies in the Stieglitz family, of whom few remained, were forced to realize, with Alfred, that she could not be contained.

O'Keeffe's relationship with the rest of the family started to come apart seriously in 1929 when she accepted for herself an invitation to summer at Mabel Dodge Luhan's Taos ranch, which Alfred, forbidden its high altitude (and disinclined anyway to go) had turned down. The family was not unsympathetic to her wish to be away from him, even though she did not enunciate her feelings about Dorothy Norman's ascendancy; Stieglitz wives were accustomed to the syndrome. Had she headed for Europe for the traditional six-week family cure for the doldrums that was culturally uplifting as well, they would have thought her sensible—but a full summer in the desert? Such a choice could only be regarded as self-indulgent neglect of a husband who, surely guilty less of infidelity than of susceptibility, was after all aging, ailing, and dear.

Most of the family had thought Georgia a little strange from the beginning. Disconcerted by her seeming indifference to her appearance, by the strong will they felt she expressed too freely, they were also more than a little conde-

scending toward her Midwest "farm-girl" upbringing—and positively shocked that she showed neither respect for nor curiosity about the European culture they found de rigueur for civilized people. Thus, it was not surprising that some of them felt empathy for Dorothy Norman, whose origins and values more nearly resembled their own. Alfred was surely foolish for taking up with someone so young, but with the soulful dark eyes and soft features of Hedwig, she was a far less alien creature than Georgia; no doubt her adoration was as restful to him as it was flattering. Others in the family, however, found it incomprehensible that he should have fallen for her. They would greet skeptically Alfred's rationalizations about helping Dorothy's talents to bloom and would wonder how large a part her increasing usefulness at the new gallery, An American Place, played in his infatuation, in money as well as time.

His rationalizations, epic and circuitous, were familiar to everyone who knew him well. Those who have described Alfred as basically intellectual and O'Keeffe, by contrast, as intuitive, have erred. In fact, he worried issues to tatters, acted intuitively, rationalized his decisions, and then started to worry all over again. Constantly seeking self-understanding, he was constantly misled—and far more self-deluding than Georgia, who, while acknowledging inconsistencies, acted usually without forethought or regret, and seldom wasted effort on rehashings.

Among the more bizarre rationalizations of Alfred's entire creative repertoire were those surrounding his 1932 summer campaign to persuade Georgia to become Dorothy's friend. His imagination doubtless pictured them as sisters in talent, contentedly sharing his affections while he helped each to reach her full artistic potential—in the course of which they would absolve him of any sense of guilt. He enlisted three visiting writer friends in this absurd enterprise, enjoining them to come up with acceptable strategies. I can still see Ralph Flint, Cary Ross, and Fred Ringel grimly climbing the back fields and roosting like crows atop a sand cliff. One, foolishly seeking the aid of Georgia Engelhard, succeeded only in having her spill the beans to O'Keeffe. Thereafter, whenever the two Georgias saw the lugubrious trio set off (they dubbed them the "Happiness Boys"), they collapsed in laughter. Soon to leave on a joint painting expedition in the Gaspé, both women failed to realize that O'Keeffe, continuing to bottle up her pain over Norman, was on the verge of the breakdown that would strike her in December.

She would be out of commission for over a year, during which Alfred—shocked into realizing that his love for her was paramount, and overwhelmed

with remorse—tempered his feelings for Dorothy to a platonic level acceptable to him, and to her, but never to O'Keeffe. At Lake George in the 1933 summer, he stood watchdog over Georgia's recovery, allowing only Lee, Elizabeth, and Donald to visit her briefly in the household run smoothly by Margaret Prosser. In 1934, recognizing that their relationship hung in the balance of a mutual trust, and that Georgia's health as well as her art depended on annual revitalization in the Southwest, he sent her on her way. The decision was generous, morally correct, and intellectually gratifying. Its implementation, however, would always be painful.

In this matter, his siblings were worse than useless. Where previously they had criticized Georgia only for neglecting him, and them, at the lake, they now railed against her for deserting him. (Selma was cruel enough to suggest, echoing Alfred's own private fears, that she was just looking for younger company; Alfred had turned seventy in January, and Georgia was not yet forty-seven.) In the face of his siblings' nagging empathy, he vacillated between wallowing in self-pity and furiously defending Georgia's rights and needs. They would not budge from their harsh judgment, which was surprisingly almost unanimous, even among those who had been her allies; they now became the hard family of O'Keeffe's later recollections. She, in turn, with few exceptions—Georgia Engelhard, Selma's son and his wife, and the Davidsons (Donald when she wanted his help, and Elizabeth, once in a while, when she sought vestigial reassurance)—wrote off the family, constructing a New York life with Alfred in which she no longer felt obliged to see them more than once or twice a season. Soon too, although she still arranged weekly gatherings of Alfred's old gallery friends, she pursued an increasingly independent social life. She tended generously to his physical needs and was perhaps more considerate of his feelings than she had been often in the past—becoming, indeed, almost motherly—but each year she withdrew a little more from emotional engagement with him.

It is doubtful that he was as successful as she in ridding himself of the jealousy that was common to them both, despite grandiose pronouncements of its absence, but gradually he too experienced the peace of true accommodation. In his last years, the trust that had been the cornerstone of their early relationship, the profound respect for each other's art, and character, erased a great deal of the pain their passions and self-absorptions had inflicted on each other. O'Keeffe wrote her critic friend, Henry McBride, in the 1940s, "I see Alfred as an old man that I am very fond of—growing older . . . Aside from my fondness for him personally I feel that he has been very important to something that has

made my world for me—I like it that I can make him feel that I have hold of his hand to steady him as he goes on."

The picture evokes in a minor key the idyllic isolation of their early years together, when they worked in tandem through long autumns at Lake George. It omits what she sought always to expunge from consciousness: people, especially his family. Irritating, disruptive, and subsidiary they may have been, but they had also provided the basic security that freed Georgia to concentrate on her art. Like them or not, they had been Alfred's—and her—constantly renewable resource.

O'Keeffe, Stieglitz, and the
Stieglitz Family

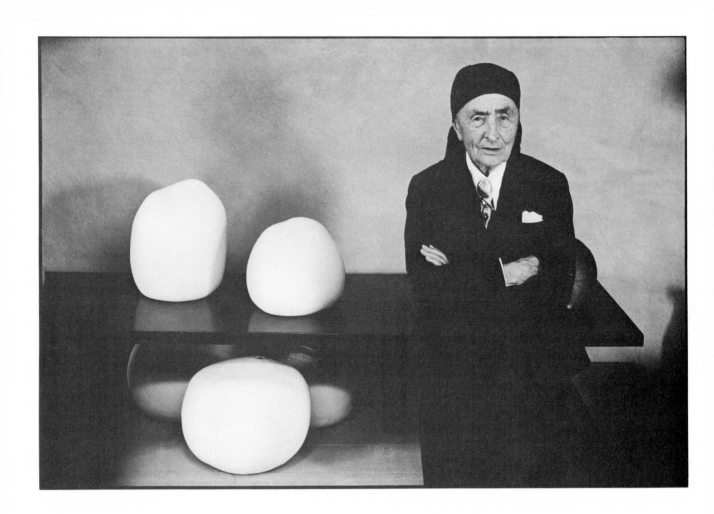

O'Keeffe

An Inspirational Life

Alan Cheuse

Certain kinds of paintings have always intrigued me—American paintings of the Hudson River school out of the nineteenth century when artists depicted the great Emersonian space of nature as a kind of amphitheater broad enough and high enough to hold our national (and nationalistic) ambitions, and in our own century the work of western painters, particularly the work of Georgia O'Keeffe. Here were canvases that allowed the dreamy national mind the kind of interior space in which to ruminate on broad plans for destiny while at the same time allowing the spirit of the viewer to stretch itself toward a level of beauty commensurate with that design. In O'Keeffe I saw the necessary elements of the representational—the equivalent in novelistic fiction of story—wedded to the visionary passions that take ordinary reality and transform it into shapes and forms that shimmer beyond the edge of the everyday, making the raw stuff of nature into something that hints of permanence. These images, most of the best of them western, or rooted in our western landscape, became emblematic to me of the American idea—that of the ever-receding frontier and the struggle to keep life vital and values whole in the face of this.

But these are ideas and abstractions. Novels begin with characters and scenes. *The Light Possessed* began for me with an image—that of an old woman standing straight and staring off into the western sky, a stick or paintbrush in hand, a barn behind her, a figure of fortitude and mystery, an ancient mother. Who was she? The novelist wants to know as much as the reader eventually seeks to find. As it turned out, she was an aging artist named Ava Boldin, born in the Sand Hills of Nebraska, educated at the Art Institute of Chicago, em-

ployed as an art teacher in Charleston and then in west Texas before she married a successful New York photographer nearly twice her age, and became the central figure in an art world populated mainly by men and Boys. The parallels to the life of Georgia O'Keeffe are there for those who know the latter's chronology. Not Charleston but Charlottesville, not Nebraska but Wisconsin. But similar.

Yet I wasn't out to write either fictionalized biography or a biographical novel. I'd already done the latter, in my novel based on the life of journalist John Reed—*The Bohemians*. Just as any novel has characters who are composites of many people the writer knows and some he attempts to invent, *The Light Possessed* has a central figure—Ava Boldin—who is a composite of many women I know, have read about, and imagined, many of them painters, many of them geniuses, all of them struggling, all of them each in her own way fascinating. So this is not a novel *based on* the life of O'Keeffe but *inspired by* it, a book that I think of as my "artist" novel. In *The Bohemians*, I have my novel of politics and adventure, in *The Grandmothers' Club* a novel about family and society. So this one is my "artist" book, one in which I have tried to make a picture of reality that allows the reader to live through the life of a woman and a painter whose vision is both specific and at the same time emblematic of the American artist's life—and the American woman's.

To write a novel is to wrestle with nearly insurmountable problems, and each novel offers its own difficulties. In *The Light Possessed* the problem was to depict the life of a painter in such a way as to give the feel and vision of her work on canvas. The major aesthetic problem involved in this is the representation of one medium by another. The danger, as with program music, is to become too literal, to merely describe the work she makes and not attempt to allow the reader to construct it finally in his or her own imagination. Another problem connected to this is the seeming paradox of depicting a spatial form—painting—in a temporal form—narrative fiction. In the extreme we do find paintings with "narratives" contained within them (as in, say, the mythological canvases of Poussin) and narratives that evolve in "space" rather than time (or so that is their fictive premise), the major example here being *Ulysses*. I have attempted to modify elements of both extremes and use them toward the end of making Ava's life and work come to life for the reader.

Moreover, I have tried to depict her life in such a way as to make the drama give the feel and essence of her work. First, I have employed multiple narrators; and second, I have told the story in such a way that the reader moves back and forth in time—from the origins of Ava's family life and her birth on through her demise in one time-stream that is punctuated by the appearance between major sections of what I call "door" narratives: the frame of the novel in

which the art student Amy Cross, companion of Ava's amanuensis Michael Gillen, who is the son born out of wedlock to Stieglitz and the family maid in upstate New York, sifts through the materials of Ava's life. The effect, I hope, is that of a palimpsest, in which one painting is constructed over the remains of a previous canvas, concluding with the coincidence of the two time-streams toward the end of the story.

Painting—and story-telling, the making of narrative—becomes for me a metaphor for recollection and memory, an image of time itself, as events become overlaid in our mind one on the other, and the mind bears the scars of time and shows forth age and growth as the rings in the boles of great trees. The stories of our lives and the histories of our communities once seemed linear—now we know how much of the living past is contained within the cells of memory. The past exists as a mental activity and is thus overlaid beneath the constantly growing series of moments we call the present. In this way I believe that time and space belong, as some physicists say, more to a continuum than to discrete realms.

The lyrical element in fiction, which I find myself emphasizing in this book in many places, particularly toward the end, dramatizes this paradox of time-as-space, space-as-time (which Robert Boldin, Ava's geologist brother, expresses in terms of his theory of geographic plates as a metaphor for time periods). The lyrical has always been categorized as belonging to the moment, the epic as belonging to evolving time or the linear sense of development. If the space—time continuum has anything to suggest for fiction, it may be that we should begin to notice the way in which the lyric moment, resonating (as Poe makes us see both by means of his epigraph with the image of the resonating note of the lute and the unfolding of the monophonic story itself in "The Fall of the House of Usher") throughout a long narrative, marks each phase of what seems to be a linear narrative with the essence of the first moments.

All this is only the vehicle for what is, I hope, the electric shimmering story of a haunted girl, half an orphan, who discovers that she possesses a huge gift, the talent for showing others that the light of the world shines forth as much from within our bodies as from without. And the source of all light, the light of creation, both in terms of physics and theology, may have to be regarded in the same way.

Ava is an artist, Ava is a woman, Ava is a creature of flesh and blood, Ava is an angel—Ava is an American painter who from the first seeks to portray the light of her world as no one has done it before her, so that the rest of us can see.

(In the following excerpt from *The Light Possessed,* Ava arrives in New Mexico for the first time, in the company of her lifelong friend, Charlestonian Har-

riet Perera, teacher, pianist, poet, and they are met by Mabel Dodge, and Ava's geologist brother, Robert Boldin. Harriet is the narrator.)

"Oh! Oh! Look at the clouds! Look! Look! Poor Stig!" Ava said as we climbed down from the train in Albuquerque. I was tasting the oddly flavored air while Ava hopped about in a little dance among the baggage. "Stig!" she hollered. "You poor fool! You damned fool!"

Dark-eyed, dark-skinned men in dusty clothing hefted our suitcases.

"There!" Ava said, pointing toward a cloud of dust rising in the wake of a large black automobile roaring toward us.

"Here you are!" said the big-boned, red-faced woman in the large yellow sun hat as she stepped down from the passenger's seat. It was someone named Mabel Dodge, who had written to Ava saying that she would pick us up at the station after Robert Boldin had told her that we were coming. I knew this about her: that she was a pioneer woman in many ways and had come west to give herself room in which to live her life larger than she could comfortably in New York. Among her famous loves had been Jack Reed, who had died in Russia of typhus about a dozen-or-so years ago, and recently, or so we'd heard in New York, David Lawrence, the British writer. He had brought his German wife with him to this part of the country, who might not have enjoyed the spectacle of Mabel working her charms on the man. As I watched Mabel direct the handlers with our luggage, I noticed that she had very large charms, or could put them on if she so desired.

A man leaned out of the car window, and I could see that Mabel Dodge was currently employing her charms to good advantage. "This is my husband, Tony," she said to us.

Tony, his face as dark as old clay, moved his mouth in a smile, though his eyes did not waver. He was the living picture of an Indian chief in his prime.

"Hello, Tony," Ava said from where we stood on the pavement.

Silence.

"Hello, Tony," I said.

Silence.

"Darling?" Mabel spoke as if to a child or an animal she had trained.

"Welcome to my land," the man spoke at last. His eyes were large, beautiful black pools of emptiness. I watched him watch us, and when I wasn't watching him, I was watching Ava watch him. It was as though she had just turned her eyes on a large tree the likes of which she had never seen before, or a waterfall at the edge of a forest. Or—or—I couldn't find the words to describe it, the

way she stared at him. This was new to her—the air, the glow, the men, the sound of Tony's odd, uninflected voice on our ears—and new, very new to me. The only thing I found familiar was the way that watching her excited me.

We drove north out of Albuquerque and saw something of "Tony's land": the desert that fell straight away on either side of the narrow highway, the mountains—the Jemez, Mabel named them—to the west, the Sangre de Cristo range growing more and more visible to the north . . . and the great thunderclouds already gathering over both stretches of peaks. Tony's land included the sky. The sky seemed almost half the land, so close down did it bear upon us, and so broadly did it spread out above us. In the East if you see that much sky, as when, say, you're floating on your back just off our Isle of Palms, you don't truly look upon it; the sun makes it so bright that you have to blink and blink and quickly turn away. And when there is no sun, you see clouds only, or only parts of sky. Here you could stare at the sky all morning and not be blinded— the light, the sun was so distinctive.

We bumped along the bad road past Santa Fe at far too great a speed for the car—and for us, the passengers—but Mabel was in a hurry to get us settled before dinner, and the bad roads be damned. "Hurry, Tony," she said to her companion behind the wheel, "hurry it up—watch out for that rock!—here's the curve—hurry it up!" Tony remained silent, concentrating on the road that led northward into a vast blank space of sky.

Ava had grown up beneath such skies as these, though nothing, as she later assured me, as pure and empty all the time as this New Mexico space. But she at least knew something of what to expect. For myself I kept noticing how in this great dusty valley between the mountains and the horizon, you could put all of my home state and still have room left over for much of the ocean besides.

Ava seemed steady, quiet, as though she were imitating Tony the driver in his Indianness—but I couldn't help myself for pointing out, in counterpoint to Mabel's instructions to Tony, that rock formation, those mountains, that stretch of valley!

Here! We arrived! And then there was Robert waiting for us in the doorway, Robert, whose presence I had allowed myself to play hide and seek with during our long train trip.

Will we become something, he and I, or will we not? He looks at me and I look at him, I look away, and then look back to see him just looking away, and then I stare, and he comes back to looking at me. My head is spinning—all this space around us—this man here with us, when we repair to the patio to drink wine and stare at the land falling away on all sides.

"Why, it's as though . . ." I started to say.

O'Keeffe

167

"As though what?" Robert stared down at me with his pigeon-wing gray eyes.

"As though . . . I'm trying to find the words, Robert . . . as though the ocean off Charleston had evaporated and all that was left was the bottom of the sea. That's what it looks like to me out here."

"And we're the sea creatures," Mabel Dodge stepped up behind me. "Though the water's been gone so long, we're all dried out, not so wet and wriggling as you might imagine."

"We're the what?" Ava came over and touched a finger to my bare arm.

"Sea creatures," Mabel said.

"Sea?" Ava look puzzled.

"This was all once a great sea, a great ocean," her brother said. "Here where we stand."

"Even the peaks were underwater for a time," Mabel said. "That's what I like. An entire world underwater."

"And we've risen from beneath?" Ava asked. "We've come back from a world all drowned?"

"I like that idea," I said. "I feel that way sometimes."

"Do you really?"

Something crumpled inside me, as though she'd taken one of her small drawings on paper and crushed it in her fist—and then tossed it in the trash basket. I couldn't explain it myself, but my knees nearly went.

"Here," Robert said, taking me under the arm. "You look as though you can hardly hold up that glass. Too much traveling in one day; that can get to you. Too much train, too much car. I know. In my work I do too much of it myself."

"Yes, you do look a little tired," Ava said, staring at his hand on my arm.

"It's the altitude," he said. "I pay a price for coming here."

Ava touched his cheek in a fashion almost maternal. "Robert, I forgot about your heart. I shouldn't have, but I did."

By this time evening had descended, like some huge muslin curtain that had dropped quickly from above and caught us all with glasses in hand, still thinking about the light. A net of odors fell upon us as well, a mixture of dry wood that had soaked up sun all day, all season, and something like the memory of moisture, the last vestiges of recollection in the senses of the old sea that might have roiled here so many millions of years ago.

"A hundred eons, give or take a few million," was how Robert put it. "Some people think when I talk like this that it's godless, but geology makes you realize greater glory, if you consider it, the way it enlarges any notions of creation you might have. It makes you think big, so it makes God bigger."

"Have you been worrying about these things?" Ava said to him.

"When your heart worries you, you think about such matters," he said.

She touched his cheek again. "Are you having more trouble?"

"No more, no less than usual," he said.

Mabel and her husband floated up to us, moving quite lightly for two heavy creatures. She was a big woman, but Tony in his bulk made her seem, if not diminished, at least normal-sized. Her curiosity was not. "What are you discussing?" she asked.

"We're talking about geology and mortality," Robert said. "Such matters as that."

"Look up and you'll feel better," Mabel said. "The stars are coming out. You can't worry about mortality under a sky like this, not out here."

All of us turned our attention to where millions of gallons of light seemed to have spilled across the vast landscape of the sky at sunset. Silence weighted on us for an uncountable series of minutes; silence buoyed us up closer to these brilliant, unclouded heavens, where all the turbulent water in the old oceanbed below seemed to have found a luminescent second home.

Robert did not stay more than a few days with us before heading off on company business. "To the Jemez Mountains," he told us.

"He's always on the trail of some powerful fuel or other," Ava said as we waved our last good-byes and he drove away from the hacienda, south through town toward the main highway south. "I've always thought him as solid as the rocks he chases," she added. "Despite the trouble he's had with his heart."

"Yes, he seems so."

She had noticed something in my manner, and she wasn't about to let it go. "He is a good man," she said.

"Did I say that he wasn't?"

Ava shook her head. "No," she said, giving me a shy look.

I excused myself, turning quietly back to the house. With Mabel ensconced there, it was not a place to talk about anything one cared about. She was one of those people, artists without an art, who made it her business to be in charge of everything that came her way, on the excuse that she had a need to make a design of it all.

I got to think of him a lot that night after bedtime when I stole from my room and went out onto the patio and stood beneath a great cascade of stars— stars stars stars stars stars—a balcony of stars—more stars—wondering what was to become of me. For something had come over me, or left—it was difficult to describe the sensation of these past few weeks; meeting Robert and deciding to come: the two things compounded in my mind; and after we moved the next day to the small house high up the mountain where we would stay for the rest of our time here—admittedly, thanks to Mabel—Ava painting and me working on

my poems, I thought a great deal about my new condition. My premature change of life is what I'm referring to. There is not a lot of talk about this situation, though, unlike childbirth, which will always remain a mystery both to me and my friend Ava; it is something that all women will eventually know, no matter how they choose to live or how the world chooses for them. Remain alive and it will come to you—or should I say, it will steal from you the old feeling of knowing always since your girlhood who and what you are about.

Some morning I followed Ava's progress with my eyes from the house to the point where she disappeared behind the tall rocks to the east of us where she would spend the day at work, and before going in to sit at the little table with my paper in front of me, I wondered if everything I had done before was a prelude to what I had recently become—an aspiring poet and a woman in menopause—or if the life I had now entered was the coda to all my other days. The vast plain before us had been a seabed millions of years before, and I had been a girl in Charleston, a not-ungifted pianist with suitors at my door, and, I thought: Look at me now.

"This must be what a lobster feels like when he's being boiled for dinner," I said over our meal one night soon after.

"Don't demean yourself," Ava said. "Take courage. It's part of your life."

"Courage?" I took out one of the cigarettes I had borrowed from Mabel Dodge before we left for the mountain and smoked on through dinner, the first time I had ever done that.

"Does smoking help?" Ava asked.

"Don't you know anything about this?" I asked her.

Ava shrugged and offered me more salad, made of the greens which Mabel's mozo—a sort of handyman, janitor, and houseman—had plucked from the little garden he tended behind the main house. It had cheered us at first to see the inviting patch of green against the dry, clay-brown earth, a touch of the East against this blank western ground. I suppose that by this time I took for granted that someone out here would work to grow such familiar things, despite the hardship of a land where water was as precious as mother's milk in a nursery.

"I don't know, actually," she said, and shook her head. "I haven't gone through it yet, and if anything, I'm afraid my girlhood's coming back, now that we're west of the Rockies."

A thunderstorm lighted up the western sky after dinner. Ava and I stood out on the flat roof of our little house, careful not to damage any of the tiles, and watched the sharp white-yellow flashes of light, bright explosions that showed up the edges of clouds that might have been hundreds of miles long and five or six miles high, up to where they faded in the afterlight back into the night, where the stars used to be before the storm.

"What must it be like out there right now?" Ava asked.

"Out where?"

"Out in those mountains, under that storm. Great bolts of lightning so close, striking trees nearby? Can you smell the burning of the gases in the air? Hear the hiss of the clouds as they evaporate in the heat?"

"It would be quite frightening," I said. "Caught in that rain that must come with it."

"It would be like suddenly finding yourself underwater," she said. "Or in the heart of a sudden river."

"I don't know," I said.

"I'd love to find out," she said. "When I think how the colors might be, the storm from the inside, I wouldn't mind trying to find out."

I slept rather fitfully that night, with the storm rumbling hour upon hour. Once I sat up in what seemed like a dream, sudden utter stillness in the midst of the thundering, and imagined I saw Ava standing at the foot of my bed. Next I awoke to light—that was a dream, I know—and the next time back into the storm, with the night air around me in my room like water stirred by a stick, and sticking to me, too, as though it were more like makeup or paint than something we breathed. Taking myself to the window, I looked out upon the last traces of the storm, faint flashes of light where the road led out across the old oceanbed, spurts of light bursting faintly across the tops of mesas, those little mountains worn down as if by the gods pressing irons against them for eternity. If I had walked out into the surf off Sullivan's Island, might I have seen, if I descended far enough, scenes somewhat like this: underwater and atmosphere mirrors of each other, slightly off kilter in time?

The next time I awoke it was fully light, nearly seven o'clock, and I took my breakfast alone, Ava having already gone off to work out-of-doors. My body felt extremely heavy to me, and I walked through the first few minutes after breakfast as though dragging weights. A bath seemed in order, but I didn't yet know how to light the little charcoal heater that would prepare the water to my liking. I sat in the new sun for an hour or so, notebook on my lap. But nothing came. When I retreated inside, it took me a while to adjust my eyes to the interior shade. My mind, it appeared, couldn't adjust at all. For no reason I began to tremble and then I sat in tears for even longer than it took my eyes to become accustomed to the absence of direct sun. I tore myself from my chair and dashed outside again, getting as far as the edge of the patio, where I saw a lizard sunning itself on the tiles. It skittered away at my approach, and against all reason I once again burst into tears.

Lizard, lizard, lizard, lizard!

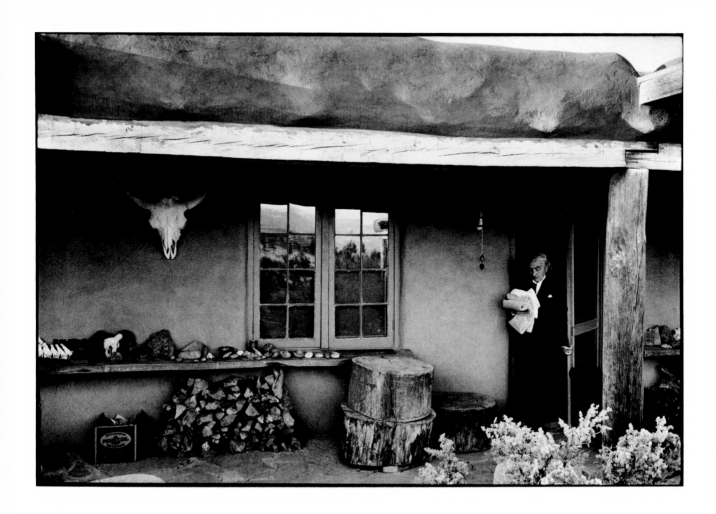

Of Blossoms & Bones

Christopher Buckley

I began to look at the work of Georgia O'Keeffe at the end of 1974 during my first year in the writing program at the University of California, Irvine. I was attracted to it by the images, by her use of light, by her very direct celebration of the world in its elemental parts. Subconsciously at least, I think the bones, trees, flowers, and hills among all that air and light, the cherishing of life that was implied in the paintings, appealed to some vision I had of the world that I had not as yet fully articulated to myself. I had no plan to write anything about O'Keeffe or her work, and for the next year or so her images and whatever themes I may have perceived just rolled around in my mind, underwater as it were.

However, after the publication of the Penguin/Viking book of her paintings and writing in 1976, *Georgia O'Keeffe,* I began to think about a poem that might take up her ideas and view of the world. I spent a good deal of my free time looking at reproductions of her work and rereading her own thoughts about it. I was fortunate to see a dozen or so paintings firsthand in various museums and traveling shows. After a while, her voice and vision began to seep into my mind, into that place that makes and orders images, that finds the lines for them. I had by that time written a handful of poems on other paintings and painters and so had some notions about ways to approach the general subject. For two summers running I promised myself I'd take a block of time, sit down and try a sequence of poems. But I was teaching part-time all of the time, sum- mers included, and I did not come up with that block of time; I did not even make notes—ideas just floated around in the back of my mind. Finally, in the summer of 1979, after I had moved to Fresno, I had two weeks free before the

fall semester began, and I sat down to work. In draft form, eleven poems came in a flash, like a dam breaking. A couple of weeks later, two more poems worked their way to the surface; I was working mainly from the Viking/Penguin book of 1976, which was really the first one to offer a significant group of reproductions and writing about her work. Soon, I had a group of thirteen. The poems were all written as monologues, as if O'Keeffe herself were speaking, and luckily, it did not occur to me that this might be monumentally presumptuous.

I had written a painting poem or two before as monologue, as the artist speaking, but always with some conscious choosing and maneuvering. These poems just *happened* this way. From first to last, the poems came out of my mind and typewriter as monologues, and I never questioned them or the voice. The poems I wrote on O'Keeffe's paintings, and on a famous photograph or two of her, were in fact not much like anything I had done before; they were shorter, more concentrated and imagistic. The rough drafts came in a rush, often two a day, sometimes three. I accepted the sound and the phrasing when it arrived. A little mystical, yes—but really, I was just so soaked in, absorbed with O'Keeffe, her world and voice, that the process was natural.

O'Keeffe was alive when I was writing most of the poems. After the initial burst, I wrote another ten poems over the next six years. I then wrote the last five or six poems, which brought the book up to thirty, after O'Keeffe's death. In 1980, after I moved back to Santa Barbara, I sent out a manuscript of thirteen poems to a small, letter press publisher in Minnesota who accepted it. Each year thereafter, when the chapbook was not published due to a new excuse, I added a poem or two as I encountered paintings I had not seen before or ones I had looked at but not really "seen." By the time I moved to Pennsylvania in 1987 the manuscript was close to book length. I traveled to Washington, D.C., to see the retrospective show, and seeing that much work firsthand provided new energy and ideas, and I wrote another handful of poems, which brought the manuscript up to book length. I withdrew it from the small press, figuring seven years was enough time to do something if they really wanted to, and then submitted the complete manuscript to Vanderbilt University Press, which had published my third collection of poems. They took it and it was published in 1988. The first printing of *Blossoms & Bones* sold out in about nine months, and so it was lucky for me that the small press never acted. I do not flatter myself too much, however. O'Keeffe was so popular in the late eighties (and still into the nineties) that I used to joke you could sell sand in a can as long as her name

was on it. I have always suspected that there were people who bought a copy of my book, with its beautiful reproduction of O'Keeffe's *Cow's Skull with Calico Roses* (1931) on the cover, who were surprised to find poems inside when they got home and looked through it. My concern at the time was that I not look like someone trying to "cash in" on O'Keeffe's recent popularity. I had been working on my modest project for about ten years.

I have a preface, a disclaimer really, in the beginning of that book which explains my methods and concerns:

This collection of poems is homage, not homily. I am not attempting to speak for Georgia O'Keeffe, nor am I trying to define her work in an absolute academic or aesthetic way. In my opinion, too many have made that mistake over the years.

These poems are written as monologues, and in that sense they do assume O'Keeffe's voice. . . . I found this the most natural way to write the poems. It would be going too far to say that O'Keeffe's actual voice, the texture and vision of her life and work, entered my conscious or subconscious mind as I wrote. But I do not think a person can spend a long time looking at her art and thinking about it and not be, to some degree, favorably influenced by how she saw the world, how she phrased her perceptions in art or in words.[1]

The monologue seemed the only "true" way to write, a risky way to be sure, but the only one in which the poems would have some immediate power and range and a chance of not sounding pretentious. And so the poems also became persona poems, and the combined methods gave the voice a bit more authority and hence latitude for my speculations about her subjects and concepts. I tried to bring the emotional and conceptual center of the poems to a resolution that was not only true to my own feelings but true to O'Keeffe's avowed ideas, her biography, and her painterly details. Although whatever I have said using this poetic device is finally only my own take on O'Keeffe's images, I hope the affinity I felt with her view of things was close and accurate enough to do her no great disservice.

Her paintings celebrate life—a life made beautiful by individual fortitudes, but by its wonder and uncertainty as well, by its shining reductions. She found vitality in everything from desert bones to skyscrapers in New York. She had a practical cast, one that found value in the earth and praised the strength of the

natural and human spirits as they endured. I wrote my own poems doing the best I could to continue to see what she was showing us, using my own words to say what the images, in part, might add up to.

The three new poems I offer here were written in the early spring of 1990, three years after I wrote the last poems that went into the Vanderbilt book. I had been looking at some of the paintings from that new book, *Georgia O'Keeffe: In The West*; I think we are all grateful for a look at more of the paintings. I was especially taken with *Spring* (1948) and *The Beyond* (1972), her last painting. Along with the painting *Pelvis IV* (1944), they still held for me the wonder and mystery, the mystical assemblage and light that O'Keeffe's best work has always held. That same voice entered my mind one night just before sleep, *before* dream. I wrote down some notes for one poem and the next day drafted the three poems; and when the poems came, they came in that quiet meditative rush, just as if some voice were in fact entering me, or at least as if I were listening to some real voice. In the following weeks, I reshaped them, focusing on the idea and feeling of "last things," as seemed appropriate for "The Beyond" especially. I listened to that voice, lived with those images, and tried again to find the forms for that particular wondering about the earth and what might lie beyond it.

Spring

What to tell you now
 of everything
I've come to here?
 First and last I am
given to this light,
 its scenarios and silver wash
pulled down and
 threaded among the fabrics of Spring—
then the sky
 which frames my thinking like water settled

through sand,
 and air that has backbones breaking away in their lines
like wings
 left over from another life. . . .
 But I'm not here to argue
against the blue, that usual view of time
 riding the flat distance out, light
less and far beyond the Pedernal.
 I only have the pilgrim's burning hope
which carries me year to year
 until I stand in the consuming sun with images
of a world re-made
 whirling through my hands again, and the day-mists lifting
all this space
 its weightlessness, in its high, white, primrose bloom. . . .

Pelvis IV

Close up, far away,
what could be
clearer than this
equivalency
of earth to sky—
brace that held
something heavy up,
now a flower-white
form for air, a stem
with the watery petals
of the sky working
through.
 And these
shapes let us slip
away—two-toned

Of Blossoms & Bones

and half-absent with
the light of the earth
released and yet over-
whelming in our bones?
When dreaming off
into space sometimes,
I can put it right—
allow my thoughts
to be airborne
like the cloudy
layers of the soul.
like a spare new language—
circle upon circle,
a circle within
which plays out
at arms' length, and,
as the heart takes in
its recoveries and its loss,
is also breathtaking—
as for example,
just for once,
this smoke-blue moon . . .

The Beyond (last, unfinished painting)

I rarely paint anything I don't know very well. Nothing is more simple,

just as when I've been flying, time and history straighten out and fade

into the flat edge of the planet below. Any time I'm up there, it's a study

of basic things: the rim of space squares-off absolutely above the earth

which is black, which I'm finally done with, and which I'm content to leave

as pure abstraction as it may have always been. There's the sky-window blue

beyond, the swirl and sea-clouded residue of our thought risen bright and

breathing, then a darker blue. A crepuscular lift of light skims the middle

ground, some vanishing point. I would one time have given a rusty hue, a blood-

tincture, but now I know better. A white horizon—bone—clear and cutting through—

is left unfinished, unknown—it was what I wanted to say about all this anyway.

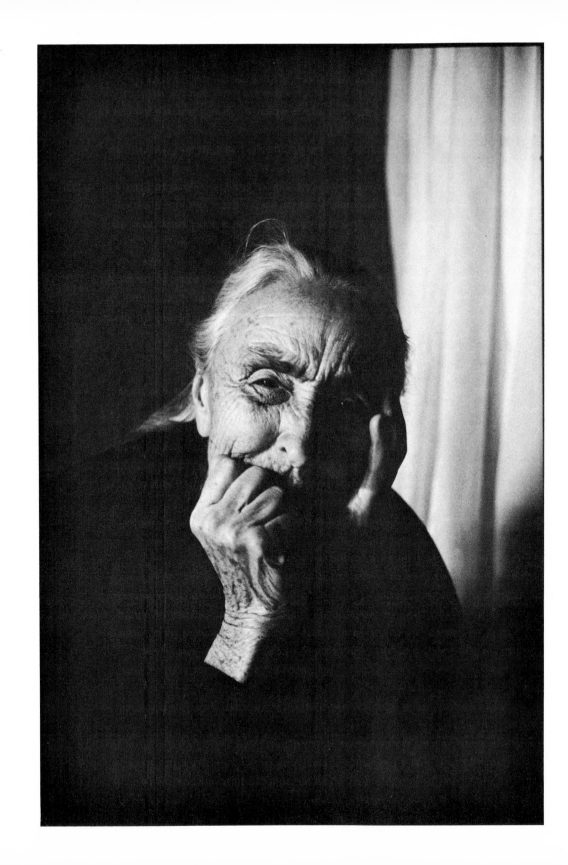

In Cahoots with Coyoté

Terry Tempest Williams

Rumor has it, Georgia O'Keeffe was walking in the desert, her long black skirt swept the sand. She could smell bones. With palette and paintbrush in hand, she walked west to find them.

It was high noon, hot, but O'Keeffe would not be deterred. She walked down arroyos and up steep slopes; her instincts were her guide. Ravens cavorted above her, following this black-clothed creature through the maze of juniper and sage.

Suddenly, O'Keeffe stopped. She saw bones. She also saw Coyoté and hid behind a pinyon.

Coyoté's yellow eyes burned like flames as he danced around the cow carcass with a femur in each hand. His lasso made of barbed wire had brought the bovine down. Maggots, beetles, and buzzards had miraculously cleaned the bones. The skull glistened. Coyoté had succeeded once again. He had stripped the desert of another sacred cow.

Georgia stepped forward. Coyoté stopped dancing. They struck a deal. She would agree not to expose him as the scoundrel he was, keeping his desert secrets safe, if he promised to save her bones—bleached bones. Stones—smooth, black stones would also do. And so, for the price of secrecy, anonymity, and just plain fun—O'Keeffe and Coyoté became friends. Good friends. Through the years, he brought her bones and stones and Georgia O'Keeffe kept her word. She never painted Coyoté. Instead, she embodied him.

Eliot Porter knew O'Keeffe as Trickster. It is a well-known story. I heard it from the photographer himself at a dinner party in Salt Lake City.

Mr. Porter told of traveling with Georgia into Glen Canyon, how much she loved the slick rock walls, and the hours she spent scouring the edges of the riverbed in search of stones.

"She was obsessed," he said, "very particular in what stones she would keep. They had to speak to her."

He paused. Grinned.

"But I was the one that found the perfectly black, perfectly round, perfectly smooth stone. I showed it to Georgia. She was furious that it was in my hands, instead of hers. This stone not only spoke to her, it cried out and echoed off redrock walls!"

Porter smiled deviously.

"I didn't give it to her. I kept it for myself, saying it would be a gift for my wife, Aline."

"A few months later," Mr. Porter continued, "we invited Georgia to our home in Tesuque for Thanksgiving dinner. Aline and I knew how much Georgia loved that stone. We also knew her well enough to suspect she had not forgotten about it. And so we conducted an experiment. We set the black stone on our coffee table. O'Keeffe entered the room. Her eyes caught the stone. We disappeared into the kitchen to prepare the food, and when we returned, the stone was gone. Georgia said nothing. I said nothing. Neither did Aline. The next time I saw my black smooth stone, it was in a photograph in *Life* magazine taken by John Loengard, in the palm of O'Keeffe's hand."

Georgia O'Keeffe had the ability to trick the public, as well as her friends. She seduced critics with her flowers arousing sexual suspicion.

Well—I made you take time to look at what I saw and when you took
time to really notice my flower you hung all your own associations with
flowers on my flower and you write about my flower as if I think and see
what you think and see of the flower—and I don't.[1]

She transformed desert landscapes into emotional ones, using color and form to startle the senses. Scale belonged to the landscape of the imagination. When asked by friends if these places really existed, O'Keeffe responded with her usual candor, "I simply paint what I see."

What O'Keeffe saw was what O'Keeffe felt—in her own bones. Her brush strokes remind us again and again, nothing is as it appears: roads that seem to stand in the air like charmed snakes; a pelvis bone that becomes a gateway to the sky; another that is rendered like an angel; and "music translated into something for the eye."

O'Keeffe's eye caught other nuances besides the artistic. She was a woman painter among men. Although she resisted the call of gender separation and in

many ways embodied an androgynous soul, she was not without political savvy and humor on the subject:

When I arrived at Lake George I painted a horse's skull—then another horse's skull and then another horse's skull. After that came a cow's skull on blue. In my Amarillo days cows had been so much a part of the country I couldn't think without them. As I was working I thought of the city men I had been seeing in the East. They talked so often of writing the Great American Novel—the Great American Play—the Great American Poetry. I am not sure that they aspired to the Great American Painting. Cezanne was so much in the air that I think the Great American Painting didn't even seem a possible dream.

I knew cattle country—I was quite excited over our own country and I knew that at the time almost any one of those great minds would have been living in Europe if it had been possible for them. They didn't even want to live in New York—how was the Great American Thing going to happen? So as I painted along on my cow's skull on blue I thought to myself, "I'll make it an American painting. They will not think it great with the red stripes down the sides—Red, White and Blue—but they will notice it."[2]

Georgia O'Keeffe had things to do in her own country and she knew it. She would bring the wanderlust men home, even to her beloved Southwest, by tricking them once again, into seeing the world her way, through bold color and the integrity of organic form. O'Keeffe's clarity would become the American art scene's confusion. The art of perception is deception—a lesson Coyoté knows well.

Perhaps the beginning of O'Keeffe's communion with Coyoté began in Canyon, Texas. The year was 1916, the place Palo Duro. The art critic Dan Flores explains, "What Georgia O'Keeffe found in the Texas Panhandle was the American Southwest in all its sweep and atmosphere, simplicity of line and visceral power. Palo Duro Canyon, in particular prepared her for what would become her lifelong love and artistic inspiration—the deserts and mesas of New Mexico."[3] O'Keeffe saw the cut in the earth called Palo Duro as "a burning, seething cauldron, almost like a blast furnace full of dramatic light and color."

Her pilgrimages to the canyon were frequent, often with her sister Claudia. "Saturdays, right after breakfast we often drove the twenty miles to the Palo Duro Canyon. It was colorful—like a small Grand Canyon, but most of it only a mile wide. It was a place where few people went. . . . It was quiet down in the canyon. We saw the wind and snow blow across the slit in the plains as if the slit didn't exist." She goes on to say:

The only paths were narrow, winding cow paths. There were sharp, high edges between long, soft earth banks so steep that you couldn't see the bottom. They made the canyon seem very deep. We took different paths from the edge so that we could climb down in new places. We sometimes had to go down together holding to a horizontal stick to keep one another from falling. It was usually very dry, and it was a lone place. We never met anyone there. Often as we were leaving, we would see a long line of cattle like black lace against the sunset sky.[4]

Painting No. 21, *Palo Duro Canyon* (1916), celebrates an earth on fire, an artist's soul response to the dance of heat waves in the desert and the embrace one feels when standing at the bottom of a canyon with steep slopes of scree rising upward to touch a cobalt sky. It is as though O'Keeffe is standing with all her passion inside a red-hot circle with everything around her in motion.

And it is not without fear. O'Keeffe writes, "I'm frightened all the time . . . scared to death. But I've never let it stop me. Never!"

Once, after descending into a side canyon to look closely at the striations in the rock that resembled the multicolored petticoats of Spanish dancers, Georgia could contain herself no longer. She howled. Her companions, worried sick that she might have fallen, called to her to inquire about her safety. She was fine. Her response, "I can't help it—it's all so beautiful!"

I believe Coyoté howled back.

O'Keeffe's watercolor *Canyon with Crows* (1917) creates a heartfelt wash of "her spiritual home," a country that elicits participation. The two crows (I believe they are ravens) flying above the green, blue, and magenta canyon are enjoying the same perspective of the desert below as the artist did while painting. O'Keeffe is the raven, uplifted and free from the urban life she left behind.

I had forgotten about Georgia O'Keeffe's roots in Palo Duro Canyon. I was traveling to Amarillo, Texas, for the first time in June 1988 to speak to a group of Mormons about the spirituality of nature. A woman in charge of the conference asked if I had any special needs.

"Just one—" I replied. "We need to be outside."

What had originally been conceived as an indoor seminar was transformed into a camping trip. One hundred Mormons and I descended into Palo Duro Canyon in a rainstorm.

The country was familiar to me. It was more than reminiscent of my homeland. Certainly, the canyons of southern Utah are sisters to Palo Duro, but it was something else, a déjà vu, of sorts.

Cows hung on the red hillside between junipers and mesquite. I saw three new birds—a scaled quail, a golden-fronted woodpecker, and wild turkeys.

Other birds were old friends: roadrunner, turkey vulture, scissor-tailed fly-catcher, and wren. Burrowing owls stood their ground as mockingbirds threw their voices down canyon, imitating every other. It was a feathered landscape.

The Lighthouse, Spanish Dancers, and Sad Monkey Train were all land-marks of place. The bentonite hills were banded in ochre and mauve. Strange caves within the fickle rock looked like dark eyes in the desert, tears streaming from the rain.

We crossed three washes with a foot of water flowing through. Markers indicated that five feet was not unusual. Flash floods were frequent.

Mesquite had been brought in for a campfire. Food was being prepared. The rain stopped. The land dried quickly. A group of us sat on a hillside and watched the sun sink into the plains—a sun, large, round, and orange in a lavender sky.

At dusk I knelt in the brown clay, dried and cracked, and rubbed it between my hands—a healing balm. Desert music of mourning doves and crickets began. Two ravens flew above the canyon. I looked up and suddenly remembered O'Keeffe. This was her country. Her watercolor *Canyon with Crows* came back to me. It was an animated canvas. I wondered if Georgia had knelt where I was, rubbing the same clay over her hands and arms as I was, some seventy years ago?

It was time for the fireside.

I stood in front of the burning mesquite with chalked arms and my Book of Mormon in hand. If I quoted a scripture first, whatever followed would be legitimate. This was important. The Priesthood holders, men, had inquired about my status in the church. When I replied, "Naturalist," they were not comforted.

I opened my scriptures and spoke of the earth, the desert, how nature mirrors our own. I began to read from the Doctrine and Covenants, section 88, verse 44—"And the Lord spoke . . ."—when all at once, a pack of coyotes behind the rocks burst forth in a chorus of howls.

God's dogs, O'Keeffe's pals.

I was so overcome with delight, at the perfectness of this moment, I forgot all religious protocol and joined them. Throwing back my head, I howled, too—and invited the congregation to do likewise—which they did. Mormons and coyotes, united together, in a desert howl-lelujah chorus!

I said, "Amen." Silence was resumed and the fireside ended.

That night, we slept under stars. I overheard a conversation between two women.

"Mary Lou, did you think that was a little weird tonight?"

"I don't know, Sue Ellen, howling with the coyotes just seemed like the natural thing to do!"

In Cahoots with Coyoté

185

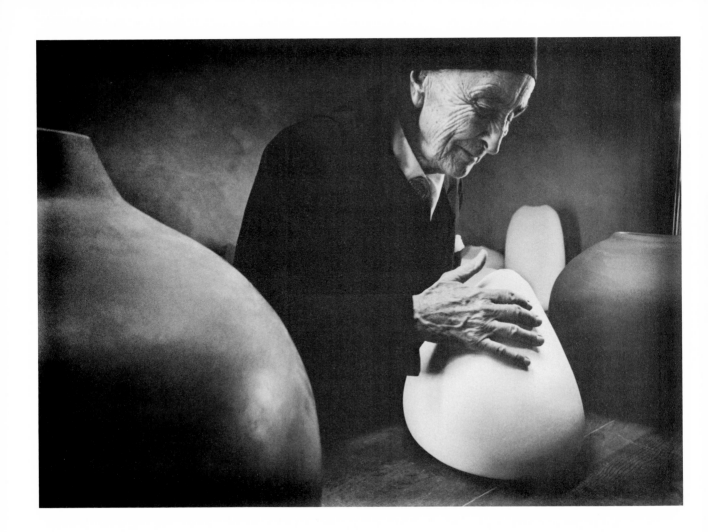

Georgia O'Keeffe as a Role Model

Meridel Rubenstein

Camille Claudel, the infuriating film about the great French sculptress who was also Rodin's mistress, made me realize that Georgia O'Keeffe was the first woman artist I was introduced to as a young woman who didn't go mad, kill herself, or disappear from sight or history. Claudel was driven mad and put away, like Virginia Woolf, Sylvia Plath, Diane Arbus—women whose biographies I read twenty years ago, just out of college, trying to make sense of my desire to find my own voice and commit myself to the life of an artist.

1973 was my first year in New Mexico and my first year of graduate school at the University of New Mexico. In the M.F.A. photography program I found myself surrounded by young men who, for the most part, had lovely, supportive wives or girlfriends, seemed not to lack confidence in their chosen profession, and mirrored the attitudes and appearances of our professors, all of whom were men. I, on the other hand, felt very alone. My decision to be an artist seemed perilous. I remember the chill I felt when one of my professors swiftly dismissed the budding career of a young woman, saying "Oh, marriage ruined her." Well, it hasn't: she's gone on to become a highly successful curator.

I searched restlessly for role models. I began a difficult research project on women photographers from the turn of the century; in a more liberal time— between world wars—they had taken part in a rash of "women's photography" exhibitions on the East Coast and in Europe. They had all been forgotten. Their imagery was disappointing—pictorialist in nature, children and women holding glass balls and parasols in white romantic light. Several of these photographers, however, were ambitious: Jessie Tarbox Beals, Alice Austen, Francis Benjamin

Johnston, in particular—three women who led colorful, independent lives, but whose imagery didn't excite me. Still, I planned to write my M.F.A. dissertation on them.

My own dear teacher, Beaumont Newhall, whose seminal *History of Photography* had included only a few women, was very encouraging about my project. (He's since added more women to his *History*.) At the same time, for his seminar on Stieglitz I decided to write a paper on Stieglitz and O'Keeffe. Using only the three available texts, Doris Bry's *Stieglitz* (1965), Doris Bry and Lloyd Goodrich's *O'Keeffe* (1970), and Dorothy Norman's *Stieglitz: An American Seer* (1973), I made a simple study of their imagery and lives. Gripped by their imagery, I was also struggling with a terrible image I carried of myself as an artist working completely alone, denied entry into the art world of men and the domestic world of women. My little paper helped me refute that image, brazenly challenging the idea of Stieglitz's discovery and promotion of O'Keeffe by demonstrating her profound influence not only on his imagery but also on his entire way of working. To many, O'Keeffe was still seen as Stieglitz's creation.

Nancy Newhall, a successful writer and curator, was Beaumont's professional partner as well as his wife; and when he showed her my paper, she invited me over to her house, where she encouraged me to pursue it further. She herself was a talented photographer who seemed to have put her gift on the back burner in order to work with her husband, and I felt her inability to put her own art and writing first gnawed at her. I left Albuquerque for the summer, with much to think about.

That had been my first year of art school. I needed a model. I had a highly idealized image of O'Keeffe—a strong woman artist whose husband didn't leave her out of envy, competition, or desire for a more domestic and secure life. Indeed, Stieglitz saw her as his equal. And what she showed me was the necessity at critical points in one's development of breaking away and going it alone. She had done this three times—gone away. I too could last a little longer in New Mexico—alone. I had pictures to make, a dissertation to write, myself to find.

Back on the East Coast, however, my resolve wavered. Offered a huge sum of money (by some charming, aloof men) to transfer to Yale, where I would be closer to my nineteenth-century lady photographers, family, material comfort, and security, I grew indecisive—like O'Keeffe, as I've since learned, in similar situations. I was almost lost. The tragic and sudden death of Nancy Newhall did little to shake me out of my blithering self-doubt. She had encouraged me to return to New Mexico and take a good, hard, unsentimental look at O'Keeffe and Stieglitz; that summer, in fact, she had sent O'Keeffe a copy of my paper.

The news of Nancy's death prompted O'Keeffe to read my paper. She had a note sent to me in Vermont, thanking me and inviting me to come to tea. Weeks of indecision, tears, and angst suddenly vanished. I packed my belongings and went back to New Mexico, not to be a researcher of other women photographers but to make my own images. I knew a larger study of O'Keeffe and Stieglitz would show me how.

Every artist I know has these moments—torn between an easier way out and getting down to the real business of staring oneself, one's own work, in the face. It can produce illness, mental or physical. Both O'Keeffe and Stieglitz experienced much illness—the kind self-doubt can produce. Camille Claudel let herself be committed; Virginia Woolf and Sylvia Plath just got tired of doubting. If we're lucky, at these moments the decision to serve one's true self wins out over the needs and demands of some other part of one's being. O'Keeffe was in touch with that part of herself when she left art school, when she went to Texas to teach, and when she started coming to New Mexico. Beyond the fantasy of the apocryphal O'Keeffe stories, it's possible to discern the real O'Keeffe, a woman torn between internal and external worlds, dividing her time, juggling her career, relationships, spiritual sources—like any artist. Understanding this has been invaluable to me, especially during my own periods of self-doubt.

By the time I had tea with O'Keeffe the following year, I was well into making my own images and researching my dissertation: I was hesitant to meet her. I had done my homework in the great libraries and museums on the East Coast—Yale's Beinecke Library, the Boston Museum of Fine Arts, the Metropolitan Museum of Art, the Museum of Modern Art, the Whitney Museum of American Art, the Brooklyn Museum, the National Gallery of Art, and the Phillips Collection. I wanted to see every image I could. Determined to rid myself of sentimentality and personal need regarding my subject(s), I wanted to show in an objective manner image by image, decade by decade, how these artists had influenced each other's work. My dissertation, *The Circles and the Symmetry: The Reciprocal Influence of Georgia O'Keeffe and Alfred Stieglitz,* would be a study of the two artists at work, borrowing from each other, recycling each other's ideas, trading places—conceptually speaking—later in life.

I needed to see the work. O'Keeffe's big monograph was in its beginning stages. Everywhere I went, if I was even allowed to see the work, I wasn't allowed to reproduce it. I was given the impression that Miss O'Keeffe would have been furious if she knew I was gazing at her portrait, trying to see her paintings and Stieglitz's photographs. By the time I met her, I had read everything about them—except their own inaccessible correspondence. I felt I knew

her, and I worried she might disappoint my image of her. I feared she would be displeased to learn I had gained entry to see her work—worse yet, that she would be furious to know I was planning to write an even larger piece about her. I was terrified.

She just wanted to thank me.

"This is your time," she said. "I've saved it for you."

She thought that since I was a photographer, I would want to hear mainly about Stieglitz, not her. She wanted to know all about my research—what it was like to see the images I had seen. "Were there lots of people at the National Gallery?" she asked. Then: What did I think of her portrait?

I had to tell her no one had been there: only serious scholars were allowed in to see the work, and they couldn't write about it, nor could they reproduce the images.

For the first time in her life O'Keeffe was managing her own career. Her new monograph was about to come out, and she wanted to show me the text she was writing, the eight-by-ten-inch transparencies of the paintings that would be included in it. "Wouldn't your research be easier," she said, "if you just used my notebooks of copy prints? Every painting I've ever done is in them, in *chronological order*." I was welcome to come back and study them; she wanted me to bring my recipe for the banana bread I had given her.

Almost blind, she sat with me looking at the transparencies, able to recognize each one. I thought her freest works were the early watercolors on brown paper she did in Texas, before she met Stieglitz. When I asked her about the uniqueness of that period, she said, "I was singular then. I didn't have to worry about what was in." I asked her why she stopped? When she got to New York, she said, people would buy her fancy watercolor paper so expensive it intimidated her; in Texas she had used whatever she could find to start her fires. Now we know it was Stieglitz furnishing her with paper that got in her way.

She was relaxed, talkative, unpretentious. I mustered up the courage to tell her some of my "theories." She dismissed each one with a laugh. "Do you remember 1924?" I asked. "Oh, I can't remember names and dates," she said. "Well, that was the year you and Stieglitz stayed through the fall at Lake George. You'd had shows together at the Anderson Galleries, you were both beginning to receive major recognition, museum acquisitions and sales, positive reviews. You began to paint the enlarged flowers, and then you got married." I didn't tell her that fall was the first and perhaps only time in all their years together, according to Stieglitz's letters to friends everywhere, when illness or exhaustion weren't problems, when both artists were working at full capacity—at

the same time. But what seemed to me an intensely rich and significant time in her life meant nothing to O'Keeffe.

Sitting in her Abiquiu studio twenty-six years after she had closed Stieglitz's last gallery, An American Place, I could still see in her room qualities of light and order that had influenced his galleries. She dissolved my fantasy of her charmed life: not only did she hang all the shows in his galleries, but she also designed the frames, painted the walls, chose the colors. I understood how difficult his constant talk had been for her; I hadn't realized the toll it and all the critics' words had taken on her choice of imagery. Strangely, when she first went to New Mexico, she told Mabel Dodge Luhan she left New York for Stieglitz's sake: "I know many people love Stieglitz and need what he has to give. I feel I have two jobs—my own work—and helping him function his way—and I don't want to get in his way. That is why I came out here." As for the critics? As she wrote to Luhan: "I thought you could write something about me that men can't—what I want written I do not know—I have no definite idea of what it should be—but, a woman who has lived many things and who sees lines and colors as an expression of living, might say something a man can't. I feel there is something unexplored about women that only a woman can explore. Men have done all they can do about it."

It had taken her three years to settle Stieglitz's estate and close the gallery. The boys, as she called his circle, wanted her to keep it open to continue showing them. For the last show there she hung the gallery with her own work and then left permanently for New Mexico. And that was where I met her, wrote about her, and learned to dispel the notion—both for myself and others—that it is dangerous to be a woman artist—alone or in a relationship.

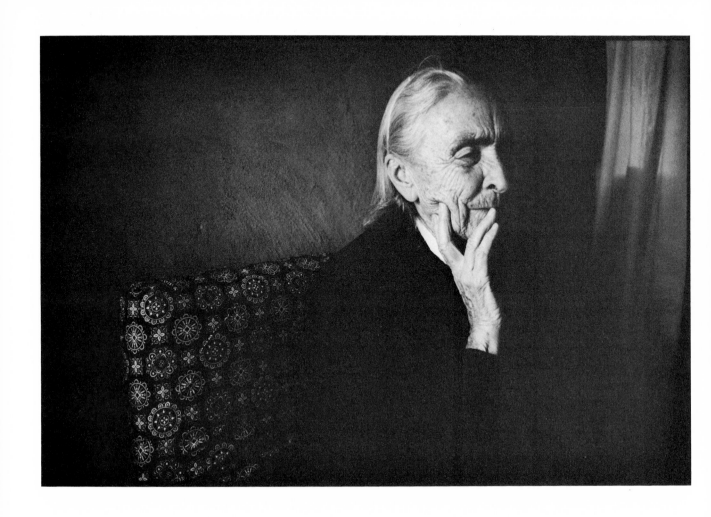

Painting with Georgia O'Keeffe

John D. Poling

In the summer of 1976 I began painting with Georgia O'Keeffe. We completed one painting that summer in the *Patio Door* series and, the following fall, completed the first two paintings in the *Day with Juan* series. To my knowledge, these are the first and only documented instances of O'Keeffe's collaboration with another person in her career as a painter.

Many of my memories from that time are clear and fresh. Others are less defined, and I have reconstructed conversations from words and phrases. This little piece makes no claim to completeness; it has no special status. The picture here offered is excerpted from a longer memoir setting out the shape of my relationship with O'Keeffe over roughly a two-year period, from 1975 to 1977, and what her world was like. For a brief time I was part of that world.

My introduction to O'Keeffe goes hand-in-hand with my introduction to northern New Mexico. I moved to Barranco, near the village of Abiquiu where O'Keeffe resided, late in the summer of 1975, with two desires in mind: one was to live in the country; the other was to walk the land. O'Keeffe knew that country well, and I have included descriptions, necessary ones, of the area around Abiquiu. Take away the people, few though they are, and one is left alone with land whose beauty is almost unbearable.

These pages are written in acknowledgement of a debt to O'Keeffe. Undoubtedly she was a teacher of mine, though not only in the trivial sense that she taught me some of the rudiments of oil painting. O'Keeffe was an individual; her world reflected the kind of intention that goes into constituting a self. That range of matters that goes into forming a life often is something shown to

another, but never said or stated directly. O'Keeffe's life was ordered, things had their place. But everything, from a remark in conversation to the food she ate, was done deliberately.

A debt to a teacher is an odd thing. If the teacher has taught the student well, the student becomes autodidactic; hence, the diminishing significance of the teacher, and, one would think, the alleviation of the debt. I have returned too often to the time to feel any lessening in what I owe her. What I have taken is the raw material for reflection; the task has been to shape and make sense of it. The constancy to her passions and pursuits makes for twin accomplishments limning O'Keeffe's life. One is personal, the other artistic/aesthetic.

The second accomplishment, slightly more formal and not dealt with here, has to do with her reflections on her painting. Throughout her life, in remarks at once spare, dogmatic, and cryptic, O'Keeffe denounced critics who construed her work as mere symbols standing in need of interpretation. She thought such interpretations misunderstood not only her painting but something altogether deeper in the arts. I remember reading to her over several afternoons from a Ph.D. dissertation by a woman. The subject was O'Keeffe's paintings, and the key to understanding them derived from some kind of psychosexual analysis. O'Keeffe not only thought the approach wrong but also thought it "nonsense" to fill one's head with ideas having nothing to do with painting.

Drawing, in addition to these clues, on remarks written by herself or recorded by others, I think O'Keeffe, far from asserting something quixotic and invidiously privatistic, pointed to a range of permissibilities either violated or overlooked by the majority of her critics. Quite rightly, O'Keeffe realized she could not, in a very strong sense of "could," state the meaning of a painting. There was a logical limit on what could be said. The interpretations she contested were not, in fact, interpretations, or even misinterpretations, at all. Her refusal to "state the meaning" of a painting was indicative of an attitude forced upon her by a grasp of practices appropriate to an understanding of painting.

What remains vivid to me is the force of her personality, what I previously called her "personal" accomplishment. Action, reflection on what one is and would like to become, repetition, habit, consistency in wanting, and more, all added up to something, an individual existence well rooted in patterns of living. A variety of concerns, and the activities supporting them, had been held in place over a period of time: a love of solitude and the Southwest; a preoccupation with health, nutrition, and food preparation; an attention to the arrangement and furnishing of her homes; and, of course, a realization in painting of her own inspi-

rations. Walking into O'Keeffe's world was to walk into a way of life long established.

In this way O'Keeffe is a model, an example, of sorts, pointing past herself in virtue of what she presented. She points past herself in the sense that her personal achievements transpired, for her as for us, in the realm of wants, needs, deep emotions and passions, interests, talents, responsibilities, and the like. There is no access to that realm without the presence of O'Keeffe. Without the pattern of a life lived according to this range of considerations, her counsel would have been vacuous. Literally, her words would not have hooked up with anything.

O'Keeffe showed me something indirectly, something simple, though no less defying; namely, that each person has the capacity to put her or his life together in a way that stands up to her or his own reflection. It was as if O'Keeffe saw life and living as an occasion for all kinds of possibilities. A person could do almost anything, she said, talking to me as though everything she had accomplished I could accomplish also. She did not mean "accomplishments" in terms of wealth or belongings, though she was surrounded by that, too. Nor was she suggesting that being an artist was intrinsically better than pursuing other occupations. There was a "how" involved in going about one's work just as important as the nature of one's work. No, something more fundamental was pointed to, like a satisfaction with what one did, and that one's life could bear its own weight. First, one had to grow accustomed to the thought that one's deepest needs could become possibilities and, finally, achievements.

O'Keeffe counseled a kind of courageous and go-ahead-and-try attitude. For someone twenty-four years old, somewhat confused about the direction and shape of his own life, her interest was welcome, her presence formidable. Not surprisingly, her example and counsel ring true many years later.

Perhaps, then, it is not so much a debt to be acknowledged as it is thanks to be given. It is in this spirit that these pages are passed on to those who will find them useful.

My decision to move to Barranco arose in part from a preoccupation with the direction of my life. During a visit to my sister and her husband in the Abiquiu area, I met Mary Grether, then O'Keeffe's nighttime companion and cook, who was living in Barranco. She told me the house next to hers was coming up for rent at fifty dollars a month. This seemed the opportunity I was seeking.

My formal introduction into O'Keeffe's world came through Juan Hamilton, then her combination secretary-business manager-confidant-companion.

Juan was acquainted with my sister and her husband, who rented an old adobe he had once lived in. One day when I was at their house, Juan stopped by. His visit was short. We were introduced to each other, and he invited me to see the work he was doing on his home.

Some days later, exploring the environs of Barranco, I arrived at his house. He was rebuilding most of it, adding a large back room and a second floor. On another visit Juan asked whether I would like to work for him along with his friend Ted.

I worked one- or two-week stretches much of the fall at Juan's. The periods fell into chunks like that for a variety of reasons: sometimes Juan could not be there, or Ted was gone, or supplies did not arrive, or the next step in building was unclear, or I wanted to go hiking. I peeled vigas he and Ted had felled in the forest, mixed mud for adobe mortar, helped lay adobes. The days were perfect. Week after week of blue sky and sun shone over us. Far below along the Chama River the cottonwoods changed to yellow. I was grateful to Juan for the work, and I remember thanking him.

In the spring of 1976, I met Juan while driving to Bode's, the general store in Abiquiu. He rolled down his window and mentioned something to the effect that O'Keeffe wanted the trim on her Ghost Ranch house painted—would I be interested? I was. The following afternoon, Juan came to my house. The Ghost Ranch job, he estimated, would last over the summer. In addition, he had some projects he wanted done at his home. He also asked whether I would housesit for him—he thought he would spend most of the summer in New York, overseeing the printing of color plates of O'Keeffe's paintings for her book by Viking Press. Before he left for New York, Juan said, he would take me to the Ghost Ranch house so I could get some idea of the extent of the project.

One cloudy afternoon Juan and I drove to the Ranch, where O'Keeffe was living that summer. The trim on the house was in terrible shape. All the windows needed attention. As we walked around the perimeter, Juan pulled off large chunks of dried putty. The large garage door also needed work. He pointed out minor repairs—rotting wood and trim on doors or above windows—to be done before painting. He said I could expect O'Keeffe to ask me to help her with various chores; I was to drop whatever I was doing to assist her.

A few days after Juan left, O'Keeffe began asking me daily to help her with small tasks, to read out loud her mail or from a book. Her eyesight was bad, and she could not perform tasks requiring keen vision. However, because she knew where everything was in her house—chairs, tables, what should be in this

closet or that drawer—it sometimes seemed as if she saw much better than she did.

One morning as I was priming the outside trim, Mary Grether came out and said O'Keeffe needed my help. I followed Mary into the studio, but not until I had wrapped the paintbrush in a cloth dampened with thinner. I never knew how long I would be away. O'Keeffe and Mary were looking at a white canvas, around four feet by six feet, resting on an easel.

"We put a coat of primer on this several days ago. Mary says the white isn't even." I, too, noticed inconsistencies in the white primer coat: the cream-colored canvas bled through the paint in many places. O'Keeffe gestured toward the canvas. Her left hand rested in typical fashion, upside down on her hip.

"The primer *must* be even. Do you think you can put on another thin coat? Have you ever painted before?"

I never had except for a paint-by-number set when I was very young and what I was doing outside.

"Then you never have painted," she said, smiling. She and Mary showed me the paint, gum turpentine, assorted containers, brushes, palette knives, and mixing tools. Mary left to attend to other duties.

O'Keeffe directed me to a worktable. Some primer was already mixed in a wide, low can, like a two-pound coffee can cut in two.

"Take some of the lead white and squeeze it in there. You must be careful not to get too much of it on you. It used to have lead in it. Some of these tubes are quite old." I squeezed out a quarter of a tube.

"Now, take one of these sticks here and stir it. We'll have to add some turpentine."

She leaned over the worktable; found, by its shape, a tall cylinder of turpentine; and moved it slowly toward the mixing can. Then, entirely by feel, she gently poured two quick splashes of turpentine into the paint.

"There. Now try that."

I stirred the mixture slowly. The consistency she wanted was not very thick; it was only an undercoat to cover the canvas. At one point, she took the stick in hand, testing the thickness of the paint by feeling its resistance against the stick. When she was satisfied the primer was ready, she told me to apply it with a large brush. I put the brush in the paint, then began to apply it to the canvas. I asked her how thick the coat should be.

"Those patches have to be covered. You don't want bare canvas showing through." I continued to ask her questions, simple ones about how long the

paint took to dry, how soon one could paint over it, whether she primed a number of canvases in advance, and so on.

After fifteen minutes she left, saying I should come get her when I finished.

The primer was to dry over the weekend. When I drove to the ranch Monday morning, I learned O'Keeffe and Mary had been fussing with the canvas. They invited me into the studio.

"I want to draw a line with charcoal along the top here." There was a yardstick and some twine nearby.

"How far down do you want it?" I asked.

"Oh, I think something like this." Her hand casually suggested a ten- or twelve-inch width from the top.

I measured several marks with the yardstick at regular intervals and then, with a small piece of charcoal, lightly drew a line across the top of the canvas. I did not know what kind of painting she had in her head; I do not think she wanted me to know at that time, either. She moved close to the line, trying to gauge the width of the band and get a sense of its relation to the rest of the canvas. She seemed satisfied.

"Now, what this needs is some blue along the top. Just a long blue band." Again she waved her hand in the direction of the canvas. Her eyes held mine as though I should appreciate this information. She turned away from the canvas to the worktable. "Mary and I have some paints out on the table." There were many small boxes which held tubes of paint; some were open. Several tubes of blue were clustered together.

"I want the blue, the cerulean blue," she said, emphasizing the "ru" in "cerulean." "There's a glass plate and some palette knives there. Squeeze some out on the glass and stir it up."

I squeezed out coils of cerulean paint. Then she asked for one of the palette knives. She used it to flatten out the paint, pushing it around in circles until it was of a more uniform texture and consistency. After a few moments she handed me the knife and told me to do the same. Soon there was a thin layer of paint covering five or six inches of the glass.

She painted quickly, almost pushing the paint into the canvas. I watched quietly. After a few minutes I noticed something odd about her movements. On the one hand they looked authoritative and practiced. Her left hand rested on her hip, her right moved regularly from palette to canvas.

Yet there was something amiss, too. Bare patches of canvas were overlooked: it looked like she was painting patches of blue. She dipped the brush in the paint even when there was paint visible on the bristles. Sometimes she

painted the same small area twice, and paint would be thick and rough on the surface. Then she might continue several inches away, thinking she was where she had left off. Again and again she asked me how she was faring. The longer she painted—up to ten minutes—the greater the inconsistencies in application. I had an odd feeling: her brush movements should have produced something significantly different from what appeared on the canvas. I realized she must have made those movements by habit, from memory. Though her motions were sure and those of a master, she could not monitor or adjust them based on what came to her through her eyes. After several minutes she asked me how far she was from the charcoal line.

"I don't know if you want it this way or not, but the paint is very thick here"—I indicated a general area—"and there is white primer showing through over here," and pointed out some of the patchy spots. I was uncertain about saying anything.

"We can't have that." She tried to fix those areas, asking me whether she was in the right place. After a few minutes of my patiently pointing and explaining, she seemed to weary.

"I think you better do it," she sighed, looking at me almost wistfully. That was all she said. Her voice was tired, she sounded disappointed in a remote way, but the transition to reaccepting her state of affairs took only that long. The brush was in my hand; I was to start painting with the same readiness with which she had ceased.

Suddenly I had many questions. Just how thick did she want it? What about the top and sides, should they be painted too? What happened if you painted over the tacks holding the canvas on the stretcher? The paint did not cover the canvas easily or evenly. I became obsessed with the importance of a perfectly even application. The newness of the activity—not to mention undertaking it with her standing by—seemed overwhelming.

"The paint's a little thick here—should I just brush it around?"

"If it's too thick then you take a palette knife and scrape it off. That's all."

I tried that and was surprised how well it worked. As I painted she continued to stand next to me, watching in silence. I felt uneasy. I was aware of her accomplishment in painting, more so than when applying the coat of primer. But I continued, the blue gradually lengthening along the top. Periodically I stopped to mix more paint.

"Are you getting close to the line?" she asked.

I was, but I had avoided painting up to it. She went to the worktable and felt the ends of some smaller brushes. She brought me two or three, suggesting I try one. Painting to the line went much slower. She would ask me how it was

going and whether I liked the brush I was using, encouraging me to try any size I wanted.

When I had painted about a quarter of the way across the top of the canvas, O'Keeffe introduced me to a new brush and a new technique. The new brush was kept in its own box. She seemed to treasure it in particular, and when I began to use it, she told me to always handle it with great care and clean it thoroughly. It was a large, thick brush of a kind she said was not readily available; this one she'd had for many, many years. It was used only after paint had been applied.

Working almost solely from her sense of touch, she demonstrated how to gently brush the surface of the canvas to smooth out the ridges and rough texture of brush marks in the paint. This technique could also be used to soften transitions from one color to another. She stood with her back to me, her left hand inverted, resting on her hip, her right carefully executing the motions she wanted me to duplicate. Ever so gently she brushed the area I had painted, her arm moving from left to right, covering a three- to four-inch area each pass. It was as if she dusted the paint with air. I began to get the idea of it. It is very important, she said, to stop often and clean the brush so that paint does not build up on the bristles and make them stiff. She used a paper towel lightly moistened with gum turpentine to wipe off the paint; another towel was used to dry off the brush thoroughly. Later I added another step, brushing a clean towel to be sure there were no traces of paint left.

It was a painstaking and time-consuming task for an area or painting of any size, but she insisted on doing it this way, for it effected the kind of finish and texture she demanded. Several days later in the week I learned how one color could be drawn into another. This was done by placing the two colors to be blended side by side, one painted to the border of the other. Then a clean brush was used to roughly paint back and forth along the line, mixing the two. Finally, the large brush—what I called the "finishing" brush—gracefully accomplished a variety of gentle transformations in texture and shade, from one color, to an intermediate shade, to the second color.

That morning was exhilarating for both of us. I think she enjoyed it for two reasons. First, an idea she had for a painting was being realized on canvas. Even at this early stage, her face showed an enthusiasm and pleasure with the whole business surrounding painting; I had never seen this in her before. It was obvious she liked having the tools of painting around. Though initially she knew nothing about my ability to paint, at no point was it an obstacle for her. In fact, she wanted someone who had no painting experience prior to working

with her and, hence, had no ideas about how to paint. The second reason for her enjoyment was my enthusiasm. As I pushed and brushed the paint around the canvas, I began to see how wonderful painting could be—and I was only applying a single color! "How neat," I would blurt out, or, "Just look at that!" A long, bold swath of cerulean blue set off strikingly the white below. "No wonder you like painting so much," I said. To all these remarks she responded with a chuckle, delighting in my own untutored fervor.

When I had finished the band at the end of the day, we stood back from the canvas. There was not much to see but a brilliant, inviting contrast of white and blue.

"Well, that's something." Her eyes looked at me with evident satisfaction.

"Yes," I replied. "I *like* that."

What we had painted thus far was like the anticipation of some wonderful secret; it was as if O'Keeffe knew the secret and took pleasure in withholding it from me. Yet she knew that I would soon know what it was. And she assumed, rightly, that I would be equally pleased.

The next morning I went straight to the studio. O'Keeffe came in from her bedroom after I called out. Today, she said, we were going to draw a large square in the middle, again using charcoal and the yardstick. She and Mary had put out some tubes of yellow ocher paint.

Then, turning to the canvas, she said: "I think our blue looks quite fine, don't you?"

I agreed. "Maybe we should leave it as it is," I said. "It makes a great painting just like that." She chuckled.

Her concern that day was with the square in the center. She asked me how the light was, if I could see where we had the easel positioned. The canvas ran parallel to a short wall that ended by the door to the patio. The light coming into the room was direct at this early hour; it glanced off the surface of the canvas. From late morning on, most of the light in the studio was indirect; by the end of the day, it reflected off the towering sandstone cliffs several hundred feet in back of the house. I moved the canvas so that it angled slightly toward the fireplace. It was almost diagonal to the tall windows, the gray and yellow cliffs still in shadow out beyond.

I began experimenting with the size of the square that was drawn and redrawn several times. O'Keeffe's eyesight made it difficult to convey to her its precise position. I gestured with the yardstick or my arm, holding either one in place while she scrutinized its placement. If she wanted the top line of the

square, for instance, in a certain place, I would draw a light charcoal line. A paper tissue was used to brush away lines that had to be changed. O'Keeffe often came up to the canvas, one hand gently touching the surface as if her touch showed her what her eyes could not. The blue was easily visible—she could see that—but small, thin charcoal lines were not. She could not tell exactly where they ended, and the proportions were crucial. We managed though, and eventually settled on the size.

Before I mixed the paint, O'Keeffe asked me to check something about the color we would be using that day—yellow ocher—in a book on oil painting.[1] It was an old book, and contained a section describing the basic colors and noting the compatibility of their qualities and tones in relation to other colors.

When I finished, she said, as if to herself: "That's alright then." I did not know what her remark was directed to.

"I suppose you know about all these colors," I remarked, flipping through the pages of the book.

"Well, you have to. The first thing you learn is what colors go with other ones. You learn all that and get it out of the way so you can paint."

"So you learn the techniques first?" I asked.

She paused. "Well, *yes,*" she said, the emphasis conveying a kind of qualified agreement, as though there were other, unspoken considerations, as well.

I prepared a portion of paint on the glass palette, spreading and smoothing out the ridges with a palette knife. It looked anything but yellow and was more brown in substance. O'Keeffe wanted to try applying the paint around the square. She found a brush and loaded it with paint. She pushed paint into the canvas as much as brushed it across the surface. I told her what sections she was missing as she worked on the yellow ocher section. Some areas were too thick, so much so that the pattern made by the canvas underneath the paint was obscured. When I told her this, she tried to remedy it. Often her touch, though sure, was so light that a thick area or inconsistency remained.

As she came to the charcoal line marking off the square, I told her how many inches she was from its edge. Her motions quickly changed. She painted as if she were along a line, yet her uneven edge of paint was a good three or four inches from the line. After five minutes or so of painting like that, knowing that she was far from the mark, she said: "You can do it now."

I now realize I watched her come up against something vitally important to her and her painting: her eyesight. She was determined to paint again although her eyesight was failing. Yet, remarkably, she seemed to accept readily, even matter-of-factly, her shortcoming.

Not all of the ocher background was painted that day. The color was difficult to apply evenly. The brown seemed thin in some areas, and white primer showed through. In other places, the paint was too thick. I worked hard to apply an even coat, scraping off paint from thick areas that had been built up by either of us.

After I had done a small area, O'Keeffe suggested I use the big brush. The results, I was discovering, were dramatic. I imitated her motions with the brush, asking her as I painted what she wanted the area to look like. The brushed areas looked flatter, reflecting less "shine" than those yet untouched. Ridges and uneven areas were feathered into adjoining surfaces. I particularly enjoyed this part of painting. Using this brush, even on a single color, was an excellent, repetitive way to practice the technique. One's touch had to be deft and light, softly stroking the paint.

It was not until that day, when we drew the large square, that I recognized we were working on something similar to O'Keeffe's *Patio Door* paintings. An earlier one hung in her studio, on the other side of the half wall near her bedroom.[2] During the days we painted, I studied *White Patio with Red Door* (1960) for long periods. I eyed closely her brushwork to see how she feathered a color or shaded a hue; I noted the ways in which the primer coat was covered lightly to allow nuance; I studied her lines, comparing the close-up version to the effect produced at a distance. Then I would shift my vision to see the picture as a whole, as if seeing the painting for the first time, while bracketing those technical features from the artist's point of view. This was how I began to develop a feel for the relation between the activity of painting and the picture finally proposed to the viewer.

As we continued, O'Keeffe gave me a sense of what she wanted to achieve in an area or in the painting as a whole. My task was to effect this on canvas in any way I could, and she gave me the freedom to play with the painter's tools. The time spent alone, simply completing, for example, the background of a painting, allowed me to define my own ways of achieving both the effects observed in her paintings and those depicted verbally by her to me.

I learned to convey to her the way the texture of the canvas showed through the paint, and how quickly or slowly one color moved into another. These were ways of gauging what she wanted. She compared the descriptive information I gave with the knowledge embedded in her memory. Painting with someone was new to her. She was forced to rethink her techniques and convey them to me so I could realize the picture, and idea, she wanted. We developed a constant give-and-take. I asked questions and described what I saw; she made

suggestions. But she always had an air of "Let's try this" or "Just go ahead and do it."

O'Keeffe was a patient teacher. Many of my anxieties dissolved in the relaxed manner in which she taught me. She never seemed to tire of my questions. Her explanations and manner made painting immediately accessible to me. It was, however, hard work. I wanted to achieve perfection. This was, in large part, self-imposed, a feature of my personality, but it also stemmed from the quality of O'Keeffe's work and my desire to please her.

Painting was the appropriate opportunity for me to begin relaxing around O'Keeffe; it provided the ideal activity as a focus for both of us. From the outset she wanted my opinions and input. Her ideas were conveyed sparingly. The great looseness in her manner freed me to make mistakes and offer suggestions, to correct them and start over again. If there is a single way to characterize the mood of working with O'Keeffe, it is one combining her accommodating temperament, the casual ease of her instruction, and the tacit air of companionship, with her willingness to experiment and to allow me to interpret her directions.

None of this could have transpired without the time spent together in the previous weeks. To paint with O'Keeffe required more than a minimum facility with one's hands or primitive artistic sensibilities. There had to be compatibilities on another level, it seemed, ones made apparent and predictable by the time we painted. The simple tasks done with her were the means of becoming acquainted, of exchanging likes and dislikes, and ultimately of becoming her friend. Not surprisingly, painting gave me access to a side of O'Keeffe seldom shared with anyone else; the activity presupposed the companionship of the previous weeks and suddenly compressed the time usually traversed in getting to know another person. The more I was with O'Keeffe and melded into her world, the more removed we were from the traditional employer–employee relationship that first characterized our time together. The rapidity and depth of change that summer were remarkable.

The morning was the best time to work. O'Keeffe was brighter and more energetic then than later in the day, although she sat most of the morning while I painted. Lunch and a rest period followed. Then we would resume at two or two-thirty, working until five-thirty or six. She wanted to proceed steadily once something began to take shape. By the end of the day I was exhausted. I welcomed the offer for dinner, and we sat quietly, both tired but satisfied.

O'Keeffe often stood beside me when I painted. If I seemed to be going along all right—that is, if I asked few questions—she usually sat to the side and

slightly behind me. We talked regularly, though our conversation reflected O'Keeffe's economy of words. Other times, O'Keeffe sat outside on the patio, reclining on a padded chair under the cool overhang, a light wrap covering her legs. From the patio she could see Pedernal, a flat-topped mountain whose presence even at a distance seems to draw to itself the surrounding country. She rested, preoccupied with her thoughts. Sometimes I found her sitting in the small eating area off the kitchen. A banco ran along the wall, covered with a pad and assorted cushions and pillows. There she sat, a small table before her, facing two large picture windows. The cliffs loomed large through the north window, red hills and the ranch road disappearing through the window looking east.

She remarked to me more than once, "I always had such good eyes, such good vision." Her fingers would come together as if reaching for a detail or some small object, or showing me a very fine point in the air. Her eyes squinted. "I could see great distances," the "great" gently inflected.

One day, after sketching with a small piece of charcoal, perhaps a half inch long by an eighth of an inch thick, I set it down on a black table, an all-purpose work area. I noted where I placed the charcoal, next to some papers, because it otherwise could have been easily lost to sight. O'Keeffe and I had been talking about lines on the canvas. I asked her what she could see. She turned to the picture windows, toward the cliffs and Mesa Montosa rising high above them. Large shapes she could make out: she could see, she said, where the rocks ended and the blue began. Her hand suggested the line through the glass. She turned toward the canvas: she could sometimes make out the charcoal lines, she said, but not clearly or easily. Then she moved toward the black table, scanning its surface. Suddenly and unerringly she picked up the piece of charcoal! I was surprised.

"It's like there are little holes in my vision," she said. "I can't see straight on very well. But around the edge there are little holes where I can see quite clearly."

The next day O'Keeffe wanted to bring the yellow ocher close to the bottom of the canvas. Later, she said, we would draw in small rectangles or steps along the bottom; for now, it was enough to leave room for them. The paint still looked uneven to me. I went over some of the areas where the yellow ocher was thin.

"This should be very red here." O'Keeffe pointed to the center square. "We can start by mixing some orange, yellow, and red."

The color I mixed wasn't right. She eyed the palette intently. I made some adjustments, then mixed it again, spreading the paint over the glass so she could see it better. When she thought it seemed right, I began applying it. I painted only the bottom third of the square. More red was added and applied alongside and above the first color. To blend the two I took another, clean brush and worked rapidly an area between the two colors. Soon there was a rough blend of the two colors. Again the large finishing brush removed brush strokes. The final coat of red, to cover the upper third of the square, was applied over these two colors. It hung over the center of the square and surrounded the more orange area. As the final coat came down the sides, it tapered to a finer and finer point, almost vanishing near the bottom of the square.

The effect of these first colors was striking. O'Keeffe could see how it looked and was invigorated by it. It was as if the burning core of a fire had been transferred to the canvas. Color arched in the center; the brown surrounding the center square seemed almost unable to contain the fire within. And over it all shone the blue. Though the painting was far from complete, it was arresting. Later that day she showed it to Ida and Mary.

When I saw the painting the next morning, I was immediately struck by the way the orange and red added movement to the painting—that is the only way to describe its effect. One's eye shifted continually from the center of the painting up to the blue and back again to the center, which was enfolded by the brown. The simplicity of the composition was equally apparent. I marveled at the conjunction of colors and elements.

When I walked into the studio, O'Keeffe and Mary were near the painting. O'Keeffe smiled at me.

"Mary and I were just admiring our painting," she said. "She thinks it's quite fine." O'Keeffe seemed almost proud.

Mary thought it was tremendous, especially since I had never painted before. I was as amazed as she was. It seemed at that moment a great privilege to be working for O'Keeffe. Working so hard and having O'Keeffe take such pleasure in what we were doing was deeply satisfying to me. Mary excused herself, and O'Keeffe looked over the canvas for a few more minutes. I noted things to her, describing how the paint looked, touching it in places (which she did not like), pointing to areas I thought could have been done better.

"We want to put some small steps along the bottom, down around here I think." I did not know how big or how many nor did she when I asked her.

"What if I check the other one?" I referred to the *Patio* painting hanging in the adjacent room. She agreed.

I counted twelve steps of roughly uniform size. "You did twelve on the other one." I was kneeling, figuring out the spacing along the bottom so that twelve would fit without one on top of the other.

"Shall I place them about the same distance from the bottom?" I showed her with the yardstick where that would be. That seemed fine to her.

"Do you want twelve steps here too?"

"Oh, let's put in one more. It won't be the same then." Her reply had a playful, almost mischievous edge. I ruminated out loud what the art critics would make of that, reminding her of the woman's thesis she found so abhorrent. O'Keeffe chuckled. I marked off the spaces. The thirteenth square looked a little stunted, since I had altered a couple of the other steps to make room for it.

The squares were painted in colors complementary to the ones above, yet they were more subdued, less brilliant, almost like a diffused, flat, peach-toned red. I wasn't as fond of these tones, but, as more and more spaces were painted, I saw how they fit with the composition. I had to use smaller brushes now, and painting was time-consuming. I found it impossible to use the finishing brush in such a small space—I could only use it for the center of the steps and had to switch to a smaller one not designed for the purpose. Everything seemed cramped at the bottom of the canvas, and I spent much of the time on the floor, twisting my body to get at the steps, painting with both my left and right hands.

The day was exceedingly long, the concentration on details exhausting. O'Keeffe left me to finish the work. Besides lunch and a short afternoon break I worked steadily. I mixed small amounts of paint for the squares, comparing the color freshly mixed on the palette with the canvas. If I was uncertain about the match, I asked her to compare the two. Every time I stopped, I wrapped the brush in a towel wetted with turpentine.

I remember painting the thirteenth square. It was after six and the light was poor. I did not break for dinner, not wanting to interrupt the day's momentum. Finishing this area, the bottom of the canvas, was the most demanding work I had done. After every few strokes I had to clean the brush. If a line wasn't as sharp or clean as I wanted, or if the paint had built up in a ridge between the pinkish-red squares and the brown, I scraped off the edge and applied a thinner, finer coat. These endless details used up the hours of the day.

Finally, I spoke to O'Keeffe.

"I think we're done," I said.

I stood up and moved away from the painting. O'Keeffe came to my side. For several long moments she looked silently at the canvas. Then she almost beamed; I could tell she was as pleased and as tired as I was.

"Well, I think that looks just fine." She turned toward me and paused, her eyes holding mine. "What do you think?"

"I think it looks wonderful." We stood quietly. I moved to get a different view of the painting, another sense of it.

"Are you ready to become a painter?" she asked.

"After one painting?"

"No," she laughed, "it would take a little more than that."

We looked the canvas up and down. Warm shadows softened the room, pleasantly deepening its silence.

"We'll have to see what it looks like in the morning," she remarked finally. The light was not good. I turned to clean the brushes and tools.

When I was done, I went to find O'Keeffe. She was in a closet by her bedroom. I wanted to thank her for asking me to help with this painting.

"I must give you something," she said, and produced a small postcard, a photograph of a bust of her done in 1927 by the sculptor Gaston Lachaise. The bust was white against a black background. "Have you seen this?"

I said I hadn't. She did not seem to particularly like or dislike it. She sat down at the table and reached for a pen that always lay in a white box or on white paper. She removed the cap. Squinting intently, she leaned close to the picture and carefully wrote her name across the bottom of the card, on the pedestal. She wrote almost perfectly—somewhat unevenly, perhaps, but all the letters and script were contained within that tiny space. Turning the card over, she wrote her name again, adding the date: "8/20/76."

It was 8:30 when I left. Soon the sky was dark black-blue. I asked O'Keeffe whether I could come in later than usual the next morning, since I had some work to do at Juan's. I also wanted to rest! No one except her help at the Ranch knew what we had been doing, though that very night I stopped by my sister's house to tell her and her husband of the events of the week. A heady, satisfying mood gripped me as I drove home. The world never seemed so grand. It did not matter to me if anyone ever knew.

I had begun working for O'Keeffe in early summer. The days were hot, the afternoon thunderheads of midsummer yet a few weeks away. In the evening, light began to linger later, reflecting the mesas' unwillingness to let go of the day. The weather around these days of painting was astonishingly clear. They

were like the summer version of the halcyon days of fall, when the whole world seems aglint, the air clear like crystal. I came to appreciate light and color in new ways when I began to paint with O'Keeffe, learning, in some small way, to see as she did. That affected not only our painting, but also the wider world around me.

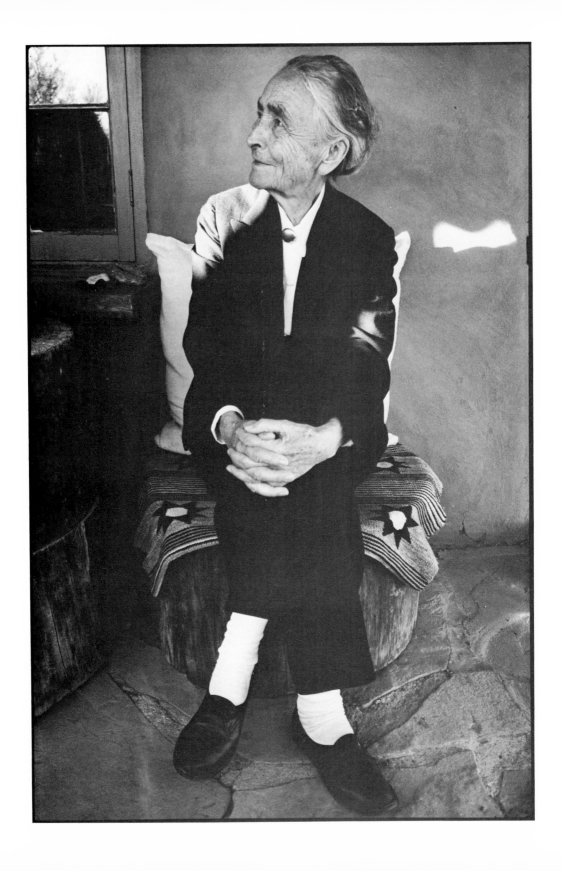

On Being Georgia O'Keeffe's First Biographer

Laurie Lisle

What compelled me to write about Georgia O'Keeffe during her lifetime, when the powerful persona emanating out of Abiquiu was mysterious, aloof, off-limits, and threatening to anyone who violated the taboos?

My interest in O'Keeffe began in 1970 at her large retrospective at the Whitney Museum, the first large showing of her work in New York in a quarter century. The brilliant colors, serenity, and clarity in her paintings riveted me for a number of reasons: there was the pure wonder of the art but also the personality behind it. That year I also visited East Africa, where I was deeply moved by the vast arid landscape, and I had the sense of being at the beginning of creation. Back in Manhattan where I worked for *Newsweek,* I found my urban life interesting but now painfully severed from nature. I began to vacation in New Mexico every year or two as a more accessible version of the highlands of Kenya. Inevitably, I became more aware of O'Keeffe as I got to know and love her landscape.

I began a quiet personal quest to learn more about this woman, who divided her life between New York and New Mexico for twenty years. I started with the *Newsweek* files, which contained interviews with both Stieglitz and O'Keeffe dating from the 1940s. But I did not get far. In the early 1970s surprisingly little had been written about O'Keeffe. Certainly, no informative books existed. I found a few dissertations and a handful of articles and exhibition catalogues. The most complete account was the 1970 Whitney catalogue essay written by Lloyd Goodrich, the former director of the museum.

A few years later I ran into an old friend at a writers' conference and blurted out to him—to my own astonishment—that I wanted to write a biography about Georgia O'Keeffe. The idea had obviously been incubating since the retrospective, and once I articulated it, it seemed to be an obvious fact. The year was 1976, the same year O'Keeffe published the story of her aesthetic journey and reproductions of her paintings for Viking's Studio Books. Her voice came

across loud and clear, but its elusive and fragmentary nature raised more questions in my mind than it answered. For one thing, she never mentioned her relationship with Alfred Stieglitz. I wanted to discover the rest of the story—beyond these charming but impressionistic images—the one that turned out to be passionate, dark, and disturbing.

My curiosity had as much to do with my own personality as with O'Keeffe's. There was my instinctive empathy for the creative individual who struggles to reveal his or her feelings and imagination in a largely indifferent culture. I believed I shared many of her values. Certainly, I admired her expressiveness and independence, a rare and triumphant combination for a woman to achieve in any culture. I was aware of the first stirrings of the neofeminist movement in New York in the late sixties and was attempting to redefine my life in the hope of finding a gratifying combination of intimacy and autonomy. I was later to agree with Andre Maurois that biography is in some degree "autobiography disguised as biography."

In 1976 I paid a visit to Lloyd Goodrich, who had worked with O'Keeffe's longtime assistant, Doris Bry, on the Whitney catalogue. A family friend, I saw him in his summer studio near an old apple orchard in a seaside village in Rhode Island. He had visited O'Keeffe in Abiquiu while preparing for the show, and he described his vivid impressions of her to me. Goodrich confirmed my sense that O'Keeffe had achieved a rare degree of self-fulfillment. He warned me about her controlling nature, which he had experienced firsthand: he had intended to hang her exhibition, but she declared, "You hang by the idea and I hang by the eye," and hung it herself. Nonetheless, he kindly encouraged me, directed me to some good sources, and offered some candid advice. He advised me to be as secretive as possible about my intention to write a book until it was well underway so that the people around O'Keeffe would be unable to stop me.

That autumn I went to Yale University and, with the blessing of Donald Gallup, read O'Keeffe's letters to Anita Pollitzer, Dorothy Brett, and others. Reading a more varied and complicated O'Keeffe voice had the effect of sealing my fate for the next few years. I wrote in the introduction to my book that "their intensity seemed to vibrate off the paper and transmit a vigorous jolt the way her paintings did." After that, events moved swiftly. I wrote a book proposal, asked for a year's leave of absence from *Newsweek,* found an agent, and then a publisher, W. W. Norton—in that order. By May 1977 I had packed up my old Karman Ghia and set out to visit places O'Keeffe had lived, interview people she had known, and search museums, archives, and historical societies.

I am often asked about my relationship with O'Keeffe. Well, there really wasn't one, although at first I attempted to have one. Despite Lloyd Goodrich's warning, I decided to inform O'Keeffe before leaving New York about my intention to write a biography. After all, I was ready to begin interviewing, and I did

not want her to hear about the book from someone else. When I received no reply to my letter, a member of the Stieglitz family, Dorothy Schubart, telephoned O'Keeffe to urge her to meet with me, and apparently she agreed. When I arrived in Santa Fe a few months later, I acquired O'Keeffe's unlisted telephone number and telephoned her. She answered the phone, and I repeated what I had told her in the letter. She was curious but cautious, and when I asked about a meeting, she stated she was not seeing anyone that summer; it was the summer she was beginning legal proceedings against Doris Bry. I was very disappointed, but she told me that I was welcome to what information I could find on my own. I took her at her word.

In August I went to Ghost Ranch and stayed at the conference center and usually said, when asked, that I was doing research on small mammals. The few people I confided in urged me to drop in on O'Keeffe unannounced like others had successfully done. One morning, against my better judgment and natural reserve, I walked to O'Keeffe's house and knocked on the door. She appeared and stood behind the screen door. It was instantly obvious that I had arrived at a bad moment: she was holding a toothbrush and her long gray hair was hanging down her back. But because her face was softened by the screen, I saw the same hooded eyes and face framed by loose hair that I had seen in Stieglitz's early photographs and was quite moved. When I introduced myself, she reacted angrily. Word of my interviews had indeed gotten back to her, and she complained about my "bothering her friends." But clearly it wasn't her friends who were on her mind. The interviews seemed to be a threatening violation of her fierce sense of privacy. I beat a retreat, and she called Dorothy Schubart, who then telephoned my editor—presumably to relay O'Keeffe's disapproval. I remember telling my troubles to a geologist staying at the conference center, who responded by saying she was glad her subject was rocks.

Nevertheless, I continued interviewing as many people as possible, including Claudia O'Keeffe, most of whom had never been interviewed before about O'Keeffe. I felt it was essential to continue interviewing O'Keeffe's few remaining contemporaries, and I met with Dorothy Brett a few weeks before her death. I was working in an atmosphere of risk, adventure, and even danger. Juan Hamilton not only refused to see me but even telephoned officials at the conference center to complain about my presence there. During those weeks at Ghost Ranch, which prides itself on its absence of locked doors, several of my notebooks containing interview notes were stolen from my room. Luckily, I had already copied their contents to index cards. So it was with a feeling of relief that I finally packed my car and headed north to Wisconsin to interview another one of O'Keeffe's sisters.

Although I was saddened and concerned about O'Keeffe's attitude, I had never assumed or promised my publisher that I would interview her. The

standoff was uncomfortable for me, but I gradually developed an attitude of detachment as I learned about O'Keeffe's distrust of the written word. I never wanted to get into a position where she would control the manuscript; I was aware of the way she had suppressed the work of others who became dependent on her approval. As I made important discoveries in the next few months—for example, the Jean Toomer letters at Fisk University, the medical records at Doctors' Hospital in New York—I realized that if she learned about my discovery of these sensitive personal materials, she would attempt to stop publication. Lloyd Goodrich had been right. Being incommunicado was the only way I could effectively and swiftly work. That fall I resigned from *Newsweek* when my leave of absence ended.

The disadvantages of writing an unauthorized biography made it difficult for me to get repeat interviews, since I was operating one step ahead of O'Keeffe's telephone calls. I was cut off from some important sources, and I was limited in quoting from letters and publishing photographs. Also, because of the secrecy, there was a degree of intellectual isolation. The important advantage, of course, was that I could use and interpret freely the information I discovered. I benefited from the fact that the people around O'Keeffe were involved in their own rivalries, and that they did not understand that a biography could be written without their permission.

I was on sound legal ground because in our cultural and legal tradition the law considered O'Keeffe a public figure. She simply had less right to privacy than someone who had never sought public attention. Not only had she regularly exhibited her work since before World War I, but in recent years she also had released the Viking book, participated in a television documentary, and permitted Stieglitz's nude photographs of her to be displayed.

Although O'Keeffe was involved in three lawsuits over control of her paintings while I was working on the book, none of them was over control of her words. Since words are unusually susceptible to theft, the Constitution provides for the concept of intellectual property, or copyright, so the writer can earn a living from the more or less exclusive use of his or her expression. The Constitution also establishes the right of dissemination of knowledge about ourselves and our culture, called "the public right to know." There's an inherent conflict between the two rights, and the battleground is over the fair use of other people's words—published or unpublished. This was a deliberately undefined area when I was writing the O'Keeffe book, and it gave historians and biographers a certain amount of latitude. (Unfortunately, it is no longer possible to quote from unpublished letters without permission.) After my editor moved to Seaview Books, an imprint at Playboy Press, and took along my book, it was *Playboy* magazine's lawyers who reviewed my book before publication. They were in the forefront of the law in this area and willing to go to the Supreme Court to defend principles.

As it turned out, I was more cautious than my lawyers, preferring to err on the side of fair play and good taste, since I expected to publish during O'Keeffe's lifetime.

After publication I sent a copy of my biography to O'Keeffe. The silence from Abiquiu was deafening. I was not surprised, since she was virtually blind by then, and I was not at all certain that it had been read to her. When reports of her irritation reached me, I was relieved not to be the recipient of a punitive legal action. Some people resented that I was not an art historian, especially after a reviewer concluded in *Smithsonian* magazine "that journalist Lisle has scooped the art world." (I don't think I scooped the art world; I think I stimulated the art world.) But I believe that it was necessary—given the hostility and paranoia I encountered—for me, publishing during O'Keeffe's lifetime, to have journalistic experience since I felt forced to function like an investigative reporter many times. An art historian might have been unwilling to risk a career or an institutional affiliation to write in opposition to O'Keeffe's wishes.

Since O'Keeffe's death more of her letters have been published, to the enrichment of us all. This process will continue until the O'Keeffe–Stieglitz correspondence is finally opened; I've been told that it will reveal important surprises about O'Keeffe's early years. The fact that O'Keeffe said she felt protected by the uncorrected "lies" written about her always made me nervous, and it's important for all information to emerge. This process of developing a body of work in an area is a normal one for historians, scholars, and biographers, who make their own contribution in their own way and in their own time, enriched by each other's work and enriching future writers' work. It's important to be as generous as possible to each other under the guidelines of fair use because O'Keeffe belongs to America, not to any one of us.

Most biographers go through various stages of feelings about their subject. One of the pitfalls of biography is false identification with one's subject, when you become too judgmental or too admiring or too angry with him or her and lose your objectivity. My initial idealization of O'Keeffe eventually gave way to repulsion at her egoism, and I backed off for a while until I arrived at a more complex understanding of her. I came to accept that art, not the artist, can be enormously selfish in the way it demands time and energy, and that O'Keeffe's generosity to us was through the large and rich body of work she produced and exhibited.

Writing about O'Keeffe as a vulnerable human being and struggling artist has helped to deepen our understanding of her art. I have the letters, particularly from both aspiring and elderly artists, that attest to that. I was especially rewarded by a handmade valentine from an anonymous reader—a collage made up of a paper lace doily, a picture of a mesa against a starry sky, and a gold heart moon—with the message on the back: "Thanks for the Georgia O'Keeffe book."

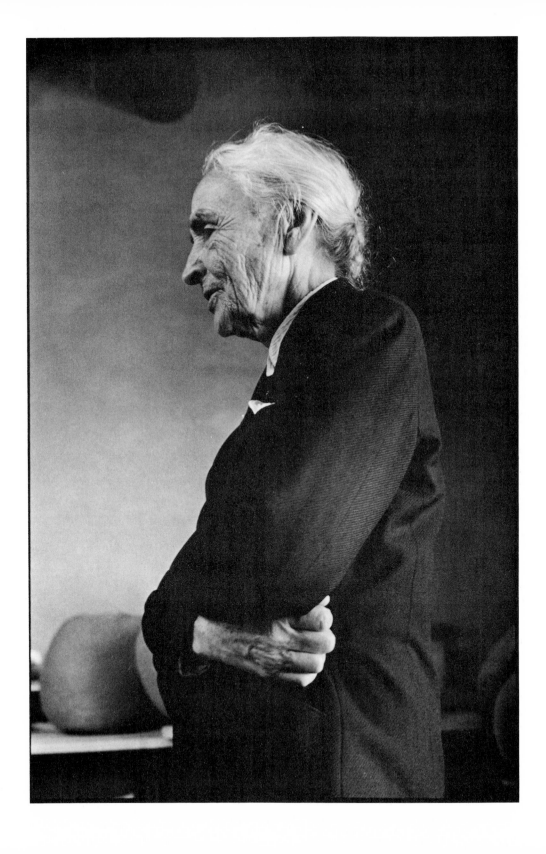

The Underside of the Iris

Conversations with Georgia O'Keeffe

Mary E. Adams

The extraordinary Georgia O'Keeffe died in March 1986 at the age of ninety-eight. While memories are often inaccurate, colored and discolored by individual bias, these are mine, taken from journal notes recorded immediately after each of my visits with her, usually at Abiquiu or Ghost Ranch. We saw each other over a period of more than twenty years during the last quarter of her life.

My memories of her are of a friend sometimes irritating in her implacability, yet paradoxically warm, generous, and eager to please. She has been the subject of published articles and biographies, and the myths are many; even so, these notes may add another dimension. I have tried to be fair and selective—and, as far as my fallible memory permits, descriptively honest.

A Changing Image

The first time I saw O'Keeffe, straight-backed and sunlit in her Abiquiu compound, she wore *the* black dress with silver conch belt. A white handkerchief bound her head. Her face was etched like the hills and arroyos of the Chama Valley; her bearing, unbending; her walk, purposeful with economy of movement. She appeared as a particularly austere mother superior and as a proper but private lady.

In later times, particularly after the advent of Juan Hamilton in the mid-seventies, the image softened around the edges; feminine vanity, color in her dress, and a flavor of eroticism appeared. The ramrod toughness became less assertive, as did a touching need for approval and a concomitant need to reassert her private self. "I've always had good hair. Do you see any new growth here?"

she asked, smoothing her recently shampooed head—but no mirror looking. As always, she was immaculate and critical of slovenly or improper dress. Advice to me: "Your skirt is too short. Not becoming." And later: "Don't complain about protocol—entertaining for guests. Do it right. When we [Stieglitz and O'Keeffe] moved to Lake George in the summers, I had to pack and move complete services for twelve. And there were always many people for lunch. I would rather have been painting but I did what was expected. . . . I have black Wedgewood cups which I bought at Neiman's, and a raincoat. I never use things I buy until I've had them two years."

Travels

"I'm going to the British Museum to see the Elgin marbles [the sculptures taken from the Parthenon by Lord Elgin to England in the early nineteenth century] and to see what else the British stole."

"I have to go to Greece to feel the stones." And: "I want to go to Vienna to see the Lippizaners [the renowned Austrian horses] again. They're wonderful."

"I've always wanted to go to Ethiopia. The Sudan has always fascinated me but not as much as Ethiopia, particularly the white Coptic churches with the friars walking about them in the early morning light. Must be like New Mexico." (She frequently visited a monastery near Abiquiu and was friendly with the Brothers.) "I like best to travel with Catherine [her sister]."

Music

"My tastes in music stop at the seventeenth century. I have this special person who sets up the machine for me. Bring me recordings next time you come up and we'll listen." And we did. Three hours of plain chants before lunch. No conversation; she was a *total* listener. Special concerts (most not seventeenth-century music) were played in her honor by various chamber groups, resident or visiting in Santa Fe. It was all very festive. She spoke of her memories of the Budapest String Quartet. After the concerts, as at her exhibition openings, she held court. She became very gracious on these occasions—although she often protested her dislike of crowds and formality, and if she traveled, "strange beds, people fussing over me, and not enough rest." But she thrived on it all, despite her ambivalent attitude toward pleasing anyone but herself.

On the occasion of a visit and concert in New Mexico by Pete Seeger, an old friend, she invited (more like commanded) him and his wife to visit her. I

was to bring them to Abiquiu for lunch. To me: "I'm embarrassed. Pete made me a flute from the bones of a bird which I brought back from Lake Titicaca in Peru. And I sat on it and it broke." Later she confessed to Seeger: "I broke the flute, but I have more bird bones." These she fetched from a high shelf in the storeroom. Pete volunteered to make her another flute. Late in the day we all drove up the valley to a cave that had a fine resonating echo. Seeger tested it. She enjoyed this afternoon immensely. During the drive, she and Toshi Seeger gossiped about mutual friends and revived memories of Anita Pollitzer.

Houses and Households

"I waited a long time to get the Abiquiu land. There was a spring over there but it was covered with trash and junk. I bargained a long time, years, with Mr. C—— and I finally got what I wanted, a place to build this house with a view of the valley." Later she paid to have the spring freed, built the walled compound, and planted the extensive garden and fruit trees.

As for her house at Ghost Ranch, she moved there with her housekeeper and household accoutrements each spring. She was sentimental about this special place, which was given to her by Stieglitz and was where her love affair with the New Mexico landscape flourished. "I fought the Presbyterians in court a long time for my water rights. Finally won." Ghost Ranch, except for O'Keeffe's property, was largely owned by the Presbyterian church. In arid lands like New Mexico, water rights are vital to survival and therefore are the nexuses of both endless family and social disruptions and quarrels. "I didn't like Presbyterians much and I am surprised how much I like Jim and Ruth [the Presbyterian minister and his wife in charge of Ghost Ranch]. . . . They have been good friends to me for many years."

Visitors, *if invited,* were to be fed. Luncheons were memorable. The fruit and vegetables were from her orchard and garden, the latter an agricultural and visual tour de force. O'Keeffe supervised all planning, planting, and harvesting of fruits, flowers, and vegetables. The garden was tended by villagers, her sister Claudia when she visited, and an endless series of transient young people. "When Claudia is here, she supervises the garden . . . but she doesn't come to lunch." (At one lunch, Claudia, quiet and shy, joined us.) O'Keeffe was rightly proud of her cuisine. At one luncheon she had her relatively new housekeeper "practice the soufflé" prior to the arrival of guests. "The first soufflé wasn't good enough. This one is better, but not perfect. . . . The cress comes from my own mountain stream. . . . Don't jiggle the wine bottle!" She planned all menus,

purchased the food not found in her garden, and supervised the cooking: "Never spread herbs to dry; always hang them."

Dogs were as much a part of her household as were her other more or less permanent helpers—the cook-housekeeper (Dorothea) and the gardener-handyman-chauffeur (Frank)—with whom she maintained a firm and affectionate relationship until their age and infirmities necessitated replacements. The dogs, two chows, had their own chair in the Abiquiu house. When one died, the other pined, died, and was replaced by a chow puppy. She loved and respected all animals, especially dogs and horses, but took care not to flaunt her sentimentality for them. In the 1960s she remarked, "I once rode my horse—I like horses—up and down these canyons. Now I just walk, especially when I'm at Ghost Ranch."

Her Chama Valley Neighbors

Georgia O'Keeffe's neighbors in Abiquiu and in the Chama Valley, with few exceptions, were descendants of seventeenth- and eighteenth-century Spanish settlers. The community for centuries was geographically isolated from both mainstream Anglo technical and economic advantages and remained, well into the twentieth century, culturally and linguistically Hispanic. Raising of cattle, subsistence agriculture, and a mix of Native American and Spanish craft industries barely maintained it economically. It was also the heart of the Penitente sect of Catholicism.

"I don't know anything about these people. B——lives over there. I paid to send him to school but he quit. I told him if he got A's and could graduate, I'd pay him more, but he didn't choose to do so. He lives down there with his wife and children. . . . I don't intrude on the Penitentes and their ceremonies. But during a procession in Abiquiu (with flute playing and the Christ figure carrying the cross) I watched through a chink in my wall. One of the young men from the village who worked for me had a badly scarred back. He would never admit it but I knew he got the scars from being the Christ. . . . No, I've never been in a *morada* [a church of the Penitentes].

"When the little boys climbed over the wall to steal my apricots, I took my quirt and whipped one of them. I was afraid his mother would be angry with me but she wasn't."

Despite her assertions of noninvolvement with the people in the village, she had seen to the restoration of the church, built a gymnasium/town hall, put up the matching money for a new water system ("I wanted good water to drink

. . . and the tax deduction"), paid for countless children's education, bought the local equivalent of Little League baseball uniforms and dictated their design, employed and trained numerous people as gardeners, cooks, carpenters, and on and on. Demanding loyalty and denying her generosity, O'Keeffe surely must have suffered conflict between her natural frugality and her need to demonstrate noblesse oblige, and between her near xenophobia and her genuine care for others and desire for their approval. Except for one storekeeper, she was for many years the sole Anglo in Abiquiu.

The villagers in Abiquiu and the people of Chama Valley saw Georgia O'Keeffe in various lights. Was she a saint or a devil? Some Spanish people said the former, for she "does good works"; some said the latter, for she "may be a *bruja* [witch]." This rich Anglo woman in the long black dress frequently bewildered them. According to the local people with whom I was acquainted, "She strikes hard bargains with the butcher and grocer and always wins" but is "both kind and very hard to please."

Many did not understand her relationship to Juan Hamilton—he displaced many of them in O'Keeffe's affection. Over a period of many years she and her neighbors had established a mutual dependency. After Juan arrived at her door in 1973 and became her confidant, surrogate son, ceramics teacher–artist, and critic upon whom, as her eyesight failed, she became dependent, resentment increased among the conservative valley people. Nasty graffiti appeared on her compound wall. Gossip spread about her relationship to Juan. The women who cooked for her changed constantly. (Dorothea and Frank had left, breaking a long-time bond.) She remained loyal to Juan. She frequently repeated to me the story of Juan's arrival at her door in Abiquiu and his help with the first pots she made—partly as if to justify his usefulness to her and her art, her loss of village affection, and her iconoclastic rejection of local mores—as she had rejected them in small Texas and South Carolina towns so many years ago.

Artists, Poets, and Others

In the early 1920s in New York, O'Keeffe, closely involved with Arthur Stieglitz's 291 gallery and its stable of artists—Demuth, Marin, Hartley, and others—most admired and liked Arthur Dove. She remarked, "Arthur Dove raised chickens but his wife—a terrible woman [and one of O'Keeffe's former friends]—couldn't stand them. . . . Arthur once lived in a skating rink. There was an old broken-down couch in the middle and a wrought-iron stand to hold plants. Very fancy, but no plants were in it. . . . Then of course he lived on a houseboat too. . . . I bought the first collage he ever sold for $150. The Met

wanted to buy it from me for $500 but I wouldn't let them have it." My notes differ from what others have remembered about whether she bought the first or second Dove collage, as well as when, which, and how much she paid for it. Her memory was not always accurate. No matter. She was one of the first who appreciated Dove's remarkable work.

Since her first 1929 visit and summer stay in Taos and eventual return to New Mexico, O'Keeffe was friend and confidante to many of its writers and artists. These included Tony Luhan (Mabel Dodge Luhan's husband), Frieda Lawrence (D. H. Lawrence's wife), and Lady Dorothy Brett, artist and close friend of Lawrence's.

According to O'Keeffe, "Frieda Lawrence was a worldly but child-like person. Really a fine woman. She wanted to spend one summer with me at the Ranch. She was writing a book. But I had to say 'no' because I was too busy. However, she came to see me often. . . . I never met Lawrence but I know him better than if I had met him. He wrote to both [Lady Dorothy] Brett and Frieda and they both showed the letters to me. Of course I never let either one of them know I'd seen the other's letters."

She knew Mabel Dodge Luhan well: "I liked Tony Luhan."

"I can't understand the great interest in Taos. All the major artists [including O'Keeffe] stayed briefly and left."

"I can understand Chinese poetry because it's visual. Witter Bynner [poet and translator of Chinese poetry] sent me some and I loved it. He read it to me also."

Charles Tomlinson, the British poet, visited her during one of his trips to New Mexico. He presented her with a small badger skull, "a British one," which obviously pleased her. She said, "I do not like poetry much. But my friend K—— wrote a book of poetry [a slim paperback volume, which O'Keeffe immediately fetched and handed to Tomlinson] and I want to know what you think of it." She followed this request with a long story of K's loves and life. "Now read the book." Tomlinson read it all. "What do you think?" she asked. "It's not grossly bad," he replied. She was amused; they were friends, photographs were taken after she rearranged her hair and other amenities were enjoyed, although she apologized for not providing lunch.

Herself as Role Model for Women Artists
"I don't understand what the fuss over me is by women artists. I didn't like hearing I had been represented as a Christ figure in a 'Last Supper' painting but

I won't say anything." (My guess: she was somewhat offended but also flattered?) "When I was a young woman and painting, the men artists didn't want me around much so I decided to just paint better and better."

She liked June Wayne, the founder of Tamarind Lithography Workshop, had visited the Los Angeles shop, and had intended to work there. Her stay was interrupted by President Kennedy's assassination, which deeply affected her, and she declined to try her hand at lithography. Of June Wayne she said, "She's a remarkable woman."

She also liked Sarah Greenough, the author of a fine book on Stieglitz. The interviews during the preparation of the book gave Georgia opportunities to talk about him, and Sarah was a responsive listener.

When artist Louise Nevelson came to New Mexico to make lithographs at Tamarind Institute in Albuquerque, she arranged to see O'Keeffe for a day in Abiquiu. After Nevelson's visit, O'Keeffe refused any comment about her or their conversation—at least to me.

While she felt sympathetic with women—but competitive with women artists—she thrived in the company of men. I never left Abiquiu or Ghost Ranch after a visit that she didn't say, "Tell Clinton [my artist-husband] to come see me." He did from time to time and they talked "painting," about artists she had known, and lithography.

O'Keeffe as Adversary and Gift Giver

Georgia O'Keeffe's predisposition to litigation when aroused was a well-known fact to several decades of friends and ex-friends. She loved a good fight. "I enjoyed playing that game [over the monetary value of her paintings] with [Joseph H.] Hirschhorn [of the Washington, D.C., museum]. We had dinner and we argued about money." She got what she wanted. Maintaining prices was the name of the game.

Both her affections and her enmities were quixotically bestowed. Her perceived adversaries and her real ones were many. She frequently feared that she and her paintings were not receiving proper respect, or that confidences had been broken, or that her privacy and, paradoxically, her place in history were threatened.

She often spoke at length of her rationale for whatever legal or nonlegal battle she was waging. Both the nature of the real or imagined offense and her rationale for the war were often unclear, at least to me. But it was not difficult

to perceive when she was upset and angry. My notes on these conversations are as confusing as were the conversations themselves. I shan't attempt to repeat them.

She fiercely defended those who she felt were loyal to her and to her political heroes. Her position during the Senator Joseph McCarthy hearings was well-known. She was on Richard Nixon's "enemies list" (and he on hers), but her complaint to me (before the word reached her) was that she wasn't on the list. She donated money and her work in behalf of political causes such as Senator George McGovern's campaign for the presidency. "I wrote that dear man . . . and I want to meet him when he is in New Mexico." Donations of her art in behalf of political causes was in contradiction to her policy of "never giving away" her work.

"Young people come to me and tell me how much they like my pictures but can't afford to buy them. I'd sometimes like to give them one, but I remember that Stieglitz made me promise never to undersell or give away my paintings or drawings." She gave work to some people, of course. To one woman friend whose husband was currently on her enemies list, she handed a painting, saying, "This is *yours*."

At the end of one of my visits to Abiquiu, she spontaneously sent to the University of New Mexico Art Museum on loan three pictures (including her Hartley and Dove). I have never driven from Abiquiu to Albuquerque more carefully than on that trip. At a later time, she agreed to permit the museum to purchase at a reduced price her watercolor *Tent Door at Night* (c. 1913). Astonishing—but she made us promise not to tell what the price had been. She also loaned to the museum three of her own paintings, including *Clam Shell* (1926), which she later recalled when Hirschhorn was trying to buy them.

Her reputation for successfully and combatively fending off unwanted and/ or unannounced guests and her insistence on privacy continued throughout her life. But in her later years, while she never courted visitors and denied her wish for company or publicity, she found more and more ways of encouraging both, not only if she perceived that her reputation as an artist could be enhanced but also if she wanted to assuage her loneliness. She was leery of art historians, critics, and biographers. She had said she wanted her old friend and museum director, the late James Johnson Sweeney, to write her biography but found ways to avoid actually giving him her time. "I was too busy. . . . The floor needed redoing. . . . I wanted more time in the studio. . . . I must see about business." Pity. Among those she trusted, he was one of the most astute. He understood her and her importance to art in America.

Occasionally I would receive a telephone call: "When are you coming to the Chama Valley again [to see the fall colors, or check on the water projects, go to a meeting at Ghost Ranch, or . . . ?]"; then came the invitation to lunch or the favor to be asked—often to transport records or visitors. Sometimes the request came in the form of a brief note. The rules were strict: Never come without a request via the mail, or if one used the telephone, never reveal her number. But in later years, she became more welcoming, less isolated, although after the advent of Juan she became fractious over intrusions and eager to finish her work before her eyesight failed completely. She nevertheless encouraged visitors. She became uncharacteristically dependent on others' opinions of what was best for her—perhaps an echo of her relationship to Stieglitz—or because she no longer trusted her failing eyesight or her critical judgment.

O'Keeffe the Artist

We didn't talk much about art except when other artists were present or when she was working on a series of paintings, such as the black rock or cloud series. "That one [she points to a painting of a black boulder] is the best, I think. The first ones weren't as good." When confronted with a lithograph stone brought to her for experiment (from the Tamarind Institute in Albuquerque), she was obviously interested, but her eyesight was failing: "We don't talk about my eyes." Eventually she returned the stone to Tamarind—fear of failure and subsequent loss of status as an artist? But she said, "I didn't have time to do it."

She did talk about other artists and her relationship with Stieglitz. She gossiped about dealers, was critical of museums and galleries, and threatened (or started) litigation if aggrieved over the disposition of her paintings. Her criticisms of other artists were often subtly denigrating, but she avoided *talking* about ideas in her own work other than the thematic content—that is, the object (flower, rock, cloud) as she perceived it—or of technical matters.

At lunch with me and a painter who admitted that she used cotton canvas, O'Keeffe said, "Use good canvas, the finest possible. I always used the best, as fine as a linen handkerchief." She hated any failure to achieve technical perfection, even in the hanging of her pictures. She supervised the installation of her one-woman exhibitions at the Amon Carter Museum and at the University of New Mexico Art Museum (the latter, her first in New Mexico); she insisted that walls be white and that museum assistants wear white gloves in the handling and hanging of her pictures. She was consistent in her attention to precision and detail, especially before Juan Hamilton was able to help her.

But she could also poke fun at her own efforts in other media of artistic expression. As Juan Hamilton's arrival in Abiquiu and engagement in making pots coincided with her progressive loss of sight, she began to make ceramic pieces. "Let me show you what I've done," and we proceeded to the studio. "The first pot I made, I dropped and broke it." And she laughed.

In her involvement with the drama and spectacular beauty of the microcosmic world of a flower and the macrocosmic world of a road through a mountain landscape, her place in the Chama Valley was "the best place in the world." Her abstraction of the object, flower or road, interested her as a painter. She spoke only metaphorically about her symbiotic connections as an artist to her "best place" (the Chama Valley), but she wrote it. Facing plate 88, *Dark Abstraction* (1924) in her book *Georgia O'Keeffe, A Studio Book,* published in 1976 by The Viking Press, she said, "The abstraction is often the most definite form for the intangible thing in myself that I can only clarify in paint." Her writings about what she was about as an artist are as clear, poetic, and precise as her paintings.

Our Last Conversation

We sat in the studio at Abiquiu. The afternoon light was fading but strangely not dimming the whiteness of the special place O'Keeffe created inside the Abiquiu house. She contemplated a half-completed canvas.

"Are you painting these days?" I asked.

She hesitated, almost said yes, but evaded a direct answer. After a moment of looking at the painting, she said, "Well, if I see it in here"—she put her hand on her chest—"I can *see* it." She did not say she could *paint* it.

She was very quiet this day. Sad, reflective. "I've lost two babies. I took one, a boy, home with me. Then the grandmother took him to be blessed by the archbishop. . . . [He] was kissed by many people and got sick. . . . I had to go to New York and when I came back, the baby had not been returned to me . . . and they had promised. . . . There was another baby, a girl. . . . But she got sick—she wasn't cared for properly—and was in the hospital, and I had to let her go. . . . I remember all these things suddenly. Like a novel . . . I am writing a book about—" and she left the sentence unfinished. Her longing for a child had been expressed frequently and usually in metaphors and circumlocutions but never so directly to me. It was as if her immortality was not yet assured through the continuing life of her art. She spoke of her affinity for young people, particularly the ones who shared her love of rocks, bones, growing

plants, echoing caves, dogs and animals, and of her poignant deprivation of children.

I had brought her a sand dollar as a gift from my son, with whom she had exchanged rocks since he was a young child. Today she asked about him and about his dog, whom she had petted while dining at our home many years before. She moved to a cabinet, picked up and began to pack the nautilus (the model from which she had painted in the past), and said, "This is for your boy"—now a grown man. "I'm bored with my history, my myth . . ." We talked briefly of painting and the abstraction of the objects she loved.

Near dusk, we walked in the compound. "Seven times around it every day" (but she tired at six) and "looked" over the valley for some time. She was "seeing" it perhaps more clearly than I, since she had internalized it as a part of her inner vision. We walked and talked and looked some more. She was wrapped against a chill evening breeze and wore her ancient and impressive broad-brimmed hat. She became more animated as she spoke of "the Chinese army partially and recently excavated" and longed to go to China to see the completion of the project. She also spoke of Chinese poetry and her affinity with its economy and visual evocations. As she had told Charles Tomlinson, Witter Bynner had introduced her to it in translation, as well as read his own poetry with her. They had become close friends.

As we walked, she recalled a visit from Noguchi the previous Christmas and that cheered her. They were old friends, and she seemed grateful he had come. She admitted to being very tired; her external visual world was disappearing, and she was lonely but "wouldn't give up."

The visit ended with the careful packing of the nautilus in my car.

In my journal on that early spring day I noted: "I never know how to explain the kind of exhilaration Georgia O'Keeffe gives to me and others. I have an urge to weep for her. She can at the same time be so infuriating and childish—but I don't care much because of her power, her kindness to me, and her perverse charm. And I so admire her thirst to absorb and recreate her world."

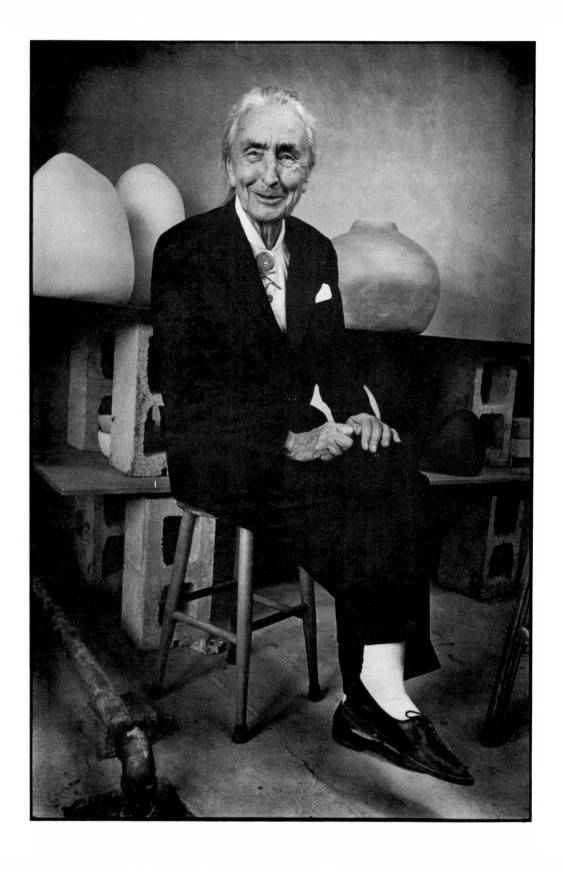

From *Miss O'Keeffe*

Christine Taylor Patten and
Alvaro Cardona-Hine

I met Christine [Taylor Patten] in 1987, and one evening at her studio, talking
about this and that over dinner, she spoke of having been one of Georgia
O'Keeffe's companions—or nurses, as they were called. The matter came up
round-about and she was very reticent about going into much detail. It was at
my urging that she told me how she had cared for the famous woman for almost
a year, beginning in 1983. How fascinating, I remember thinking: a female art-
ist taking care of another one. Assuming that Christine had a great deal to tell
about O'Keeffe's opinions and ideas on art, I kept firing question after question
at her. To my surprise, it was the human story that grew larger than life, full of
warmly remembered detail and love for the nonagenarian.

A problem emerged almost from the beginning: Christine's reticence. This
reticence was due to her natural instinct to protect O'Keeffe from mere curiosity
and because, as I was to find out, she knew so much about what had transpired
during those days when O'Keeffe was finally transferred from her beloved Abi-
quiu house to a noise-ridden mansion in Santa Fe. It had not taken her long to
become attached to O'Keeffe, to discover the real woman behind the myths as
prevalent then as now, and to learn to serve her. She had to deal with the real
Juan Hamilton, and observed his volatile ways, so she had formed the prudent
habit of keeping the story of her days with O'Keeffe much to herself.

That night, on my way home, I thought the world needed to know the
story, and I made up my mind to approach Christine as soon as possible with
the suggestion that we write an account of it in a collaborative fashion. She
would write down everything she remembered, or put it down on tape, and I

would transcribe the material, write the account of it, and present it to a publisher.

For me, it has been a privilege to listen to Christine and record her story. It is her story. I quickly discovered that she wrote with an eloquent sense of style. It dawned on me early that I could not drown this voice in an attempt to turn out a standard biographical piece. . . .

I feel that the use of two voices, mine and Christine's, allows a portrait of the younger woman to emerge. In the end, the reader can see that the spirit of O'Keeffe suffuses everything, as does the bandaging love of the younger woman for her charge. This caring is everything. All else is circumstantial detail mirroring, as life always mirrors, the true natures of individuals involved in their daily lives, in all of their pursuits and schemes.

A. C.-H.

Georgia O'Keeffe was one of the ways to be a woman and an artist, and it seems important not to see her life as a mold, a pattern that determines form, defining a way to live. The circumstances of her life are not the example. It is the abstracting—as with the flowers, bones, the simplicity—that should be the example, the abstract continuity of unseen patterns and clues, culled in perhaps unrecognizable form at first, but, revealing, when examined, a simple clarity, wholeness.

Her example is as simple as the evidence: it is that she cared intensely about what she did each moment and, most important, that she allowed that caring to show. It was this elemental human quality in Miss O'Keeffe that provided power and intensity, and gave her life definition. She didn't feel a need to apologize for that caring by hiding it, or by pretending that "getting it right" didn't matter, or by being indifferent, detached, about what she was doing.

I was one of a long continuum of women who took care of Georgia O'Keeffe at different times in her life, in different capacities. Much of this story could be told by any of these women, each in her own way. Late in Miss O'Keeffe's life, we were attending to her simplest needs, and the truth is, it was she who taught us about caring. . . .

Georgia O'Keeffe is an example to us that we can be independent, powerful, and caring, that those can be one and the same; and that in the consummate

act of harmonizing with nature's ways, in its deceptively contradictory forms, we are strengthened, and rather than lose identity, find it.

C. T. P.

Early in August (1984), O'Keeffe's will was changed, much in favor of [Juan] Hamilton. It was a particularly chaotic week in the [Santa Fe] household; there was a lot of activity preparing the main house and guest house for visitors. O'Keeffe's lawyer from New York arrived on Tuesday, and people had been in and out for days. Her local doctor had unexpectedly interrupted lunch the day before to take a sample of O'Keeffe's blood. The house was full of flowers, many more than usual, brought by Anna Marie [Hamilton, Juan's wife] from a local florist.

Hamilton seemed agitated. All week, his directives had seemed more brusque than usual, and he appeared excited by the arrival of the guests. Before he left to pick up the lawyer from the airport, he came in to tell O'Keeffe and she said, "Tell him about our plan, Juan." "Oh yes, Georgia . . ." he replied, finishing the sentence inaudibly.

When Christine heard O'Keeffe say that, she immediately recalled a conversation she and O'Keeffe had the month before. Occasionally, Hamilton would visit O'Keeffe in her room in the afternoons or early evenings for perhaps a few minutes. At such times he would ask the nurse to take a break.

On this particular occasion, he stayed in the room for over half an hour. When Christine returned, O'Keeffe was very agitated and told her that Hamilton said that he and she had to get married.

Christine always had a drawing book with her and, as O'Keeffe began to relate what had taken place between her and Hamilton, Christine realized she wanted to write down what she was hearing, she was so stunned.

They were sitting together on the couch; O'Keeffe spoke very slowly, pausing to think between words. This made it easier for Christine to write down the conversation accurately. The date was July 10, 1984.

O'K: Do you think of this as my house?

CTP: Well, of course.

O'K: Or does it seem like Juan's?

CTP: Well, there are some of your things around it.

o'k: Well, I just don't have any feeling of possession. The house in Abiquiu feels like my house. When we went up there [this was shortly after she had gone to Abiquiu with Juan and Dr. Friess] it didn't feel like my house anymore. Well, you know, it seems like it's Juan's house, and if I have that feeling maybe I should just give it to him. Are you sure it feels like my house?

CTP: Well, his family does live here. Maybe that's why it doesn't feel like it's your house. That would be a very nice thing to do, to give a house to someone.

o'k: But it would have to be made legal. If that girl—what's her name, Mary Eva [Anna Marie Hamilton]—would quit, then Juan and I could get married and be done with it. Does that seem a funny thing to you?

CTP: Funny?

o'k: Well, if I give him the house and we aren't married, there are taxes, he said. The government wanted to have the house in Abiquiu—there've been many plans and I don't know what will happen.

CTP: I've always thought the Abiquiu house would be a great art school—a small one.

o'k: Oh yes.

CTP: This house used to be a school.

o'k: Yes, Juan . . . do you think it's a funny idea?

CTP: What's a funny idea?

o'k: This idea of getting married. You see, the people have always gossiped about us, and they've never known and if we get married, I suppose that will start it up again. And it would be a legal way. And they've already gossiped. And then people will tell us: we told you so. Because he takes care of my affairs . . . he knows more about my affairs than I do. And I wonder if he talks to his friends as I've talked to you?

[Pause]

But I'm afraid that maybe that sort of thing will change if he thinks it's a duty.

CTP: Do you mean his taking care of you?

o'k: It's not just care—it's a kind of feeling. You take a great big risk [laughs]. You see, the house would then belong to the two of us, and we'd have to get married to prove it, and that seems very funny because we've been talked about anyway.

[Pause]

When it comes to taxes, that's what is. And if he's a partial owner, only he pays taxes. I don't think the government looks into and [*sic*] wherefore of such things but I think they should. He has talked to Ann Marie, and it's all right with her to stop being married.

CTP: Would they keep living together?

O'K: Well, I don't think there's much living together going on. Well, it seems funny for him to go around strangers saying, "This is my wife."

CTP: You mean you?

O'K: Yes [laughs]. I'm rather indifferent about it. I think I'm more indifferent than a lot of people would be. And it would be strange to go around saying he's my husband [laughs] . . . I'm afraid that he might have less feeling that way than he does now.

CTP: Well, that happens, Miss O'Keeffe.

O'K: It would take awhile to get people adjusted to it. See, Mary Eva, or whatever her name is, seems to have no feeling about giving him up. And here he is a desirable young man [laughs]. Oh dear, it is funny.

CTP: I wonder what she will do—she doesn't have a job . . .

O'K: Well, she's just to go on the way it is. I doubt that that's what's giving her a backache. It may be, it just occurs to me.

CTP: It seems like an interesting plan.

O'K: It seems like an interesting plan? Well, years ago occasionally he would say, "Let's go up to Tierra Amarilla to get married," and I laughed at it. It wasn't in my plan at all.

CTP: When did he start talking about it again?

O'K: Well, when this became a tax situation.

[Pause]

Well, here we have all of this house and all that goes with it and the things that he intends to put in it. I doubt he'll change his plan much about the house.

CTP: What plan?

O'K: Oh well, a lot of things he intends to do to it. And it'll take quite a little money to do them.

CTP: Like what?

O'K: Well, like making a glass across the courtyard. Making it daylight. Now who else would do it? Well he has a lot of ideas about the house that way.

CTP: And it'll be easier to do those things if you get married?

O'K: Uh huh. We've already been taking this walk down the side of the house and back the other side up. It may be the people who work here who

From *Miss O'Keeffe*

make words about it. I never talked to Dr. Friess about it. I should have talked to her about it . . .

CTP: Why?

O'K: Oh, just because she is a wise person.

CTP: Well, you're pretty wise yourself.

O'K: Well, I'm not too stupid, I don't mind saying that about myself.

[Pause]

One of the principal things is the feeling he has now is very special. And it could change. And I suppose I'm just going to do it. And I hope that's not what's giving the backache to that other girl. There'll be something I haven't even thought of.

CTP: Well, can I come?

O'K: Well, of course!

CTP: I'll help you dress.

O'K: Well, I can dress in that pink dress. I can wear a white dress. We don't have to dress up and do anything special. Well, I've already given him the Ghost Ranch house, but he says I haven't done anything to prove it, so I've been called upon to sign something proving it. That's my back yard and then around it is my front yard.

Some people will say what a terrible thing this is we are doing. The people will gossip about us. They already have, haven't they?

CTP: Yes, but one mustn't live life worried about what people say about you, you know that.

O'K: Well, that's a nice broad way of looking. I just don't know if he won't feel a little funny attached to me in that way. And if we're going to do anything about it we have to do it soon.

CTP: Tomorrow?

O'K: [Laughs] Well, the sooner the better. And here that—what's her name—Anna Marie just gets ailing—as if it bothers her that much. You see, it makes a fine line of gossip. Well, you've been to the kitchen. You've seen what she's like.

CTP: She seems very tired.

O'K: Tired? Anna Marie? Well, I don't think this business is what's making her tired.

CTP: What?

O'K: I don't know but I know there'll be something. I don't know what'll be done with all of that machinery up at the ranch. I suppose he'll put it in one of the buildings here. There is a lot of machinery of one kind and another.

CTP: Do you want to talk to Dr. Friess about it?

O'K: Well, I could telephone if I could get my ear [her hearing aid] so it works. I guess that's one of the better things to do, isn't it?

CTP: Well, why don't you get Juan to call her tomorrow?

[Very long pause]

O'K: And you see the way we live is he has the upstairs and I haven't gone up because it's so hard, but he just races up and lies on his bed to rest.

And if he should die and leave all this to be divided among his family, that's another item I just thought of.

CTP: And maybe you . . .

O'K: Well, I would only have half. Which I don't especially mind, but it's a fact. That light up there is very bright. I never thought of her getting her backache because of this idea which he has undoubtedly told her about. And you know, it's halfway done if you start talking to one person or another about it.

[I got up to close the window and door.]

O'K: Did you lock it? That's the door he will use to come in if he has forgotten his key, which he probably has. Candelaria, she has hurt her foot?

CTP: Yes.

O'K: So she can't cook?

CTP: No.

O'K: Well, that's too bad. It never occurs to me that I own this big house. Don't you think it's a little funny?

CTP: Why?

O'K: [Laughs] Well, it's a very big house and I always think of it as his house.

CTP: Why?

O'K: Well, he has all the say about everything. Everybody asks him about what they should do.

CTP: Even you?

O'K: Well, I am sort of funny that I can't walk around alone and I have to have someone with me.

I go through the gate and I stand on the other side until the person on the other side closes it and has it settled and goes to the house [this was a routine in Abiquiu]. Now, I haven't gotten up a habit here like that at this house.

CTP: Maybe when you do, it will seem more like your house . . . when you do more living in the other rooms.

O'K: Yes, they object to the arrangement of the kitchen and stove and all of that.

CTP: Yes they do.

O'K: And if that little house of his on the hill [in Barranca] . . . I wonder if that's half mine?

CTP: If you get married?

O'K: Yes. I don't care if it is or not. There's what you think and wish and there's also the legal end of it. Now if I give up the house and half of it is his and half of it is mine, that makes a difference. But I don't have any feeling of ownership. And I've talked to you forward and backward, haven't I?

CTP: It's O.K. It's been interesting. Does the idea of getting married make you happy?

O'K: [Laughs] It makes me puzzled.

CTP: Why puzzled?

O'K: Well, it is a kind of a puzzle when you've had a husband for twenty years to go to him in the winters and stay in Abiquiu in the spring and summers. You establish something. I'd been out here summertime and always gone back for the fall and winters, and he was a very special person.

CTP: Stieglitz?

O'K: Yes.

CTP: So that makes you puzzled?

O'K: Well, it is puzzling.

CTP: Because of the memory of Stieglitz?

O'K: Oh no, that doesn't bother me.

[Long pause]

But I think if he would die I would have half right to everything he has, wouldn't I?

CTP: I think so. It's complicated though.

O'K: And he's always so afraid I will die and leave him. He said, "What am I going to do if you're not around?" I wonder if his wife has to be legally disattached from him.

CTP: Well, I think so . . .

O'K: I can't feel very gay about that kind of a marriage. It just doesn't feel very gay.

CTP: Is Juan gay about it?

O'K: Well, I think he's more interested in it than I am because he's giving up his rights.

CTP: What rights?

O'K: That's what I was just thinking. Well, he has a right with the people on the place. I don't pretend to have any rights with them. His opinion goes.

And I think it will still go. There's evidently everybody who does things on the place . . . dilapidated . . . [the rest was lost, couldn't hear]

I wonder if he'll come back tonight. Well, my seat is getting tired. I just noticed.

[Got ready for bed]

The things I told you were funny, weren't they? Well, we didn't get the hair combed, but that we just can't help. You know, I think if I could rub it [Anna Marie's back is what I believed she meant], I could do it a lot of good.

[Went to bed]

Roxana Robinson, in her book *Georgia O'Keeffe: A Life* (1989), in discussing the possibly undue influence brought to bear on O'Keeffe in her last years to change her will, tells how attorney David Cunningham, retained by the state of New Mexico to look into the possibility of having the state accept Hamilton's offer to give the Museum of New Mexico $1.5 million worth of artwork from the O'Keeffe estate in lieu of paying taxes, came upon "the transcript of an exchange between O'Keeffe and a nurse." She calls the report of this exchange, within the context of the full report prepared for Cunningham by a former FBI agent, "an electrifying passage, which altered irrevocably the public perception of the Hamilton–O'Keeffe relationship."

O'Keeffe told Christine after the conversation she wrote down that when she wanted to discuss the proposed marriage with Dr. Friess by calling her long distance, Hamilton didn't think it was a good idea. She also speculated about what was happening with Hamilton's marriage to Anna Marie.

She seemed to be getting more and more distant, and yearning for the Abiquiu house and for Ghost Ranch. She was very wistful about those places many times. She used to say, "I want to go to Ghost Ranch. Will you take me to Ghost Ranch?" and she made the statement once, "I'll probably never see Ghost Ranch again."

On that Wednesday morning in August, O'Keeffe, possibly in reaction to the increased restlessness in the house, slept considerably later than usual. Upon awakening, she insisted on a few more minutes before rising. Hamilton came into the room suddenly and wanted O'Keeffe ready on the spot. They had important business to take care of.

O'Keeffe sat on the couch barely eating a piece of toast. Christine reminded her that her New York lawyer was coming, as he had the previous afternoon. She murmured, "Oh yes. I suppose I should wear the white kimono today."

From *Miss O'Keeffe*

237

While O'Keeffe finished her toast, Christine went to get her clothes, wishing this once that her clothes were not kept so far away from her room. As requested, she chose the long white kimono with its full, billowing sleeves. She then bathed and dressed O'Keeffe in record time, both of them agitated by then, fumbling everything, trying to make certain she was ready quickly, making sure her braid looked particularly fine. She took the lace handkerchief and held it.

"You'd think they could just wait until we were ready," O'Keeffe said, and then became silent.

The two of them sat together on the couch, finally ready. O'Keeffe took hold of Christine's hand for a few minutes. They waited all morning. Christine searched for Hamilton several times; she was finally told by Pita (Lopez, Candelaria's daughter) that he had left—that he had driven the lawyer out to his Tesuque studio to show him some of his sculptures.

When they returned, everyone had lunch in the dining room. There was no apology for having kept O'Keeffe waiting, but during lunch Hamilton laughed and said, "We should go out dancing tonight and celebrate, eh, Georgia?"

She took a short nap. Her Santa Fe lawyer had arrived and Hamilton and the two lawyers went to the living room to talk. O'Keeffe was restless, so Christine stayed nearby. She was enjoying the breeze coming in from the grassed courtyard, but eventually closed that door as well as the one leading into the dining room to muffle the noise, hoping O'Keeffe could get some rest.

Before long, O'Keeffe was up and Christine was brushing her hair, braiding it again, washing her face with a cloth. "Georgia, this place is hopping today, isn't it?" Christine remarked. "Well wait until you see the festivities this afternoon," she replied without explaining herself. A knock on the courtyard door startled Christine, as people seldom used the door from that side. She opened it to see a tall, elderly man.

"I'm Judge Seth," the man said. "I'm here to see Juan. Hello, Georgia." Her face lit up, visibly happy to see an old friend.

He sat down on the couch next to her, taking her hand. Christine left the room to find Hamilton. Pita told her he was in his office so Christine gave her the information that Judge Seth had arrived and, curious, asked what was going on. "I don't know, Christine. Nobody ever tells me anything." She and Candelaria appeared to be getting ready to leave for Abiquiu.

Christine returned to O'Keeffe's room when she heard Hamilton's voice as he emerged from his office. Judge Seth joined Hamilton and the others in the living room. Soon they were engaged in animated talk, discussing the provisions of the will.

That day Christine left at 3:00 P.M. Judge Seth had already left, to Georgia's protests. "I'll have to come back," he told her, adding that there were some papers he had to get. "That's not good enough," she had responded, laughing. The Santa Fe lawyer had left earlier. As Christine was driving off, a woman drove in swiftly, followed closely by the lawyer in another car.

Christine was off the schedule for that afternoon and the whole of the next day. When she returned at seven o'clock the following morning, O'Keeffe was still asleep and, once again, reluctant to rise. Christine was alarmed at her disposition when she finally got up. For an hour she was very sour, scowling, snapping at Christine, calling her by other names. Christine had been worried about her for about ten days, having recorded in the nursing log that she seemed less coherent, more detached and tired than usual, more confused. Her posture was slumped, she showed a lack of appetite. On this day she tightly clenched her handkerchief.

After watching her, Christine asked if she wouldn't like to lie down again to relax, but O'Keeffe said nothing, as though she hadn't heard, her lower lip protruding more. Worried and mystified, Christine asked her how the day before had gone.

"I could've done without it," O'Keeffe said. She remained essentially silent the rest of the morning, and never mentioned the day again.

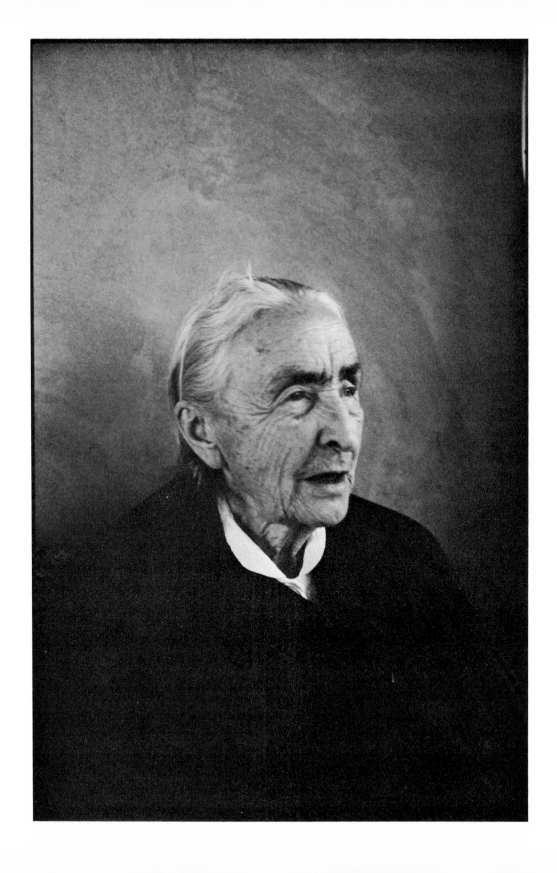

O'Keeffe Left to Herself

Marvin Bell

It was particularly fine at night
with the stars above the tree.
 —O'Keeffe, on several weeks she
 spent at the Lawrence ranch

1

Blue Lines are blue people, blue spines, and the one
with the angles has a midsection. Thus, already in 1916,
O'Keeffe, who would never spill her guts, begins to.
From the Plains, I (and later *II*) are the views of one
crawling on her stomach toward streaks of a horizon.
In the center of the canyons is a living hell:
a painter, to know this of the earth and the sky,
would have had to have heard herself scream,
a whole scream, a scream that sends a shiver through
the *Evening Star,* pulling from the center of it
a red slime as slow as the path of a snail
and as pushed by gravity as the stairway of a nautilus.
Finally, light comes over the plains, into her eye,
as if it were the egg of the blue universe. And when

it leaves, it leaves behind a fabric, a lacework
behind which the stars show—or is it a mask?

Crows fly over the living hell of the canyon,
music parts the sheets which arch over the pelvis;
and in the midst of all lights, an insistent *Black Spot.*
She said she never knew from where it came.
She called it an idea, and one sees often that idea
through doors and windows, and in the egg, too,
of a city streetlamp, hanging before the moon.
Elsewhere, sunspots obliterate the faces of buildings.
One sees an iris inside the polluted sun
and can only imagine the red spot inside
her eggs of light and lamps and moons. It was
a confetti of sensation, New York and Stieglitz,
the combined beauty of the model and dispassionate
seduction of the lens. Oh how the *City Night* slid
between skyscrapers, and how they accepted it.
Then came the flowers, open to invitation,
welcome, discomfiting in their constant explosions,
the rose thrilling in its wide spread of entrance,
the orchid swirling, *The White Trumpet Flower*
engulfing the canvas, pushing, flattening.

2

Her will, the *Bleeding Heart,* a composite of associations,
the sunflower of New Mexico looking, staring,
while the pistils of calla lilies proclaim themselves
in sun colors among the soft, swooning petals,
and there returns the black spot to the poppy
and the *Black Iris,* black as a defunct bulb.

On her table, private, sheer, the alligator pear
sniffed at the painter's "unacceptable" colors,

while outside the crows defined Lake George
and one can see the bladder shape of it at last.

There were calm times, no less intense.
A streak of light that penetrates some leaves
of corn returns inside a Jack-in-the-Pulpit—
she moves in close and paints only the Jack.
There will be birches and barns and ordinary
views across the water at the distance of mortality,
as well as a message to a friend, she said,
that resembles a flattened white wing cast into space.
This image will echo her *Black Abstraction*
which followed her operation. We know only
that she lifted and dropped each arm in turn,
all the while watching the conspicuous skylight.
We know "only" that her every abstraction
rose from within, taking shapes of that which
has been lost—almost a way of sending forth
from the body the shadow of some negative.
For what is lost to love can never be regained,
though it flare briefly in hollyhock and larkspur
or—it comes to such a point—be acknowledged
at the top of a tree where one who has studied
the isolation of the feeling part of a flower
may see for the first time a net of constellations.

Afterwards, it was probably not enough.
There was the *Cow's Skull* with fractured jaw,
the puffy grey hills, the hills that lay like mounds
upon, one thought, the remains of beating hearts,
and then again a *Black Place* to paint into memory.

3

Among the flames, the silent scream of the desert,
her fragments took the place of innards, saying

more by the foreshortened distance of her eye
than a pinhole camera lens might capture over miles.
Naturally, her best cross is a *Black Cross,* standing
over the mostly orderly hills with final benevolence.
After that, the crosses come and go. One sees them
glimpsed in the horns of a ram's head, so when
the painter herself portrays a mightily antlered skull
as *From the Faraway Nearby* (an oil of 1937),
it seems that she has struck a bargain with her body.
In six years she will generate *Pelvis with Moon*;
in seven, a *Pelvis* that is mostly a blue hole in sky;
and in eight, a *Pelvis* of permanent red and yellow
absorbing the sun, barely abstaining from the pain
that appears around it in an open-ended yoke of red.

One looks back at the canvases of clam shells
(the *Closed Clam Shell* and the *Open Clam Shell*),
two things rocking on a spine—and the closed one
not wishing to open much, and the open one
so bare as not to have wished to open at all.
I don't say that she was a woman of regret,
for everyone must regret something—an empty
patio, a door with nothing but night behind it—
but still she whitened the patio and reddened
the door, and when she remembered the conjunction
of earth and sky, it was likely in the shape
of loving forms, lying together, crevasse to crevasse,
and I suppose that is why I sense her joyful fear
in the black relentless bird she saw over hills—
they were white with snow but red below;
and in the *Black Bird Series,* her *Black Spot*
of thirty-one years past, rises now again. The old—
light that honed itself to a point over hidden distances,
earth that rubbed itself raw over unfathomable time,
skulls and other bones that knew feeling now lost—
would have come and gone and come and gone,
and a painter might be left with the colors

of how things were, blue above and red down here,
and riverbeds scratched into deserts,
which she said she first saw from the air,
but may have seen beforehand from the ground,
looking up Lawrence's tree through the red branches
that ran away like young rivers, and above that
all the bright moments receding beautifully.

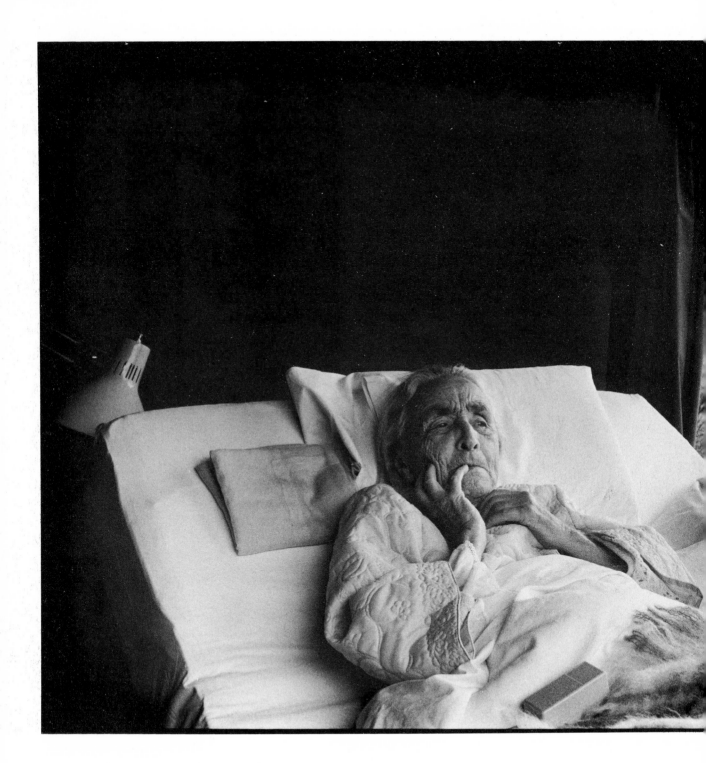

Notes

Introduction

1. Laurie Lisle, *Portrait of the Artist: A Biography of Georgia O'Keeffe* (Albuquerque: University of New Mexico, 1986), p. 25.
2. Ibid.
3. Letter from Georgia O'Keeffe to Anita Pollitzer, 14 October 1915, Collection of American Literature, Beinecke Rare Book and Manuscript Library, Yale University, New Haven. Copyright © 1989 Estate of Georgia O'Keeffe.
4. Ibid., 9 February 1916.
5. Dorothy Norman, *Stieglitz: An American Seer* (New York: Random House, 1960), p. 130.
6. Roxana Robinson, *Georgia O'Keeffe: A Life* (New York: Harper & Row, 1989), 155.
7. Henry Tyrrell, "New York Art Exhibition and Gallery Notes: Esoteric Art at '291,'" *Christian Science Monitor,* 4 May 1917, p. 10.
8. Letter from Georgia O'Keeffe to Henry McBride, 11 May 1928, Collection of American Literature, Beinecke Rare Book Library, Yale University, New Haven. Copyright © 1989 Estate of Georgia O'Keeffe.
9. Robinson, *Georgia O'Keeffe,* 368.
10. Ibid., 421.
11. *Georgia O'Keeffe: A Portrait by Alfred Stieglitz.* Introduction by Georgia O'Keeffe. (New York: Metropolitan Museum of Art, 1978) Copyright © 1978 The Metropolitan Museum of Art. Copyright © 1978 Estate of Georgia O'Keeffe.
12. Letter from Georgia O'Keeffe to Jean Toomer, 11 May 1934, Collection of American Literature, Beinecke Rare Book Library, Yale University, New Haven. Copyright © 1989 Estate of Georgia O'Keeffe.
13. Wassily Kandinsky, *Concerning the Spiritual in Art* (New York: Dover Publications, 1977), 1.
14. O'Keeffe to James Johnson Sweeney, 11 June 1945; printed in Cowart, Hamilton, and Greenough, *Georgia O'Keeffe,* 241.

O'Keeffe and the Masculine Gaze

1. At the Metropolitan, the O'Keeffe show was open to the public for sixty-eight days (19 November 1988 through 5 February 1989), drawing an average of 5,411 visitors a day; the Degas show was open for ninety-seven days (27 September 1988 through 8 January 1989), drawing around 5,561 visitors a day—that is, about 160 more per day than the O'Keeffe show.
2. Michael Brenson, "How O'Keeffe Painted Hymns to Body and Spirit," *New York Times,* 8 November 1988.

3. Jack Flam, "The Master on View at New Met Galleries," *Wall Street Journal,* 27 December 1988.

4. Teresa de Lauretis, *Alice Doesn't: Feminism, Semiotics, Cinema* (Bloomington: Indiana University Press, 1984).

5. Yann Lardeau, as quoted and translated by de Lauretis, *Alice Doesn't,* 26.

6. Alfred Stieglitz staged his own comeback as a photographer in 1921, with an exhibition featuring the ongoing study of O'Keeffe that he had begun in 1917. Those intimate photographs, in which she was often posed nude or lightly clad, fueled both the public perception that O'Keeffe was "oversexed" and the gossip about the artists' liaison. (Stieglitz, who enjoyed a reputation as something of a libertine, was not only much older than O'Keeffe but was at this time still married to his first wife.) What is now publicly available of O'Keeffe's private correspondence, including accounts of relationships with some men other than Stieglitz (the letters to him remain sealed), reveals a sensual and passionate woman, but not (by present standards) an abnormally or pathologically sexual one. Sensationalized attention to O'Keeffe's sexuality persists, however. See Benita Eisler, "Scenes from a Marriage," *Mirabella,* July 1989, 178–87 (part of a forthcoming biography). Eisler makes numerous undocumented claims.

7. See Jack Cowart, Juan Hamilton, and Sarah Greenough, *Georgia O'Keeffe: Art and Letters* (Washington, D.C.: National Gallery of Art, 1987). Further (though a more minor point), the banner for the show on the Metropolitan's main facade spelled out "Georgia O'Keeffe 1887–1986," by contrast with the banner that said simply, boldly, "DEGAS."

8. Lewis Mumford, "O'Keefe [*sic*] and Matisse," *New Republic,* 2 March 1927, 41 (hereafter cited without reference to the error in the source).

9. Allan Burroughs, *New York Sun,* 3 February 1923; reprinted in *Alfred Stieglitz Presents Fifty-one Recent Pictures: Oils, Water-colors, Pastels, Drawings, by Georgia O'Keeffe, American* [exhibition brochure] (New York: Anderson Galleries, 1924), n.p.

10. William Murrell Fisher, "Georgia O'Keeffe Drawings and Paintings at '291,'" *Camera Work* (1917); reprinted in *Camera Work: A Critical Anthology,* ed. Jonathan Green (Millerton, N.Y.: Aperture, 1973), 328.

11. Search-Light, *Time Exposures* (New York: Boni and Liveright, 1926), 32. Waldo Frank, who used the pseudonym "Search-Light," also described O'Keeffe as a tree: "If a tree thinks, it thinks not with a brain but with every part of it. So O'Keeffe" (pp. 34–35).

12. Mumford, "O'Keefe and Matisse," 41.

13. Paul Rosenfeld, "Georgia O'Keeffe," *Port of New York* (1924; reprint, Urbana: University of Illinois Press, 1961), 204.

14. Because it conflicts with her image as an intuitive, O'Keeffe's appetite for books tends to get suppressed in the literature. In a recent volume of early correspondence, most of her many references to what she was reading (from 1915 through 1917) were excised from the published versions of her letters. Her reading at the time included *The Masses,* Aldous Huxley, Wassily Kandinsky, H. G. Wells, Willard Huntington Wright, Clive Bell, John Synge, Euripides' *The Trojan Women,* Anton Chekhov, Percy Bysshe Shelley, Dante's *Divine Comedy,* Goethe's *Faust, The Seven Arts, Forerunner,* Charlotte Perkins Gilman, Henrik Ibsen, and Friedrich Nietzsche, among other things. See Anita Pollitzer, *A Woman on Paper: Georgia O'Keeffe: The Letters and Memoir of a Legendary Friendship*

(New York: Simon and Schuster/Touchstone, 1988).

15. Statement by O'Keeffe in *Alfred Stieglitz Presents One Hundred Pictures: Oils, Water-colors, Pastels, Drawings, by Georgia O'Keeffe, American* [exhibition brochure] (New York: Anderson Galleries, 1923), n.p.

16. Letter from O'Keeffe to Sherwood Anderson, September 1923[?]; printed in Cowart, Hamilton, and Greenough, *Georgia O'Keeffe,* 174. The artist's imperfect punctuation has been left intact throughout.

17. On 14 October 1915, Anita Pollitzer wrote excitedly to O'Keeffe (then nicknamed Patsy, Pat, or occasionally Patrick) about her most experimental works to date: "They made me feel—I swear they did—They have emotions that sing out or holler as the case may be . . . They've all got feeling Pat—written in red right over them—no one could possibly get your meanings . . . but the Mood is there everytime . . . The crazy one—all lines & colors & angles— . . . it pleases me tremendously . . . It screams like a maniac & runs around like a dog chasing his tail" (Pollitzer, *A Woman on Paper,* 27).

18. Henry McBride wrote: "There were more feminine shrieks and screams in the vicinity of O'Keeffe's work this year than ever before. I begin to think that in order to be quite fair to Miss O'Keeffe I must listen to what women say of her—and take notes" ("Modern Art," *Dial,* May 1926, 437).

19. Henry Tyrrell, "Esoteric Art at '291,'" *Christian Science Monitor,* 4 May 1917, quoted in Laurie Lisle, *Portrait of an Artist: A Biography of Georgia O'Keeffe* (New York: Washington Square Press, 1980), 106; Paul Rosenfeld, "American Painting," *Dial,* December 1921, 666–67; and Lewis Mumford, "O'Keefe and Matisse," 41–42.

20. Edmund Wilson, "The Stieglitz Exhibition," *New Republic,* 18 March 1925, 97; Wilson was comparing O'Keeffe favorably to Marin, Hartley, Dove, and Demuth in a review of a group show called "Seven Americans." Henry McBride, "Georgia O'Keeffe," *New York Herald,* 4 February 1923; reprinted in *The Flow of Art: Essays and Criticisms of Henry McBride,* ed. Daniel Catton Rich (New York: Atheneum, 1975), 168.

21. Clement Greenberg, "Review of an Exhibition of Georgia O'Keeffe," *Nation,* 15 June 1946; reprinted in *Clement Greenberg: The Collected Essays and Criticism, vol. 2: Arrogant Purpose, 1945–1949,* ed. John O'Brian (Chicago: University of Chicago Press, 1986), 87.

22. Letter from O'Keeffe to Waldo Frank, 10 January 1927; printed in Cowart, Hamilton, and Greenough, *Georgia O'Keeffe,* 185.

23. O'Keeffe to Mabel Dodge Luhan, September 1929; ibid., 199.

24. O'Keeffe to Waldo Frank, 10 January 1927; ibid., 185.

25. O'Keeffe to James Johnson Sweeney, 11 June 1945; ibid., 241.

26. Quoted in Blanche Matthias, "Stieglitz Showing Seven Americans," *Chicago Evening Post,* 2 March 1926; cited in Lisle, *Portrait,* 162.

27. An unnamed *Camera Work* reviewer wrote of the first showing of O'Keeffe's work in 1916 (an exhibition with two other artists at 291, arranged by Stieglitz without her knowledge), "In spite of the lateness of the season . . . this exhibition, mainly owing to Miss O'Keeffe's drawings, attracted many visitors and aroused unusual interest and discussion" (quoted in Pollitzer, *A Woman on Paper,* 138). The *New York Sun* reported that her first major solo show, in 1923, drew five hundred people

daily (Pollitzer, ibid., 183). When Stieglitz mounted a gallery retrospective of her work in January 1934, seven thousand people attended (Lisle, *Portrait,* 269). In her lifetime, O'Keeffe had major museum retrospectives in Chicago in 1943, at the Museum of Modern Art in 1946, at the Amon Carter Museum of Western Art in Fort Worth in 1966, and at the Whitney Museum in 1970.

With his exclusionary or anti-populist bent, Stieglitz had difficulty with his other artists in building a sufficient public to assure them of a living, but with O'Keeffe he had the opposite problem—keeping the public at bay. From 1927 on, O'Keeffe supported herself entirely on the sales of her work; see Mary Lynn Kotz, "Georgia O'Keeffe at Ninety," *Art News,* December 1977, 44. By 1935 or 1936 she was fully supporting Stieglitz as well (just as his first wife had, though on an inherited income); see Sue Davidson Lowe, *Stieglitz: A Memoir-Biography* (New York: Farrar, Straus and Giroux, 1983), 52–53.

O'Keeffe's paintings have always brought high prices. Because she and Stieglitz both disliked parting with her work, he preferred to sell fewer paintings at higher prices rather than the other way around. "[T]hree thousand dollars' worth [of pictures] were sold" from her 1923 show, "perhaps adding up to half a dozen pictures" (Lisle, *Portrait,* 142). In 1927 she exhibited thirty-six paintings, and in the first few days six were sold for prices up to $6,000 each. In 1928 a French collector bought six small calla lily paintings (of 1923) for $25,000, and the tabloids picked up the story. More recently, a painting of poppies brought $120,000 in 1973, and at auction in 1987 two O'Keeffe works went for $1.9 million and $1.4 million. See Rita Reif, "Record Price for a Work by O'Keeffe," *New York Times,* 4 December 1987.

28. The exception is a series of watercolors of her own body done in 1917 and sent to Stieglitz. O'Keeffe despised life drawing, finding the customary use of the model by artists mortifying and degrading. See Georgia O'Keeffe, *Georgia O'Keeffe* (New York: Viking, 1976; New York: Penguin Books, 1985), n.p.

29. Luce Irigaray, *Speculum of the Other Woman,* trans. Gillian C. Gill (Ithaca, N.Y.: Cornell University Press, 1985), 22–23, 29, and passim. Significantly, around the time O'Keeffe began painting, Karen Horney was already challenging Freud's phallocentric view of women's sexuality in favor of a specifically feminine, vaginal sexuality.

30. Mumford, "O'Keefe and Matisse," 42. (Stieglitz reprinted this passage in the brochure for an O'Keeffe exhibition at the Intimate Gallery in 1928.) Not everyone was so direct, however. The effusive Rosenfeld described how "rigid, hard-edged forms traverse her canvases like swords through cringing flesh. Great rectangular menhirs plow through veil-like textures; lie in the midst of diaphanous color like stones in quivering membranes" ("The Paintings of Georgia O'Keeffe," *Vanity Fair,* October 1922, 112).

31. McBride, "Georgia O'Keeffe," 167.

32. John d'Emilio and Estelle B. Freedman, *Intimate Matters: A History of Sexuality in America* (New York: Harper and Row, 1988), 233. The battle for the political self-determination of women through suffrage is, of course, no less a factor in the 1910s. As for O'Keeffe's role in the women's movement, although some feminists complained in the 1970s of her poor feminist consciousness, she was for many decades (when there was far less support for such a stance) a vociferous feminist. She read feminist literature,

belonged to the National Woman's Party from 1913 through World War II (and was a featured speaker at their convention in 1926), and lobbied for the equal rights amendment. See Lisle, *Portrait*, 73; and letter from O'Keeffe to Eleanor Roosevelt, 10 February 1944 (printed in Cowart, Hamilton, and Greenough, *Georgia O'Keeffe*, 235).

33. O'Keeffe, *Georgia O'Keeffe*, n.p.

34. O'Keeffe, "About Painting Desert Bones," in "Georgia O'Keeffe: Paintings, 1943" [exhibition brochure] (New York: An American Place, 1944), n.p.

35. Louis Kalonyme, "Georgia O'Keeffe, *Creative Art*, January 1928, xi; Rosenfeld, "O'Keeffe," 203–4.

36. Lisle, *Portrait*, 93.

37. See Alfred Stieglitz, "Notes on 'Woman in Art,' 1919," quoted in Dorothy Norman, *Alfred Stieglitz: An American Seer* (Millerton, N.Y.: Aperture, c. 1973), 137. Rosenfeld, who shared Stieglitz's view, resumed this theme in his writings on O'Keeffe: "Women . . . always feel, when they feel strongly, through the womb. . . . In the womb lies the race" ("American Painting," *Dial*, December 1921, 666).

38. Lisle, *Portrait*, 160. Stieglitz's grandniece, Sue Davidson Lowe, observed, "Pessimism over money contributed heavily, no doubt, to the firmness with which Alfred turned down repeated importunings [from others in the family as well as O'Keeffe herself] to grant Georgia's wish to have a child" (Lowe, *Stieglitz*, 247). His rationalizations also included "his proven failure as a father" (p. 248). What finally closed discussion of the matter, by this account, was the institutionalization in 1923 of Stieglitz's daughter (by his first wife) for postpartum dementia praecox, from which she never recovered (p. 248).

39. O'Keeffe complained, "I think I would never have minded Stieglitz being anything he happened to be if he hadn't kept me so persistently off my track," in a letter to Mabel Dodge Luhan (July 1929, Beinecke Library, Yale University). After Stieglitz died, she disclosed, "Alfred once admitted that he was happiest when I was ill in bed because he knew where I was and what I was doing" (Lowe, *Stieglitz*, 323). Further, O'Keeffe became ill rather regularly on the occasion of her annual shows. In 1932, O'Keeffe suffered a severe breakdown after Stieglitz interfered with her executing a commission she had eagerly accepted to paint murals in the women's powder room at Radio City Music Hall; he reportedly told the designer in charge of the decoration for the project that O'Keeffe was "a child and not responsible for her actions" in agreeing to the commission (Lisle, *Portrait*, 258–61).

40. Lisle, *Portrait*, 189. When Stieglitz closed 291 in 1917, giving O'Keeffe the final show there, he declared, "Well I'm through, but I've given the world a woman" (ibid., 107). O'Keeffe once suggested that a curator working on a catalogue essay "put in a sentence to the effect that he [Stieglitz] did not know me personally when he gave me the 2 shows at 291—It often sounds as if I was born and taught to walk by him—and never thought of painting till he worked on me" (letter from O'Keeffe to Carl Zigrosser, April 1944; printed in Cowart, Hamilton, and Greenough, *Georgia O'Keeffe*, 236). What galled her most, as Lowe describes it, was "the continuing suggestion that she was a Galatea brought to life by Alfred's Pygmallion, a suggestion to which . . . Alfred himself seemed secretly to subscribe" (p. 258). Or not so secretly: when he organized major shows of O'Keeffe's work at the Anderson Galleries in 1923 and 1924,

the brochures were headlined "Alfred Stieglitz Presents . . . Pictures . . . By Georgia O'Keeffe . . . ," with his name in letters the same size as hers.

41. By O'Keeffe's account, Stieglitz initially refused to show the skyscraper paintings—surely among the most compelling images ever painted of New York City—on the grounds that she should keep to subjects more befitting her gender; see O'Keeffe, *Georgia O'Keeffe,* n.p. The first enlarged flower was done in 1924, shown in 1925. Stieglitz reportedly said of it: "I don't know how you're going to get away with anything like that—you aren't planning to show it, are you?" (Lisle, *Portrait,* 171).

42. Letter from O'Keeffe to Pollitzer, 4 January 1916; printed in Cowart, Hamilton, and Greenough, *Georgia O'Keeffe,* 147. A subsequent letter closed with the confession: I want real things—live people to take hold of . . . Music that makes holes in the sky—and Anita—I want to love as hard as I can and I can't let myself— When he is far away I can't feel sure that he wants me to—even though I know it—so Im only feeling lukewarm when I want to be hot and cant let myself" (ibid., O'Keeffe, letter to Pollitzer, Jan. 4, 1916, Cowart et al., O'Keeffe, p. 149). The word *sure* is underlined three times in the original.

43. O'Keeffe, 1925[?] letter in Cowart, Hamilton, and Greenough, *Georgia O'Keeffe,* 180. The essay Mabel Dodge Luhan wrote was never published; it represented O'Keeffe's art as the unknowing excrescences of a repressed woman in thrall to Stieglitz. The four-page manuscript (Beinecke Library, Yale University) suggested that O'Keeffe

externalizes the frustration of her true being out on to canvases

which, receiving her out-pouring sexual juices, lost while in the sleep of Unconscious Art, permit her to walk this earth with the cleansed, purgated look of fulfilled life! . . . The deposits of art, then, lie all about us, no more significant than the other deposited accretions and excrements of our organisms. . . . The art of today . . . the art in these "Intimate" galleries . . . [is] among the other "comfort stations" of our civilized communities. . . . This woman's sex, Stieglitz, it becomes yours upon these canvases. Sleeping, then, this woman is your thing. . . . [W]e others, we go to look on this filthy spectacle of frustration that you exalt and call by the name of Art. . . . Let live this somnolent woman by your side.

44. Letter from O'Keeffe to Anderson, September 1923?; printed in Cowart, Hamilton, and Greenough, *Georgia O'Keeffe,* 174.

45. de Lauretis, quoting and amplifying a phrase from Catherine MacKinnon, *Alice Doesn't,* 184.

46. Marsden Hartley, "Some Women Artists," in *Adventures in the Arts* (New York: Boni and Liveright, 1921), 116–17; Rosenfeld, "American Painting," 666; and Kalonyme, "O'Keeffe," xi. The notion, suggested by Kalonyme, that in representing women's sexuality, she was also imaging their masochistic nature—the idea that women characteristically take pleasure from pain—is another topos of the O'Keeffe literature. Wrote Rosenfeld (to take another example), "Darkly, purely painted flower and fruit pieces have not a little sorrow. Pain treads upon the recumbent figure. Pain rends the womb to shreds

with knives. Pain studs the universe with shark's teeth" ("O'Keeffe," 207).

47. Oscar Bluemner, "A Painter's Comment," in *Georgia O'Keeffe Paintings, 1926* [exhibition catalogue] (New York: Intimate Gallery, 1927); reprinted in *Georgia O'Keeffe: Exhibition of Paintings, 1919–1934* [exhibition catalogue] (New York: An American Place, 1935), n.p.

48. Klaus Theweleit, *Women, Floods, Bodies, History,* vol. 1 of *Male Fantasies,* trans. Stephen Conway (Minneapolis, Minn.: University of Minnesota Press, 1987), 284.

49. "Art: Austere Stripper," *Time,* 27 May 1946, 74; Mark Stevens, "Georgia on My Mind," *Vanity Fair,* November 1987, 72, 76.

50. Letter from Stieglitz to O'Keeffe, 31 March 1918; quoted in Pollitzer, *A Woman,* 159.

51. Hartley, "Some Women Artists," 116–17.

52. Rosenfeld, "O'Keeffe," 202, 205.

53. Rosenfeld, "American Painting," 666. This notion that women do not, will not, and so, perhaps, cannot describe their orgasms became an idée fixe also of Jacques Lacan, who told how, on his knees, he had begged women analysts "to try to tell us about it, well, not a word! We have never managed to get anything out of them" (Jacques Lacan, "God and Jouissance of The Woman," in *Feminine Sexuality: Jacques Lacan and the École Freudienne,* eds. Juliet Mitchell and Jacqueline Rose, trans. Jacqueline Rose [New York: Pantheon, 1985], 146). For Lacan, as for Stieglitz, women's "jouissance" represented a moment of experience potentially "over and above the phallic term"; Woman served in a mystical way as an epigone of nature and so as a site of truth.

54. When O'Keeffe first saw Hartley's article about her, she recalled, "I almost wept. I thought I could never face the world again" (Grace Glueck, "'It's Just What's in My Head,'" *New York Times,* 18 October 1970). In a fall 1922 letter to Mitchell Kennerley, she said she felt embarrassed by Hartley's and Rosenfeld's articles, that she did not recognize herself in them, and, significantly, that they gave her "a queer feeling of being invaded" (in Cowart, Hamilton, and Greenough, *Georgia O'Keeffe,* 171).

55. McBride, "O'Keeffe," 166.

56. Ibid., 167.

57. Murdock Pemberton, "The Art Galleries," *New Yorker,* 13 March 1926, 36–37; Pemberton, "The Art Galleries," *New Yorker,* 20 February 1926, 40.

58. Irigaray, *Speculum,* 50.

59. Ibid., 105.

60. Jacques Lacan, "The Meaning of the Phallus," in Mitchell and Rose, eds., *Feminine Sexuality,* 81. As Irigaray describes it, "Woman does not so much choose an object of desire for herself as she lets herself be chosen as an 'object'" (*Speculum,* 104).

61. de Lauretis, *Alice Doesn't,* 15.

62. Janet Hobhouse, "A Peculiar Road to Sainthood," *Newsweek,* 9 November 1987, 74.

63. O'Keeffe was both self-identified and identified as a feminist from the outset. The *Nation* reported in 1927, "If Georgia O'Keeffe has any passion other than her work, it is her interest and faith in her own sex. . . . She believes ardently in woman as an individual—an individual not merely with the same rights and privileges of man but . . . with the same responsibilities. And chief among these is the responsibility of self-realization" (Frances O'Brien, "Americans We Like: Georgia O'Keeffe," *Nation,* 12 October 1927, 362). Paul Strand wrote a few years earlier of

that kind of intensity which burns women [*sic*] like Carrie Nation, Pankhurst, and Emma Goldman, which has become organized and philosophic in the paintings of O'Keeffe. . . . [H]er work stands as the first veritably individualized expression by a woman, in plastic terms, which is differentiated from, yet meets comparison with the best work of men. . . . [W]omen have indeed set out upon a search for their own particular Grail. Georgia O'Keeffe is . . . releasing in her work, the deepest experiences of her search ("Georgia O'Keeffe," *Playboy,* 9 July 1924, 19–20).

The Language of Criticism: Its Effect on Georgia O'Keeffe's Art in the 1920s

1. Georgia O'Keeffe, statement in *Alfred Stieglitz Presents One Hundred Pictures: Oils, Water-colors, Pastels, Drawings, by Georgia O'Keeffe, American* [exhibition brochure] (New York: Anderson Galleries, 1923), n.p.; reprinted in Barbara Buhler Lynes, *O'Keeffe, Stieglitz and the Critics: 1916–1929* (Ann Arbor: UMI Research Press, 1989; Chicago: University of Chicago Press, 1991), app. A, no. 11, pp. 184–85.
2. By 1915 she had absorbed the ideas of John Vanderpoel, William Merritt Chase, and Arthur Wesley Dow, her teachers at, respectively, the Art Institute of Chicago (1905–6), the Art Students League (1907–8), and Teachers College, Columbia University (1914–15).
3. They met in late May or early June 1916. Although, when O'Keeffe was a student at the Art Students League, she saw the January 1908 Rodin exhibition at 291, she did not, at that time, make Stieglitz's acquaintance.

For her account of this early visit to 291, see Georgia O'Keeffe, *Georgia O'Keeffe* (New York: Viking Press, 1976; New York: Penguin Books, 1985), n.p.
4. Letter from Anita Pollitzer to O'Keeffe, 1 January 1916, Collection of American Literature, Yale University, New Haven; printed in *Lovingly, Georgia: The Complete Correspondence of Georgia O'Keeffe and Anita Pollitzer,* ed. Clive Giboire (New York: Touchstone/Simon and Schuster, 1990), 115–16; and with slight variations in Jan Garden Castro, *The Art and Life of Georgia O'Keeffe* (New York: Crown Publishers, 1985), 30–31.
5. See [Alfred Stieglitz], "Georgia O'Keeffe—C. Duncan—Réné [*sic*] Lafferty," *Camera Work,* October 1916, 12–13; reprinted in Lynes, *O'Keeffe, Stieglitz,* app. A, no. 2, pp. 166–67.
6. The essay was first published in Dorothy Norman, *Alfred Stieglitz: An American Seer* (New York: Random House, 1973), 136–38.
7. See Marsden Hartley, in *Adventures in the Arts: Informal Chapters on Painters, Vaudeville, and Poets,* intro. Waldo Frank (New York: Boni and Liveright, 1921; New York: Hacker Art Books, 1972), 116–19; and Paul Rosenfeld, "American Painting," *Dial,* December 1921, 666–70, and "The Paintings of Georgia O'Keeffe: The Work of the Young Artist Whose Canvases Are to Be Exhibited in Bulk for the First Time This Winter," *Vanity Fair,* October 1922, 56, 112, 114; reprinted in Lynes, *O'Keeffe, Stieglitz,* app. A, nos. 5–6, 8, pp. 170–79.
8. Hartley, *Adventures in the Arts,* 116.
9. In Norman, *Stieglitz: Seer,* 137.
10. Rosenfeld, "American Painting," 666–67.
11. In their reviews, Alan Burroughs and Helen Appleton Read, for example,

included Hartley's phrase—"shameless private documents"—and Henry McBride's and Elizabeth Luther Cary's reprinted his most dramatic sentence: "Georgia O'Keeffe has had her feet scorched in the laval effusiveness of terrible experience; she has walked on fire and listened to the hissing of vapors round her person" ([Alan Burroughs], "Studio and Gallery," *New York Sun,* 3 February 1923, 9; Helen Appleton Read, "Georgia O'Keeffe's Show an Emotional Escape," *Brooklyn Daily Eagle,* 11 February 1923, 2B; Henry McBride, "Art News and Reviews—Woman as Exponent of the Abstract: Curious Responses to Work of Miss O'Keefe [*sic*] on Others; Free without Aid of Freud, She Now Says Anything She Wants to Say—Much 'Color Music' in Her Pictures," *New York Herald,* 4 February 1923, sec. 7, p. 7; and [Elizabeth Luther Cary], "Art—Competitions, Sales, and Exhibitions of the Mid-Season: Georgia O'Keeffe, American," *New York Times,* 4 February 1923, sec. 7, p. 7; reprinted in Lynes, *O'Keeffe, Stieglitz,* app. A, nos. 12, 17, 13–14, pp. 185–86, 191–92, 186–89).

12. Alexander Brook pointed out that O'Keeffe "painted with her very body," and Herbert Seligmann wrote that "her body acknowledges its kindred shapes and renders the visible scene in those terms" (Alexander Brook, "February Exhibitions: Georgia O'Keefe [*sic*]," *The Arts,* February 1923, 130; Herbert J. Seligmann, "Georgia O'Keeffe, American," *MSS.,* March 1923, 10; reprinted in Lynes, *O'Keeffe, Stieglitz,* app. A, nos. 19–20, pp. 194–96).

13. Rosenfeld, "The Paintings of Georgia O'Keeffe," 112.

14. Letter from O'Keeffe to Mitchell Kennerley, fall 1922, Mitchell Kennerley Papers, Rare Books and Manuscripts Division, New York Public Library, Astor, Lenox, and Tilden Foundations; printed in Jack Cowart, Juan Hamilton, and Sarah Greenough, *Georgia O'Keeffe: Art and Letters* (Washington, D.C.: National Gallery of Art, 1987), letter 28, pp. 170–71. Throughout, O'Keeffe's words have been quoted exactly as they appear in the sources cited, without calling attention to irregularities of spelling or punctuation.

15. Georgia O'Keeffe, statement in *Alfred Stieglitz Presents Fifty-one Recent Pictures: Oils, Water-colors, Pastels, Drawings, by Georgia O'Keeffe, American* [exhibition catalogue] (New York: Anderson Galleries, 1924), n.p.; reprinted in Lynes, *O'Keeffe, Stieglitz,* app. A, no. 22, pp. 197–98.

16. Letter from O'Keeffe to Sherwood Anderson, 11 February 1924, Sherwood Anderson Papers, Newberry Library, Chicago; printed in Cowart, Hamilton, and Greenough, *Georgia O'Keeffe,* letter 30, pp. 175–76.

17. That O'Keeffe's abstractions became increasingly related to identifiable forms in the late 1920s has been noted by Lisa M. Messinger (*Georgia O'Keeffe* [New York: Metropolitan Museum of Art, 1989], 41–42).

18. For a discussion of O'Keeffe's decision to paint large-format flower paintings, her attitude toward them, and the response of the critics, see Barbara Buhler Lynes, "O'Keeffe and Feminism: A Problem of Position," in *The Expanding Discourse: Feminism and Art History,* ed. Norma Broude and Mary D. Garrard (New York: HarperCollins, forthcoming).

19. Margaret Breuning, "Seven Americans," *New York Evening Post,* 14 March 1925, sec. 5, p. 11; reprinted in Lynes, *O'Keeffe, Stieglitz,* app. A, no. 35, pp. 224–25.

20. "Exhibitions in New York: Georgia O'Keeffe, Intimate Gallery," *Art*

News, 13 February 1926, 8; reprinted in Lynes, *O'Keeffe, Stieglitz,* app. A, no. 45, pp. 240–43.

21. Henry McBride, "Georgia O'Keeefe's [sic] Work Shown: Fellow Painters of Little Group Become Fairly Lyrical over It," *New York Sun,* 15 January 1927, 22B; partially reprinted in Lynes, *O'Keeffe, Stieglitz,* app. A, no. 58, pp. 258–59.

22. "I Can't Sing, So I Paint! Says Ultra Realistic Artist; Art Is Not Photography—It Is Expression of Inner Life!: Miss Georgia O'Keeffe Explains Subjective Aspect of Her Work," *New York Sun,* 5 December 1922, 22; reprinted in Lynes, *O'Keeffe, Stieglitz,* app. A., no. 9, pp. 180–82.

23. Virgil Barker, "Notes on the Exhibitions," *The Arts,* April 1924, 222; partially reprinted in Lynes, *O'Keeffe, Stieglitz,* app. A, no. 31, p. 215.

24. Paul Rosenfeld, *Port of New York: Essays on Fourteen American Moderns* (New York: Harcourt, Brace, 1924; reprint, with introduction by Sherman Paul, Urbana: University of Illinois Press, 1961), 204–5; reprinted in Lynes, *O'Keeffe, Stieglitz,* app. A, no. 28, pp. 204–9.

25. McBride, "Georgia O'Keeefe's [sic] Work Shown," 22B.

26. In Perry Miller Adato [producer and director], *Georgia O'Keeffe,* videotape (59 min. [produced by WNET/THIRTEEN for Women in Art, 1977; Portrait of an Artist, no. 1, series distributed by Films, Inc./Home Vision, New York]).

27. Marya Mannes, "Gallery Notes: Intimate Gallery," *Creative Art,* February 1928, 7; reprinted in Lynes, *O'Keeffe, Stieglitz,* app. A, no. 74, pp. 282–83.

28. Letter from O'Keeffe to Henry McBride, 16 January 1927, Henry McBride Papers, Collection of American Literature, Yale University, New Haven; printed in Cowart, Hamilton, and Greenough, *Georgia O'Keeffe,* letter 39, pp. 185–86.

Sources for O'Keeffe's Imagery: A Case Study

1. O'Keeffe studied art at the following schools: School of the Art Institute of Chicago (1905–6); Art Students League of New York (1907–8); University of Virginia, Charlottesville (Summer 1912); Teachers College, Columbia University, N.Y.C. (1914–16).

2. See Georgia O'Keeffe, *Georgia O'Keeffe* (New York: Viking Press, 1976; New York: Penguin Books, 1985).

3. Ibid., opposite plate 52.

4. See Paul Rosenfeld, "Stieglitz," *Dial,* no. 4, April 1921, 397–409.

5. "Weston to Hagemeyer: New York Notes, 1922"; reprinted in *Edward Weston: On Photography,* ed. Peter C. Bunnell (Salt Lake City: Peregrine Smith Books, 1983), 36.

6. Ibid., 35.

7. Ibid., 35.

8. Ibid., 38.

9. Letter from Weston to Stieglitz, 12 July 1923; printed in Amy Conger, *Edward Weston in Mexico, 1923–1926* (Albuquerque: University of New Mexico Press, for San Francisco Museum of Modern Art, 1983), 5. Collection of American Literature, Beinecke Rare Book and Manuscript Library, Yale University, New Haven.

10. "Weston to Hagemeyer," 38.

11. See O'Keeffe's letter to the editor in *MSS.,* 4 (December 1922): 17–18. Remy de Gourmont (1858–1915), a French poet, critic, and novelist, wrote the novel *Mr. Antiphilos.*

12. "Weston to Hagemeyer," 36.

13. Phone conversation between author and Margaret W. Weston at Weston Gallery, Carmel, Calif., on 8 March 1990.

14. See "Stieglitz–Weston Correspondence," compiled by Ferdinand Reyher; printed in *Photo Notes* (Spring 1949): 11–15.

15. O'Keeffe, *Georgia O'Keeffe,* opposite plate 53.

16. Ibid., opposite plate 64.

17. Georgia O'Keeffe, "About Myself," *Georgia O'Keeffe Exhibition of Oils and Pastels* [exhibition brochure] (New York: An American Place, 1939), n.p.

"Who Will Paint New York?": "The World's New Art Center" and the Skyscraper Paintings of Georgia O'Keeffe

1. "French Artists Spur on an American Art: For the First Time Europe Seeks Inspiration at Our Shores in the Persons of a Group of Modernist French Artists, Who Find Europe Impossible Because of Its War-Drenched Atmosphere—Macmonnies Predicts that the Effect of This Migration Will Be Far-Reaching on Art of America and the Older Continent," *New York Tribune,* 24 October 1915; reprinted in *New York Dada,* ed. Rudolf E. Kuenzli (New York: Willis Locker and Owens, 1986), 133. The other quotations are from ibid., 130, 132, 131. (Frederick Macmonnies [1863–1937] was an American sculptor who had worked and taught for many years in Paris.)

2. "The Iconoclastic Opinions of M. Marcel Duchamps [*sic*] Concerning Art and America," *Current Opinion* 59 (November 1915): 346.

3. F. J. G. [Frederick James Gregg], "The World's New Art Centre," *Vanity Fair,* January 1915, 31.

4. Clement Greenberg, "The Situation at the Moment," *Partisan Review,* January 1948, and "The Decline of Cubism," *Partisan Review,* March 1948; reprinted in *Clement Greenberg: The Collected Essays and Criticism, vol. 2: Arrogant Purpose, 1945–1949,* ed. John O'Brian (Chicago: University of Chicago Press, 1986), 193, 215.

5. According to William Leuchtenberg:

 In 1914 the United States was a debtor nation; American citizens owed foreign investors three billion dollars. By the end of 1919 the United States was a creditor nation, with foreigners owing American investors nearly three billion dollars. In addition the United States had loaned over ten billion dollars to foreign countries, mostly to carry on the war, in part for postwar reconstruction. These figures represent one of those great shifts of power that occurs but rarely in the history of nations (*The Perils of Prosperity: 1914–1932* [Chicago: University of Chicago Press, 1958], 108, 225–6).

6. Leuchtenberg, *The Perils,* 227, 182.

7. Claude Bragdon, "The Shelton Hotel, New York," *Architectural Record,* July 1925, 1. Bragdon had moved into the building in January or February of that year (almost as soon as it began accepting tenants); O'Keeffe and Stieglitz moved in in November. Recalled Dorothy Brett, a painter: "Four of us would foregather in the cafeteria for breakfast. Stieglitz, Georgia, Claude Bragdon, and I . . . the talk never flagged" (Brett, "The Room," in *America and Alfred Stieglitz: A Collective Portrait,* ed. Waldo Frank et al., [New York: Literary Guild, 1934], 259). The Shelton (now the Halloran House) Hotel, is on the east side of Lexington Avenue between 48th and 49th streets.

8. Henry McBride, "American Expatriates in Paris," *Dial,* April 1929; re-

printed in *The Flow of Art: Essays and Criticisms of Henry McBride,* ed. Daniel Catton Rich (New York: Atheneum, 1975), 256.

9. And then O'Keeffe found they didn't compare: "The city is extraordinary, and my ideal city is New York. European cities seem villages in comparison" (quoted in Thomas Lask, "Publishing: Georgia O'Keeffe," *New York Times,* 25 June 1976). O'Keeffe made her first trip to Europe in 1953.

10. Cited in Joshua C. Taylor, *America as Art* (New York: Harper and Row, 1976), 190.

11. R. J. Coady, "American Art," *Soil,* January 1917, 55, and December 1916, 3.

12. "A Complete Reversal of Art Opinions by Marcel Duchamp, Iconoclast," *Arts and Decoration,* 5 (September 1915), 428.

13. Merrill Schleier, *The Skyscraper in American Art, 1890–1931* (Ann Arbor: UMI Research Press, 1986), 55.

14. Henry Tyrrell, *New York World,* 21 January 1923. (My thanks to Carol Willis for sharing this text with me.)

15. Naum Gabo, "The Constructive Idea in Art," in *Circle: International Survey of Constructive Art,* 1937, ed. J. L. Martin, Ben Nicholson, and Naum Gabo (reprint, New York: Praeger, 1971), 4, 3.

16. Said Duchamp: "I believe that your idea of demolishing old buildings, old souvenirs, is fine. It is in line with that so much misunderstood manifesto issued by the Italian Futurists. . . . The dead should not be permitted to be so much stronger than the living. We must learn to forget the past, to live our own lives in our own time" ("A Complete Reversal," 428). Matisse also believed: "The great quality of modern America is not clinging to its acquisitions. Over there, love of risk makes one destroy the results of the day with the hope that the next day will provide better" ("Statement to Tériade," 1930, reprinted in *Matisse on Art,* ed. and trans. Jack D. Flam [New York: E. P. Dutton, 1978], 63–64).

17. Charles Downing Lay, "New Architecture in New York," *The Arts,* August 1923, 67.

18. The prognostications in question have often been found by dint of wishful thinking or even manipulation, as Thomas A. P. van Leeuwen has nicely demonstrated. As the skyscraper's story is usually told, Louis Sullivan emerges as its father, Chicago as its birthplace; but the Sullivan given that role is a man most unlike himself, one who spurned ornament and placed function above all else. See van Leeuwen, *The Skyward Trend of Thought: The Metaphysics of the American Skyscraper* (Cambridge: MIT Press, 1988), 22–25 and passim. (My thanks to Ann Gilkerson for directing me to this book.)

19. Van Leeuwen, *The Skyward Trend,* 3.

20. Ibid., 3.

21. "A Complete Reversal," 428.

22. The way the story is usually told, 1925 marks the turning point in skyscraper design, as the moment Americans looked to Paris, to the Exposition of Decorative and Industrial Arts, to formulate an art deco style; by Willis's account, however, the art deco aesthetic "was hardly more than a decorative applique" (Carol Willis, "Drawing Towards Metropolis," in *Metropolis of Tomorrow,* ed. Hugh Ferriss [1929; reprint, Princeton, N.J.: Princeton Architectural Press, 1986], 166).

23. Ferriss published several drawings of the Shelton: in the *Christian Science Monitor,* 27 August 1923, on the cover of *Pencil Points,* October 1923, and in *Vanity Fair,* February 1924. He

drew the Radiator Building in ca. 1925 and showed it at the Anderson Galleries that April (O'Keeffe had been in a show in the same location the previous month); see Willis's appendix 2 in Ferriss, *Metropolis,* 190.

24. A photograph of the Shelton by Sheeler, who did architectural photography to earn a living, was published in *The Arts,* August 1923, 86; his photographs of the Berkley (taken in 1920) and of the Ritz Tower Hotels were reproduced in *Cahiers d'Art 2* (1927): 180, 182. O'Keeffe wrote admiringly of his photography in 1922; see "Can a Photograph Have the Significance of Art?" *Manuscripts,* December 1922, 17.

25. Lay, "New Architecture," 68.

26. The seven stories of the ziggurat represent the seven planetary heavens (as at Borsippa) and have "the colors of the world (as at Ur)" (Mircea Eliade, *The Myth of the Eternal Return,* trans. W. R. Trask [Princeton, N.J.: Princeton-Bollingen, 1971], 13).

27. Ferriss, *Metropolis,* 30.

28. Letter from Alfred Stieglitz to Sherwood Anderson, 9 December 1925; printed in Sarah Greenough and Juan Hamilton, *Alfred Stieglitz: Photographs and Writings* (Washington, D.C.: National Gallery of Art, n.d.), 214.

29. Willis, "Drawing," 167.

30. Frances O'Brien, "American We Like: Georgia O'Keeffe," *Nation,* October 1927, 361–62.

31. Ibid., 362.

32. Virgil Barker, "Notes on the Exhibitions," *The Arts,* April 1924; reprinted in Barbara Buhler Lynes, *O'Keeffe, Stieglitz and the Critics, 1916–1929* (Ann Arbor UMI Research Press, 1989; Chicago: University of Chicago Press, 1991), 215.

33. Henry McBride, "Paintings by Georgia O'Keefe [*sic*]: Decorative Art that Is Also Occult at the Intimate Gallery," *New York Sun,* 9 February 1929; reprinted in Lynes, *O'Keeffe,* 296.

34. Henry McBride, "O'Keeffe at the Museum," *New York Sun,* 18 May 1946.

35. Sullivan, as paraphrased and quoted by Claude Bragdon, *The Secret Spring: An Autobiography* (London: Andrew Dakers, 1938), 147.

36. O'Keeffe was able to find an apartment on a top floor of a skyscraper in 1925, whereas Duchamp had failed in his efforts to do so a decade earlier (see "Iconoclastic Opinions," 346) because the building codes had changed in the interim, allowing not only office buildings but also residential hotels (though not, as yet, apartment houses) to take the form of towers. (My thanks to Carol Willis for this information.) O'Keeffe was emulated in 1930 by the pioneering photojournalist Margaret Bourke-White, who made her studio and wanted (but was not permitted) to make her home high up in the newly completed Chrysler Building, one of her favorite photographic subjects; see Vicki Goldberg, *Margaret Bourke-White: A Biography* (New York: Harper and Row, 1986), 115. Making their offices on the top floors of skyscrapers, preferably of their own design, was also the practice of numerous architects in this period.

37. Georgia O'Keeffe, *Georgia O'Keeffe* (New York: Viking, 1976), n.p.

38. Inevitably, some critics have intimated that O'Keeffe's gender precluded her picturing the city effectively: In her city pictures (which are mostly painted in neutral tones and black), "her prettiness of color is an intrusion, her lack of strength obvious. Such paintings as *The Shelton* . . . and *The American Radiator Building* . . . in which she introduced irrelevant embellishments, are decorative designs

no more substantial than flower petals," wrote Milton W. Brown (*American Painting: From the Armory Show to the Depression* [Princeton, N.J.: Princeton University Press, 1955], 127–28). Said another critic: O'Keeffe's "views of the Shelton . . . are tributes to the perceptual power Stieglitz exercized over the city from inside it"; in *The Shelton with Sunspots,* "the burning upper storeys are a camera eye seared in the stone by Stieglitz's power to see through it. . . . Stieglitz—in this painting [*sic*] and in his own photographs—is he who dares to affront that flaming source" (Peter Conrad, *The Art of the City: Views and Versions of New York* [New York: Oxford University Press, 1984], 85).

39. Katharine Kuh, *The Artist's Voice: Talks with Seventeen Artists* (New York: Harper and Row, 1960), 191.

40. Henry McBride, "O'Keeffe's Recent Work," *New York Sun,* 14 January 1928; reprinted in *The Flow of Art,* ed. D. C. Rich, 236.

41. 24 December 1926 letter; quoted in Roxana Robinson, *Georgia O'Keeffe: A Life* (New York: Harper and Row, 1989), 288. O'Brien also described finding her on the twenty-eighth floor in October 1927 ("Americans," 361).

42. B. Vladimir Berman, "She Painted the Lily . . . ," *New York Evening Graphic,* 12 May 1928; reprinted in Lynes, *O'Keeffe,* 286. See Lynes, 280 and 284, for additional confirming evidence.

43. Lillian Sabine, "Record Price for Living Artist," *Brooklyn Sunday Eagle Magazine,* 27 May 1928; reprinted in Lynes, *O'Keeffe,* 290.

44. Berman, "She Painted," 287.

45. Herbert J. Seligmann, "Georgia O'Keeffe," unpublished manuscript, n.d., Beinecke Library, Yale University; quoted in James Moore, "So Clear Where the Sun Will Come . . . : Georgia O'Keeffe's *Gray Cross with Blue,*" *Artspace,* Summer 1986, 35.

46. O'Keeffe, *Georgia O'Keeffe,* n.p.

47. As O'Keeffe tells it, the huge buildings springing up all over the city were what impelled her to enlarge her flowers in the first place; see Kuh, *The Artist's Voice,* 191.

48. O'Keeffe, *Georgia O'Keeffe,* n.p. As the painting is not listed by that title in the brochure of the 1926 show, she may have exhibited it under another title.

49. "Goings On About Town," *New Yorker,* 13 March 1926, 5. The show was so popular that its run was extended.

50. The 1926 show included *The Shelton—New York, I–IV, Street, New York I–II,* and *East River from the Shelton, I–III.* The 1927 show included *New York Night, A Building New York—Night, The Shelton at Night,* and *East River, No. 1–3.* In 1928, O'Keeffe showed *East River from the Shelton, VI–VII,* and *Ritz Tower, Night.* In 1929, she had no solo show. The following year, the second painting listed was *New York Night.*

51. See Murdock Pemberton, "The Art Galleries: The Great Wall of Manhattan, or New York for Live New Yorkers," *New Yorker,* 13 March 1926, 36–37; and "The Art Galleries," *New Yorker,* 21 January 1928, 44.

52. A photograph of the set was reproduced in *Theater Arts Monthly,* March 1926. O'Keeffe's painting has not been reproduced since it was first shown, and she is said to have destroyed at least part of it. Each of the triptych's panels was forty-eight by twenty-one inches, with the center panel done in a second, full-scale version, seven by four feet (the dimensions were set by the museum); see *Murals by American Painters and Photographers* (New York: Museum of Modern Art, 1932), n.p.

53. Stieglitz objected to the commission because he did not believe in the "democratization" of art, and because of the low fee; he told the head of design for the Music Hall, Donald Deskey, that O'Keeffe was a child and not responsible for her actions in signing the contract. Deskey and O'Keeffe both proved immovable in the face of Stieglitz's pressure until O'Keeffe discovered that the walls she was to paint had been improperly prepared and that there was insufficient time for her to complete the project; she then withdrew and suffered a breakdown, which left her virtually unable to work for over a year (December 1932–February 1933); see Laurie Lisle, *Portrait of an Artist: A Biography of Georgia O'Keeffe* (New York: Washington Square Press, 1980), 258–61. She painted New York only once more, and she started to spend more time in New Mexico, where Stieglitz would not go. (O'Keeffe's ambition to work on a large scale—even to design an entire house—dated to 1926, when she first exhibited her New York paintings; see Herbert J. Seligmann, *Alfred Stieglitz Talking: Notes on Some of His Conversations, 1925–1931* [New Haven: Yale University Library, 1966], 60.)

54. Statement made 27 January 1926, according to Seligmann, *Stieglitz Talking,* 27–28.

55. Matisse, "Statements to Tériade," 63.

56. Passing through New York while en route to Tahiti, Matisse wrote to his wife at the end of his first day in the city (5 March 1930):

If I were not in the habit of seeing my decisions through, I would go no further than New York, for what I find here is really and truly a new world: it's great and majestic like the sea—and on top of that one senses the human effort behind it. . . . On my way to see idle primitives, I've started out seeing active primitives,—two extremes. Where do we fit in? That's the question! (quoted in Pierre Schneider, *Matisse* [New York: Rizzoli, 1984], 606–7).

57. Matisse, "Statements to Tériade," 62.

58. "Brancusi Returns Here for Display, *New York World,* 30 September 1926.

59. Jeanne Robert Foster, "'It's Clever, but Is It Art?' Is Asked by Critics of Brancusi," *New York Herald Tribune,* 21 February 1926.

60. "America Holds Future of Art, Brancusi Says," [Springfield, Mass.] *Evening Union,* 20 December 1927 (by-lined Paris).

61. It was "New York at night that most enchanted him" as a compelling prevision of "the city of the future" (Charmion von Wiegand, "Mondrian: A Memoir of His New York Period," *Arts Yearbook* 4 [1961]: 65).

62. Von Wiegand, "Mondrian," 62. So wedded was Mondrian to his final home that "he never spoke Dutch here and said he never wished to return to Holland. He had taken out his first papers for American citizenship" (ibid., 65).

63. The commercial show was at the Valentine Dudensing gallery in 1942; the Museum of Modern Art honored Mondrian with a memorial retrospective in 1944. The same museum had acquired the first of its major collection of Mondrian paintings in 1937, whereas the Musée National d'Art Moderne in Paris did not acquire a painting by the artist until 1975.

64. "America Holds."

65. That show was followed by major exhibitions elsewhere in New York in 1926 and 1933. The outbreak of World War II forced the Museum of Modern Art to abandon plans for a

retrospective, but the Guggenheim Museum organized one in 1955. In 1956 a retrospective was held in Bucharest; Brancusi died in 1957. (The first public solo show of Henri Rousseau's painting, a commemorative exhibition in 1910, was also held at Stieglitz's 291 gallery.)

66. Aline B. Saarinen, "The Strange Story of Brancusi," *New York Times Magazine,* 23 October 1955, 42.

67. The exceptions to the rule were the Russians Sergei Shchukin and Ivan Morosov, who discontinued collecting Matisse's work in 1914. Matisse had the first showing anywhere of his sculpture at the 291 gallery in 1912.

68. Matisse, "Statements to Tériade," 63.

69. Most of Duchamp's work remains in this country; his first solo show was held in Chicago in 1937, and his first major retrospective occurred in Pasadena in 1963. See Moira Roth, "Marcel Duchamp in America: A Self Ready-Made," *Arts,* May 1977, 92.

70. Fernand Léger, "New York," *Cahiers d'Art,* 1931; reprinted in Léger, *Functions of Painting,* trans. Alexandra Anderson, ed. Edward F. Fry (New York: Viking, 1973), 90, 84–86.

71. Letter from O'Keeffe to Blanche Matthias, [March 1926]; printed in Cowart, Hamilton, and Greenough, *Georgia O'Keeffe,* 183; and letter from O'Keeffe to Henry McBride, [March 1925?]; ibid., 179. Her estimation of her city pictures and her sense that they had been unjustly treated emerged when, as an old woman, she troubled to show an interviewer an almost-fifty-year-old reference in a review by McBride to "one of the best skyscraper pictures that I have seen anywhere. It combines fact and fancy admirably," and remarked pointedly: "I'd be pleased to have that said in your article" (Mary Lynn Kotz, "Geor-

gia O'Keeffe at Ninety," *Art News,* December 1977, 45).

72. Clement Greenberg, "The Present Prospects of American Painting and Sculpture," *Horizon,* October 1947; reprinted in *Clement Greenberg,* ed. O'Brian, 166.

73. The Musée National d'Art Moderne would not acquire its first Pollock until 1972 (gifts of Pollock paintings followed in 1975 and 1979). (My thanks to Mary Werth for this information.) Observed the sculptor Constantine Nivola, "The French would say of de Kooning, 'As painting, we can recognize this.' Of Pollock, '*This* is not painting! Only in America could it happen'" (Jeffrey Potter, *To a Violent Grave: An Oral Biography of Jackson Pollock* [Wainscott, N.Y.: Pushcart, 1985], 221).

Beholding the Epiphanies: Mysticism and the Art of Georgia O'Keeffe

1. See *The Spiritual in Art: Abstract Painting, 1890–1985,* ed. Edward Weisberger (New York: Los Angeles County Museum of Art and Abbeville Press, 1986).

2. Maurice Tuchman, "Hidden Meanings in Abstract Art," in *The Spiritual in Art,* 19.

3. See, for example, Arthur Jerome Eddy, *Cubism and Post-Impressionism* (Chicago, 1914), and Sheldon Cheney, *A Primer of Modern Art* (New York: Boni and Liveright, 1924).

4. Clement Greenberg, review, *The Nation,* 15 June 1946, 6.

5. A group of O'Keeffe's letters, selected and annotated by Sarah Greenough, is included in Jack Cowart, Juan Hamilton, and Sarah Greenough, *Georgia O'Keeffe: Art and Letters* (Washington, D.C.: National Gallery of Art, 1987).

6. Julia Kristeva, "Women's Time," *Signs*

7 (1981): 13–35, passim (trans. Alice Jardine and Harry Blake).

7. William Innes Homer, *Alfred Stieglitz and the American Avant-Garde* (Boston: New York Graphic Society, 1977), 242.

8. See Lawrence W. Chisholm, *Fenellosa: The Far East and American Culture* (New Haven: Yale University Press, 1963).

9. See Frederick C. Moffatt, *Arthur Wesley Dow (1857–1922)* (Washington, D.C.: National Collection of Fine Arts, 1977), 102–3.

10. Letter from O'Keeffe to Anita Pollitzer, 17 January 1917; printed in Cowart, Hamilton, and Greenough, *Georgia O'Keeffe,* no. 16, p. 159. Collection of American Literature, Beinecke Rare Book and Manuscript Library, Yale University, New Haven. The authors and texts referred to are the following: Willard Huntington Wright, *Modern Painting* (New York, 1915), and *The Creative Will: Studies in the Philosophy and the Syntax of Aesthetics* (New York, 1916); Clive Bell, *Art* (London, 1914; New York, 1915); Marius de Zayas, *African Negro Art: Its Influences on Modern Art* (New York, 1916); Arthur Jerome Eddy, *Cubism and Post-Impressionism* (Chicago, 1914); Charles H. Caffin, *Art for Life's Sake: An Application of the Principles of Art to the Ideals and Conduct of Individual and Collective Life* (New York, 1913).

11. Eddy, *Cubism and Post-Impressionism,* 122.

12. Kandinsky, quoted in *The Spiritual in Art,* 11.

13. Sarah Greenough, "From the Faraway," in Cowart, Hamilton, and Greenough, *Georgia O'Keeffe,* 136.

14. Wassily Kandinsky, *Concerning the Spiritual in Art* (New York: Dover Publications, 1977), 32. The first English translation was under the title *The Art of Spiritual Harmony* (London, 1914).

15. See, for example, *The Spiritual in Art* plates 8 and 9. The profound influence of Theosophy on early artistic abstraction has been acknowledged by a number of writers, including Sixten Ringbom, who notes:

Whatever one might otherwise think about the claims and intellectual quality of the theosophical teachings, the crucial role of Theosophy in the emergence of nonrepresentational art is becoming increasingly clear. In a seemingly endless stream of publications Theosophy provided artists with a wealth of artistically exploitable ideas and images. Most important was its interpretations of the spiritual as being formless in a physical but not an absolute sense ("Transcending the Visible: The Generation of the Abstract Pioneers," in *The Spiritual in Art,* 136–37.

16. See, for example, Sharyn R. Udall, *Modernist Painting in New Mexico, 1913–1935* (Albuquerque: University of New Mexico Press, 1984), 6–7. Members of the Stieglitz circle adopted modernism's spiritual concerns as it suited their personal inclinations; Hartley, Dove, and Weber were vitally interested, Marin—a self-professed Yankee independent—less so.

17. Sue Davidson Lowe, *Stieglitz: A Memoir/Biography* (New York: Farrar, Straus and Giroux, 1983), 290.

18. Letter from O'Keeffe to Anita Pollitzer, 4 January 1916; printed in Cowart, Hamilton, and Greenough, *Georgia O'Keeffe,* no. 6, p. 147. Collection of American Literature, Beinecke Rare Book and Manuscript Library, Yale University, New Haven.

19. O'Keeffe's feminist attitudes were not

often publicly stated, but in one important interview she tried to draw together her feminist concerns with aesthetic issues:

I am interested in the oppression of women of all classes . . . though not nearly so definitely and so consistently as I am in the abstractions of painting. But one has affected the other. . . . I am trying with all my skill to do painting that is all of a woman, as well as all of me (O'Keeffe, interview with Michael Gold [editor of the *New Masses*]; published in Gladys Oaks, "Radical Writer and Woman Artist Clash on Propaganda and Its Uses," *New York World,* 16 March 1930, sec. 1, 3).

20. See letter no. 68; note 2, p. 274; and note 68, p. 285 in Cowart, Hamilton, and Greenough, *Georgia O'Keeffe.*

21. Letter from O'Keeffe to Henry McBride, February 1923; printed in Cowart, Hamilton, and Greenough, *Georgia O'Keeffe,* no. 27, p. 171. Collection of American Literature, Beinecke Rare Book and Manuscript Library, Yale University, New Haven. In an annotation to this letter Sarah Greenough comments that O'Keeffe believed that "men were of a separate, 'different class,' but not a superior one" (note 27, p. 278).

22. See letter from O'Keeffe to Blanche Matthias, March 1926; printed in Cowart, Hamilton, and Greenough, *Georgia O'Keeffe,* no. 36, p. 183; and note 36, pp. 280–81. Collection of American Literature, Beinecke Rare book and Manuscript Library, Yale University, New Haven. See also Robert Galbreath, "A Glossary of Spiritual and Related Terms: Fourth Dimension," in *The Spiritual in Art,* 373.

23. See Gail Levin, "Marsden Hartley and Mysticism," *Arts,* November 1985, 16–21.

24. Marsden Hartley, *Adventures in the Arts* (New York: Boni and Liveright, 1921; reprinted, New York: Hacker Books, 1972), 116–17.

25. Letter from O'Keeffe to Donald Gallup, 31 March 1952; printed in Cowart, Hamilton, and Greenough, *Georgia O'Keeffe,* no. 110, p. 262. Collection of American Literature, Beinecke Rare Book and Manuscript Library, Yale University, New Haven.

26. Tuchman, "Hidden Meanings in Abstract Art," 43. See also Sherrye Cohn, "Arthur Dove: The Impact of Science and Occultism on His Modern American Art" (Ph.D. diss., Washington University, 1982), and "Arthur Dove and Theosophy," *Arts,* September 1983, 86–91.

27. Charles C. Eldredge, "Nature Symbolized: American Painting from Ryder to Hartley," in *The Spiritual in Art,* 124.

28. Dove, quoted in Cowart, Hamilton, and Greenough, *Georgia O'Keeffe,* note 73, p. 286.

29. Edith Evans Asbury, "Silent Desert Still Captivates Georgia O'Keeffe, Nearing Eighty-one," *New York Times,* 2 November 1968, p. 39.

30. See Cowart, Hamilton, and Greenough, *Georgia O'Keeffe,* note 19, p. 277.

31. O'Keeffe, statement in O'Keeffe, *Georgia O'Keeffe* (New York: Viking Press, 1976; New York: Penguin Books, 1985), n.p. See, for example, "Portrait W, No. III" (1917), reproduced as plate 26 in Cowart, Hamilton, and Greenough, *Georgia O'Keeffe.*

32. O'Keeffe, quoted in Jo Gibbs, "The Modern Honors First Woman: O'Keeffe," *Art Digest,* 1 June 1946, 6.

33. See Linda Dalrymple Henderson, *The*

Fourth Dimension and Non-Euclidean Geometry in Modern Art (Princeton, N.J.: Princeton University Press, 1983), 31–46, 78, for a discussion of Theosophy's role as popularizer of these ideas.

34. Max Weber, "Fourth Dimension," *Camera Work,* 25. Linda Dalrymple Henderson has written on the relationships between such ideas in modern art. See, for example, her essay "Mysticism, Romanticism and the Fourth Dimension" in *The Spiritual in Art,* 219–37.

35. Letter from O'Keeffe to Anita Pollitzer, 13 December 1915; printed in Cowart, Hamilton, and Greenough, *Georgia O'Keeffe,* no. 5, p. 146. Collection of American Literature, Beinecke Rare Book and Manuscript Library, Yale University, New Haven.

36. O'Keeffe to William Howard Schubart, 25 July 1952; ibid., no. 111, p. 262. Estate of Georgia O'Keeffe, Abiquiu, New Mexico.

37. O'Keeffe to Sherwood Anderson, September 1923[?]; ibid., no. 29, pp. 173–74. Collection of American Literature, Beinecke Rare Book and Manuscript Library, Yale University, New Haven.

38. O'Keeffe to Dorothy Brett, February 1932; ibid., no. 60, p. 206. Harry Ransom Humanities Research Center, University of Texas at Austin.

39. O'Keeffe to Caroline Fesler, 5 February 1956; ibid., no. 114, pp. 265–66. Archives of American Art, Smithsonian Institution, Washington, D.C.

40. Weber, "Fourth Dimension," 25.

41. Roxana Robinson, *Georgia O'Keeffe: A Life* (New York: HarperCollins, 1989), 195.

42. Alfred Stieglitz [catalog introduction], *The Third Exhibition of Photography by Alfred Stieglitz* (New York: Anderson Galleries, 1924), n.p.

43. Quoted in Laurie Lisle, *Portrait of an Artist* (New York: Seaview Books, 1980), 115.

44. Letter from O'Keeffe to Dorothy Brett, October 1930; printed in Cowart, Hamilton, and Greenough, *Georgia O'Keeffe,* no. 54, pp. 201–2. Collection of American Literature, Beinecke Rare Book and Manuscript Library, Yale University, New Haven.

45. O'Keeffe to Aaron Copland, 19 July 1968; ibid., no. 120, p. 269. Collection of Aaron Copland.

46. Kandinsky, *Concerning the Spiritual in Art,* 37.

47. Avid reader of Kandinsky that she was, O'Keeffe probably knew in 1919 of his *Black Spot* drawings and painting from ca. 1912 (illustrated in *The Spiritual in Art,* 142). By 1976 she had forgotten any extraneous influence when she wrote of her own *Black Spot* series: "I never knew where the idea came from or what it says. They are shapes that were clearly in my mind— so I put them down" (statement in O'Keeffe, *Georgia O'Keeffe,* opposite plate 15).

48. Letter from O'Keeffe to William M. Milliken, 1 November 1930; Cowart, Hamilton, and Greenough, *Georgia O'Keeffe,* no. 55, p. 202. Cleveland Museum of Art.

49. O'Keeffe to Ettie Stettheimer, 24 August 1929; ibid., no. 49, p. 195. Estate of Georgia O'Keeffe, Abiquiu, New Mexico.

50. Often during her life, O'Keeffe spoke of her nurturing by Stieglitz, whom she sometimes resented. She wrote, "I feel like a little plant that he has watered and weeded and dug" (quoted in ibid., note 36, p. 280).

51. Robinson, *Georgia O'Keeffe,* 139.

52. Tuchman, "Hidden Meanings in Abstract Art," in *The Spiritual in Art,* 20.

53. Paul Rosenfeld, "Musical Chronicle," *Dial,* 1926, 530.

54. Quoted in Lois Rudnick, "Re-Naming

the Land: Anglo Expatriate Women in the Southwest," in *The Desert Is No Lady: Southwestern Landscapes in Women's Writing and Art,* ed. Vera Norwood and Janice Monk (New Haven: Yale University Press, 1987), 16.

55. Mary Austin, *Lost Borders* (New York: Harper and Bros., 1909), 10. See also Elizabeth Duvert, "With Stone, Star, and Earth: The Presence of the Archaic in the Landscape Visions of Georgia O'Keeffe, Nancy Holt and Michelle Stuart," in *The Desert Is No Lady,* ed. Norwood and Monk, 197–222.

56. Lois Rudnick, personal communication 27 April 1989; see also her article in *D. H. Lawrence Review* 14 (1981). Luhan gave two Buddha statues to Hartley.

57. Mabel Dodge Luhan, "Georgia O'Keeffe in Taos," *Creative Art* 8 (June 1931): 407.

58. From a manuscript in the Mabel Dodge Luhan Archives, Yale Collection of American Literature, Yale University; quoted in Cowart, Hamilton, and Greenough, *Georgia O'Keeffe,* note 34, p. 280.

59. See Cowart, Hamilton, and Greenough, *Georgia O'Keeffe,* note 53, p. 283.

60. Lawrence, quoted in *D. H. Lawrence and New Mexico,* ed. Keith Sagar (Salt Lake City: Gibbs M. Smith, 1982), ix.

61. O'Keeffe, statement in O'Keeffe, *Georgia O'Keeffe,* opposite plate 64.

62. This is also a theosophical tenet, a belief that the human "health aura" surrounding a person draws its strength from the sun. See Ringbom, 140.

63. Letter from O'Keeffe to Russell Vernon Hunter, October 1932; printed in Cowart, Hamilton, and Greenough, *Georgia O'Keeffe,* no. 63, p. 211. Estate of Georgia O'Keeffe, Abiquiu, New Mexico.

64. O'Keeffe to Cady Wells, early 1940s; ibid., no. 93, p. 243. Archives of American Art, Smithsonian Institution, Washington, D.C.

65. O'Keeffe, statement in O'Keeffe, *Georgia O'Keeffe,* opposite plate 3.

66. O'Keeffe, quoted in Lloyd Goodrich and Doris Bry, *Georgia O'Keeffe* (New York: Whitney Museum of American Art, 1970), 23.

67. Alan W. Watts, *Nature, Man and Woman* (New York: Mentor Books, 1958), 102.

68. Lucy Lippard, *Overlay: Contemporary Art and the Art of Prehistory* (New York: Pantheon Books, 1983), 50.

69. Letter from O'Keeffe to William Howard Schubart, 28 July 1950; printed in Cowart, Hamilton, and Greenough, *Georgia O'Keeffe,* no. 102, p. 253. Estate of Georgia O'Keeffe, Abiquiu, New Mexico.

70. See Barbara Rose, "Georgia O'Keeffe's Universal Spiritual Vision," in *Georgia O'Keeffe* (Seibu Museum of Art, Tokyo, and Gerald Peters Gallery, Santa Fe, New Mexico, 1988), 98–100.

71. Carl G. Jung, commentary to *The Secret of the Golden Flower,* rev. ed. (ca. 1931; [New York: Harcourt Brace Jovanovich, 1962]), 115.

72. O'Keeffe, statement in O'Keeffe, *Georgia O'Keeffe,* opposite plate 88.

73. Letter from O'Keeffe to William Howard Schubart, 19 January 1951; printed in Cowart, Hamilton, and Greenough, *Georgia O'Keeffe,* no. 107, p. 258. Estate of Georgia O'Keeffe, Abiquiu, New Mexico.

Georgia O'Keeffe in Hawaii

Except where noted otherwise, all correspondence cited is in The Collection of American Literature, Beinecke Rare Book and Manuscript Library, Yale University, New Haven.

1. O'Keeffe to Russell Vernon Hunter, [October–November 1939, New

York]. The Georgia O'Keeffe Estate/ Foundation, Abiquiu, New Mexico; reprinted in Cowart, Hamilton, and Greenough, p. 229.

2. Her retrospectives include one at the Art Institute of Chicago in 1943; the Museum of Modern Art in 1946; the Worcester Art Museum in 1960; and traveling exhibitions organized by the Amon Carter Museum of Western Art, Fort Worth, in 1966, the Whitney Museum of American Art, New York, in 1970, and the National Gallery of Art, Washington, D.C., in 1987. For her biographies, see Jan Garden Castro, *The Art and Life of Georgia O'Keeffe* (New York: Crown, 1985); Laurie Lisle, *Portrait of an Artist: A Biography of Georgia O'Keeffe* (Albuquerque: University of New Mexico, 1986); and Roxana Robinson, *Georgia O'Keeffe: A Life* (New York: Harper and Row, 1989).

3. The history of N. W. Ayer and Son is thoroughly documented in Ralph M. Hower, *The History of an Advertising Agency: N. W. Ayer and Son at Work, 1869–1949* (Cambridge, Mass.: Harvard University Press, 1949).

4. Letter from O'Keeffe to William Einstein, 19 July [1938]; printed in Jack Cowart, Juan Hamilton, and Sarah Greenough, *Georgia O'Keeffe: Art and Letters* (Washington, D.C.: National Gallery of Art, 1987), 226.

5. Letter from Stieglitz to Arthur Dove, [21 January 1939]; printed in *Dear Stieglitz, Dear Dove,* ed. Ann Lee Morgan (Newark: University of Delaware Press; London: Associated University Presses, 1988), 414.

6. Daniel Pope, *The Making of Modern Advertising* (New York: Basic Books, 1983), 3–6.

7. Walter Abell, "Industry and Painting," *Magazine of Art* 39, no. 3 (March 1946): 114.

8. Raymond P. R. Neilson, "Advertising Paintings," *Advertising Arts and Crafts*

1 (1924): 15, 404. See also Russell Lynes, "Suitable for Framing," *Harper's Magazine* 192, no. 1149, February 1946, 163–64.

9. Abell, "Industry and Painting," 89.

10. Ibid.

11. "Marketing: Fine Art in Ads," *Business Week,* no. 768, 20 May 1944, 76.

12. The best discussion of the relationship between the advertising industry and American art can be found in Neil Harris and Martina Roudabush Norelli, *Art, Design, and the Modern Corporation* [exhibition catalogue] (Washington, D.C.: National Museum of American Art, 1985).

13. Charles T. Coiner, "Art with a Capital 'A,'" in *Nineteenth Annual of Advertising Art* (New York: Longmans Green, 1940), 49.

14. Quoted in Harris and Norelli, *Art, Design,* 19.

15. Harris and Norelli, *Art, Design,* 19.

16. Dole's annual reports, minutes from the meetings of the board of directors, scrapbooks of newspaper clippings, and other archival holdings detail product advertising.

17. Interview of Charles T. Coiner by Howard L. Davis and F. Bradley Lynch, 16 March 1982, 45–46; transcript at N. W. Ayer offices, New York.

18. "I talked to her about the romance of Hawaii, etc.," and she went. Coiner interview, 13.

19. Letter from Stieglitz to William Einstein, 30 January 1939.

20. "Georgia O'Keeffe Is Arrival [*sic*] on Lurline; To Illustrate Ads," *Honolulu Star-Bulletin,* 9 February 1939, 2.

21. "Famous Painter of Flowers," *Honolulu Advertiser,* 12 February 1939, music, art, books, drama sec., p. 8; see also "Noted Artist Visits Hawaii to Paint 'Intimate' Feeling," *Honolulu Star-Bulletin,* 14 February 1939, 6.

22. "Distinguished Painters Are Complimented," *Honolulu Advertiser,* 12 Feb-

ruary 1939, music, art, books, drama sec., p. 1. O'Keeffe's "hunter's green wool ensemble accented by crown flower leis and pink camellia blooms which came from [a local] garden" drew comment in the society column of the *Honolulu Advertiser* (Edna B., "Bagatelles," *Honolulu Advertiser,* 12 February 1939, music, art, books, drama sec., p. 5.

23. Steichen was in Hawaii as the guest of the Matson Navigation Company photographing for the firm's advertising purposes; Pierre Roy, a now largely forgotten French artist, was participating in Dole's campaign.

24. "O'Keeffe's Pineapple," *Art Digest* 17, no. 11, 1 March 1943, 17.

25. "O'Keeffe's Pineapple." Several newspaper and magazine articles review the pineapple field incident and, as will be discussed later, O'Keeffe's negotiations in New York with Ayer and Coiner regarding a painting of the fruit. This article offers the greatest detail into the pineapple story, which has since become part of the O'Keeffe mythology.

26. "Painter on Maui Visit," *Maui News,* 15 March 1939, 2.

27. Robert Lee Eskridge, "Autobiography" (ca. 1975), 276–77. Julius S. Rodman, Olympia, Washington.

28. Patricia Jennings Morriss Campbell, telephone conversation with author, 13 September 1989.

29. Letter from O'Keeffe to Ettie Stettheimer, [March 1939], Wailuku, Maui; Georgia O'Keeffe Estate/Foundation, Abiquiu, New Mexico. Ettie Stettheimer and her sisters Carrie and Florine, also an artist, were central to New York art and literary circles and were good friends of O'Keeffe.

30. Wilhelmina L. Markiewicz, telephone conversation with author, 7 August 1989. She kindly shared her memories of O'Keeffe's visit to her mother, Judge Edna Jenkins.

31. O'Keeffe to Stettheimer.

32. O'Keeffe to Stettheimer.

33. "Noted N.Y. Artist Visits Valley Isle," *Maui News,* 25 March 1939, 3; "Noted Woman Artist Arrives for Visit," *Hilo Tribune Herald,* 29 March 1939, 1; Jean Bryan Harrison, telephone conversation with author, 4 December 1989.

34. Richard Pritzlaff, telephone conversation with author, 17 October 1989. There do not seem to be records specifically outlining O'Keeffe's visit to the Big Island other than general newspaper references; Pritzlaff provides the most detailed information about the artist's activities on this island. (I thank Roxana Robinson for informing me of his Hawaii acquaintance with O'Keeffe.)

35. Lloyd Sexton, telephone conversation with author, 7 August 1989. The local painter Shirley Russell took O'Keeffe to the Hilo home and studio of Sexton, a painter from Hawaii who also participated in the Dole advertising campaign. Ironically, Sexton was sketching on the other side of the island and was not there to receive his visitor.

36. Letter from O'Keeffe to Russell Vernon Hunter, October–November 1939, New York, 1990. The Georgia O'Keeffe Estate/Foundation, Abiquiu, New Mexico; printed in Cowart, Hamilton, and Greenough, *Georgia O'Keeffe,* 229.

37. "News About Town: Ends Visit Here," *Hilo Tribune Herald,* 11 April 1939, 1.

38. Reuben Tam, conversation with author, 15 August 1989.

39. O'Keeffe to Robert Allerton and John Gregg, 10 May 1940, New York, National Tropical Botanical Garden, Lawai. David Forbes alerted me to this letter, and William L. Theobald, the director of the National Tropical Botanical Garden, Lawai, kindly forwarded a copy of it.

40. O'Keeffe to Allerton and Gregg.

41. "Woman Artist Off For Mainland After Work in Islands," *Honolulu Star-Bulletin,* 14 April 1939, 10.

42. Robinson, *Georgia O'Keeffe,* 435.

43. R.F., "New Exhibitions of the Week: A Show of the Most Recent Paintings of Georgia O'Keeffe," *Art News* 36, no. 19, 5 February 1938, 15.

44. George L. K. Morris, "Art Chronicle: Some Personal Letters to American Artists Recently Exhibiting in New York," *Partisan Review* 4, no. 4 March 1938, 39.

45. O'Keeffe once remarked: "I have never cared about what others were doing in art, or what they thought of my own paintings. Why should I care? I found my inspirations and painted them" (quoted in Leo Janos, "Georgia O'Keeffe at Eighty-Four," *The Atlantic* 228, no. 6, December 1971, 117.

46. Robinson, *Georgia O'Keeffe,* 266.

47. Letter from O'Keeffe to Catherine O'Keeffe [Klenert], 8 February 1924, © 1989 Estate of Georgia O'Keeffe, Abiquiu, New Mexico; quoted in Robinson, *Georgia O'Keeffe,* 265.

48. *Maui No Ka Oi* (Wailuku, Hawaii: Valley Isle, [1940s]), 6.

49. Letter from Stieglitz to Dove, 3 May 1939, [New York]; printed in Morgan, 416.

50. Stieglitz was very worried about O'Keeffe's "nervous prostration," frequently giving updates on her condition in correspondence with friends and associates such as Dove, Einstein, Dorothy Brett, Edith Halpert, and Duncan Phillips. These letters are housed at the Beinecke Rare Book and Manuscript Library at Yale and the Archives of American Art, Smithsonian Institution, Washington, D.C.; his letters to Dove are published in *Dear Stieglitz, Dear Dove,* ed. Ann Lee Morgan, 416–28.

51. "Advertising Art Lures Brush of Miss O'Keeffe," *New York Herald Tribune,* 31 January 1940, 10.

52. "Pineapple for Papaya," *Time* 35, 12 February 1940, 42; Maria Chabot, telephone conversation with author, 30 October 1989. O'Keeffe's friend Maria Chabot remembers that O'Keeffe told her about the spraying of the plant.

53. "Advertising Art Lures."

54. Letter from Stieglitz to William Einstein, 11 July 1939.

55. The *Pineapple Bud* advertisement was published in *Woman's Home Companion* (November 1940, p. 59) and *Ladies Home Journal* 57, no. 10 (October 1940, p. 61). The ad featuring *Heliconia—Crabs Claw Ginger* appeared in the *Saturday Evening Post* 212, no. 42 (13 April 1940, p. 115) and *Vogue* (1 February 1941, p. 58). The copy statement accompanied *Heliconia—Crabs Claw Ginger.*

56. O'Keeffe, *Georgia O'Keeffe: Exhibition of Oils and Pastels,* exhibition brochure (New York: An American Place, 1940), see in particular "Pineapple for Papaya."

57. O'Keeffe, *Georgia O'Keeffe: Exhibition.*

58. Hortense Saunders, "Eventful and Exciting Week in the World of Art," *New York World-Telegram,* 10 February 1940, 28.

59. Henry McBride, "Georgia O'Keeffe's Hawaii," *New York Sun,* 10 February 1940, art sec., p. 10.

60. Letter from Stieglitz to William Einstein, 2 February 1940, New York.

61. Stieglitz to Eliot Porter, 9 February 1940, New York. A photographer, Porter was Stieglitz's friend and exhibited at An American Place.

62. Stieglitz to Dove, 22 and 29 February 1940; printed in *Dear Stieglitz, Dear Dove,* ed. Ann Lee Morgan, 431, 433.

63. Stieglitz to Einstein, 18 March 1940.

64. Cary Ross's correspondence detailing this transaction is housed at the

Beinecke Rare Book and Manuscript Library. Information regarding Ross is fragmentary. Fran Schell, at the Tennessee State Library and Archives, Knoxville, provided invaluable assistance in investigating him and his family, and Sue Davidson Lowe notes that other Ross correspondence is at Princeton University.

65. Letter from O'Keeffe to William Einstein, 8 June 1939, New York.
66. Letter from O'Keeffe to Russell Vernon Hunter. Hunter was an artist and administrator in New Mexico and shared with O'Keeffe a love of the desert.
67. O'Keeffe, *Georgia O'Keeffe: Exhibition.*
68. O'Keeffe to Ansel Adams, 8 July 1958, © 1990 Georgia O'Keeffe Estate/Foundation. (Amy Rule, of the Center for Creative Photography, University of Arizona, Tucson, kindly brought this letter to my attention.)

House Beautiful

1. Kermit Vanderbilt, *Charles Eliot Norton* (Cambridge, Mass.: Harvard University Press, 1959), 127–28, quoted in Jackson Lears, *No Place of Grace: Antimodernism and the Transformation of American Culture 1880–1920* (New York: Pantheon, 1981), 66. All subsequent quotes are taken from Lears.

A Graven Space

1. Roxana Robinson, *Georgia O'Keeffe: A Life* (New York: Harper and Row, 1989), 358.

O'Keeffe, Stieglitz, and the Stieglitz Family: An Intimate View

1. Dorothy Seiberling, "Horizons of a Pioneer: Georgia O'Keeffe in New Mexico," *Life,* 1 March 1968, 53.

2. Knighted for his donations to London's National Gallery and British Museum, Duveen was the leading advisor and dealer in the formation of the Frick, Hearst, Kress, Mellon, Morgan, Rockefeller, et al., art collections.
3. Calvin Tomkins, "The Rose in the Eye Looked Pretty Fine" [Profile of Georgia O'Keeffe], *New Yorker,* 4 March 1974, 47.

Of Blossoms & Bones

1. Christopher Buckley, *Blossoms & Bones* (New York: Vanderbilt University Press, 1988), ix.

In Cahoots with Coyoté

1. Georgia O'Keeffe, *Georgia O'Keeffe* (New York: Viking, 1976; Penguin Books, 1985), 24.
2. Ibid., 58.
3. Dan Flores, "Canyons of the Imagination," *Southwest Art* (March 1989), 74.
4. O'Keeffe, *Georgia O'Keeffe,* p. 5.

Painting with Georgia O'Keeffe

1. The book was Max Doerner's *The Materials of the Artist and Their Use in Painting; With Notes on the Techniques of the Old Masters,* trans. Eugen Neuhaus (New York: Harcourt, Brace, 1934).
2. The painting I consulted either was or was similar to *White Patio with Red Door;* see Georgia O'Keeffe, *Georgia O'Keeffe* (New York: Viking Press, 1976; New York: Penguin Books, 1985), plate 83. I do not know whether O'Keeffe painted more than one painting in the *Patio Door* series with the same composition and color scheme as this plate.

Select Bibliography

Articles and Periodicals

Aldrich, Hope. "Art Assist: Where Is Credit Due?" *Santa Fe Reporter,* 31 July 1980.

Ashbury, Edith Evans. "Georgia O'Keeffe Dead at 98; Shaper of Modern Art in US," *New York Times,* 7 March 1986.

———. "Georgia O'Keeffe Is Involved in 2 Suits Linked to Agent Fees on Her Paintings." *New York Times,* 20 November 1978.

———. "Silent Desert Still Charms Georgia O'Keeffe, Near 81." *New York Times,* 2 November 1968.

Breuning, Margaret. "Art in New York." *Parnassus,* December 1937.

———. "Current Exhibitions." *Parnassus,* March 1937.

———. "Georgia O'Keeffe." *New York Evening Post,* 24 January 1931.

———. "O'Keeffe's Best." *Art Digest,* 1 March 1944.

———. "Seven Americans." *New York Evening Post,* 14 March 1925.

Bry, Doris. "Georgia O'Keeffe." *Journal of the American Association of University Women* January 1952.

———. "The Stieglitz Archive at Yale University." *Yale University Library Gazette,* April 1951.

Budnik, Dan. "Georgia O'Keeffe at 88 Finds Contentment—and a New Art—in the New Mexican Desert." *People,* 15 December 1975.

Canaday, John. "O'Keeffe Exhibition: An Optical Treat." *New York Times,* 8 October 1970.

Coates, Robert M. "Abstraction—Flowers." *The New Yorker,* 6 July 1929.

Coke, Van Deren. "Why Artists Came to New Mexico: 'Nature Presents a New Face Each Moment.'" *Art News,* January 1974.

Cortissoz, Royal. "An American Place." *New York Herald Tribune,* 4 March 1934.

———. "Georgia O'Keeffe." *New York Herald Tribune,* 3 February 1935.

———. "Georgia O'Keeffe." *New York Herald Tribune,* 7 February 1937.

Drojowska, Hunter. "Georgia O'Keeffe, 1887–1986." *ARTnews,* Summer 1986.

Eldredge, Charles C. "The Arrival of European Modernism." *Art in America,* July–August 1973.

Engelhard, Georgia. "Alfred Stieglitz, Master Photographer." *American Photography,* April 1945.

Fillin-Yeh, Susan. "Innovative Moderns: Arthur G. Dove and Georgia O'Keeffe." *Arts Magazine,* Special Issue, June 1982.

Glueck, Grace. "It's Just What's in My Head." *New York Times,* 18 October 1970.

Greenberg, Clement. "Art." *The Nation,* 15 June 1946.

Greenough, Sarah. "The Letters of Georgia O'Keeffe." *Antiques,* November 1987.

Hall, Jim. "Memories of Georgia O'Keeffe." *Ghost Ranch Foundation Quarterly* 1 Spring 1986.

Jewell, Edward Alden. "A Family of Artists." *New York Times,* 28 February 1933.
———. "Adventures in the Active Realm of Art: Lost Chord Retrieved." *New York Times,* 24 February 1929.
———. "Autumn Art Show at American Place." *New York Times,* 18 October 1940.
———. "An American Place." *New York Times,* 4 February 1934.
———. "Another O'Keeffe Emerges." *New York Times,* 29 March 1933.
———. "Exhibition Offers Work by O'Keeffe: Modern Art Museum Presents a Chronological Showing of Woman Artist's Paintings." *New York Times,* 14 May 1946.
———. "Georgia O'Keeffe in an Art Review." *New York Times,* 2 February 1934.
———. "Georgia O'Keeffe, Mystic." *New York Times,* 22 January 1928.
———. "Georgia O'Keeffe Shows New Work: All but One Picture Exhibited at An American Place Was Painted Last Year." *New York Times,* 6 February 1937.
———. "O'Keeffe: Thirty Years." *New York Times,* 19 May 1946.

Johnston, David. "Portrait of the Artist and the Young Man." *Los Angeles Times,* 23 July 1987.

Keller, Allan. "Animal Skulls Fascinate Miss O'Keefe [*sic*], but Why?" *New York World-Telegram,* 13 February 1937.

Klein, Jerome. "Georgia O'Keeffe." *New York Post,* 20 February 1937.

Kotz, Mary Lynn. "A Day with Georgia O'Keeffe." *ARTnews,* December 1977.

Kramer, Hilton. "Georgia O'Keeffe." *New York Times Book Review,* 12 December 1976.

Luhan, Mabel Dodge. "Georgia O'Keeffe in Taos." *Creative Art,* June 1931.

Matthias, Blanche. "Georgia O'Keeffe and the Intimate Gallery." *Chicago Evening Post,* 2 March 1926.

McBride, Henry. "Curious Responses to Work of Miss O'Keefe [*sic*] on Others." *New York Herald,* 4 February 1923.
———. "Georgia O'Keeffe's Hawaii." *New York Sun,* 10 February 1940.
———. "Miss O'Keeffe's Bones: An Artist of the Western Plains Just Misses Going Abstract." *New York Sun,* 15 January 1944.
———. "O'Keeffe in Taos." *New York Sun,* 8 January 1930.
———. "O'Keeffe's Recent Work." *New York Sun,* 14 January 1928.
———. "Paintings by Georgia O'Keeffe: Her Symbols of Life in the Southwest Mysteriously Attract." *New York Sun,* 11 January 1936.
———. "Skeletons on the Plain." *New York Sun,* 1 January 1932.
———. "Skeletons on the Plain: Miss O'Keeffe Returns from the West with Gruesome Trophies." *New York Sun,* 2 January 1932.

———. "Star of An American Place Shines in Undiminished Luster." *New York Sun*, 14 January 1933.

Morris, George L. K. "To Georgia O'Keeffe: An American Place." *Partisan Review*, March 1938.

Mumford, Lewis. "The Art Galleries, Sacred and Profane." *The New Yorker*, 10 February 1934.

———. "Autobiographies in Paint." *The New Yorker*, 18 January 1936.

———. "Georgia O'Keeffe." *The New Yorker*, 9 February 1935.

———. "O'Keefe [*sic*] and Matisse." *New Republic*, 2 March 1927.

Norman, Dorothy. "From the Writings and Conversations of Alfred Stieglitz." *Twice-a-Year*, Fall–Winter 1938.

O'Brien, Frances. "Americans We Like: Georgia O'Keeffe." *The Nation*, 12 October 1927.

O'Keeffe, Georgia. "Alfred Stieglitz: His Pictures Collected Him." *New York Times Magazine*, 11 December 1949.

———. "Can a Photograph Have the Significance of Art?" *MSS.*, December 1922.

———. "Letter to the Art Editor." *New York Times*, 23 February 1941.

Plagens, Peter. "A Georgia O'Keeffe Retrospective in Texas." *Artforum*, May 1966.

Pollitzer, Anita. "Finally, a Woman on Paper." *American Review* [U.S. Office of War Information] 2 (1945).

———. "That's Georgia!" *Saturday Review*, 4 November 1950.

Rose, Barbara. "Georgia O'Keeffe, 1887–1986." *Vogue*, May 1986.

———. "The Great Big Little Paintings of Georgia O'Keeffe." *House & Garden*, December 1987.

———. "O'Keeffe's Trails." *New York Review of Books*, 31 March 1977.

Rosenfeld, Paul. "American Paintings." *The Dial*, December 1921.

———. "The Paintings of Georgia O'Keeffe." *Vanity Fair*, October 1922.

Schwartz, Sanford. "Georgia O'Keeffe Writes a Book." *The New Yorker*, 28 August 1978.

Strand, Paul. "Georgia O'Keeffe." *Playboy*, July 1924.

Strawn, Arthur. "O'Keeffe." *Outlook*, 22 January 1930.

Taylor, Carol. "Lady Dynamo." *New York World-Telegram*, 31 March 1945.

———. "Miss O'Keeffe, Noted Artist, Is a Feminist." *New York World-Telegram*, 31 March 1945.

Tomkins, Calvin. "Look to the Things Around You." *The New Yorker*, 16 September 1974.

———. "The Rose in the Eye Looked Pretty Fine." *The New Yorker*, 4 March 1974.

Tyrrell, Henry. "Esoteric Art at 291." *Christian Science Monitor*, 4 May 1917.

———. "Exhibitions and Other Things," *World*, 11 February 1922.

———. "Two Women Painters Lure with Suave Abstractions." *New York World*, 4 February 1923.

Warhol, Andy. "Georgia O'Keeffe and Juan Hamilton." *Interview*, September 1983.

Watson, Ernest. "Georgia O'Keeffe." *American Artist*, June 1943.

Willard, Charlotte. "Georgia O'Keeffe." *Art in America,* October 1963.

Wilson, Edmund. "The Stieglitz Exhibition." *New Republic,* 18 March 1925.
———. "Wanted: A City of the Spirit." *Vanity Fair,* January 1924.

Winsten, Archer. "Georgia O'Keeffe Tries to Begin Again in Bermuda." *New York Post,* 19 March 1934.

Books

Abrahams, Edward. *The Lyrical Left: Randolph Bourne and Alfred Stieglitz.* Charlottesville: University Press of Virginia, 1986.

Bell, Clive. *Art.* New York, 1913.

Brown, Milton, et al. *American Art.* New York: Abrams, 1979.

Bry, Doris. *Alfred Stieglitz: Photographer.* Boston: New York Graphic Society, 1965.

Castro, Jan Garden. *The Art and Life of Georgia O'Keeffe.* New York: Crown, 1985.

Chicago, Judy. *Through the Flower.* New York: Doubleday, 1975.
———. *The Dinner Party.* New York: Doubleday, 1979.

Cowart, Jack, Juan Hamilton, and Sarah Greenough. *Georgia O'Keeffe: Art and Letters.* Washington and Boston: New York Graphic Society/Little, Brown, 1987.

Dijkstra, Bram. *The Hieroglyphics of a New Speech: Cubism, Stieglitz, and the Early Poetry of William Carlos Williams.* Princeton: Princeton University Press, 1969.

Dow, Arthur. *Composition.* Garden City, N.Y., 1913.

Eldredge, Charles C. *Georgia O'Keeffe.* New York: Harry N. Abrams, 1991.

Eldredge, Charles C., Julie Schimmel, and William H. Truettner. *Art in New Mexico.* New York: Abbeville, 1986.

Eliot, Alexander. *Three Hundred Years of American Painting.* New York: Time-Life, 1957.

Foster, Joseph. *D. H. Lawrence in Taos.* Albuquerque: University of New Mexico Press, 1972.

Frank, Waldo, et al. *America and Alfred Stieglitz: A Collective Portrait.* New York: Doubleday, Doran, 1934.

Gallup, Donald C., ed. *The Flowers of Friendship.* New York: Knopf, 1953.
———. *Pigeons on the Granite.* New Haven: Beinecke Rare Book and Manuscript Library, Yale University, 1988.

Goodrich, Lloyd, and Doris Bry. *Georgia O'Keeffe: Retrospective Exhibition.* New York: Whitney Museum of American Art, 1970.

Green, Jonathan, ed. *Camera Work: A Critical Anthology.* Millerton, N.Y.: Aperture, 1973.

Greenough, Sarah, and Juan Hamilton. *Alfred Stieglitz: Photographs and Writings.* Washington, D.C.: National Gallery of Art, 1983.

Hahn, Emily. *Mabel: A Biography of Mabel Dodge Luhan.* Boston: Houghton Mifflin, 1977.

Harris, Ann Sutherland, and Linda Nochlin. *Women Artists, 1550–1950.* New York: Alfred A. Knopf, 1976.

Hartley, Marsden. *Adventures in the Arts*. New York: Boni & Liveright, 1921.

Haskell, Barbara. *Arthur Dove*. San Francisco: San Francisco Museum of Art, 1974.
———. *Charles Demuth*. New York: Whitney Museum of American Art/Harry N. Abrams, 1987.
———. *Marsden Hartley*. New York: Whitney Museum of American Art/New York University Press, 1980.
———. *Georgia O'Keeffe: Works on Paper*. Santa Fe: Museum of New Mexico Press, 1985.

Helm, Mackinley. *John Marin*. Boston: Pellegrini and Cudahy/Institute of Contemporary Art, 1948.

Hoffman, Katherine. *An Enduring Spirit: The Art of Georgia O'Keeffe*. Metuchen, N.J.: Scarecrow Press, 1984.

Homer, William Innes. *Alfred Stieglitz and the American Avant-Garde*. Boston: New York Graphic Society, 1977.
———. *Alfred Stieglitz and the Photo-Secession*. Boston: New York Graphic Society, 1983.

Johnson, Arthur W. *Arthur Wesley Dow: Historian, Artist, Teacher*. Ipswich, Mass.: Ipswich Historical Society, 1934.

Kandinsky, Wassily. *Concerning the Spiritual in Art*. New York: Dover, 1977.

Kerman, Cynthia Earl, and Richard Eldridge. *The Lives of Jean Toomer*. Baton Rouge: Louisiana State University Press, 1987.

Kuhn, Annette. *The Power of the Image: Essays on Representation and Sexuality*. London: Routledge and Kegan Paul, 1985.
———. *Women's Pictures*. London: Routledge and Kegan Paul, 1982.

Lippard, Lucy. *From the Center: Feminist Essays on Women's Art*. New York: E. P. Dutton, 1976.

Lisle, Laurie. *Portrait of an Artist: A Biography of Georgia O'Keeffe*. New York: Washington Square Press, 1981.

Longwell, Dennis. *Steichen: The Master Prints, 1895–1914, The Symbolist Period*. New York: Museum of Modern Art, 1978.

Lowe, Sue Davidson. *Stieglitz: A Memoir/Biography*. New York: Farrar, Straus and Giroux, 1983.

Luhan, Mabel Dodge. *Intimate Memoirs: Edge of the Taos Desert*. New York: Harcourt Brace, 1937.

Lynes, Barbara Buhler. *O'Keeffe, Stieglitz and the Critics, 1916–1929*. Ann Arbor, Mich.: UMI Research Press, 1989.

McBride, Henry. *Florine Stettheimer*. New York: Museum of Modern Art, 1946.

Messinger, Lisa Mintz. *Georgia O'Keeffe*. New York: Thames and Hudson and The Metropolitan Museum of Art, 1988.

Morgan, Ann Lee. *Arthur Dove: Life and Work*. Introduction by Roxana Barry (Robinson). Newark: University of Delaware Press, 1984.

Morgan, Ann Lee, ed. *Dear Stieglitz, Dear Dove*. Newark: University of Delaware Press, 1988.

Mumford, Lewis. *Findings and Keepings*. New York: Harcourt, Brace, 1975.

Newhall, Beaumont. *The History of Photography from 1839 to the Present Day.* Rev. ed. New York: Museum of Modern Art, 1964.

Norman, Dorothy. *Alfred Stieglitz: An American Seer.* New York: Random House, 1973.
———. *Alfred Stieglitz.* Millerton, N.Y.: Aperture, 1976.
———. *Dualities.* New York: An American Place, 1933.
———. *Encounters.* New York: Harcourt Brace Jovanovich, 1987.

Georgia O'Keeffe: A Portrait by Alfred Stieglitz. Introduction by Georgia O'Keeffe. New York: Metropolitan Museum of Art, 1978.

O'Keeffe, Georgia. *Georgia O'Keeffe.* New York: Viking, 1976; New York: Penguin Books, 1985.
———. *Introduction to Georgia O'Keeffe: A Portrait by Alfred Stieglitz,* n.p. New York: Metropolitan Museum of Art, 1978.
———. *Some Memories of Drawings.* New York: Atlantic Editions, 1974.

Pack, Arthur N. *We Called It Ghost Ranch.* Abiquiu, N.M.: Ghost Ranch Conference Center, 1966.

Paul Strand: Sixty Years of Photographs. Millerton, N.Y.: Aperture, 1976.

Pisano, Ronald G. *William Merritt Chase.* New York: Watson-Guptill, 1986.

Pollitzer, Anita. *A Woman on Paper: Georgia O'Keeffe.* New York: Simon & Schuster, 1988.

Reich, Sheldon. *John Marin: A Stylistic Analysis and a Catalogue Raisonné.* Tucson: University of Arizona Press, 1970.

Rich, Daniel Catton, ed. *The Flow of Art: Essays and Criticisms of Henry McBride.* New York: Atheneum, 1975.

Robinson, Roxana. *Georgia O'Keeffe: A Life.* New York: Harper & Row, 1989.

Rose, Barbara. *American Art since 1900: A Critical History.* Rev. ed. New York: Holt, Rinehart and Winston, 1975.
———. *American Painting: The Twentieth Century.* New York: Skira, Rizzoli, 1977.

Rubenstein, Meridel. *The Circles and the Symmetry,* Master's thesis, University of New Mexico, Albuquerque, 1977.

Rudnick, Lois P. *Mabel Dodge Luhan: New Woman, New Worlds.* Albuquerque: University of New Mexico Press, 1984.

Saville, Jennifer. *Georgia O'Keeffe, Paintings of Hawai'i.* Honolulu: Honolulu Academy of Arts, 1990.

Seligmann, Herbert J. *Alfred Stieglitz Talking.* New Haven: Yale University Library, 1966.
———. *Selected Letters of John Marin.* New York: An American Place, 1931.

Steichen, Edward. *A Life in Photography.* Garden City, N.Y.: Doubleday/Museum of Modern Art, 1963.

Tomlinson, Charles. *Some Americans: A Personal Record.* Berkeley: University of California Press, 1951.

Weigle, Marta, and Kyle Fiore. *Santa Fe and Taos: The Writer's Era, 1916–1941.* Santa Fe: Ancient City Press, 1982.

Weisberger, Edward, ed. *The Spiritual in Art: Abstract Painting, 1890–1985.* New York: Los Angeles County Museum of Art and Abbeville Press, 1986.

Wilson, Edmund. *The Thirties,* ed. Leon Edel. New York: Farrar, Straus, 1975.
————. *The Twenties,* ed. Leon Edel. New York: Farrar, Straus, 1975.

Exhibition Catalogues

Alfred Stieglitz Presents "Seven Americans." New York: The Anderson Galleries, 9 March–28 March 1925.

The Second Exhibition of Photography by Alfred Stieglitz. The Anderson Galleries, beginning 2 April 1923.

Alfred Stieglitz Presents One Hundred Pictures, Oils, Water-colors, Pastels, Drawings by Georgia O'Keeffe, American. The Anderson Galleries, 1923. (O'Keeffe Statement.)

Alfred Stieglitz Presents Fifty-one Recent Pictures, Oils, Water-colors, Pastels, Drawings by Georgia O'Keeffe, American. The Anderson Galleries, 1924. (O'Keeffe Statement.)

"About Myself." *Georgia O'Keeffe: Exhibition of Oils and Pastels.* New York: An American Place, 1939.

"About Painting Desert Bones." *Georgia O'Keeffe: Paintings—1943.* An American Place, 1944.

Fifty Recent Paintings by Georgia O'Keeffe. New York: Intimate Gallery, 11 February–11 March 1926.

Georgia O'Keeffe at An American Place: Forty-four Selected Paintings, 1915–1927. An American Place, 29 January–17 March 1934.

Georgia O'Keeffe: Catalogue of the Fourteenth Annual Exhibition of Paintings with Some Recent O'Keeffe Letters. An American Place, 1938.

Georgia O'Keeffe: Exhibition of Oils and Pastels. An American Place, 22 January–17 March 1939.

Georgia O'Keeffe: Exhibition of Oils and Pastels. An American Place, 1940. (O'Keeffe Statement.)

Georgia O'Keeffe: Exhibition of Paintings, 1919–1935. An American Place, 27 January–11 March 1935.

Georgia O'Keeffe: Exhibition of Recent Paintings, 1935. An American Place, 7 January–27 February 1936.

Georgia O'Keeffe: New Paintings. An American Place, 5 February–17 March 1937.

Georgia O'Keeffe: New Paintings. An American Place, 27 January–11 March 1941.

Georgia O'Keeffe Paintings. Intimate Gallery, 11 January–27 February 1927.

Georgia O'Keeffe Paintings, 1928. Intimate Gallery, 4 February–18 March 1929.

Georgia O'Keeffe: Paintings, 1942–1943. An American Place, 27 March–22 May 1943.

Georgia O'Keeffe Paintings: New and Some Old. An American Place, 7 January–22 February 1933.

O'Keeffe Exhibition. Intimate Gallery, January–February 1928.

Twenty-one New Paintings (Hawaii): Georgia O'Keeffe. An American Place, 1 February–17 March 1940.

About the Contributors

Mary E. Adams has been a teacher, journalist, editor at the University of New Mexico Press, and managing editor of *New Mexico Quarterly*. She is the author of profiles of many artists.

Marvin Bell has taught at Goddard College, the University of Hawaii, and the University of Washington and is currently Flannery O'Connor Professor of Letters at the University of Iowa. His most recent book of poetry, *Iris of Creation,* appeared from Copper Canyon Press in 1990.

Christopher Buckley teaches creative writing at West Chester University in Pennsylvania. He is the author of several books of poetry, including *Blossoms & Bones: On the Life and Work of Georgia O'Keeffe.*

Dan Budnik studied at the Art Students League in New York City and was an associate member of Magnum. He has photographed such artists as David Smith, Willem de Kooning, Jasper Johns, and Louise Nevelson, and his works appear in a number of publications, including *Look, Vogue,* and *Life.*

Alvaro Cardona-Hine is a poet and translator whose books include *The Gathering Wave, The Flesh of Utopia, Words on Paper, Two Elegies,* and *The Half-Eaten Angel.*

Anna C. Chave, an art historian, teaches in New York City. She is the author of *Mark Rothko: Subjects in Abstraction* and a forthcoming monograph on Brancusi, both from Yale University Press.

Alan Cheuse is the author of many books, including *The Bohemians, The Grandmother's Club, Fall Out of Heaven,* and *The Light Possessed.* A regular reviewer for National Public Radio's "All Things Considered," he teaches at George Mason University.

James Kraft, Assistant Director of Development and Membership at the Whitney Museum of American Art, is the author of the 1984 study *John Sloan, A Printmaker* and editor of the five-volume edition of *The Works of Witter Bynner.*

Laurie Lisle, a former reporter for *Newsweek,* is the author of *Portrait of An Artist* and a new biography of Louise Nevelson.

Sue Davidson Lowe has been a theater producer, translator, playwright, and landscape designer. The grandniece of Alfred Stieglitz, she is the author of *Stieglitz: A Memoir-Biography,* published in 1983 by Farrar, Straus and Giroux.

Barbara Buhler Lynes holds doctorates in French literature from the University of California, Riverside, and art history from Indiana University. She is Chairperson of the Art History Department at the Maryland Institute, College of Art and the author of *O'Keeffe, Stieglitz and the Critics, 1916–1929.*

Lisa M. Messinger, Assistant Curator, Department of Twentieth Century Art, Metropolitan Museum of Art, is the author of *Georgia O'Keeffe,* copublished with the Metropolitan Museum of Art, 1988.

Christine Taylor Patten is an artist who lives with her husband in northern New Mexico.

John D. Poling was a Fulbright Scholar in Denmark in 1989–1990. He teaches philosophy at Vanderbilt University, where he is completing his doctorate. "Painting with Georgia O'Keeffe" is part of a book-length meditation on the artist.

Melissa Pritchard received the Flannery O'Connor Award, the Carl Sandburg Literary Arts Award, and the PEN/Nelson Algren's honorary citation for *Spirit Seizures,* her first collection of short fiction. Her novel, *Phoenix,* was published in 1991.

Meridel Rubenstein is an artist using photography. After heading the photography program at San Francisco State University for five years, she is presently Professor of Art at the Institute of American Indian Arts in Santa Fe. A recipient of a Guggenheim Fellowship and several NEA grants, Rubenstein exhibits nationally on a registry basis.

Jennifer Saville is Curator of Western Art at the Honolulu Academy of Arts. She is the co-author of *19th and 20th Century European and American Prints from the Collection of the Honolulu Academy of Arts,* and author of *Georgia O'Keeffe: Paintings of Hawaii.*

Sharyn R. Udall is an art historian whose recent teaching and publications reflect special interest in the art of the American Southwest and in women in the arts. She is the author of *Modernist Painting in New Mexico 1913–1935.*

Marjorie Welish has written for *Art in America, Artsmagazine,* and *Craft Horizons.* She began exhibiting her own paintings in 1974, with her first solo show following soon after, in 1975, sponsored by the Whitney Museum Art Resources Center. Her books of poetry include *Handwritten* and *The Windows Flew Open.*

Terry Tempest Williams, naturalist-in-residence at the Utah Museum of Natural History, is the author of *Pieces of White Shell: A Journey to Navajoland*; children's books including *The Secret Language of Snow* and *Between Cattails*; a book about the Great Salt Lake, *Refuge*; and *Coyote's Canyon.*

MaLin Wilson, former Curator of Exhibitions at the Museum of Fine Arts, Museum of New Mexico, is now an art appraiser. She has held an NEA Fellowship in Arts Administration and written widely on contemporary art.

About the Contributors

About the Editors

Christopher Merrill is the author of two collections of poetry, *Workbook* and *Fevers & Tides,* and editor of several books, including *The Forgotten Language: Contemporary Poets and Nature* and *Outcroppings: John McPhee in the West.* He has been awarded the Pushcart Prize and an Ingram Merrill Fellowship in poetry.

Ellen Bradbury, Director of Recursos de Santa Fe, is the former director of the Museum of Fine Arts, Museum of New Mexico, and curator of Primitive Arts, Minneapolis Institute of Arts.

Index